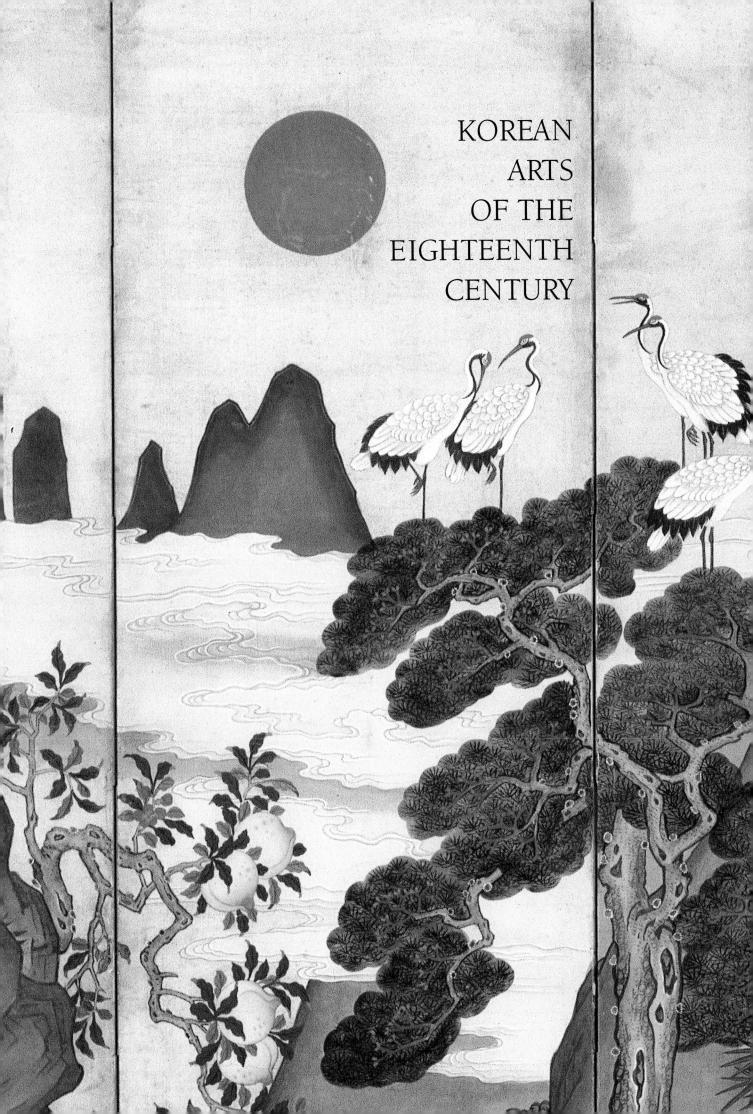

KOREAN
ARTS
OF THE
EIGHTEENTH
CENTURY

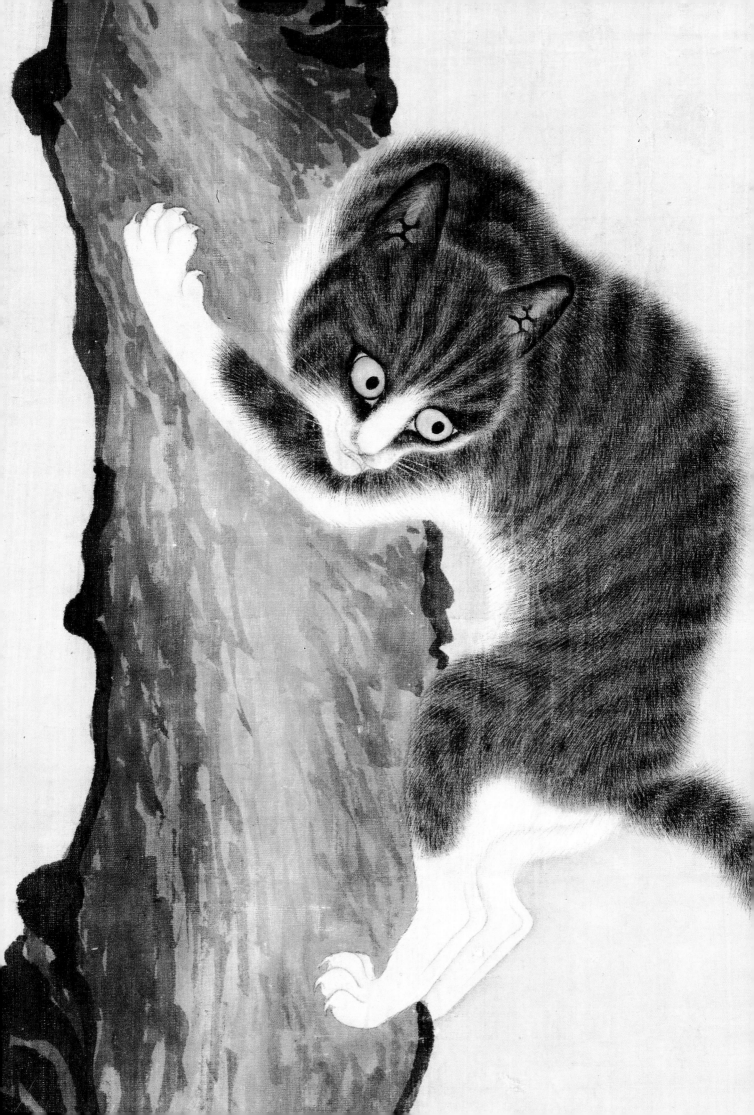

KOREAN ARTS OF THE EIGHTEENTH CENTURY

Splendor & Simplicity

Hongnam Kim, *Editor*

Curators
Chung Yang Mo
Kang Woo-bang
Hongnam Kim

Weatherhill, New York & Tokyo

The Asia Society Galleries, New York

Published by The Asia Society Galleries, New York
in association with Weatherhill, Inc., New York and Tokyo

Published on the occasion of
"Korean Arts of the Eighteenth Century: Splendor & Simplicity"
an exhibition organized by
The Asia Society Galleries, New York
in collaboration with the National Museum of Korea

The Asia Society Galleries, New York
October 3, 1993–January 2, 1994
The Arthur M. Sackler Gallery, Smithsonian Institution, Washington, D.C.
February 20–May 15, 1994
Los Angeles County Museum of Art
June 16–August 21, 1994

Editor: Joseph N. Newland
Copy Editor: Patricia Emerson
Publications Associate: Merantine Hens-Nolan
Production Assistant: Alexandra Johnson
Design: Dana Levy, Perpetua Press, Los Angeles
Typeset in Berkeley by Continental Typographics, Chatsworth, California
Printed and bound by Toppan Printing Company, Tokyo, Japan

The Asia Society Galleries
725 Park Avenue
New York, New York 10021

Weatherhill, Inc.
420 Madison Avenue
New York, New York 10017

Library of Congress Catalog Card Number 93-73084
ISBN: 0-87848-076-5 (The Asia Society Galleries)
ISBN: 0-8348-0293-7 (Weatherhill)

A modified form of the McCune-Reischauer system for romanizing
Korean has been used in this book. Historical Korean names
appear in a standardized form and names of living persons in the
form they prefer.

FRONT COVER: No. 23, *Sun, Moon, and Immortal Peaches* (detail).
The Royal Museum, Seoul.

BACK COVER: No. 25, *Jar with Dragons*.
National Museum of Korea, Seoul.

HALF-TITLE PAGE: No. 18, *Ten Longevity Symbols* (detail).
Ho-Am Art Museum, Yongin.

TITLE PAGE: No. 85, *Cats and Sparrows* (detail), Pyŏn Sangbyŏk.
National Museum of Korea, Seoul.

PAGE 6: No. 54, *Twelve Thousand Peaks of Mount Kŭmgang*,
Chŏng Sŏn. Ho-Am Art Museum, Yongin.

Contents

7 Messages
Lee Min-Sup, Nicholas Platt, Geoffrey C. Bible

10 Preface
Chung Yang Mo

11 Foreword
Vishakha N. Desai

13 Acknowledgments
Hongnam Kim

16 Funding Acknowledgments

17 Lenders to the Exhibition

19 Map

23 Rescoring the Universal in a Korean Mode: Eighteenth-Century Korean Culture
JaHyun Kim Haboush

35 Exploring Eighteenth-Century Court Arts
Hongnam Kim

59 The Art of Everyday Life
Chung Yang Mo

79 Ritual and Art During the Eighteenth Century
Kang Woo-bang

99 Plates

203 Checklist of the Exhibition with Selected Entries

236 Select Bibliography

238 Index of Works Illustrated

239 Contributors

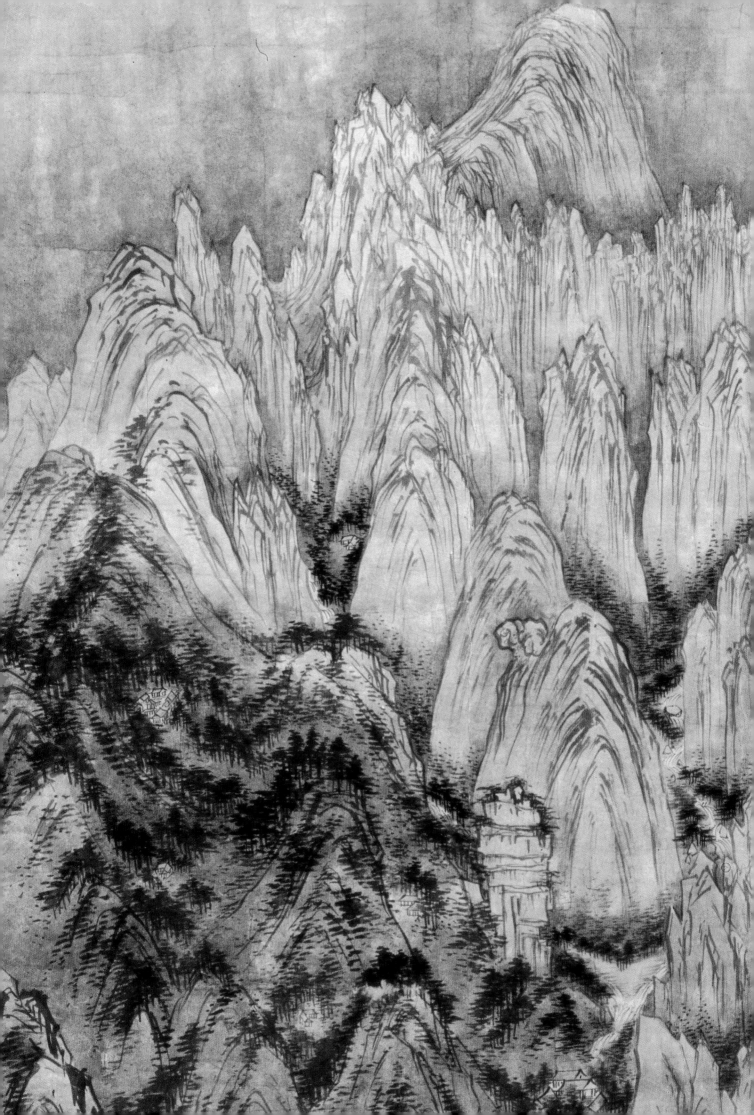

Messages

THE EXHIBITION "Korean Arts of the Eighteenth Century: Splendor & Simplicity" features the arts of the century known as the Renaissance of the Chosŏn dynasty, which lasted from 1392 to 1910. The exhibition displays the mutual influences of the arts created for the palace, religious institutions, and society at large during a century of special significance to Korean culture.

There have been a number of exhibitions of Korean historical relics. This, however, is the first time that an exhibition of this magnitude focused on such a specific period has ever been mounted; this indicates that the relationship between the United States and Korea, and the degree of understanding between the two countries, has matured. A long and friendly relationship, developed with mutual confidence politically and economically, has now gone one step further, and we are in a position to exchange artistic works representing the highest levels of our cultural and spiritual values. This exhibition is being presented as a part of the Festival of Korea, in which Korean classical music, dance, and other traditional performing arts as well as a variety of lecture series on current issues are being offered to the public across America. I sincerely believe that these events will make a significant contribution toward further improving the relationship between our two countries.

I would like to take this opportunity to express deep gratitude to The Asia Society, who initiated the festival and the exhibition, and to the National Museum of Korea, who cosponsored them, as well as to the many other Korean and American organizations and the individuals who gave significant financial assistance as well as those who organized Korea-related events throughout the United States.

LEE MIN-SUP
Minister of Culture and Sports
Republic of Korea

THE ASIA SOCIETY is proud to present the nationwide Festival of Korea, the single largest program of Korean cultural events ever held in the United States. At the heart of this year-long celebration is the magnificent exhibition, "Korean Arts of the Eighteenth Century: Splendor & Simplicity." Organized in collaboration with the National Museum of Korea, this unprecedented exhibition highlights one of the most vibrant periods in Korean history. We are grateful to the government of the Republic of Korea for agreeing to lend these rare and beautiful masterpieces, many of which have never been seen outside of Korea.

It is our hope that the exhibition and all other programs of the Festival—ranging from performances of traditional dance and music to symposia on Korea's past and present to programs dealing with the Korean American experience—will provide a better understanding of this important East Asian culture.

NICHOLAS PLATT
President
The Asia Society

THE YEAR-LONG Festival of Korea brings to the United States an unprecedented array of art treasures and performing arts, thus giving Americans a remarkable opportunity to become better acquainted with Korea's unique history and its importance in Asian culture.

The exhibition documented by this catalogue, "Korean Arts of the Eighteenth Century: Splendor & Simplicity," is one of the Festival's highlights in its own right. It captures a society in the midst of social and intellectual discovery, and it celebrates Korea's special contributions during an era of worldwide change.

At Philip Morris Companies Inc., we know that the cultural worlds of dance, painting, music, and sculpture are not only enjoyable in themselves; they also lead us to better communication with and understanding of those with whom we share this ever-shrinking globe. And so we are delighted to join The Asia Society in making it possible for Americans to enjoy this vast and varied display of Korean culture and to learn more about a country that has contributed so much to our nation and the world.

GEOFFREY C. BIBLE
Executive Vice President
Philip Morris Companies Inc.

Philip Morris Companies Inc.
Celebrating thirty-five years of support of the arts

Preface

CLOSE FRIENDSHIP between two nations is made possible by the understanding of each other's culture. Moreover, a concern with and an understanding of traditional rather than only contemporary culture deepens such friendship: the finest cultural legacy of a people transcends obstacles of racial and national difference. In two previous exhibitions loaned by Korea to the United States, "Masterpieces of Korean Art" (1957) and "5000 Years of Korean Art" (1979–81), the historical development, achievements, and essence of Korean art were shown, and it is well known that these exhibitions contributed to the increasing understanding between our two countries.

As you may know, the eighteenth century was a remarkable period in which Korea's individuality and originality were asserted throughout the entire culture and all the arts. In 1989, The Asia Society Galleries' international symposium on the period created a sensation and stimulated interest in eighteenth-century Korean culture. Building on this, it is deeply meaningful that "Korean Arts of the Eighteenth Century: Splendor & Simplicity" has been organized and presented through the joint sponsorship of the National Museum of Korea in response to The Asia Society Galleries' initiative.

This exhibition has added luster because it opens at The Asia Society in New York—which has a proud history and tradition of promoting the study of Asian culture in the United States and throughout the world—and then proceeds to the Arthur M. Sackler Gallery of the Smithsonian Institution in Washington, D.C., and the Los Angeles County Museum of Art. This national loan exhibition differs from its predecessors and has great significance because three aspects—royal, religious, and popular—of the arts of one period, the eighteenth century, are systematically exhibited.

I should like to thank The Asia Society Galleries and their supporters, and the persons involved throughout the United States, for sponsoring this cultural interchange. I believe that this exhibition will make a great contribution toward increased friendship and mutual understanding between both peoples.

CHUNG YANG MO
Director General
National Museum of Korea

Foreword

MORE THAN six years in the making, "Korean Arts of the Eighteenth Century: Splendor & Simplicity," opens to American audiences as one of the highlights of the year-long Festival of Korea. This nationwide celebration is designed to illuminate the best artistic and cultural traditions of this economically powerful but too-little understood nation with its own strong and distinctive cultural roots.

In the popular Western imagination, Korea is often seen as an intermediary between the East Asian cultures of China and Japan. This has led to a certain lack of knowledge about and interest in the arts of the Korean peninsula in the United States. Among the most effective ways to redress such a lack and promote greater awareness of a culture is through the presentation of its finest artistic traditions. This exhibition, with its splendid screens and elegant objects from one of the most important eras of Korean history, is offered in that spirit.

Korean scholars have begun to acknowledge the eighteenth century as one of the most crucial and productive periods for Korean arts. A time of peace and prosperity, the eighteenth century witnessed the flowering of many different art forms, ranging from paintings of Korean landscapes and genre scenes to distinctive forms of ceramics, furniture, lacquerware, sculpture, textiles, and calligraphy. Not only the members of the Chosŏn court but also the scholar-officials and the newly emerging professional classes began to patronize artistic production of great aesthetic merit. The vibrancy of this burgeoning culture and its interaction with the artistic traditions of the court as well as the dynamism of the period's religious syncretism—distinguishing characteristics of eighteenth-century Korea—are the themes behind the selection of the extraordinary objects brought together for this exhibition.

The planning for "Korean Arts of the Eighteenth Century: Splendor & Simplicity" had been underway for some time when I came to The Asia Society Galleries in 1990. It has been a pleasure to work with the team of distinguished Korean curators to bring the project to fruition. Many different colleagues, friends, and supporters have been instrumental in ensuring its success. Dr. Hongnam Kim has thanked most of them in her acknowledgements, but I would like to add my own words of thanks. To begin with, Hongnam Kim, guest curator, deserves special kudos for seeing the project through its various incarnations and for her perseverance despite the difficulties of planning and coordinating such a complex project.

Mr. Chung Yang Mo, now the director general of the National Museum of Korea, and Mr. Kang Woo-bang, now the chief curator, have been enthusiastic and supportive colleagues. I am grateful for their help in

all aspects of the exhibition, from organizing and negotiating the loans to helping provide a conceptual framework for the exhibition. Above all, it was the commitment of the National Museum, first under the leadership of Director General Han Byong-sam and now under the guidance of Dr. Chung, that made it possible for us to move ahead with confidence. I should also like to thank the hard-working staff members of the National Museum and other Korean colleagues who assisted with the project.

At The Asia Society, Nicholas Platt, president, continuously provided enthusiastic support for such a mammoth project. The entire Festival of Korea was conceived under the leadership of Marshall M. Bouton, the Society's executive vice president, and he deserves special gratitude for his advice and constructive suggestions. I am also grateful to colleagues from other departments—Performance, Films, and Lectures; Development; Finance; Public Relations; and Regional Centers—for their cooperation. Special thanks are in order for Namji Steinemann and the Festival of Korea staff for their support in coordinating numerous program details. Most of all, I am grateful to the staff of the Galleries, who have, as usual, produced miracles. I continue to feel blessed by their commitment to making Asian arts exciting and accessible to a wide public.

In addition to the help provided by our colleagues at the National Museum, we have benefitted from the support and advice of many individuals in Korea. Members of the exhibition's advisory committee, catalogue contributors, and representatives from the Ministry of Culture and Sports and the Ministry of Information have been helpful in many ways. Our special gratitude goes to Park Shinil, minister for public affairs at the Embassy of the Republic of Korea in Washington, D.C. His deep commitment to making the Festival of Korea a reality and his unerring support of the exhibition were particularly helpful during the inevitable difficult phases of such a complex undertaking.

The exhibition and programs of the Festival of Korea have been supported by a large group of donors. They are listed on a separate page, however, special mention must be made of Philip Morris Companies Inc., the principal sponsor of the Festival and the exhibition. Crucial additional support came from the Korea Foundation, the National Endowment for the Humanities, the National Endowment for the Arts, and an indemnity from the Federal Council on the Arts and Humanities.

In addition to The Asia Society Galleries, the exhibition will be seen at the Arthur M. Sackler Gallery, Smithsonian Institution, Washington, D.C., and at the Los Angeles County Museum of Art; our gratitude is due to Milo C. Beach and Michael E. Shapiro, directors of these two museums. In Washington and Los Angeles, the exhibition will be presented in conjunction with a wide variety of programs organized by each city's Asia Society regional center.

In all three cities—New York, Washington, and Los Angeles—the exhibition and related programs will provide a sense of the distinctiveness of Korean arts and culture within the East Asian tradition. We hope that through the Festival of Korea Americans will gain a better appreciation of Korea's distinguished culture and Korean Americans will be proud to share their rich cultural heritage.

VISHAKHA N. DESAI
Director, Galleries
Vice President for Program Coordination
The Asia Society

Acknowledgments

THIS EXHIBITION originated at a meeting in Seoul in the summer of 1987 between Dr. Andrew Pekarik, then director of The Asia Society Galleries, and Mr. Han Byong-sam, then director general of the National Museum of Korea. Andy asked for the National Museum's help in organizing a Korean art exhibition for The Asia Society Galleries, and both agreed it should focus on the eighteenth century, an important cultural era in Korean history. In the spring of 1988, the Galleries organized an international symposium, "Eighteenth-Century Korean Art," which proved the topic to be promising and worthwhile for an exhibition. I was entrusted with the task of organizing the symposium and preparing the exhibition, for which I am deeply thankful to Andy. This exhibition would not have been possible, however, without the ensuing cooperation and encouragement of many people in Korea and the United States.

No words can fully express my gratitude to Dr. Vishakha N. Desai, The Asia Society Galleries' present director, and my friends and colleagues at the Galleries who constituted the project team. I worked on it as the Galleries' curator until the spring of 1991, when I moved to Seoul and carried on as guest curator. Although this move had many positive aspects, the sheer distance between the Galleries' staff and myself often made things difficult. But they all persevered. Vishakha took over as project director with her truly dynamic leadership—I traveled twice with her to important sites in Korea, and she contributed many constructive ideas that helped shape the exhibition.

Expert fund-raising support was provided by Carol Wenzel-Rider and Dr. Nicolas G. Schidlovsky. Mirza Burgos, assistant to Vishakha Desai, made everything go smoothly. Nancy Blume's support never failed me, and her enthusiasm in coordinating the Galleries' tour program will make the exhibition an educational experience for many visitors. Yong-ah Han, Soyoung Lee, and Judy Kim generously offered their unflagging support either in New York or Seoul.

The Galleries have a superb publications team, Joseph N. Newland and Merantine Hens-Nolan, who have been ably assisted by Alexandra Johnson. Joseph recently joined the Galleries as publications manager, and I am quite certain this catalogue would not have been realized in time for the exhibition if not for his dedication. Essay and entry texts written in Korean were translated by Soyoung Lee, Mr. K. S. Lee, Dr. S. K. Shin (through Chuck Scott of Lingua Mundi), and Chee-yun Kwon, and their care and patience were crucial to this book. Chee-yun Kwon was especially helpful in many aspects. Irmgard Lochner drew the map. Patricia Emerson's expert copy editing was appreciated by all the authors, and the graphic design of Dana Levy of Perpetua Press presents the artworks and ideas to best advantage.

Dr. Denise Patry Leidy, curator of the Galleries, effectively coordinated the installation and wrote the brochure and in-gallery texts with the curatorial assistance of Richard A. Pegg and intern Chana Motobu. Amy V. McEwen's dedication as registrar ensured that the detailed logistics went smoothly and the objects were safe. Cleo Nichols and his installation team adroitly shaped numerous fragmentary ideas and architectural details into a unified whole. The exhibition graphics were coordinated by the highly capable Merantine Hens-Nolan and designed with grace by Eileen Boxer.

Thanks are also due to Milo C. Beach, Louise Cort, Jan Stuart, and Patrick Sears at the Arthur M. Sackler Gallery, Smithsonian Institution; and to Michael E. Shapiro, George Kuwayama, June Li, and Arthur Owens at the Los Angeles County Museum of Art.

In Korea, I would like to acknowledge the National Museum of Korea and its staff for their cooperation. The National Museum is the co-organizer of and biggest lender to the exhibition, and two key members of its staff served as co-curators of the exhibition and authors of essays for the catalogue: Mr. Chung Yang Mo, director general, and Mr. Kang Woo-bang, chief curator. Mr. Chung's encyclopedic knowledge of and contacts with domestic collections greatly facilitated loan negotiations. With his characteristic ease, Mr. Kang sustained the National Museum's constructive role, which was vital to the evolution of the exhibition. All three of us were helped immensely by the museum staff, particularly Mr. Kwon Seung-hwan and Ms. Yeon-soo Kim, two dedicated and capable art historians in the Fine Arts Department who handled endless details with grace and aplomb. Indispensable assistance was provided by my students Shin Ji-yong and Chun Inji.

Thanks are also due to Mr. Han Seok Hong and his staff for producing fine photographs for the catalogue illustrations. For one of the most difficult photographic projects outside of Seoul, Mr. Han, Mr. Newland, and Ms. Kim were provided crucial help by Mr. Ji Gon-gil, Director of the Kwangju National Museum, to whom we are very grateful. Mr. Han Young-hee, director of the Chonju National Museum, was helpful as well. Thanks are owed to all other staff of the National Museum in the Registrar's Department and the Cultural Exchange and Education Division who extended their help in various ways. Special mention should be made of the unwavering support of three scholars who guided and encouraged me from the beginning: Drs. Hwi-joon Ahn, Yi Sŏng-Mi, and Lena Kim. I am also grateful to those scholars and friends who supported the project by contributing to the catalogue: Professors JaHyun Kim Haboush, Yi Sŏng-Mi, Hong Sun Pyo, Cho Sunmie, and Park Young-kyu.

Mr. Shin Young Hoon generously shared his expertise in traditional architecture to help establish the overall concept and details of the installation design. In this task, Mr. Shin and I were also aided by Mr. Yu Mun-yong, who was responsible for the production of architectural details for the installation.

I would like to thank the Ministry of Culture, the Bureau of Cultural Properties, and the Ministry of Foreign Affairs for their help in organizing this exhibition; in particular, Messrs. Yi Chanyong and Park Shinil offered their unflagging support.

The lenders to the exhibition, thirty-one in Korea and two in the United States, are listed elsewhere, and on behalf of all those privileged to see the exhibition, I would like to thank them for parting with their precious objects for over a year so that they could be seen in Seoul, New York, Washington, and Los Angeles.

I feel special gratitude and affection for those who have offered me encouragement and friendship: Julia Meech, Mrs. Jackson Burke, Marilyn and William Gleystein, and Suyoun and Jean Locks. I would also like to thank Mr. Song Duck Young, president of Philip Morris of Korea, for his generous support.

My very special thanks go to Jeff and all my family, who have supported me but could not see much of me over the last two years.

As this exhibition is organized thematically and for necessarily limited spaces, the curatorial process had to be selective, and the works included represent only a small portion of the wealth of material from eighteenth-century Korea, which set the mold for the arts of the late Chosŏn period that remained essentially unchanged in subject matter and style (allowing the inclusion of a few later works in the exhibition). Yet these objects help to evoke some of the colors, textures, and shapes of the life-styles and arts that are now largely lost. "Korean Arts of the Eighteenth Century: Splendor & Simplicity" is the first exhibition in Korea and abroad to illuminate Chosŏn-period art as an artistic entity of a very special sort, a vital and important chapter of the Asian culture before its rapid westernization. We all hope that this exhibition will advance the American public's understanding of Korean culture and art and that it will contribute to Korean studies in America, especially in the history of art, by providing an in-depth look at one of the most important eras in Korea's history.

HONGNAM KIM

Funding Acknowledgments

Korean Arts of the Eighteenth Century: Splendor & Simplicity is the catalogue of an exhibition organized by The Asia Society Galleries in collaboration with the National Museum of Korea. The exhibition is part of the nationwide Festival of Korea, organized by The Asia Society, New York, and the regional centers of The Asia Society located in Washington, D.C., Los Angeles, and Houston.

The Asia Society's Festival of Korea is sponsored by
Philip Morris Companies Inc.

Major additional funding for the Festival of Korea is provided by Korea Foundation, The Korea Chamber of Commerce and Industry, The Federation of Korean Industries, and the Korea Foreign Trade Association.

Korean Arts of the Eighteenth Century: Splendor & Simplicity is also supported by grants from the National Endowment for the Humanities and the National Endowment for the Arts. Additional funding is provided by the Friends of The Asia Society Galleries, The Starr Foundation, the Arthur Ross Foundation, the New York State Council on the Arts, and the Marian Locks Foundation. The exhibition is also supported by an indemnity from the Federal Council on the Arts and Humanities.

Lenders to the Exhibition

Ch'angdŏk Palace, Seoul

Ch'angkyŏng Palace, Seoul

Changsŏgak Collection, The Academy of Korean
Studies, Sŏngnam

Choi Su-jŏng, Seoul

Chŏng Kap-bong, Seoul

Chŏng So-hyon, Seoul

Chung Hwan-kook, Seoul

Dŏkwŏn Art Museum, Seoul

Dongguk University Museum, Seoul

Hae-kang Museum, Ich'ŏn

Ho-Am Art Museum, Yongin

Huh Dong Hwa, Seoul

Im Kŭm-hŭi, Seoul

Florence and Herbert Irving Collection

Jong-myo, Seoul

Kansong Art Museum, Seoul

Kim Ki-su, Seoul

Kwŏn Ok-yŏn, Seoul

Lee Hak, Seoul

Lee Wŏn-ki, Seoul

Namkung Lyŏn, Seoul

National Folk Museum of Korea, Seoul

National Museum of Korea, Seoul

Onyang Folk Museum, Onyang

Philadelphia Museum of Art

The Royal Museum, Seoul

Seoul National University Museum

Song-am Art Museum, Inch'ŏn

Sŏng-sin Women's University Museum, Seoul

Yŏnsei University Museum, Seoul

Yun Hyong-keun, Seoul

Yun Yŏng-sŏn, Haenam

Zozayong, Po-Eun

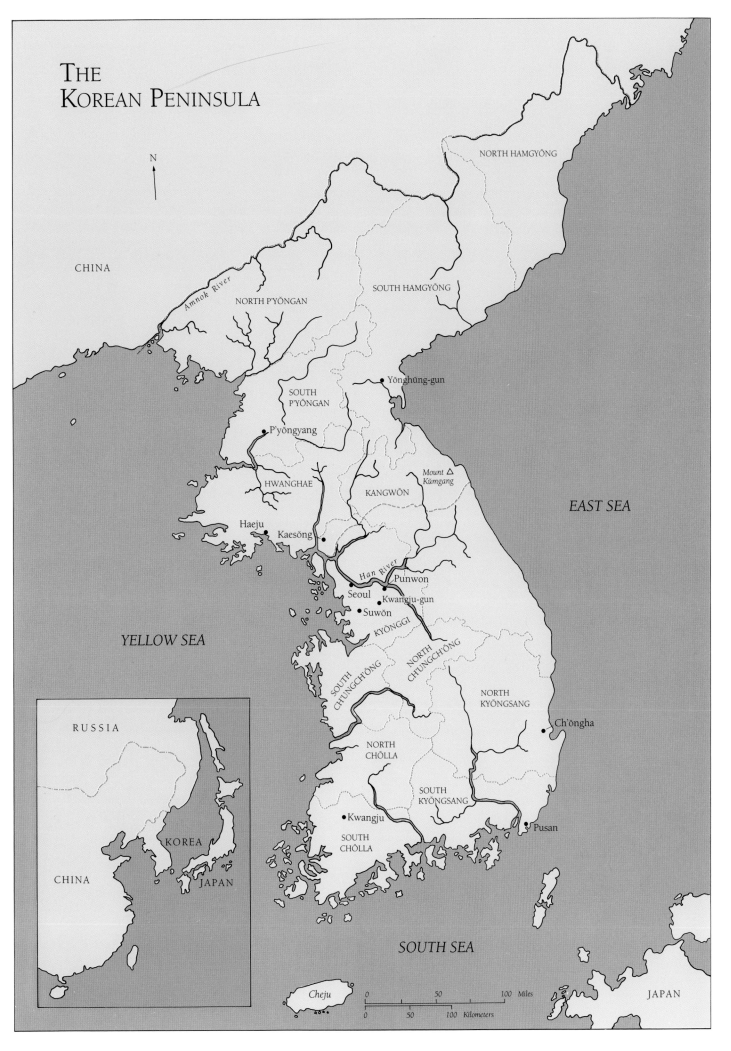

THE
KOREAN PENINSULA

N

CHINA

Amnok River

NORTH HAMGYŎNG

NORTH P'YŎNGAN

SOUTH HAMGYŎNG

SOUTH P'YŎNGAN

Yŏnghŭng-gun

P'yŏngyang

HWANGHAE

Mount △
Kŭmgang

KANGWŎN

EAST SEA

Haeju

Kaesŏng

Han River

Punwon

Seoul

Kwangju-gun

Suwŏn

KYŎNGGI

YELLOW SEA

SOUTH
CH'UNGCH'ŎNG

NORTH
CH'UNGCH'ŎNG

NORTH
KYŎNGSANG

Ch'ŏngha

NORTH
CHŎLLA

SOUTH
KYŎNGSANG

Kwangju

Pusan

SOUTH
CHŎLLA

SOUTH SEA

RUSSIA

KOREA

CHINA

JAPAN

JAPAN

Cheju

| 0 | | 50 | | 100 Miles |

| 0 | 50 | 100 Kilometers |

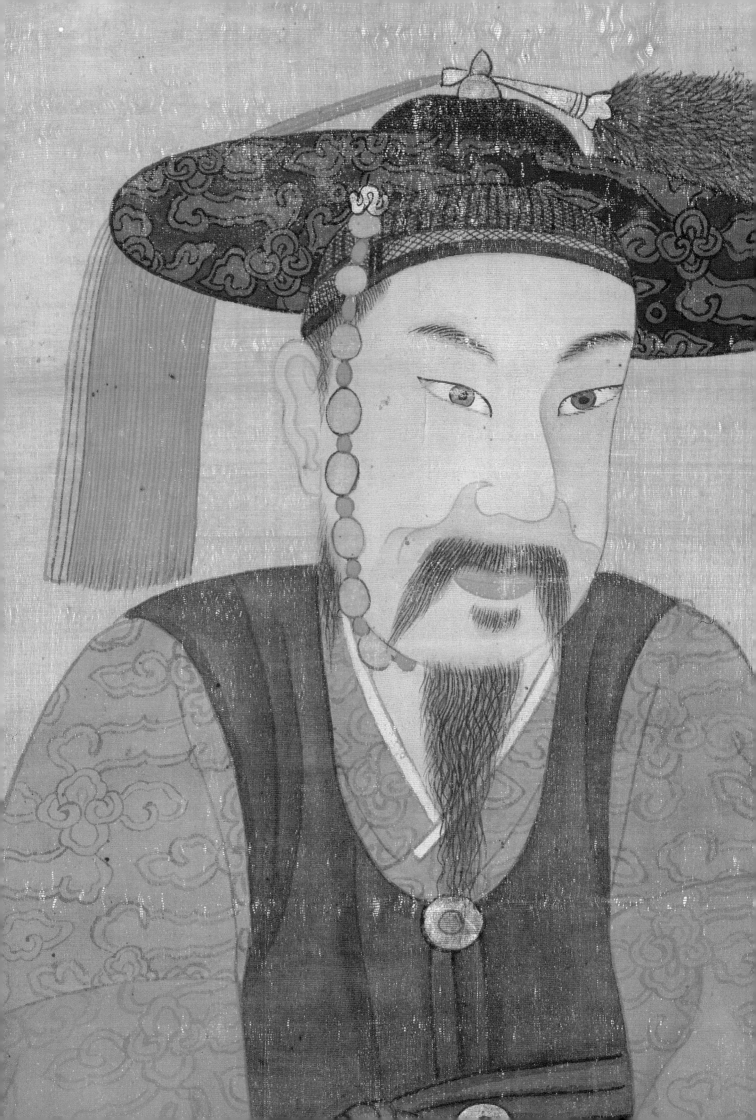

KOREAN
ARTS
OF THE
EIGHTEENTH
CENTURY *Splendor*
&
Simplicity

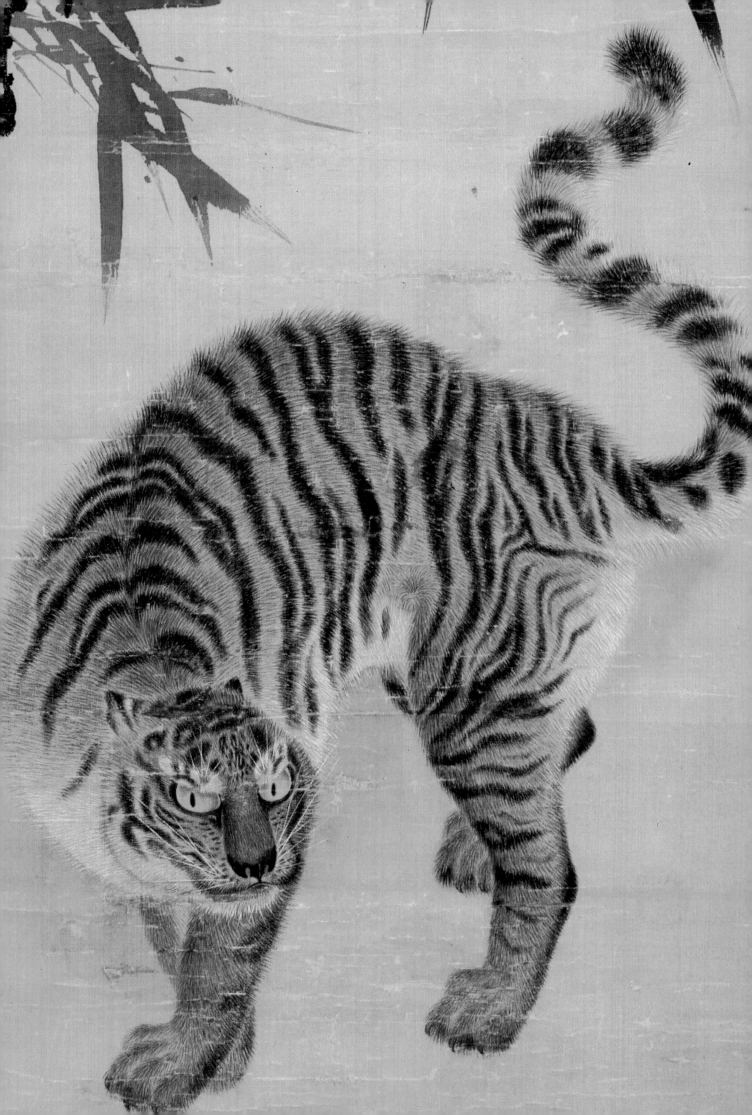

Rescoring the Universal in a Korean Mode

EIGHTEENTH-CENTURY KOREAN CULTURE

JaHyun Kim Haboush

A T FIRST GLANCE, the eighteenth century in Korea appears to fit the image routinely used to depict mainland East Asia during this period—an age of peace and prosperity exulting in and drawing strength from tradition, which nonetheless contained the contradictions and seeds of decline that would manifest themselves in the nineteenth century. In other words, it is seen as the last glorious age before the collapse brought about by the pressures of modernization and the West. This picture, however, is based upon historical hindsight rather than an understanding of the period. Although eighteenth-century Korea had its share of tension and contradictions, it was nonetheless a vibrant time, full of vigor and spirit. This vibrancy, in fact, seems to have sprung from those contradictions and the balance that was struck and maintained between them. Creative energies were sustained by the tensions between the monarchy and the bureaucracy, between nativism and universalism, between the great activity in classical scholarship and the rise of vernacular literature and art, and between the commitment to tradition and the search for innovation.

This age was distinguished by the particular way in which Koreans understood what was internal and external to the complex cultural structure that encompassed Korean tradition and Confucian civilization. By this time, Koreans had come to view Korea as the last bastion of Confucian civilization. But this belief in their land as the repository of civilization led to a celebration of things Korean. In this sense, the eighteenth century, often referred to as the latter-day golden age of Chosŏn history, seems to have been a mirror image of the golden age of the fifteenth century.

59. TIGER AND BAMBOO (DETAIL)

The Chosŏn dynasty (1392–1910) was founded with dual claims. During its last century and a half, the Koryŏ dynasty (918–1392) had been compromised by subjugation to Mongol rule. Thus, the emergent dynasty was to reclaim Korea's native heritage while affirming the country's role in the larger civilization by perfecting the Confucian order. From its inception, the Chosŏn government embarked on a massive and ambitious plan to transform Korea into a Confucian normative society.[1] It was not until the fifteenth century, however, under such able rulers as King Sejong (r. 1418–50) and King Sŏngjong (r. 1469–94), that the Chosŏn court systematically defined rituals and norms based on Confucian principles. The completion of the *Kyŏngguk taejŏn* (*National Code*) in 1474 was one such accomplishment. The first comprehensive legal code of the Chosŏn dynasty, the *Kyŏngguk taejŏn* constructs an integrated vision of the Chosŏn dynastic and social order.[2] This code clearly displays a Korean commitment to join the larger world, and this seems to have been a dominating spirit of the time. According to this scheme, local customs were to be adapted to Confucian norms, which were seen as universal and more civilized than local conventions. It is interesting to contemplate the mid-fifteenth-century invention of the Korean alphabet, the *han'gŭl* script, in this context. Even though it is difficult to perceive the invention of the *han'gŭl* script as anything other than an affirmation of a distinct, indigenous Korean culture, the project, ostensibly, was carried out in order to facilitate the Confucian education of the public. Paradoxically, qualities intrinsic to Korea were tapped as a means of universalizing Korean culture.

By the eighteenth century, Korea's notions concerning its own culture within the framework of Confucian civilization had undergone fundamental changes. At this time, Koreans not only believed that they embodied and were guided by Confucianism but that they were possibly its only authentic adherents. This perception had come about as a result of changes in the world order—the fall of the Ming dynasty (1368–1644) and the conquest of China by the Manchus in 1644—and was certainly buttressed by centuries of Confucianization, which had substantially transformed Korea into a normative Confucian society. The Manchu conquest of China had far-reaching consequences, not only for China but also for the rest of the region. The non-Chinese rule of China called into question its role as the leader and center of civilization, thereby changing the contours of East Asia.

Koreans seem to have felt this most keenly. Chosŏn Korea had been bound to Ming China by historical and ideological affinity. Although there had been inevitable tension between these two neighboring countries of unequal strength and status, Koreans had accepted the Ming dynasty as the rightful heir to Chinese tradition and the leader and center of civilization. Therefore, the demise of the Ming dynasty was seen as the loss of civilization at its very center. The sense of privation was comparable to that experienced by the Christian world after the loss of the Holy Land to the Muslim world. Challenged and threatened, Korea began to redefine its rôle in this new world order. The entire educated class grappled with such issues as the definition of civilization, ways in which Korea could perpetuate it, and the function of disparate groups in this endeavor. The power of the monarchy and the bureaucracy was contested and readjusted. Divisions within the scholarly community were deepened and became more acrimonious. The latter half of the seventeenth century and the early decades of the eighteenth were among the most volatile, bloody, and factional periods of Chosŏn political history.[3]

In the early eighteenth century, Korea had emerged with what appears to have been renewed self-confidence, based on an awareness of its resilience and strength rather than the unbounded exuberance and optimism of the earlier age. Trauma and upheaval had done their worst; yet Korea survived. The perseverance of the Chosŏn dynasty set Korea apart from China or Japan. Both had undergone a change of dynasties or shogunates during the seventeenth century. Indeed, Korea had suffered incursions—the Japanese invasions of the 1590s had escalated into a full-fledged Asian war, which also involved China, and the Manchu invasions of 1627 and 1636 had led to the capitulation of the Korean court. These wars definitely had devastating effects. But as the ruinous effects of war healed, Koreans seem to have experienced an unmistakable sense of exhilaration at their good fortune. Surely there was a recognition of a dark reality—the imperfectness in the larger world and the precarious state of civilization—but this was countered by the mission to safeguard civilization within Korea. The absence of cultural leadership by Manchu-dominated China freed Korea from the need for validation according to universal standards applied from beyond. No longer on the periphery, the Korean state was equated with civilization. Korean attributes were invested with new meaning and deemed to exemplify culture and tradition; universal norms were recast in a Korean mold.

King Yŏngjo's accession (r. 1724–76) ushered in an era of rejuvenation, which seems to have continued until the end of the reign of his successor, King Chŏngjo (r. 1776–1800). Both kings, who are remembered as two of the most brilliant Chosŏn rulers, had to perform demanding, diverse, and immediate tasks. The contentious court, which had been ravaged by decades of factional politics, had to be stabilized. Yŏngjo enforced a fairly successful containment policy. The court was still less than harmonious, but at least the bloody purges had come to an end.[4] This was also a time of profound social change. The unitary tax reform of the seventeenth century, which had changed tax collection from levying in kind to levying in a uniform currency,[5] accelerated the growth of a market economy.[6] Education became widespread. Society had come to be more multifaceted and multilayered than before. New policies or reforms were devised to meet these challenges. Both Yŏngjo and Chŏngjo proved to be activist rulers who energetically engaged in social policy, but some of the challenges facing them tested the limits of their leadership. The military tax reform of 1751[7] and the repeated attempts to curtail the proliferation of private academies[8] pitted them against the entrenched *yangban*, the hereditary aristocracy. Consequently, these kings sought to strengthen their bases of power and utilized the symbols of authority at their disposal.

Yŏngjo and Chŏngjo were consummately skillful in utilizing disparate sources to construct their images. The Confucian monarchy was in essence a theocracy in which the ruler acted as a mediator between the cosmos and the people. The Chosŏn kings were, undoubtedly, mindful of this, but after the Manchu conquest of China, they set about appropriating the cosmic symbols of kingship. For instance, Sun, Moon, and Five Peaks screens seem to have adorned the throne much more ubiquitously and prominently during the eighteenth century. The Korean kings also ritualized the Yi royal house's spiritual heirship to the now-defunct Ming imperial house, thereby seizing custodianship of Confucian civilization. These later Chosŏn monarchs also stressed the Yi house's claim as the legitimate heir to a native dynastic line, forging an unbroken connection to the mythical founder of the first Korean state and progenitor of the primordial Koreans. Their most

consistent efforts were directed toward affirming the claim that the Yi house possessed the Mandate of Heaven and that they were the rightful carriers of this mantle.[9]

Yŏngjo's and Chŏngjo's cultural activities reflected the general spirit of their rule. They were acutely aware of the symbolic value of the arts and literary texts and used them extensively. Royal patronage of the arts was channeled into several directions and endeavors, including the celebration of the Korean land and its customs. Yŏngjo is said to have commissioned Chŏng Sŏn (1676–1759) to paint Mount Kŭmgang based on his own observation, thus spurring the "true-view landscape" movement, the practitioners of which depicted actual Korean scenery. This was a departure from the traditional practice of painting imaginary, usually Chinese, landscapes. Interest in Korean customs and ways of life was also evident in the literature of the period. The court sponsored books and encyclopedias on these topics. The most comprehensive was the *Tongguk munhŏn pigo* (*Reference Compilation of Documents on Korea*), a massive encyclopedia of Korean customs and mores, which was first undertaken upon Yŏngjo's order. The first edition, consisting of 100 chapters, was completed in 1770. Chŏngjo ordered supplements and 7 more items were added, bringing the total number of chapters to 146. The final version, dating from 1908, consists of 250 chapters.[10]

The arts were also appropriated to exhibit dynastic glory. During the eighteenth century, an unprecedentedly large number of paintings and screens depicting the court and numerous rituals were produced. Their scale is monumental, and they are magnificent representations of pomp and pageantry; but, most of all, they are flawless depictions of dynastic and ancestral ritual.[11] They capture the momentary manifestation of the continuity of the dynastic mandate. The literary corollary of these ideas is the *Sok taejŏn* (*Supplement to the National Code*), published in 1746.[12] Even though this eighteenth-century code corrects and supplements the *Kyŏngguk taejŏn* of the fifteenth century, it basically reaffirms the continuity of the dynastic order and its attendant tradition. Whereas the *Kyŏngguk taejŏn* was written as a paradigm to which the Chosŏn dynastic order was to aspire, one might say that the *Sok taejŏn* confirms the actualization of this vision.

Perhaps the most ceremonial function of the arts was their utilization in linking a king to his dynastic tradition. This was achieved through the painting of a royal portrait, which would be installed in the Yi ancestral temple. During the eighteenth century, these portraits were painted on a regular basis. This occasionally led to a close relationship between patron and artist. For instance, Chŏngjo, as crown prince, had his first portrait painted by Kim Hongdo (b. 1745) in 1771. Arguably, Kim Hongdo was Korea's greatest and most versatile painter. Chŏngjo had two additional portraits painted by Kim in 1781 and 1791. The king was so impressed that, in 1795, he offered Kim, who was then employed by the royal Bureau of Painting, a post as magistrate, a post usually held only by *yangban* officials. Kim was apparently less skillful at his administrative duties than he was with his brush, for he quickly resigned from this post and resumed painting.

Beyond the court, diversity and openness characterized intellectual and cultural life. Centuries of social and political change, which had been brought about mostly by war and invasion, had added layers to social classes and groupings. The *yangban* class itself was subdivided into many layers and groups, but three main groups can be described here. The small metropolitan ruling elite, within which power was increasingly concen-

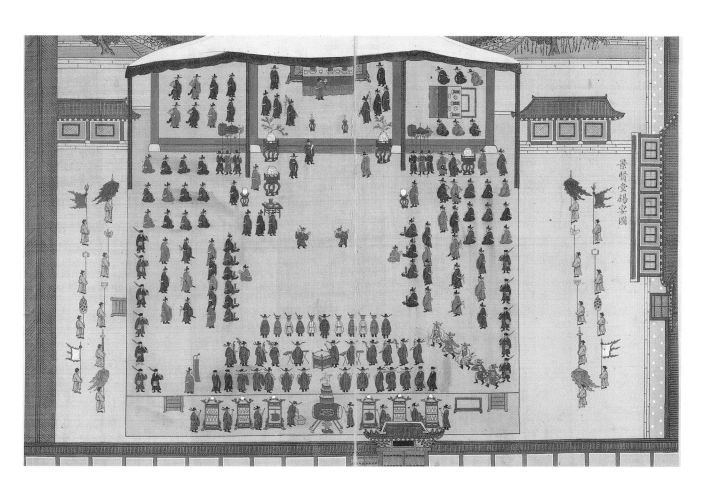

2. ALBUM COMMEMORATING THE GATHERING OF THE ELDER STATESMEN
1719–20
Kim Chinyo, Chang Dŭkman, Pak Dongbo
Album; color and ink on silk
17¼ x 26⅜ in (43.9 x 67.6 cm)
Ho-Am Art Museum, Yongin

trated and perpetuated, made up the first group.[13] The second was a group of urban intellectuals who, either because they belonged to the wrong faction or were of unsuitable lineage, had, at best, a tenuous connection to power but were still largely engaged in the social issues of the time. Finally there was a large group of rural *yangban* elite whose members boasted of illustrious ancestors who had held high posts in the bureaucracy but had gradually lost their connection to the capital and settled in distant areas to pursue lives as country scholars.

Because they occupied separate social and cultural spaces, these groups were engaged in different intellectual pursuits. Nevertheless, all made significant contributions to eighteenth-century scholarship, and all were afforded intellectual independence and freedom. It appears that the suspicion of new ideas and the vigilance against heterodoxy that had prevailed in the late seventeenth century gave way to a quest for the authentic and an agenda of exploration. Urban intellectuals exemplified this spirit most fully. As outsiders to power, they devoted themselves to the quest for reform and sought answers to social and economic questions. Known as scholars of the Practical Learning School or the School of Statecraft (Sirhak), their attention was firmly focused on such issues as land distribution, technology, economy, and class. They constituted a diverse group, advocating different reform programs, but they all showed a willingness to experiment. Indeed, some of them even explored Catholicism, albeit as a philosophical rather than religious system. Although their ideas had no direct impact on official policy-making at the time, they are regarded as the precursors to the modernization of Korea.[14]

The rural elite, despite general assumptions to the contrary, was also a diverse group, consisting of at least two distinct, though related, subgroups. Most numerous were local *yangban* who adhered to the Confucian-*yangban* way of life: they compiled genealogies, observed Confucian ritual, and pursued Confucian scholarship.[15]

There were also those who consciously chose the path of eremitism and scholarship. The factionalism of the seventeenth century seems to have swelled the ranks of this group. Unlike the scholars of the Statecraft School, this group championed scholarship unencumbered by social need and devoted itself to moral philosophy and the metaphysics of Neo-Confucianism. The most notable achievement of this group was the Horak Debate between Yi Kan (1677–1727) and Han Wŏnjin (1682–1752). This debate, which concerned the question of human nature—an issue central to Neo-Confucian philosophy—brought about advancement in Neo-Confucian metaphysics.[16] The influence of the rural elite and eremitic scholars can be seen in the proliferation of private academies, which totaled about 600 by the close of the eighteenth century. In addition to being important loci for the intellectual activities of this group, these academies functioned as meeting places for the local elite and as sites for community ritual. They also published books and sponsored other cultural activities.[17]

The metropolitan ruling elite devoted their scholarly effort mainly to the compilation of encyclopedias, annals, ritual texts, and legal codes. They were, of course, interested in issues of statecraft and were well versed in Neo-Confucian scholarship. It seems that, despite their differences, these groups maintained a certain, albeit indirect, channel of discourse with one another.

The cultural trajectory of this period, however, extended far beyond the intellectual activities of the scholar-*yangban* elite. Classical and philosophical writing in literary Chinese, for instance, constituted only a portion

화샹 긔봉 권지일

34. STRANGE ENCOUNTER AT MOUNT HWA
Late Chosŏn
Handwritten book, thirteen volumes; ink on paper
Volume 1, 13 x 8⅜ x ¼ in (31.6 x 21.8 x 0.8 cm)
Changsŏgak Collection, The Academy of Korean Studies,
Sŏngnam

of the written culture. Vernacular writing in the *han'gŭl* script emerged as a parallel cultural tradition. From the time the *han'gŭl* script was devised in the fifteenth century, works written in Korean began to appear, constituting a counterpoint to the mainstream literary Chinese style. For a while, however, Korean works were confined mostly to occasional poems and morality books. From the seventeenth century on, vernacular works multiplied and encompassed a wider spectrum of subjects. Scholarship has generally tended to view vernacular and literary Chinese writing as dichotomous traditions divided by gender and class. Within this scenario, only women and less educated men of the lower orders, who were excluded from classical education, would have participated in the vernacular written culture. This view underestimates the range and vitality of the vernacular tradition in the later Chosŏn period.

Although women were a major force in vernacular writing, neither its authorship nor its readership was confined to a particular gender or class. All kinds of writing—both in new and traditional genres—burst forth.[18] First there was personal correspondence.[19] Epistolary exchanges became an accepted feature of social life among ladies of the elite class. Then there were novels, stories, and manuals along with biographies and autobiographies.[20] New genres such as *p'ansori*, or tales sung by a professional singer, emerged as well.[21]

Why such a surge in vernacular writing? A higher level of affluence, an emerging group of wealthy commoners, the availability of printing, and the spread of education were contributing factors. Vernacular writing certainly extended the reach of written culture and allowed the proliferation of modes of discourse. Compared with works in literary Chinese, which tended to be concerned with abstract and universalistic issues, works in Korean were concerned with the ordinary and nativistic, with descriptions of everyday joys and sorrows. There was, however, constant interaction and mutual appropriation between the classical and vernacular traditions, as well as between the written and oral traditions.[22]

Privately collected anthologies of Korean writing first appeared during this period. The first, the *Ch'ŏnggu yŏngŏn* (*Enduring Poetry of Korea*), which contained about 1,000 poems and songs, was completed in 1728. Then in 1768, the *Haedong kayo* (*Songs of Korea*), which included about 900 songs and poems, appeared. Kim Ch'ŏnt'aek and Kim Sujang, the respective compilers of these anthologies, were commoners. Their efforts were reputed to have been intense labors of love. This indicates that neither the government nor the elite was able to maintain a monopoly on cultural projects and that private individuals of humble station had emerged as the agents of cultural transmission.

The visual arts exhibited tendencies and developments similar to those of the written culture. One finds a number of distinct strands with mutual influence among them, a strong inclination toward vernacularization, and the valorization of the ordinary and the moment. Scholars and officials continued as practitioners and patrons of the arts. Calligraphy and literati painting, individual works of which were always regarded as the refined accoutrements of status of the Confucian scholar-gentleman, flourished. Most prominent scholar-painters of the time, such as Kang Sehwang (1713–91), experimented with a new style of realism, participating in the true-view landscape movement.

Motifs and themes also became vernacular. Professional painters appropriated classical themes or stories from China or Korea as narrative motifs. Genre painting came into vogue. Such masters as Kim Hongdo

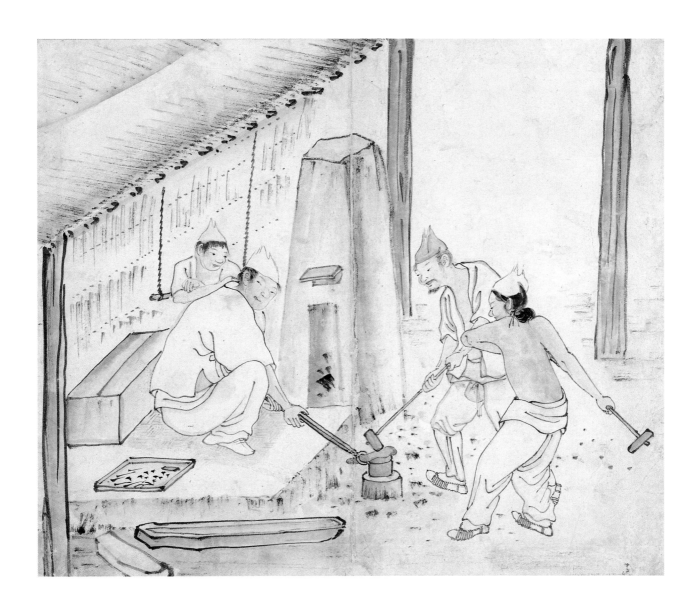

86. BLACKSMITH'S SHOP
Late Chosŏn
Kim Dŭksin (1754–1822)
Album leaf; ink and light color on paper
8⅞ x 10⅝ in (22.5 x 27.1 cm)
Kansong Art Museum, Seoul

and Sin Yunbok (b. 1758) painted vignettes from everyday life, often with humor and irony. A large proportion of the paintings of this period, however, is explicitly decorative. Colorful paintings of many new subjects emerged. Clearly, the demand for decorative paintings of this type increased.

Women also created art. There are few known women painters or calligraphers from this period because many worked anonymously in the media available to them. Women traditionally engaged in needlework—a skill that ranged from elaborate embroidery to simple sewing. Embroidery was done mostly on a small scale, but there are spectacular examples, such as multipanel screens, upon which famous stories or themes were rendered. Artistic expression was manifested in simpler forms as well. Wrapping cloths (*pojagi*), made up of sewn-together cloth remnants of various colors and sizes, are a striking example.[23]

A discussion of eighteenth-century Korea would not be complete without consideration of the developments in religion. The anti-Buddhist policies of the Chosŏn government and the subsequent Confucianization of society substantially limited the role Buddhism played in people's lives.[24] Popular religion suffered a similar setback. The Buddhist clergy and shamans no longer administered life-cycle rituals. Instead, these rituals came to be defined by and conducted according to Confucian norms.[25] Although these clergy and shamans relinquished their jurisdiction over major rituals—the capping ceremony, weddings, funerals, and ancestral sacrifices—they offered supplementary rites, such as praying for the dead, praying for cures, or praying for the granting of various wishes.[26] There were other ways in which religion, especially Buddhism, exerted continuous influence. As literary works reveal, the Buddhist world view, along with such notions as karma and reincarnation, continued to permeate popular perceptions of life and death. Buddhist monasteries, though drastically reduced in number, offered sanctuary for a life of meditation and religious devotion. In the ebullient atmosphere of the eighteenth century, Buddhist and popular religious arts accordingly underwent revival and new development.

The cultural and intellectual diversity and dynamism of this period can be directly attributed to the tolerant atmosphere in which each group, in search of authenticity, redefined the old and experimented with the new. This vigor with which competing traditions and disparate themes flourished harmoniously rather than at mutual expense seems to have been the essence of the cultural vigor that characterized eighteenth-century Korea.

NOTES

1. Martina Deuchler, *The Confucian Transformation of Korea* (Cambridge: Harvard University Press, 1993). For an introduction, see JaHyun Kim Haboush, "The Confucianization of Korean Society," in *The East Asian Region* (Princeton: Princeton University Press, 1991), 84–110.

2. *Kyŏngguk taejŏn*, 2 vols. (Seoul: Pŏpchech'ŏ, 1962). For an interpretation, see William Shaw, *Legal Norms in a Confucian State* (Berkeley: Institute of East Asian Studies, University of California, 1981), 3–21.

3. JaHyun Kim Haboush, *A Heritage of Kings: One Man's Monarchy in the Confucian World* (New York: Columbia University Press, 1988), 117–125.

4. Haboush, *Heritage of Kings*, 125–51.

5. Ching Young Choe, "Kim Yuk (1580–1658) and the *Taedongpŏp* Reform," *The Journal of Asian Studies* 23 (Nov. 1963): 21–35.

6. Kang Man'gil, *Chosŏn hugi sangŏp chabon ŭi paldal* (Seoul: Koryŏ taehakkyo ch'ulp'anbu, 1973).

7. Haboush, *Heritage of Kings*, 83–116.

8. James B. Palais, *Politics and Policy in Traditional Korea* (Cambridge, MA: Harvard University Press, 1975), 110–15.

9. Haboush, *Heritage of Kings*, 29–82.

10. *Chŭngbo munhŏn pigo*, 3 vols. (Seoul: Tongguk munhwasa, 1959).

11. JaHyun Kim Haboush, "Public and Private in the Court Art of Eighteenth-Century Korea," *Korean Culture* 14, no. 2 (Summer 1993).

12. *Sok taejŏn* (Seoul: Pŏpchech'ŏ, 1965).

13. Edward Wagner, "The Ladder of Success in Yi Dynasty Korea," *Occasional Papers on Korea* 1 (April 1974): 1–8.

14. Michael Kalton, "An Introduction to Sirhak," *Korea Journal* 15, no. 5 (May 1975): 29–46; JaHyun Kim Haboush, "The Sirhak Movement of the Late Yi Dynasty," *Korean Culture* 8, no. 2 (Summer 1987): 20–27.

15. Fujiya Kawashima, "The Local Gentry Association in Mid-Yi Dynasty Korea: A Preliminary Study of the Ch'angnyŏng Hyangan 1600–1839," *The Journal of Korean Studies* 1 (1980): 113–37.

16. Michael Kalton, "Horak Debate" (Presented to the Conference on Confucianism and Late Chosŏn Korea, University of California, Los Angeles, January 1992).

17. Chŏng Tonmok, *Han'guk sŏwŏn kyoyuk chedo yŏn'gu* (Taegu: Yŏngnam taehakkyo ch'ulp'anbu, 1979); Yi Ch'unhŭi, *Chosŏnjo ŭi kyoyuk mun'go e kwanhan yŏn'gu* (Seoul: Kyŏngin munhwasa, 1984).

18. Cho Tongil, *Han'guk munhak t'ongsa*, vol. 3 (Seoul: Chisik sanŏpsa, 1989), 378–425.

19. Kim Ilgun, *Ŏn'gan ŭi yŏn'gu* (Seoul: Kŏn'guk taehakkyo ch'ulp'anbu, 1986).

20. JaHyun Kim Haboush, *The Memoirs of Lady Hyegyŏng*, forthcoming.

21. Marshall Pihl, *The Korean Singer of Tales* (Cambridge, MA: Harvard University Press), forthcoming.

22. JaHyun Kim Haboush, "Dual Nature of Cultural Discourse in Chosŏn Korea," *Proceedings of 33d International Congress of Asian and North African Studies*, vol. 4 (Queenston, Ontario: Edwin Mellen Press, 1992).

23. Yi Sŏng-mi, *Korean Costumes and Textiles* (Seoul: Korean Overseas Information Service and IBM Corporation, 1992).

24. Robert Buswell, "Buddhism under Confucian Domination: The Synthetic Vision of Sŏsan Hyujŏng (1520–1604)" (Presented to the Conference on Confucianism and Late Chosŏn Korea, University of California, Los Angeles, January 1992).

25. Deuchler, *Confucian Transformation*, 168–257.

26. Boudewijn Walraven, "Popular Religion in a Confucianized Society" (Presented to the Conference on Confucianism and Late Chosŏn Korea, University of California, Los Angeles, January 1992).

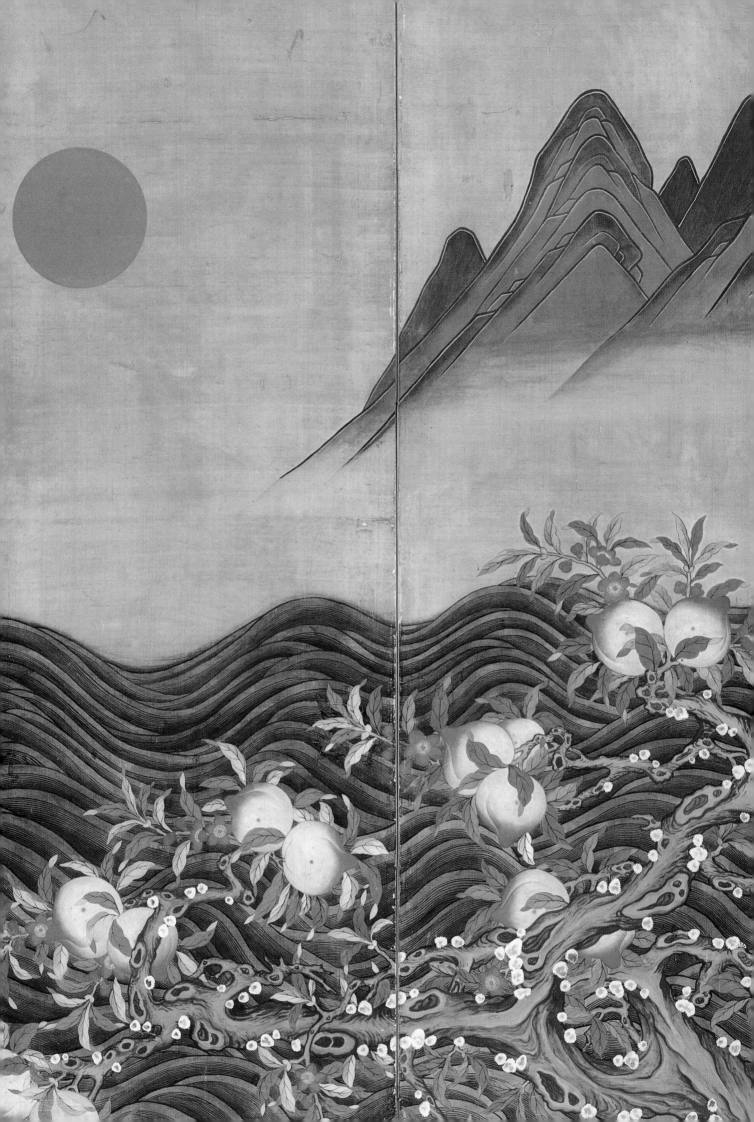

Exploring Eighteenth-Century Court Arts

Hongnam Kim

B Y THE BEGINNING of the eighteenth century, Seoul (then named Hanyang) had been the political, economic, and cultural center of Chosŏn Korea for three hundred years. In 1394, two years after General Yi Sunggye became King T'aejo, the first ruler of the Chosŏn dynasty, he moved the capital to that site, taking great pains to ensure that the setting and scale of this capital city would mirror the prestige of his new kingdom. The ambition behind the building of the new capital was threefold: first, to recreate the ideal royal city envisioned in the *Rites of Zhou* (*Zhou li*) of China, a Confucian classic; second, to find an auspicious geomantic setting for all royal buildings; and third, to build an architectural monument of authority. First to be built in the auspicious royal city were the Ancestral Temple (Chongmyo), the Altar of Soil and Grain (Sajik-dan), and a magnificent palace to manifest the Chosŏn kings' authority and power as worldly rulers. The majestic throne halls, inner palaces, and royal gardens and parks were replete with regal trappings executed by the finest artists and craftsmen.

Within the palace, many forms of art were utilized primarily to meet the symbolic and ritual needs of the ruler and his immediate family in official and private life. The ruler's primary public role was to mediate between Heaven and the terrestrial world; to secure the protection of his royal ancestors and other divine spirits; to ensure the perpetuation of rule; to manage the affairs of state, providing for the security and well-being of his subjects; and to maintain the social order. Rituals played an important and useful role in the performance of many of these monarchical functions in accordance with the political ideology of Confucianism. Thus, art and architecture in this context were produced mainly as symbols of dynastic

23. SUN, MOON, AND IMMORTAL PEACHES (DETAIL)

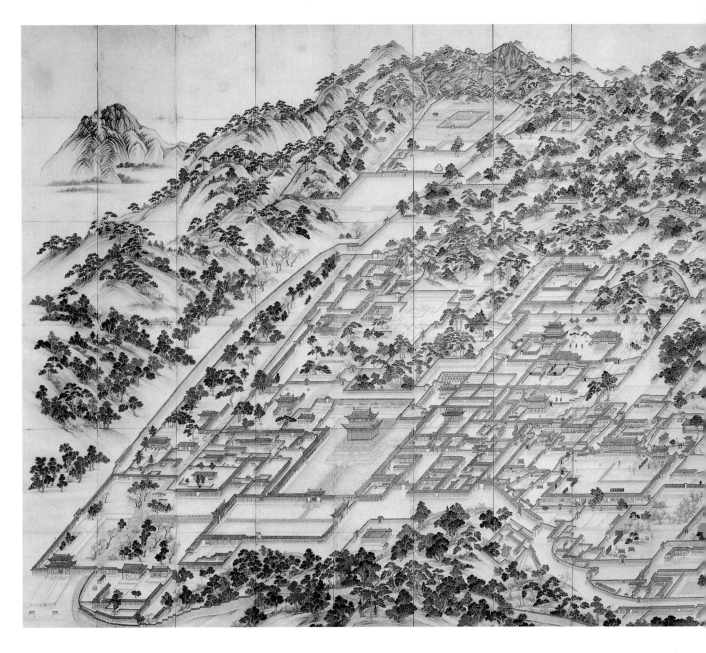

legitimacy, political authority, and the ritualistic and ceremonial dignity of the ruler. The fundamental idea of Confucian political ideology is "virtuous rule" or "the way of the king." He who could practice virtuous rule would receive the Mandate of Heaven, and this became the theoretical basis for dynastic revolutions and the perpetuation of rule. Therefore, the public arts of the court fulfilled ritual, ceremonial, political, and moral functions, which at times could be interrelated in a single work.

In private life within the inner palace, the royal family had a different set of concerns: to live long, enjoy the regal life in good health, and to produce male offspring to sustain the royal line. These major concerns were reflected in the subject matter of paintings and decorative designs on architectural details within the palace. Self-cultivation through arts—painting, poetry, and calligraphy—was also pursued in practice or through appreciation.

Although Kyŏngbok Palace was built as the most important of four major palaces in Seoul and was to be the main locus of royal pageantry, owing to the vagaries of war and rebuilding, Ch'angdŏk Palace is the best-preserved palace from the late Chosŏn period and provides a point of reference in the discussion of the architectural setting of the objects in this exhibition (see fig. 1). It can be divided into four major areas: the outer

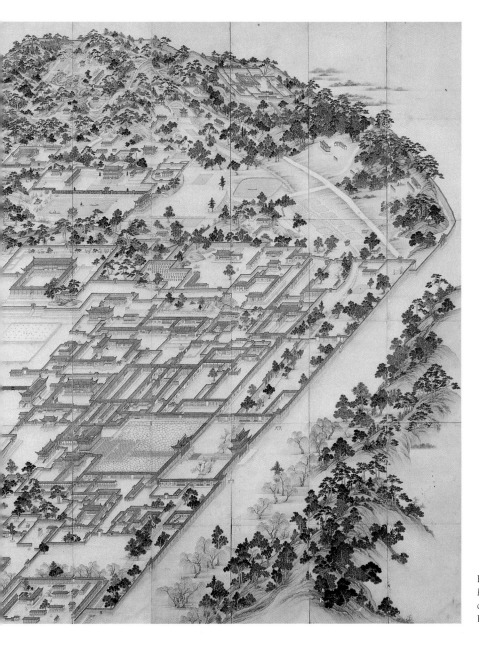

FIGURE 1. *Map of the Eastern Palace (Ch'angdŏk Palace),* 1826–30. Sixteen-fold screen, ink and color on silk; 107½ x 226¾ in (273 x 576 cm). Korea University Museum, Seoul.

court, composed of the central government buildings; the inner court of private living quarters; the complex of ancestral shrines; and, in this case, a royal park. Built along the basic layout scheme used for a typical *yangban* house, the palace can be viewed as the vast extension and elaboration of such basics, expressing the sociocultural values of Chosŏn Korea, which were deeply rooted in Confucianism: the complete segregation of men and women, the importance of ancestral worship, and the desire to live in harmony with nature. The throne hall as the center of the outer court, the private residence of the king and queen as the focus of the inner court, and the ancestral shrines (particularly the main Ancestral Temple) were not only the finest architectural specimens of Chosŏn palaces but were also important settings for the display of arts.

MAJOR THEMES OF CHOSŎN COURT ART

The Throne and the Sun, Moon, and Five Peaks Screen

The most dignified and magnificent building within a palace is the throne hall—the setting for all major ceremonial and political events attended by the king and court dignitaries. In both the Kyŏngbok and the Ch'angdŏk palaces, the throne hall was adjoined by a compound of reception halls,

1. SUN, MOON, AND FIVE PEAKS
Late Chosŏn
Six-fold screen; color on silk
77¼ x 141¾ in (196.2 x 360.0 cm)
Ch'angdŏk Palace, Seoul

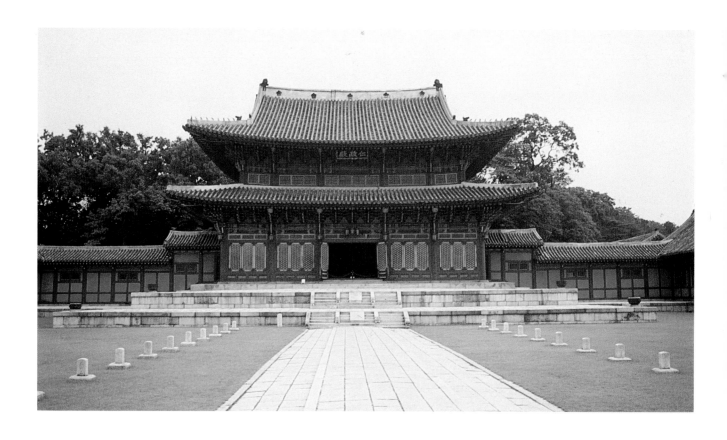

FIGURE 2. Throne Hall (Injŏng-jŏn), Ch'angdŏk
Palace, Seoul.

which were used for intimate audiences, welcoming foreign envoys, and,
occasionally, public events hosted by the queens and queen mothers.

After the 1592 destruction of the central Kyŏngbok Palace, the throne
hall of the Ch'angdŏk Palace, named the Hall of Benevolent Government
(Injŏng-jŏn), became the main throne hall, witnessing the coronation of
thirteen kings. The hall (fig. 2), which was rebuilt in 1804 after a fire the
previous year, is double-roofed and raised on a double-tiered platform. The
asymmetry of the palace's layout that harmonizes with the local topogra-
phy; the elegant proportion of the throne hall, in itself and in relation to its
surroundings; and the gentle curves of the roofs and eaves have little refer-
ence to the "Peking" pattern of Chinese imperial architecture, symmetrical
and formal, of the Ming (1368–1644) and Qing (1644–1911) dynasties.
Instead, this classic style, also evident in other palatial and religious build-
ings of the Chosŏn period, harks back to the Koryŏ architectural tradition
rooted in China's Tang (618–906) and Song (960–1279) dynasties. The
entire structure was painted predominantly in dusty red and opaque green,
the colors used throughout the Chosŏn period for palaces and other cere-
monial and religious buildings.

As in all empires and kingdoms of the ancient world, the most impor-
tant symbol of the Chosŏn monarch was the throne, the literal seat of
power and authority. The throne ensemble (*tangga*) stands tall in the rear
center of the hall, which is otherwise devoid of regalia. Behind the royal
seat in the Kyŏngbok Palace Throne Hall (fig. 3) is an openwork wooden
screen, above which is a large, colorful, Sun, Moon, and Five Peaks screen.
In the simpler throne ensemble in Ch'angdŏk Palace (fig. 4), the Sun,
Moon, and Five Peaks screen stands directly behind the king's seat. Above
the thrones are elaborately carved canopies and lushly painted and gilded
ceilings.

The Sun, Moon, and Five Peaks screen is the most critical regalia in
the throne hall (see no. 1). This highly formalized landscape manifests the
Chosŏn political cosmology based on the Theory of Yin and Yang and the

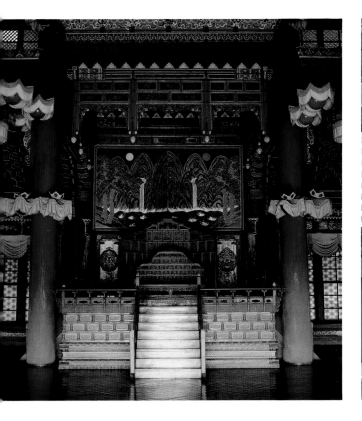
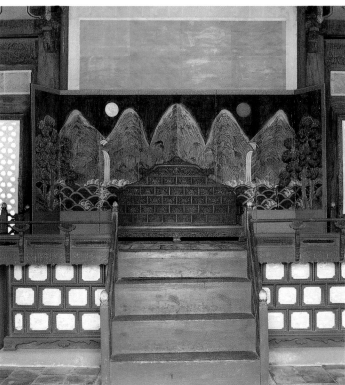

Five Elements; it may also represent the land of Korea blessed by Heaven, symbolized by the sun and moon portrayed in absolute balance. When the king sat in front of this screen, he literally became the central point of the composition and thus the pivotal point from which all force emanated and to which all returned. Thus, imbued with sacred power, the screen manifests politico-cosmology as evidence of Heaven's favor, mandate, and continued protection of the ruler. Wherever the king presented himself officially, an example of this screen was behind him, even after death. One was taken along when the king traveled, was installed in his private reception hall, and was used in the throne ensemble of the Spirit Hall (Hon-jŏn) temporarily set up for a deceased king before his formal entry into the Ancestral Temple and the Royal Portrait Shrines (Chin-jŏn). Images of the screen appear in paintings depicting events presided over by the king that include thrones (fig. 5); it was taboo to show the person of the king in such paintings.

FIGURE 3. Throne ensemble, Throne Hall (Sonjong-jŏn), Kyŏngbok Palace, Seoul.

FIGURE 4. Throne ensemble, Throne Hall, Ch'angdŏk Palace, Seoul.

Ritual and Ceremonial Arts

Rituals played an important role in the political life of the Chosŏn rulers. Five major types of state rites were solemnly carried out in accordance with the books for rituals published by the government from the early fifteenth century. The *Five Rites of State* (*Kukjo orye ŭi*), the illustrated compendium completed in 1474, largely based on the Chinese *Rites of Zhou*, is a representative text. The five types practiced during the Chosŏn dynasty were: auspicious rites for ancestral worship and sacrifices; celebratory rites, such as accession ceremonies and royal marriages; reception rites for welcoming foreign emissaries; military rites for great reviews before and after campaigns; and inauspicious rites for mourning. These rituals and ceremonies required particular architectural settings, music, dance, costumes, paintings, furniture, ceramics, metalwork, and other appointments. They constituted the major part of the Chosŏn palace's public activity and were recorded for posterity.

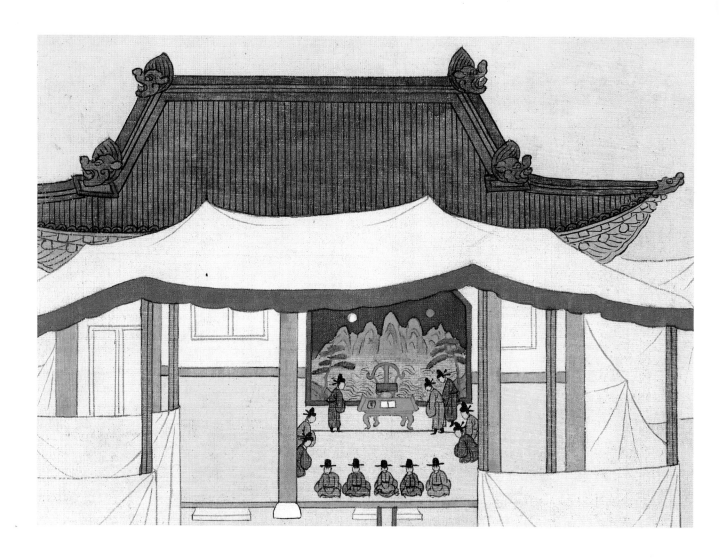

FIGURE 5. Detail of documentary painting showing a Sun, Moon, and Five Peaks screen behind the king's throne. From a leaf of *Album Commemorating the Gathering of the Elder Statesmen*, no. 3.

Auspicious rites (*killye*), those pertaining to ancestral worship, were the most significant state rituals in Chosŏn. Among these, the sacrifices at the Ancestral Temple were of foremost importance. Others included rituals performed at the Altar of Soil and Grain, the Royal Portrait Shrines, the sacrifices at the Confucian temple, and rites related to ancestor worship and filial piety, such as visits to royal tombs. The screen paintings depicting actual ritual ceremonies and programs (no. 4) and visits to royal tombs (nos. 7 and 8), the seals (nos. 5 and 12), the blue-and-white porcelain ritual vessels (no. 25), and the bamboo and jade books (nos. 10 and 11) featured in this exhibition were produced primarily for such ritual and ceremonial purposes.

Royal patronage of the arts and its institutionalization were nurtured by the need to ensure the prosperity of the ruling house through ritual and to demonstrate its noble commitment to a virtuous and enlightened government. The ritual and ceremonial arts served political purposes and vice versa. The Chosŏn court placed the royal Bureau of Painting under the control of the Ministry of Rites, one of the six main organs of the central government, whereas the production of artisanal works fell mainly under the jurisdiction of the Ministry of Works. Paintings were crucial to the ritualistic and ceremonial needs of the Chosŏn court, and their creators, despite the frequent objections raised by civil officials, were held in higher regard than were artisans.

To maintain detailed records of all major rituals and ceremonies as well as for the execution of important government projects—which included the production of royal portraits, the construction of new palaces

and mausoleums, and the renovation of palaces—the Chosŏn court established a special project office (*togam*) of supervisory officials headed by a minister or a chancellor. This brought about the great development of *uigwae* ("records of rituals") and *uigwae-do* (literally, "illustrations for the records of rituals").

Royal ancestor worship, the most elaborate state ritual, was conducted in the Ancestral Temple, which housed spirit tablets, and the Royal Portrait Shrines, which were located inside and outside the palaces. The eight-panel folding screen, *Diagram for Rituals at the Ancestral Temple* (no. 4) was executed to provide the current and future kings with rules and regulations for the performance of sacrifices at the Ancestral Temple. Multiple examples of it would have been displayed, in the studies of the king and the crown prince, at the Office of the Royal Clan, or the Ministry of Rites. Peony screens (for example, no. 22) served many functions, one of which was to embellish Royal Portrait Shrines, where they appeared behind the throne ensembles in which the portraits were displayed.

Portraits were the most important aspect of the figure-painting tradition during the Chosŏn period and were the major artistic contribution of the eighteenth century. Royal portraits afforded court painters an excellent opportunity to gain recognition. Tests were given to select the finest artists for the painting of new portraits. Although no actual eighteenth-century portraits are extant, seven royal portraits were copied in 1900. The portrait of King Yŏngjo (fig. 6) is a reproduction painting from that project. A special office for the project was established by the order of the king; it included twenty-four supervisory officials, led by the incumbent chancellor of the Deliberate Council; sixty court painters; and eight mounters. Approximately four and one-half months passed between the day the king ordered the establishment of the project office and its closing. The actual work took approximately three months. Of the sixty painters, it seems fifteen were directly involved in copying portraits since eight are recorded as having been involved in producing Sun, Moon, and Five Peaks screens, eleven in entrance screens, eight in plum-painting partitions, ten in Queen Mother of the West screens, and eight in the illustrations of records of rituals that documented the entire production. There is only one project record extant for the production of new portraits rather than copies. It describes a similar organization and process, preceded by an artists' test to determine the finest court painters for participation. (The selection of artists for copying projects was not similarly competitive.)

Artworks recording celebratory rites—the second of the five categories—such as accession ceremonies, the coronations of crown princes and queens, and marriages and birthdays, were also produced. An example of one type included in the exhibition is a list of wedding objects for the marriage of a crown prince. It was inscribed upon festive paper of different colors in the palatial *han'gŭl* style (no. 33). Although not represented in the exhibition, the Chosŏn court also produced other types of *uigwae-do* documenting reception, military, and mourning rites.

In addition to the ultimate political function of ensuring state security and the perpetuation of rule, the content of some artworks was blatantly didactic: they demonstrated the king's virtue, his benevolent management of state affairs and protection of his subjects, and his moral exemplarity. These works depicted such scenes as royal inspections of public works sites and special examinations held in remote places by the king's special grace. There were also everyday vignettes from the lives of commoners who worked in agriculture, sericulture, and other industries, intended to remind

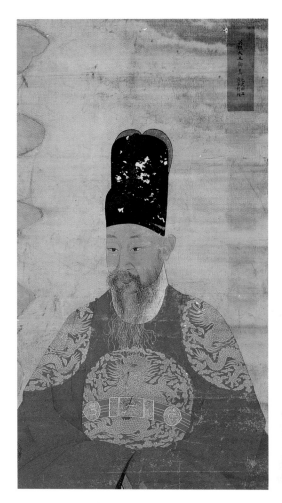

FIGURE 6. *Portrait of King Yŏngjo*, early 20th-century copy by Cho Sokjin (1853–1920) and Che Yongsin (1848–1941) of 18th-century original. Hanging scroll, color on silk; 79⅞ x 31⅞ in (203.0 x 83.0 cm). The Royal Museum, Seoul.

both male and female members of royalty of the difficult life of those who lived beyond the palace walls. These depictions naturally contained genre scenes. In fact, late Chosŏn genre painting, which has been associated exclusively with people outside of the palace, appears to have received its initial impetus from such courtly efforts.

Looking Up at the Sky and Down at the Earth

In Chosŏn Korea, astronomy, astrology, calendrical science, and geomancy were all intimately interwoven and, in addition to having practical ends, had ritual purposes. The fact that the Office of the Heavenly Patterns was under the jurisdiction of the Ministry of Rites evidences its ritualistic function. The sun, moon, constellations, and clouds were believed to contain auspicious and inauspicious signs pertaining to such issues as the year's harvest, the royal family's fortune, and the internal and external security of the state.

The worship of the deified Heaven was carried out on the court's behalf by the Office of Daoist Rituals, managed by Daoist priests, and the Office of Constellation Rituals, composed of state-hired shamans. Although these practices were officially abolished by demand of the Confucian court officials in the 1520s, Shamanism never entirely disappeared from the Chosŏn court.

The most popular constellation was the Seven Stars (the Big Dipper). It was held to affect people's calamities, fortunes, life spans, and the reproduction of male offspring. On the state level, it was considered to influence the security and peace of the nation as well. There are legends and historical documents relating this constellation to the early Chosŏn kings' ardent belief in its potency. A painting of the Seven Stars (no. 14) that, judging from its execution, materials, and scale, is a late Chosŏn work by a court artist evidences the continuation of their interest.

Geomancy also played an important role. The site of the capital city was selected as the best site geomantically, being surrounded by magnificent mountains and half-encircled by the Han River, which provided a natural fortification. The city was laid out in a cosmological pattern, and the country organized in eight areas, corresponding to the eight major hexagrams of the *Book of Changes* (*Yi Jing*). All sorts of maps—topographical, administrative, military, and geographic—were produced by the court painters and in print to ensure the security of the state and administration. Their production was most likely second in importance to portrait painting. Of these maps, two types are quite interesting: those of the palaces (such as fig. 1) and those of the royal city (for example, no. 15). These earthly maps complemented the numerous heavenly charts produced at the court in symbolizing the universe of the monarch.

Life and Art in the Inner Palace

In Ch'angdŏk Palace, the private living quarters of the king and his family, located deep in the back, were originally separated from the public area by a maze of meandering walls and buildings. The king's private office and study is in the outermost building of this complex. Passing through the back courtyard of his office quarter through a roofed corridor, the king entered the front courtyard of the innermost realm of the palace—the queen's residence.

A pair of early twentieth-century murals depicting Mount Kŭmgang that is preserved in the king's private office at Ch'angdŏk Palace supports

29. DINING TABLE
18th century
Lacquered wood with mother-of-pearl inlay
H. 10 in (25.5 cm), D. 12½ in (31.7 cm)
Chŏng So-hyŏn Collection, Seoul

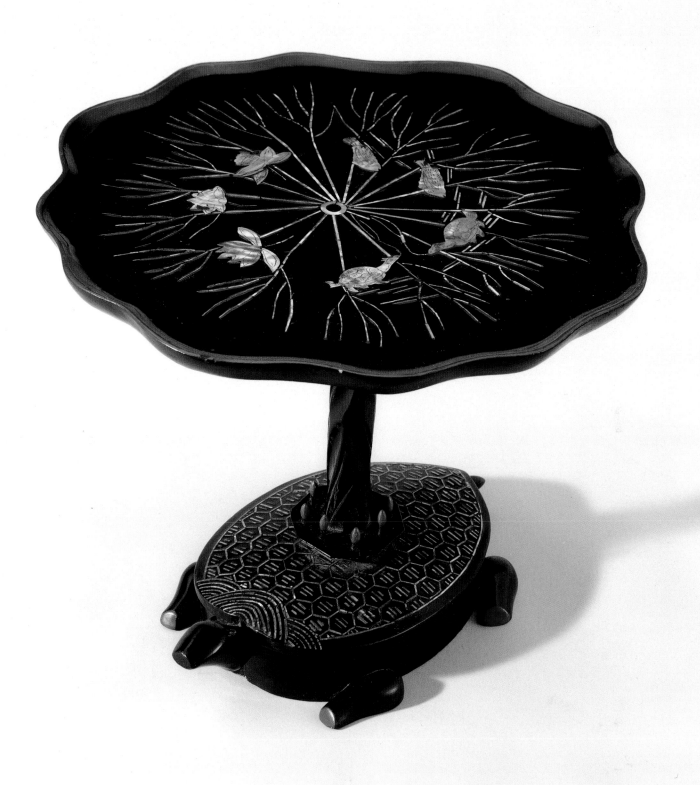

literary records of commissions for this subject throughout the Chosŏn dynasty as well as indicating the traditional placement of such works within the palace. A large number of screen paintings of books and scholar's utensils (*ch'aekkori*) is also in the court collection along with various other types of paintings that probably embellished the studies of the king and his princes, in addition to books, to express their scholarly interests, self-cultivation, and moral virtues. King Chŏngjo's poetry, works of calligraphy, and paintings demonstrate his well-rounded training in the arts of the literatus. His poem (no. 36) demonstrates his literary and calligraphic proficiency, and the ink paintings of a banana tree and chrysanthemums (nos. 30 and 31) are rare survivals directly from the king's hand.

The queen's residence followed the basic structure of all Chosŏn residences in having a main reception room with a wooden floor (*taech'ong*) flanked by rooms with a heated floor (*ondol*) and by front and rear gardens. This reception hall and the other major rooms used by the king and his wife would have displayed the house's best furniture and artworks. Residential interiors were partitioned to create rooms, but most of the walls, except those on the north, consisted almost completely of sliding or folding doors decorated with lattice designs and covered with translucent white paper. In addition, ceiling height was limited to help contain the heat that radiated from the floor in *ondol* rooms. Furniture was designed to accommodate the floor-seated life-style and was scaled to the low ceilings.

These features of Chosŏn architecture appear to have had an important bearing on the character of the interior decoration and furnishings. The limited wall space did not allow such permanent fixtures as large murals and the display of tall, wide hanging scrolls. Paintings and calligraphy were hung on the double or quadruple doors of built-in storage areas and the immovable side panels of windows. Calligraphy plaques were hung above the lintel in the reception hall. The Chosŏn period witnessed the great popularity of painted and calligraphic folding screens, which functioned as draft-breakers as well as works of art and important paraphernalia for rituals and ceremonies. They could be displayed in a limited space partly folded up, easily switched or stored away, and transferred to other places. By the eighteenth century, the folded screen had become the major format of Chosŏn court painting. Most of the court paintings that have survived from the period were done on folding screens.

The private concerns of the royal family—health, longevity, and male heirs—were reflected in the standard artistic themes for all manner of interior and exterior building decoration, garden walls, chimneys, and stone flower vases as well as painting, furniture, and ceramics. Examples include: the ten longevity symbols; birds and flowers, such as peonies, that symbolize prosperity and conjugality; subjects that bear reference to the birth of sons, such as the Hundred Boys, grapes, and pomegranates; the auspicious characters *su* ("longevity"), *bok* ("good fortune"), and *gil* ("auspicious"); and cosmological charms such as the *taiji* and eight hexagrams. All were imbued with talismanic potency and were decorative at the same time. Since such concerns were shared by the entire population, this type of Chosŏn court art was similar to that outside of the court but was distinguished by its quality and luxuriousness.

The Archaic Style as a Metaphor for the Sage Kingdom

Of all the fine and applied arts produced at the court, painting undoubtedly best represents the court tradition in Chosŏn art. As mentioned earlier,

the major subjects of Chosŏn court painting were political and didactic. Other subject matters were those originating in the Daoist cult of immortality, and cosmogonic and auspicious motifs that appeared frequently in eighteenth-century Chosŏn court paintings and all applied arts had been in use since ancient times.

Themes considered to be magically efficacious and aids to proper Confucian governance were adopted from Chinese civilization, where this courtly tradition began as early as the Zhou dynasty (1122–221 B.C.E.). Its rationale was stated in 842 C.E. in the *Record of Famous Painters of All Dynasties* (*Lidai minghua ji*; Acker translation): "Painting is a thing which perfects the civilizing teachings [of the Sages] and helps [to maintain] the social relationships. It penetrates completely the divine permutations [of Nature] and fathoms recondite and subtle things. Its merit is equal to that of [any of] the Six Arts [of Antiquity] and it moves side by side with the Four Seasons. It proceeds from Nature itself and not from [human] invention." However, the pattern of transmission and perpetuation of court art in Chosŏn Korea is elusive owing to the limits of the existing knowledge about Chinese court art and pre-Chosŏn-period Korean art. The scarcity of visual materials from the early Chosŏn period prevents the establishment of a historically intelligible sequence even within the dynasty. Does Chosŏn art represent a perpetuation of or a deliberate return to the classic tradition?

Chinese imperial patronage never discarded the traditional role of court painting that entailed the depiction of the above-named themes in a two-dimensional, ideographic manner by anonymous court artists. Nevertheless, in China, this type of art became eclipsed in a process of humanization and individualization of art and the artist that seems to have come about rather rapidly during the Northern Song period (960–1127). Additionally, landscape art displaced the importance of figure painting during the Southern Song dynasty (1127–1279)—the last glorious period of Chinese court painting. We actually know very little of the true state of Chinese court painting thereafter, as it is veiled by the dominance of landscape painting and literati theory, practice, and appreciation. Court patronage gradually came to be viewed as corrupting, and unpatronized literati artists were said to produce the great works of art. It appears that traditional court subjects generally fell into the hands of second- and third-rate court artists, and the use of archaic motifs, inherently symbolic and graphic, gradually came to be confined to the applied and decorative arts. This condescending view of court art in China persists today and is evident in the fact that relatively little research is conducted in this area. But in Japan and Korea the situation was different. The distinction between professional and amateur artistry did not loom so large in those cultures as it did in China, where the two artistic modes served radically different social purposes. In Korea, scholar-artists did not constitute an artistic force of comparable influence and productivity to professionals, and there were very few exceptional literati artists. Professional artists centered around the court were a dominant force in the art world both inside and outside the court. By the eighteenth century, they became an important part of a social class of technocrats and enjoyed considerable social and economic security.

Owing to the lack of extant visual materials, little is known about the state of Korean court art during the Buddhist period from the sixth through the fourteenth centuries. The same is true of the Chosŏn court prior to the eighteenth century. Nevertheless, historical and literary evidence suggests that the subjects and purposes of early Chosŏn court art were not so different from those of the eighteenth century. It appears that, with possible rare

exceptions, a shift from the stress on time-sanctified subject matter to that created by individual artists did not occur during the Chosŏn period. Chosŏn court art was largely a collective endeavor, engaging more than one artist in the execution of unsigned works. Although many of the participants were in fact the country's foremost painters, recruited through government examinations, most works within the palace were done anonymously.

Outside the palace, however, most Chosŏn court artists led the development of art as prominent individuals, excelling in a diverse range of styles—both foreign-derived and indigenous. Works bearing their signatures are found almost exclusively outside the court context, as seen in the cases of Kim Hongdo (for example, nos. 56 and 57) and Sin Yunbok (for example, nos. 88–91). High-level eighteenth-century Chosŏn paintings for both the public and the private sectors were supplied by artists also employed by the court.

Although the archaic courtly subject matter and motifs may have become either obsolete or out of fashion in painting at the Chinese court, they flourished at the Chosŏn court on an elevated level of conceptual intensity and expressive quality as well as in considerable quantity and scale. But the methods of combining motifs and the styles employed differ from both Chinese and Japanese practices. By the eighteenth century, a time of intense Korean self-consciousness, the Chosŏn court artists seem to have developed Korea's own formula. Indeed, so mysteriously archaistic, insistently nonindividualistic, and intensely symbolic is the courtly mode in Chosŏn art that our modern ideas of art historicity as the history of style and individual contributions proves bewilderingly inapplicable; a different framework is necessary to encompass it. I believe the formal expression of Chosŏn court art reveals the characteristics of Korean art more directly than any other mode practiced in the eighteenth century.

Built upon Korean and inherited Chinese traditions, it may be characterized as "the archaic style." Some of its critical traits are: the concept, archetypal; the motifs and forms, ideographic and repetitive; the space, two-dimensional; the structural relationships and unity, external and nonillusionistic; the modeling, conventional and linear; the colors, local, schematic, and limited in range. In most paintings discussed here, these traits are not only readily recognizable but are heightened and vitalized with a new sense of pictorial unity.

In the *Sun, Moon, and Five Peaks* screen (no. 1), the *Sun, Moon, and Immortal Peaches* screen (no. 23), the *Ten Longevity Symbols* screen (no. 18), and the *Longevity Symbols with Cranes* screen (no. 19), all motifs are drawn with a linear clarity, isolated from each other and gathered in a single, flat pictorial plane devoid of atmosphere or the illusion of depth. Although the first two screens named consist entirely of landscape motifs—sun, moon, mountains, waves, trees, and waterfalls—the way they are presented denies the painting's visual identity as a landscape, since each stands as an individual iconic motif. Highly stylized and at times exaggerated, each element fulfills a minimum requirement for naturalism to reveal its quintessential nature by means of the most characteristic forms, colors, and textures. Exercised within the confinement of the ideographic outline of each motif, a tension is created by the conflict between the overall ideographic forms and the meticulous inner details. In each screen, the arrangement of motifs is symmetrical.

Through such an ideographic visual mode, the archetypal concept is intensified, and the Sun, Moon, and Five Peaks screen satisfies the need for

iconic concreteness. The two longevity symbols screens exhibit an increased sense of spatial depth and naturalism, but not to the extent of obscuring the subject matter. The luminous mineral colors of all four screens make a pointed reference to the Daoist cult of immortality and an eternal land of auspicious clouds and immortal cranes that hover against the golden sky. Such iconographic conventions and decorative stylization contrast sharply with the naturalism of contemporaneous landscape paintings, as discussed in the following essay.

In documentary and topographical paintings, such as the *Map of the Eastern Palace* (fig. 1), the *Map of the Capital City* (no. 15), and the *Royal Visit to the City of Hwasŏng* (no. 8), the Chosŏn court artists demonstrated their familiarity with the different styles of landscape painting outside the palaces, namely the ink monochrome landscape of the Chinese literati tradition and the flourishing Korean true-view landscape. This is evidenced even within the confines of the court's typical, archaic blue-and-green landscape style. In these paintings, the sense of depth is increased and the modeling of elements is clearly based on the observation of nature.

All the examples mentioned so far exhibit such stylistic tendencies as the simplification and flattening of forms, non-naturalistic structural relationships among elements, illogical space treatment, and modeling less dependent on texture strokes.

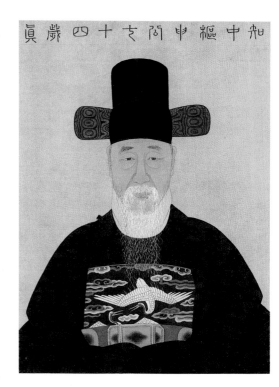

FIGURE 7. Portrait from *Album Commemorating the Gathering of the Elder Statesmen*, no. 2.

Extreme graphic conventions and stylization are seen in most of the architectural paintings, exemplified by the *Diagram for Rituals at the Ancestral Temple* (no. 4), the banquet scenes from the *Albums Commemorating the Gathering of the Elder Statesmen* (nos. 2 and 3), and the *Royal Visit to the City of Hwasŏng* (no. 8). Various points of view—bird's-eye, side, three-quarter, overhead, and reverse perspective—were combined within a single picture plane in order to render the architectural complex in its entirety and to depict indoor and outdoor activities simultaneously. Such archaistic freedom in the use of perspective and viewpoint is often salient in the topographical maps, as seen in the *Map of the Capital City* (no. 15). That this reflects a convention perpetuated at the court rather than the state of knowledge and technique of the period can be illustrated by a comparison with the *Map of the Eastern Palace* (fig. 1), rendered with more realistic perspective.

In one style of figure painting practiced at the court, seen in the portraits in the *Albums Commemorating the Gathering of the Elder Statesmen* (fig. 7), figures are either seated on a chair or simply against a blank background that has no spatial relationship to the subject. There is no intention to induce the viewer's subjective emotion. The shading technique somewhat arbitrarily employed for facial features lends a certain degree of realism. Opaque colors are used in combination with ink and various light colors. The closed, pseudorealistic composition of these eighteenth-century portraits is very much in keeping with the classical tradition of formal portraiture that had been perpetuated in China and Korea. It is interesting to observe that this highly conventionalized style of formal portraiture went unchallenged and coexisted with the incredibly subjective, expressive style found in the self-portrait by the literati painter Yun Dusŏ (1668–1715; no. 60) as well as in various genre paintings, many of which were by the same court painters who produced ancestral portraits. Again, this demonstrates that the classical style used for formal portraiture does not represent technical naivete or a mere archaizing mode but an aspect of ancestral worship sanctified by tradition.

In bird and flower paintings, bold motifs and their graphic stylization

49

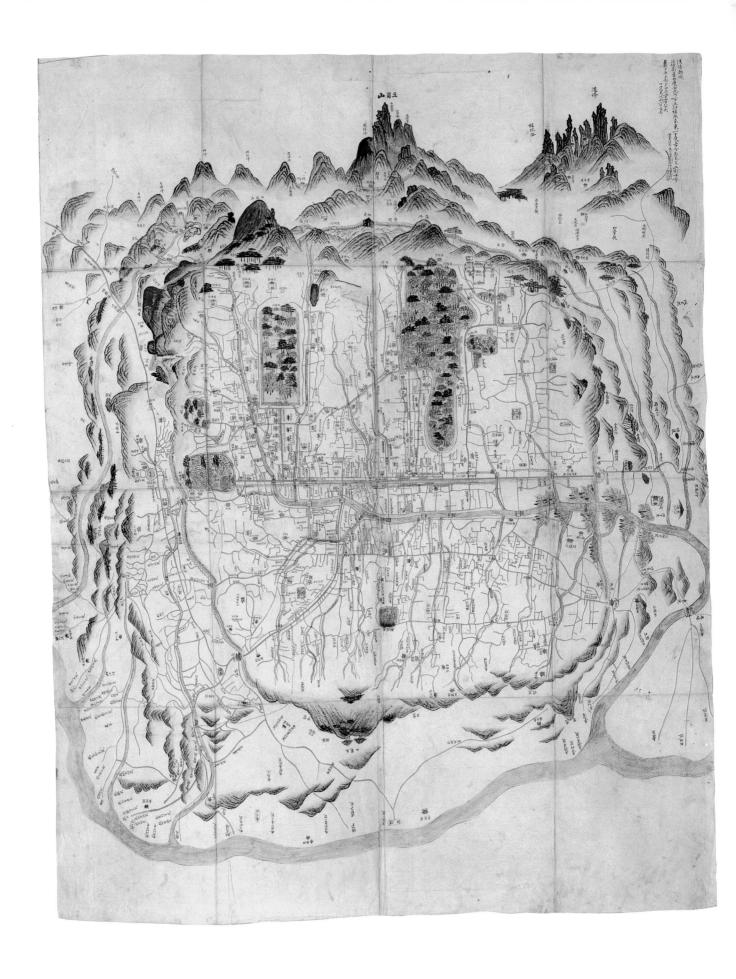

15. MAP OF THE CAPITAL CITY
Late Chosŏn
Color and ink on paper
51 x 40¾ in (129.5 x 103.5 cm)
Ho-Am Art Museum, Yongin

are striking, as the various longevity screens superbly demonstrate. Most dramatic, however, is the *Peonies* screen (no. 22). No atmosphere, no light, and no illusion of depth are allowed to obscure the clarity of the subject. Auspicious mineral colors dominate the depiction of this symbol of prosperity and fame. Schematic exaggeration forces the plant into a tall, vertical column against the blank picture plane. The peonies are no longer in the living realm; instead they are transformed into ritual objects, appropriate to weddings and ancestral worship. The auspicious motif, its exaggerated interlaced form, and its repetition reinforce the peony's talismanic symbolism.

Another significant archaic feature of Chosŏn court painting is the use of non-naturalistic color schemes characterized by heavy mineral pigments, primarily red, yellow, blue-green, black, and white. Visual evidence suggests this coloring technique probably developed sometime during the Zhou dynasty, when the concept for the archetypal "five colors" was formulated in correspondence with the cosmological Theory of the Five Elements, thus giving it a magical efficacy and an auspicious aura. The court's red-and-blue tradition in art and architecture contrasts sharply with the monochromatic style prevalent in the art and life of the literati elite. It was consciously chosen to imbue the house of Chosŏn kings with divine potency through the use of the sanctified, cosmogonic five colors.

Moreover, the frequent use of the screen format in court painting had symbolic overtones. Screen paintings had been part of the regalia of the Chinese emperor since ancient times, and screens appear behind Korean kings and queens in depictions datable as early as the fifth century. The screen kept its function as a marker of sacred space, best exemplified by the use of the Sun, Moon, and Five Peaks screen (see entry for no. 1).

The archaic style seems to have reached its summit around the end of the eighteenth and the beginning of the nineteenth century in the so-called scholar's studio screens, which depict books and scholar's utensils (for example, no. 32). The subject is classified under still life in early Chinese painting categories, but in the hands of eighteenth-century Chosŏn artists it was transformed into one of the most dazzlingly picturesque Korean idioms. The simplified, schematized forms and the mechanically produced lines for stacked books and bookshelves are archetypal symbols for culture, an important characteristic of the authentic Confucian state.

The Chosŏn emulation of Chinese antique style had broad cultural implications. It was manifested in all aspects of government-sponsored culture: city planning, architecture, the visual arts, and literature. The display of paintings, particularly screen paintings and portraits, as sacred emblems was among the requirements for public rituals and ceremonies in an ideal Confucian state. The Bureau of Painting, under the Ministry of Rites, recruited skilled artists to produce ritual paintings faithfully and skillfully. Into this sacred tradition, in which perpetuation through re-enactment was of paramount importance, such factors as stylistic individuality, innovation, and development could not be introduced.

The concept of the archaic style can redefine Chosŏn court art and secure its proper place in the history of Asian art when it is understood within the broader political and cultural context of the Chosŏn dynasty and of East Asian civilization at large.

THE ROYAL INSTITUTIONS FOR THE ARTS

Throughout the Chosŏn period, painting and ceramics undoubtedly received the most attention from the court for both practical and aesthetic

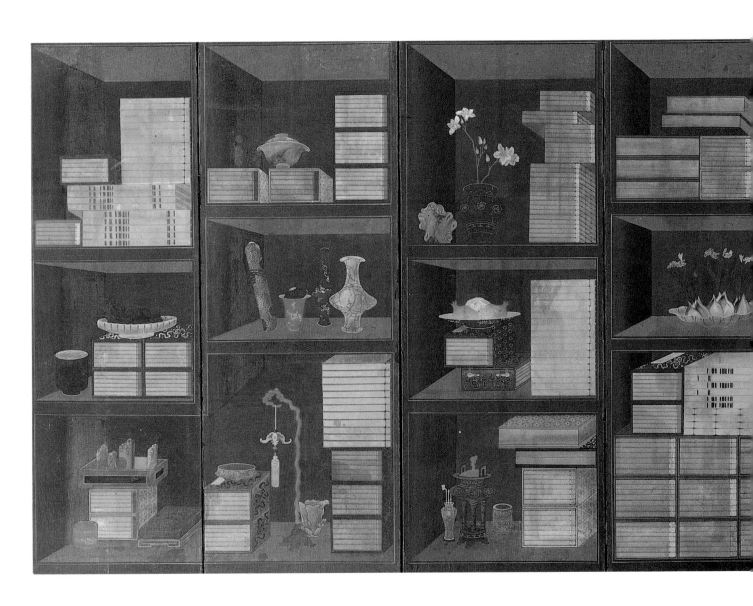

32. BOOKS AND SCHOLAR'S UTENSILS
 19th century
 Lee Hyŏngrok (b. 1808)
 Eight-fold screen; color on paper
 79½ x 172½ in (202.0 x 438.2 cm)
 Ho-Am Art Museum, Yongin

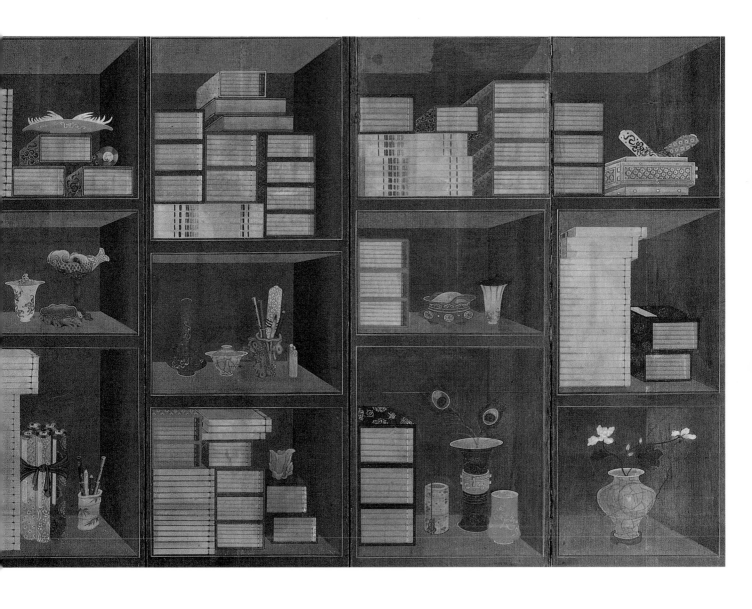

reasons. In fact, painting and ceramics largely constitute Chosŏn art as we know it.

Court art was produced mainly by the members of the Bureau of Painting, the artisans attached to various offices and the professional calligraphers from the Kyujanggak Library, and the Sengmun Academy. The court temporarily hired additional artists and artisans when new palaces were being built or to accommodate the needs of major state funerals and royal weddings. Civil and military officials and aristocrats who were proficient painters and calligraphers also contributed; however, they were set apart from the professionals by virtue of their superior status.

Chosŏn court patronage of painting went well beyond the practice of merely assigning painters-in-waiting to whatever bureau might need them as decorators. Unlike calligraphers and artisans, they were recruited through special examinations and belonged to a highly sophisticated organization. Although they seem to have occupied a lower social and official rank than calligrapher-officials, they definitely enjoyed an elevated status at the court and were held in higher regard by society than were artisans.

Of all the government institutions that controlled the manufacture of applied arts for the court, the most representative was the Punwon (literally, "branch office") of the Royal Pantry Bureau, which was established to manufacture porcelains for the court.

The Bureau of Painting

At the beginning of the Chosŏn dynasty, the Academy of Painting (Tohwawon), under central government control, had been established and attached to the Ministry of Works. In 1405 it was put under the control of the Ministry of Rites. The name was changed to the Bureau of Painting (Tohwasŏ) around 1471, which meant its degradation by one rank in the official hierarchy. The bureau was located in the Kyun-py'ong district in the vicinity of Kyŏngbok Palace, presently the Insadong area occupied by numerous antique shops and galleries.

Painters entered the bureau through the talent-recruitment examination (ch'ui-jae), a generic term for various special examinations held whenever technicians and artists were needed. Open to commoners (yangmin) and even to the lowborn (ch'ŏnmin) skilled in painting, these examinations were not operated within the regular government examination system. Technical specialists, who matriculated in the fields of foreign language, medicine, astronomy (including meteorology and geomancy), and law, were looked down upon by the yangban, whose status was hereditary and who thought them a hodgepodge. The fact that the examination for painters was not an integral part of the regular examination system initially classed painters lower in the official hierarchy than technical specialists.

The normal means of promotion was through monthly tests given at the bureau that entailed copying old paintings in the palace collection. However, there were also special promotions that allowed prominent bureau artists to receive ranked outside positions. Nevertheless, when the bureau's members were awarded such honors and promotions, even by the direct order of the king (as was Kim Hongdo), their elevated stature engendered a rivalry with civil officials and led to a series of statutory restrictions on bureau members.

There emerged an increasing number of scholar-officials who were known for their painting skills and were ordered to participate in important state projects, but they were treated differently from bureau painters and

were given supervisory titles, such as project director and inspector. They could refuse to collaborate directly with bureau painters and act solely as inspectors. When they did perform in a collaborative capacity, they requested that their names appear on the project record separately, as scholar-painters.

The governing elite's low opinion of court artists is well attested by three of the dynasty's greatest statesmen and reformers, Chŏng Dojŏn (1342–98), Yu Sŏngwŏn (1622–73), and Chŏng Yagyong (1762–1836). They all perceived the bureau's function as being more practical than artistic. In their official writings, they all characterized the bureau painters as artisans and suggested that the government reduce the bureau's scale and staff. Two of them suggested that it be placed under the jurisdiction of the Ministry of Works. Chŏng Yagyong, who was the leader of the School of Practical Learning, sought to dramatically reduce the bureau, warned against extravagance, and indicated that much of the court artists' work was for the consumption of the *yangban*.

For centuries, court painters had faced disdain and challenges to their further elevation in status. Their struggle led them to unite with others of comparable status to form a group more powerful in practicality than their treatment as second-class citizens by the *yangban* might have allowed.

The above-mentioned, so-called hodgepodge class of technicians later constituted the *chungin* (middle people). This class identification seems to have emerged sometime in the mid-seventeenth century and gradually included calligraphy technicians as well as painting technicians. In addition to such technical professionals, the *chungin* class also absorbed lowly administrative workers from the provinces as well as the male descendants of *yangban* and their secondary wives who were banned from taking the civil examinations and had begun to enter the Bureau of Painting by the eighteenth century. *Chungin* youth generally undertook technical and artistic studies, were eligible for regular government examinations on the basis of heredity, and married within their class. As a result, there was a number of painter-and-calligrapher families that produced at least one member to enter the court service over the next few generations. Such class regimentation seems to have had an important bearing on the development of art since it tended to nurture the unification and perpetuation of stylistic traditions at the Bureau of Painting.

Another significant aspect of the institutional operation of the bureau was the poor remuneration earned by the unranked court artists, which led them to seek outside income—with tacit approval from a government undergoing financial difficulty. (Potters at the government kilns were in a similar situation.) Despite an increase in the number of regular members and students in the bureau, there was little change in the number of ranked, titled positions within it, which meant that most of these artists were dependent on irregular, meager salaries. The demand to act as mere artisans and to produce highly conventional works at the court made artists seek an outside outlet for their creative inclinations, among the literati and like-minded.

Thus, the Chosŏn academization of painting, with both its beneficial and stifling effects, was as much a product of Chosŏn institutional politics as of pure aesthetic concerns and so, too, was the initial opposition to it.

Punwon, The Central Government Kilns

The eighteenth-century Chosŏn court exclusively used porcelains—mainly plain white and blue-and-white—for its general kitchenware, utensils for

funerary and memorial rituals, pharmaceutical utensils, and special ceremonial wares. Owing to such extensive use, the court required an annual supply of about 14,000 pieces plus an additional supply for special occasions, such as state funerals and weddings. These were provided by the central government kilns, called Punwon, in Kwangju–gun, in Kyŏnggi Province, which had been in operation since the mid-fifteenth century.

Originally potters were conscripted and had to devote a portion of each year to government work or pay an artisan tax to avoid it. By the turn of the eighteenth century, such compulsory service was replaced by the full-time employment of potters who worked for the Bureau of the Royal Pantry. The pay and working conditions were distressful. During the eighteenth century, as a means to alleviate the suffering of the potters, and because Punwon's maintenance and fulfillment of the annual quota were constantly threatened by a shortage of funding and potters, the government finally resorted to allowing Punwon to produce extra pieces to be sold to help defray the potters' livelihood. The resulting semiprivatization of Punwon was in keeping with the contemporaneous economic trend toward private industry; however, most likely those who profited from such practice were a few collaborating officials and head potters.

By the eighteenth century, Punwon and its potters sold their wares, through both legal and illegal channels, to the households of wealthy officials, who had developed a taste for such goods early on. The practice of private selling at Punwon started covertly but became increasingly open from the latter half of the seventeenth century as the demand increased. Thus, the central government kilns fulfilled the demand of both the public and private sectors for fine porcelains, a phenomenon of art-historical significance.

Meanwhile, the popularity of blue-and-whites and other fine porcelains outside the court had grown to such an extent that a record dated 1701 indicates that, despite the law restricting blue-and-white wares to the exclusive use of the court, blue-and-whites became so popular and readily available that they were found even in a common, rural household. Not only could the wealthier *yangban* afford such luxury, the rich peasant class, wholesale merchants, and *chungin* could too.

With government-approved private sale, Punwon attracted brokers and merchants who purchased high-quality porcelains for their nationwide markets. By the 1790s, the outflow of Punwon products had become so rampantly beyond government control that the most luxurious wares were produced for private sale rather than for the court. At some point the court found it more economical to purchase its pieces from the potters rather than pay for the operation. This signifies that the potters of the Kwangju Punwon were increasingly dependent on financiers and merchants.

The demand for fine porcelains by the populace and the increasingly open private sale of Punwon porcelains were mutually germane. The Punwon potters naturally produced their private wares in keeping with the tastes of their customers. The growing wealth among the popular consumers, along with the commercial success of the merchants, gave impetus to the production of high-priced wares of great variety, as evidenced by the change in quality, decor, shapes, and type dating from the eighteenth century. This signifies that an extensive diffusion of court and common tastes in ceramics took place during the eighteenth century. It also explains the difficulties in distinguishing court from noncourt wares. Additionally, it suggests that the expensive-looking, high-quality wares might have been used outside the court, contrary to our traditional belief. The more luxurious,

the less courtly they became. But they were never as luxurious, formal, and decorative as contemporaneous Chinese ware. They were basically simple, frugal, and more personal, and were characterized by a rare spontaneity.

Chosŏn court patronage of both painting and ceramics resulted in a phenomenon of great art-historical significance: the extensive private patronage of court artists who produced paintings and ceramics, which greatly contributed to the character of Chosŏn-period art from the seventeenth century onward. The court artists were the main suppliers of arts to both the palaces and the populace. While this led to occasional influences on some types of court painting that were not too rigidly circumscribed in style, its greater effect was in the other direction, especially in the case of ceramics. The fact that the same artists worked for two groups of patrons brought about the dissemination of the court taste and its diffusion with the private taste.

SELECTED REFERENCES

Acker, William, trans. *Some T'ang and Pre-T'ang Texts*. 2 vols. Leiden: E.J. Brill, 1954 and 1974.

Adams, Edward B. *Palaces of Seoul: Yi Dynasty Palaces in Korea's Capital City*. 2d ed. Seoul International Tourist Publishing Co., 1982.

Ahn, Hwi-joon. "An Kyŏn and 'A Dream Visit to the Peach Blossom Land.'" *Oriental Art* 26, no. 1 (Spring 1980).

———. *Chosŏn-wangjo-sillok ŭi sohwa-saryo (The Records of Calligraphy and Painting in the Veritable Records of the Chosŏn Dynasty)*. Seoul: Academy of Korean Studies, 1983.

———. "Chosŏn wangjo sidae ŭi Hwawŏn" (Court Painters of the Chosŏn Dynasty). *Han'guk munhwa (Korean Culture)* 9 (1988).

Chang, Ki-in, and Pyok-song Han. *Tanch'ong (Red and Blue)*. 2d ed. Seoul: Posun muhwa-sa, 1991.

Chong, Pyong-mo. "A Study of *Kyongjik-do* [Paintings of Agriculture] in the Second Half of the Chosŏn Dynasty." *Misulsa yŏn'gu (Korean Journal of Art History)*, no. 192 (December 1991).

Chung, Yang-mo. "18saegi ŭi ch'onghwa paekja ae taehayo" (On the Blue-and-White Porcelains of the Eighteenth Century). In *Chosŏn paekjajon III: 18saegi ch'onghwa paekja ae taehayo (Chosŏn Porcelains III: Blue-and-White Porcelains of the Eighteenth Century)*. Exh. cat. Yongin: Ho-Am Art Museum, 1987.

Hong, Son-p'yo. "Chosŏn jo p'ungsok'hwa paljon ŭi yinyom jok paegyong" (The Ideological Background of the Evolution of Chosŏn Folk Painting). In *P'ungsok'hwa*. Seoul: The Central Daily News, 1985.

Kim, Dong Won. "Chosŏn wangjo sidae ŭi Towhasŏ wa Hwawŏn" (The Bureau of Painting and Painters of the Chosŏn Dynasty). Master's thesis, Hong-ik University, Seoul, 1980.

Kim, Sunghee. "Chosŏn sidae ujin ae kwanhan yŏngu" (A Study of King's Portraits in the Chosŏn Dynasty Based on the Analysis of Uigwae). Master's thesis, Ehwa Women's University, Seoul, 1990.

Lee, Ki-baik. *A New History of Korea*. Translated by Edward W. Wagner with Edward J. Shultz. Cambridge, MA: Harvard University Press, 1984.

Lee, Ne-ogg. "Chosŏn p'ungsok'hwa ŭi kiwon" (The Origin of Genre Painting in the Later Chosŏn Period: A Study on the Basis of Yun Dusŏ's Painting). *Misul charyo (National Museum Journal of Arts)*, no. 49 (June 1992).

Seoul yukpaek nyun sa (Six Hundred Years of Seoul). Seoul: City of Seoul, 1977.

Thorp, Robert L. *Son of Heaven: Imperial Arts of China*. Seattle: Son of Heaven Press, 1988.

Yi, Hi-dok. "Koryŏ sidae ŭi ch'onmungwan kwa yukyojuui jok chongch'i inyom" (The Astronomical Observation and Political Ideology of Confucianism in the Koryŏ Dynasty). *The Journal of Korean History*, no. 17 (July 1977).

You, Jianhua, comp. *Zhongkuo hualun leipi en*. 2 vols. Beijing: Zhonghua shuzhu.

Yu, Hong-jun. "Chosŏn sidae kirok'hwa silyong'hwa ŭi yuhyong kwa naeyong" (Types and Contents of Chosŏn Documentary and Functional Paintings). *Yaesul ronmunjip (Anthology of Scholarly Articles on the Arts)*, no. 24. Seoul: Art Academy of the Republic of Korea, 1985.

Yun, Yong-i. "Chosŏn sidae Punwon ŭi songrip kwa pyonch'on ae kwanhan yŏngu—Kwangju ildae toyoji rul chungsim uro" (A Study of the Establishment and Evolution of Punwon During the Chosŏn Dynasty), pts. 1 and 2. *Kogo misul (Archaeology and Art)*, nos. 149 and 151 (1981).

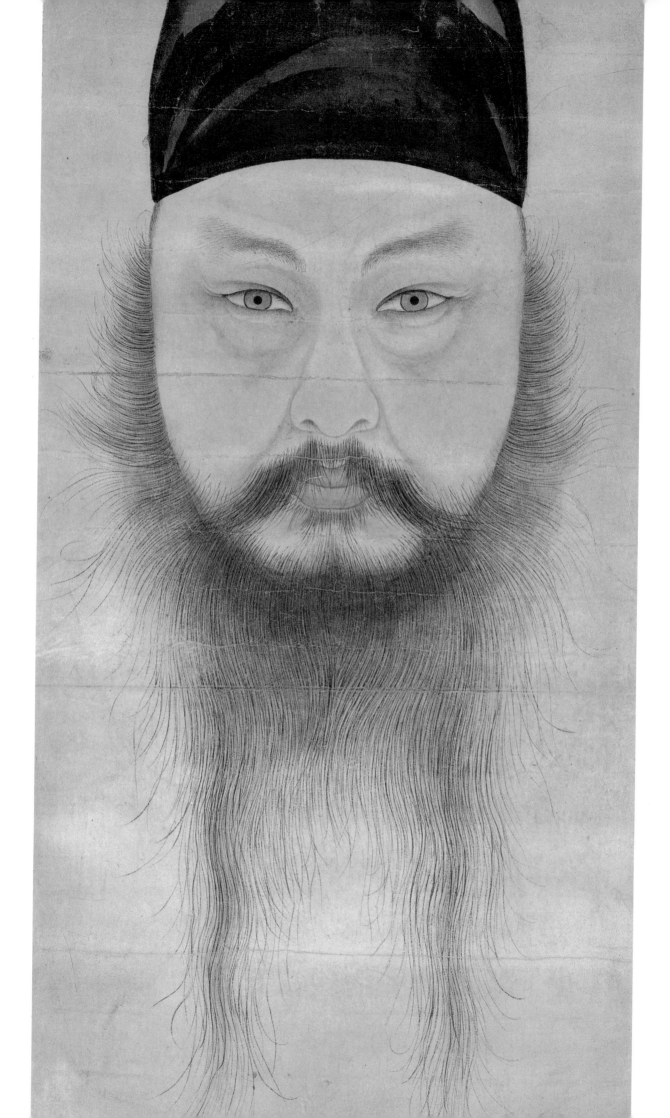

The Art
of Everyday
Life

Chung Yang Mo

THE EIGHTEENTH CENTURY was the formative period of modern Korean culture and art. Just as the art of every people expresses a particular world view, Korean arts of each era reflect the Korean people's dynamic understanding of the inner elements of the universe, which are immutable, and its surface forms, which are as changeable as water and clouds. It was during the eighteenth century that the country's arts became quintessentially Korean in their expression of nature and people's relationship to it. The role of art during the Three Kingdoms period (57 B.C.E.–668 C.E.) was to enhance the dignity of royal authority, and its characteristic forms were luxurious metalwork and tomb architecture. During the succeeding Unified Silla period (668–935 C.E.), the peninsula was united politically; Buddhism increasingly became a religion of the people, spreading beyond the royal family and the aristocracy; Confucianism was seen to have political and social applications; and there was cultural interchange with Tang China and east India. The applied arts were put into the service of the individual, not just the monarchy, and Buddhist sculpture and architecture flowered. Building on this basis, applied arts, such as ceramics, metallurgy, and lacquer (plain and inlaid with mother-of-pearl), became available to the populace at large during the Koryŏ dynasty (918–1392). With the advent of the Chosŏn dynasty (1392–1910), Confucianism replaced Buddhism as the official ideology, and new forms of thought and art that were focused on this world developed. The admixture of local customs, Shamanism, Buddhism, and Confucianism that emerged to provide spiritual sustenance to the Korean people during the Chosŏn period continued until 1950, just as the artistic forms that emerged during

60. SELF-PORTRAIT
18th century
Yun Dusŏ (1668–1715)
Hanging scroll; ink and light color on paper
15¼ x 8 in (38.4 x 20.4 cm)
Yun Yŏng-sŏn Collection, Haenam
Treasure no. 240

the latter Chosŏn period, particularly the eighteenth century, shaped the modern arts of Korea.

As Confucianism became predominant, Buddhism and the rich aesthetic of the Koryŏ dynasty began to recede. Accordingly, the green ceramic ware characteristic of the Koryŏ period, celadon, gave way to a different form of green ware, *punch'ŏng*, typical of the early Chosŏn period of the fifteenth and sixteenth centuries. This was displaced, however, by a form of delicate white porcelain that became preeminent during the seventeenth century. White porcelain had a simple, temperate, and frugal beauty that harmonized with Confucian ideals. Among early Chosŏn painters, An Kyŏn (b. 1418) was preeminent, and the *yangban* scholar-official Kang Hŭian (1419–64) produced highly personal paintings, while his brother Kang Hŭimaeng was a prominent theorist. A high level of portraiture was seen in the work of Sin Cham (1491–1554). The Japanese invasions at the end of the sixteenth century and the Chinese incursions of the early seventeenth interrupted the progress of the arts, however, and the cultural and material destruction wrought by these wars in tandem with the fall of the Ming dynasty to the barbarian Manchus (who founded the Qing dynasty) brought about many changes in Korean thought, politics, and culture.

Until the late seventeenth century, the Chosŏn monarchy was a subject state of China, and Korean Confucianism was idealistic and theoretically pure. By the eighteenth century, trends begun during the seventeenth had coalesced into a new Korean self-image. During the reigns of Sukchong (1674–1720), Yŏngjo (1724–76), and Chŏngjo (1776–1800), the simultaneous development of different schools of Confucian thought, such as the School of Practical Learning, and the increasing diffusion of the arts in society jointly fostered arts reflective of new conceptions of self and society, individual and nation. Korea began to define itself rather than be subservient to Chinese ideas. Along with the emergence of this national and self-consciousness, the middle class, both urban and rural, was becoming increasingly enfranchised and wealthier, one effect of which was the stimulation of the arts, as arts and industries developed for royalty under Sukchong became more widely available. National and self-cultivation replaced a dependence on Chinese models.

All aspects of eighteenth-century culture exhibited originality and assumed novel forms of expression through self-reflection and awakening rather than the perpetuation of old customs. The subjects of literature and poetry were Korea and Korean life. Such works featured the birds of Korean mountains rather than such symbols as the dragon or phoenix, and they extolled the scenic and historic features of Korean sites, such as the Han River, instead of those featured in the poems of Tang China. Local animals, places, and life-styles were now the subject of glorification. The works of Pak Chega, Yu Dŭkgong, Yi Sŏgu, and Yi Dŭkmu contain significant examples. "Do not try to emulate the sages in China, emulate our sages" and "the study of Chosŏn is the true study" were ideas expressed by Pak Chega. Instead of China's chronological era, Pak Chega used "the chronological era of Chosŏn." Yi Dŭkmu said, "I am not Du Fu or Li Bai, this is not the Tang dynasty, and my poems should sound like me." And Pak Chiwŏn (Yŏnam) asked, "We are different from China, why try to emulate China?" They believed that the material and content of poetry should be derived from their own ideology and thought. This trend was mirrored in the visual arts, making the eighteenth century a highly individual period of representation of unique Korean attributes, engendering the freedom and variety of the arts of the nineteenth century.

47. PAPER SCROLL STAND WITH ORCHIDS
18th century
Porcelain painted with underglaze blue
H. 6¼ in (16.0 cm)
Ho-Am Art Museum, Yongin
Treasure no. 1059

FIGURE 8. Korean landscape in autumn.

Of all eighteenth-century arts, painting and ceramics are the most characteristic, and they are well represented by extant examples; therefore, they will be the focus of this discussion.

As in poetry, the topography, flora, and fauna of Korea and its various life-styles became the subjects of painting. There was originality in expressive technique, composition, and color. These were pictorial expressions of the social trends and ideology of the time. The most important trends in eighteenth-century painting were true-view landscapes of Korean mountains and rivers; genre pictures depicting the lives and emotions of the Korean people; and the expansion of the subjects of literati pictures to include Korean animals, insects, and plants. In these new pictorial modes, quality, variety, and new subjects were introduced by adapting Chinese "Southern School" pictures and techniques. The possible effects of Western drawing techniques and knowledge about the Western world and civilization should not be discounted, either. Prior to the eighteenth century, the style and technique of the Chinese "Northern School" had been dominant. It is remarkable, however, that after the eighteenth century the techniques of the Southern School were most frequently used by the artists who painted Korean landscapes. There is no single satisfactory explanation as to why the hegemony of the Northern School gave way to the Southern style during the eighteenth century. The lack of self-expression that character-

ized painting until then might have resulted from the belief that the beauty and drawing methods of the idealized, conventionalized pictures of the Northern School were perfect.

There were a few precedents in the Korean tradition for the changes that crystallized during the eighteenth century. At the beginning of the fifteenth century, when King Sejong (r. 1418–50) established a great Korean culture, the artist An Kyŏn painted a picture of a utopia that Prince Anp'yŏng had envisioned in a dream. It was different from Chinese landscapes. During the sixteenth century, Yi Am (b. 1499) painted *A Dog and Puppies*, which represented a fresh Korean sensibility and was as refreshing as rain after a long drought. A few seventeenth-century paintings were characterized by Korean rather than Chinese sensibilities, but they were proportionally few. Cho Sok (1595–1668), an artist from the *yangban* class, exhibited a Korean style in his pictures of trees and birds. A documentary painting of a state examination by a member of the Bureau of Painting, Han Sigak (b. 1621), found special favor with the king. Painted in the blue-and-green landscape manner, it is a realistic depiction of Korean, rather than Chinese, buildings and people. Judging from this example, the backgrounds and people of pictures of literati gatherings began to be expressed in a Korean style during the late seventeenth century. A few portraits from the Koryŏ period have survived, as have many group portraits from the beginning of the Chosŏn period. They show incremental change over time and have more Korean than Chinese characteristics.

The literatus Yun Dusŏ (1668–1715; sobriquet Kongjae) infused some of his many wonderful works, which provide evidence of an advanced intellect, with real-life emotion. His self-portrait, which includes only his realistically depicted face (no. 60), provides a vivid example of the deft way in which he represented his individual thoughts and imagination. His portraits of Sim Dŭkyung and an old monk provide further evidence of his originality. These striking portraits appear very modern to us. His limning of a person's inner being required great skill and effort, yet the notion of doing so became the basis of eighteenth-century portraiture, which had its roots in the seventeenth century and was realized in the spiritual, social, and artistic revolution of the latter century.

The most remarkable achievement of eighteenth-century painting was the development of true-view landscape (*chin'gyŏng sansu*). Seventeenth-century attempts at depicting Korean scenery did not break the hold of the Northern School–style of Chinese landscape painting. However, during the eighteenth century, the great artist Chŏng Sŏn launched and refined the Korean true-view landscape painting movement.

Chŏng Sŏn (1676–1759), also known by his sobriquet Kyŏmjae, was a *yangban*, not a professional painter, yet he devoted himself to it as if he were. Even so, he did not achieve greatness quickly. Having undergone a long period of preparation and having executed numerous pictures that employed various types of drawing methods, it was during his fifties that he produced original compositions that express the meaning and beauty of Korean landscapes. Combining the acute self-consciousness of the School of Practical Learning, traditional Chinese pictorial ideas and methods, and a new Korean aesthetic, he rendered his own world.

True-view landscape painting and its new compositional methods and techniques were based upon Chŏng Sŏn's study of earlier works in the Chinese Northern and Southern styles. He daringly expropriated the technique of the latter. He was instrumental in the dissemination of the Southern style in Korea, but he employed its compositional principles and handling in a

unique way. Chŏng Sŏn balanced contrasting elements in his paintings, demonstrating the harmony between masculine and feminine principles. This is illustrated in *Valley of Ten Thousand Waterfalls* (no. 52). The distant peaks are boldly rendered with vertical strokes. One side of the base is surrounded by low mountains, which are strongly and smoothly executed with small, dark dots; the other side opens to unlimited space. The entire scene is suffused with clouds, the bottom is filled with fog, and the peaks extend to the blue sky. The mountain appears to commune with the utopian spiritual world. The painting *Twelve Thousand Peaks of Mount Kŭmgang* (no. 54), painted when he was fifty-nine, bears the following inscription: "...the aura of Mount Kŭmgang rose to the far side of the East Sea; its energy suffused the entire world...." In this painting, Chŏng Sŏn contrasted foreground and background. In the foreground, there are small, dark dots under the peaks, which give height to the main peaks.

Chŏng Sŏn excelled at sketches, and he painted portraits, animals, plants, and insects. Detail was always secondary to the entirety of the composition in his landscape paintings; his structure and harmony were an original contribution. His innovation, dynamism, and occasional roughness give his nature subjects an informal freshness, while his harmonious composition and partial description exhibit beauty and vitality particular to eighteenth-century Korea.

Other notable eighteenth-century *yangban* painters were Cho Yŏngsŏk (1686–1761; sobriquet Kwanjae), Yi Insang (1710–60), Kang Sehwang (1713–91), and Sim Sajŏng (1707–69). Bridging the eighteenth and nineteenth centuries was Chong Suyŏng (1743–1831). The birth-station of Kim Duryang (1696–1763) is uncertain, but his paintings exhibit a scholarly personality. Sim Sajŏng, who was born about thirty years later than Chŏng Sŏn, mainly painted Chinese landscapes but with originality. Sim Sajŏng painted traditional, idealized landscapes in his own way and exhibited superior skill in painting plants, insects, flowers, birds, and animals—transcending the beauty of the actual subject in his paintings (no. 94). Cho Yŏngsŏk and Kang Sehwang (no. 51) also produced paintings that bore strong personal imprints, and Kim Duryang depicted landscapes and animals rather than painting the usual idealist landscapes. Possibly acquainted, Chŏng Sŏn or Kyŏmjae, Cho Yŏngsŏk or Kwanjae, and Sim Sajŏng or Hyŏnjae were grouped as great painters and called by some the "Three Jae."

A new phase of literati painting was instituted by Yi Insang and Kang Sehwang. Their paintings feature strong subjects depicted with vitality. Yi Insang had a delicate touch and made fluent use of the contrast of light and dark in his various and unique representations of literati themes. He extended the domain of literati painting by incorporating actual views to develop a kind of Korean literati landscape painting. His special contribution was to view nature and society through his own humanistic outlook (no. 70). From Yi Insang's pictures, one can derive a sense of deep scholarship as well as the tenor of the Korean renascence. He was deeply committed to innovation even in the face of conservative currents.

From the early to the mid-nineteenth century, the number of Chinese-style literati painters in Korea was decreasing. Although there were superior Southern-style literati painters who incorporated Neo-Confucian ideas newly imported from China, such as Kim Chŏnghŭi (1786–1856; also known as Ch'usa) and his noted disciples Cho Hŭiryong (1797–1859; sobriquet Wubong) and Chŏn Ki (1825–54; sobriquet Koram), they were in the minority. Kim Chŏnghŭi was, in some ways, a greater painter than

54. TWELVE THOUSAND PEAKS OF MOUNT KŬMGANG
1734
Chŏng Sŏn (1676–1759)
Hanging scroll; ink and light color on paper
51½ x 37 in (130.7 x 94.1 cm)
Ho-Am Art Museum, Yongin
Treasure no. 217

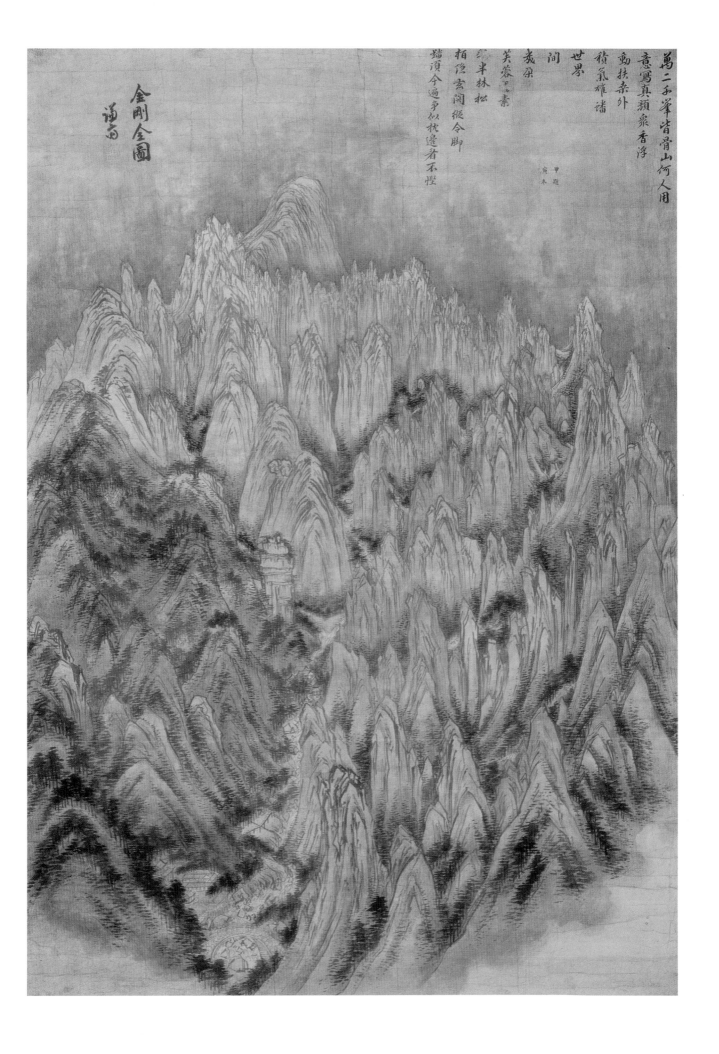

萬二千峯皆骨山何人用
意寫真顏衆香浮
動扶桑外
積氣雄諸
世界

間

炎桑

芙蓉巴巴素

氣半林松

柏隱玄閣徙令脚

端須令遍多似枕邊者不慳

甲寅
寅冬

金剛全圖
謙齋

65

82. ROOF TILING
18th century
Kim Hongdo (b. 1745)
Album leaf; ink and light color on paper
11 x 9½ in (28.0 x 24.0 cm)
National Museum of Korea, Seoul
Treasure no. 527

89. Amorous Youths on a Picnic
 Late Chosŏn
 Sin Yunbok (b. 1758)
 Album leaf; ink and light color on paper
 11⅛ x 13⅞ in (28.3 x 35.2 cm)
 Kansong Art Museum, Seoul
 Treasure no. 135

the literati artists of the eighteenth century, but, rather than building on the artistic innovations of the eighteenth century, he maintained an essentially conservative style.

What were the contributions of the *yangban* painters of the eighteenth century? Yun Dusŏ showed the way in his self-portrait; Yi Insang opened up literati painting by incorporating actual views; Kang Sehwang was a painter and a great critic; and Cho Yŏngsŏk depicted scenes of nature and the lives of scholars and ordinary people. Additionally, scholars, translators, and members of the Southern Neo-Confucian faction not named in this essay went to Qing China and brought back knowledge of Western culture and art, providing fresh ideas and materials. Kim Duryang's naturalistic painting of a dog scratching itself is a striking example. Few of the scholar-officials concentrated on painting to the degree that Chŏng Sŏn and Sim Sajŏng did—for most, painting was incidental to their scholarly pursuits. However, they tried to understand their times and boldly established their own world through the new ideology of self-examination. These painters were the standard-bearers of eighteenth-century painting, expanding its realm and giving it a new impetus.

Just as the scholar painters made significant contributions, there were professional painters who introduced refinements and innovations, such as the following artists who were employed by the Bureau of Painting: Pyŏn Sangbyŏk (active eighteenth century), Ch'oi Buk (1712–c. 1786; sobriquet Hosanggwan), Kim Ŭnghwan (1742–89), Yi Inmun (1745–1821), Kim Hongdo (b. 1745), Sin Yunbok (b. 1758), and Kim Dŭksin (1754–1822). Kim Hongdo, sobriquet Danwŏn, and Sin Yunbok, sobriquet Hyewŏn, greatly expanded the domain of Korean painting in the late eighteenth and early nineteenth centuries. Kim Hongdo was a great landscape and portrait painter and Sin Yunbok, a famous genre and portrait painter. Kim Hongdo, who was once appointed a magistrate, was an individual of high intelligence and graceful appearance. He was a student of Kang Sehwang and produced masterpieces equal to those of the *yangban* painters Chŏng Sŏn, Sim Sajŏng, and Cho Yŏngsŏk.

Kim Hongdo's subjects encompassed a wide spectrum—landscapes, stereotyped subjects, genre scenes, and portraits—but his style was never derivative. Whether he was creating a traditional, formulaic painting or recording the world that he observed, his composition and technique were original. His paintings combine bold composition with a refined drawing technique (for example, no. 84). The grandeur and vitality that characterize the works of Chŏng Sŏn were studied and absorbed by Kim Hongdo, but they are never manifested in a derivative way. Kim Hongdo built on the achievements of his predecessors with originality and a strong personal touch, forming his own style from his observations of their pictures. In Kim Hongdo's paintings, the appearance of objectivity dominates the subjective elements that are present. He was not only a remarkable genre painter, he set the precedent for Korean genre pictures. His faithful renderings of day-to-day life included all strata of society, high and low. Kim Hongdo also painted numerous pictures showing the complete passage and different phases of life. He adapted the traditional Chinese genre of depicting farming and weaving to a Korean style. He worked with other bureau painters on large documentary projects. He created prototypical illustrations for the printing plates of a book of Korean customs (*Tongguk munhŏn pigo [Reference Compilation of Documents on Korea]*), and the people and settings in them are unmistakably Korean. Sometimes he painted an isolated figure without a background, but such images effectively suggest natural settings.

78. LARGE JAR
18th century
Porcelain
H. 19 in (48.2 cm)
Lee Hak Collection, Seoul
Treasure no. 262

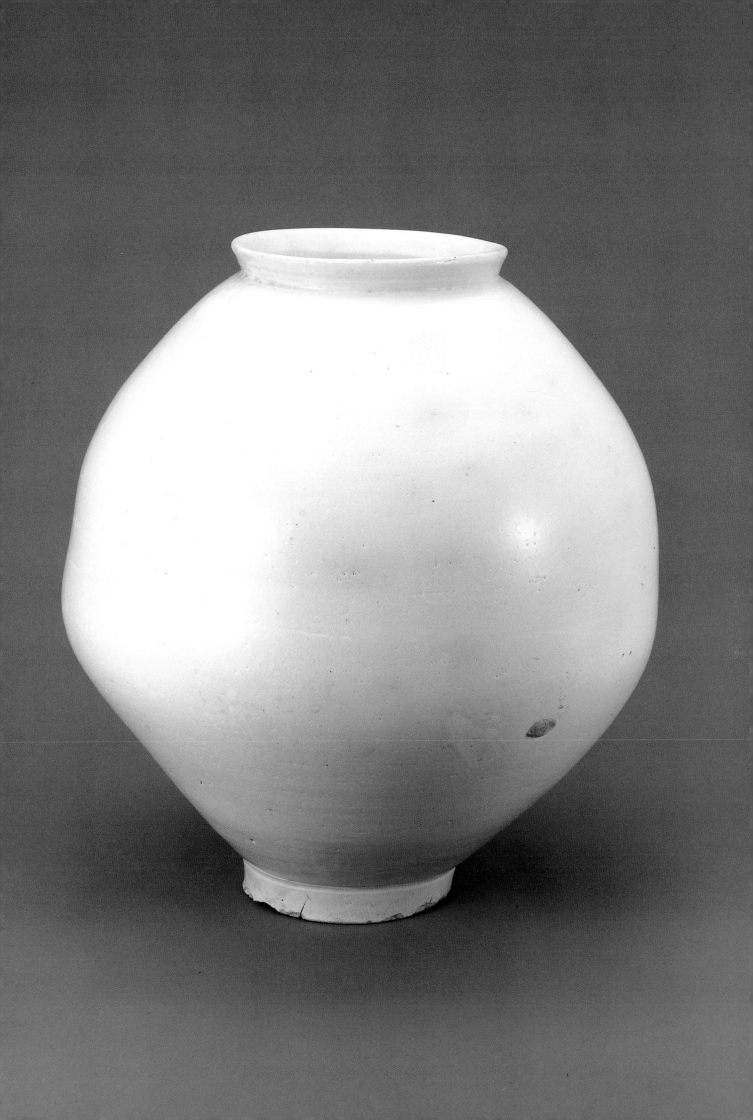

Kim Hongdo's paintings were widely imitated in his day and later became models of their type. His genre paintings impart a sense of immediacy and familiarity. Kim Hongdo's great pictorial sense and understanding of his time were brought to bear in his expressions of reality.

Kim Hongdo was close to the painter Yi Inmun as they were the same age and both members of the Bureau of Painting, but while Kim Hongdo depicted Korean life, Yi Inmun mostly painted Chinese ideal landscapes. Although he painted stereotypical Chinese subjects, Yi Inmun reinterpreted the Chinese tradition in his own, Korean way. That he and Kim Hongdo were sufficiently close to have collaborated on a work while generally painting in such different modes shows that diversity and tolerance characterized eighteenth-century painting.

The genre scenes of Sin Yunbok were set in a different milieu and have a different meaning from those of Kim Hongdo. Whereas Kim Hongdo described the farmers and the lives of the well-to-do, Sin Yunbok depicted the romantic interplay between profligate *yangban* and *kisaeng* courtesans. Kim Hongdo described the ordinary informal daily lives of people; Sin Yunbok delineated the heart-rending, frank beauty of romance and sexual desire (nos. 88–91). Where Kim Hongdo's touch was bold and informal, Sin Yunbok had a delicate line and exhibited a sense of sharpness. Kim Hongdo represented the magnanimous awakening of life, while Sin Yunbok expressed tender emotion. But both cultivated the ideology and self-examination that characterized the eighteenth century.

Every element in nature and civilization as well as everyday events were considered to be appropriate subject matter for eighteenth-century paintings. Even though these various subjects were depicted in many different ways, their innermost essence as well as their external forms were delineated.

The eighteenth century was a period of congruence among various ideologies and the arts. Intellectual and cultural processes of self-examination and discovery resulted in works of art worthy of close attention. Even though ideological and artistic traditions were subject to re-evaluation, it was an age of concord between those who occupied positions of privilege and others—members of the Southern faction, *chungin*, and the sons of *yangbans'* second wives—who became increasingly empowered. They all harmoniously coexisted. Intelligent persons of lower status—including merchants, artisans, and *chungin*—played important roles in shaping the eighteenth century. There were competent individuals among them, but only a few were able to distinguish themselves within the formal artistic ranks. Others devoted themselves to artistic pursuits without royal or private patronage.

Of greatest significance is the variety of eighteenth-century art and its function in the comprehension of a particular culture. Concurrent with the flourishing of art exploring Korean culture was an original interpretation of Chinese subjects and traditions, yet the painters of both groups were friendly with one another. New forms of painting established by Chŏng Sŏn and refined by Kim Hongdo captured the very heart—the humor, thought, emotion, and elegance—of Korea.

The eighteenth century was also possibly the most crucial period in the history of Korean ceramics, and central to it was the development of white porcelain.

The ceramic history of the Chosŏn period has been divided into three phases, based on the development of white porcelain: the first ranges from the founding of the dynasty in 1392 to the end of the reign of King Injo in

1649, a period marked by the Japanese and Chinese invasions; the middle extends from the first year of King Hyojong's reign, 1649, to 1751 (the twenty-seventh year of King Yŏngjo's reign); and the last is from 1752 to the end of the Chosŏn dynasty in 1910. The first phase was characterized by the dominance of two types, white porcelain and the greenish *punch'ŏng* ware; a few celadons and black iron-glazed wares were made as well. Celadon ware had been developed, refined, and mass-produced during the Koryŏ period, and the refined aesthetic of its Buddhist culture influenced its color, shape, and decoration. As the country decayed in the late Koryŏ period, so did the quality of this ware. During the later Koryŏ period, white slip began to be used on ceramics. The use of slip accelerated during the Chosŏn period, and the celadon ware characteristic of Koryŏ was displaced by *punch'ŏng* ware, which at first was inlaid or stamped and filled with white slip in a manner somewhat resembling the inlay of the celadon it superseded. This ware was more prevalent than white porcelain until the middle of the fifteenth century. Having a unique beauty, *punch'ŏng* ware was a bridge between celadon and white porcelain, but this green-glazed stoneware was eventually surpassed by white porcelain in popularity during the seventeenth century. (Ceramic history in China and Korea, who led the world, followed a line of development from plain earthenware to glazed earthenware to celadon, which is a glazed stoneware, to porcelain. This progression was particularly salient in Korea, where more celadon than porcelain was produced.)

The Koryŏ and Yuan courts had enjoyed long-standing relations, and at the beginning of the Ming dynasty in China, a new, off-white porcelain, *shufu* ware, was introduced to Korea. Although the technique of *shufu* porcelain was not immediately adopted, it came in at a time when the cultural context in which ceramics functioned was changing. The new Chosŏn dynasty suppressed Buddhism and adopted Neo-Confucianism. The new white porcelain was appropriate to Confucianism because it was solid and practical, with clearly inscribed patterns on its surface, matching the Neo-Confucian concept of unitarianism. Celadon was not replaced by porcelain overnight, however.

In the first phase of Chosŏn ceramics, under the influence of Confucianism, porcelain was combined with celadon in that *punch'ŏng* ware was modified to more closely resemble white porcelain. The body and glaze of *punch'ŏng* ware were similar to those of celadon, but in its early phases the body of *punch'ŏng* ware was inlaid with various kinds of beautiful patterns in white slip before the clear glaze was applied. At its peak, surfaces were entirely filled with white slip patterns. In later phases, the surface was covered, often completely, with white slip, either by brushing or dipping. In the course of the Japanese invasions, kilns were destroyed and many *punch'ŏng* potters were carried off to Japan, and during the fifteenth and sixteenth centuries, *punch'ŏng* ware was supplanted by white porcelain.

During the middle phase of Chosŏn ceramics, the white porcelain of the early period was transformed into a new type. This type began to develop slowly after the Japanese invasions, and the pace accelerated in the mid-seventeenth century. The middle period saw improvement in the quality of the white body, which was not as dense as that of works created during the preceding period, and it was called "snow white" and was intended to be pure white. Vessels became more angular, faceted shapes taller and narrower, and proportions very elegant. During the second half of the eighteenth century, the later Chosŏn style of porcelain developed. The beautiful, elegant shapes became squatter, bodies were rounder, and the foot

became wider, imparting a quality of stability. The quality of the clay was refined, and the surface was not crackled. The white porcelain again became dense, and, owing to an increase in its iron content, the glaze acquired a blue cast, giving the ware a blue-white appearance. At the beginning of the eighteenth century, traces of earlier Chinese, Koryŏ, and celadon style elements had completely disappeared, and a truly Korean porcelain emerged. Numerous variations on this type were created during the late eighteenth century (no. 79). In other words, the beauty of Korean ceramics peaked in the first half of the eighteenth century—a period during which the most purely Korean form was created under the influence of the prevailing ideology of self-examination and discovery. Beginning in the second half of the century, these classic wares began to be transfigured into modern shapes. Influences came from Qing China, and many types and forms were introduced, but the classic types were set.

Eighteenth-century Korean ceramics achieved a singular appearance of conciseness, simplicity, and excellence. Many classic works were created. Just as the mold was set for true-view landscape painting by Chŏng Sŏn and for genre painting by Kim Hongdo, a form of Korean ceramics was created that laid the groundwork for the subsequent period. The elegant, simple shapes of the vessels harmonize with gentle rather than sharp angles, and the surfaces are snow white (no. 78). Many kinds of vessels were made for various functions, but especially noteworthy are the varied and refined writing implements and the religious vessels.

The appearance of ritual vessels for home ancestral shrines was one important development in eighteenth-century ceramics. From early on, various kinds of ritual vessels in the style of traditional Chinese bronzes were used in the ceremonies at the royal Ancestral Temple (Chongmyo). Vessels of different types were used in Confucian ceremonies, but they had simpler forms and patterns than did the complex, traditional bronze vessels. Commoners might have used ritual vessels, but the lack of extant examples seems to indicate that they were not used in ordinary homes. Some pieces from the fifteenth to seventeenth centuries based on those from Confucian temples have been preserved. These have bases a little higher than regular vessels, and bear the character *che* ("offering") either inside or outside. Some of these ritual vessels were used as teacups in Japan. During the later Chosŏn period, ritual vessels were used more widely in the home, and dishes featured a high foot and the character *che* on the bottom. At the beginning of the eighteenth century, sets of ritual vessels were made that conveyed stability and elegance. The vessels of this period had an angled base, round ritual dishes were narrow and high, and other vessels resembled bowls or rectangular trays (nos. 113 and 115).

High-quality ritual wares were mass-produced in the latter half of the eighteenth century. The vessels were getting thicker and had a wide base. The influence wielded by contemporaneous ideology and literature leading to Korean forms and decoration for porcelain stationery items extended to the development of ritual vessels. The Confucian offering ceremony for which they were developed is based on the Chinese Neo-Confucian text the *Family Rites of Juxi* (C. *Juxi jiali*). The ceremony continues to be used, with modifications, in the present time. The ceremony originally had an unalloyed sense of dignity and reverence and was based on an ideology that demanded absolute obedience to the ruler, who used sets of ritual vessels. Through the process of self-examination and articulation, however, Koreans developed an ancestor ritual in a modified, Korean manner and, concomitantly, created their own set of ritual vessels for it. Because certain

71. LETTER RACK
18th century
Bamboo
32½ x 8¼ x 4⅜ in (82.6 x 21.1 x 11.1 cm)
Kim Ki-su Collection, Seoul

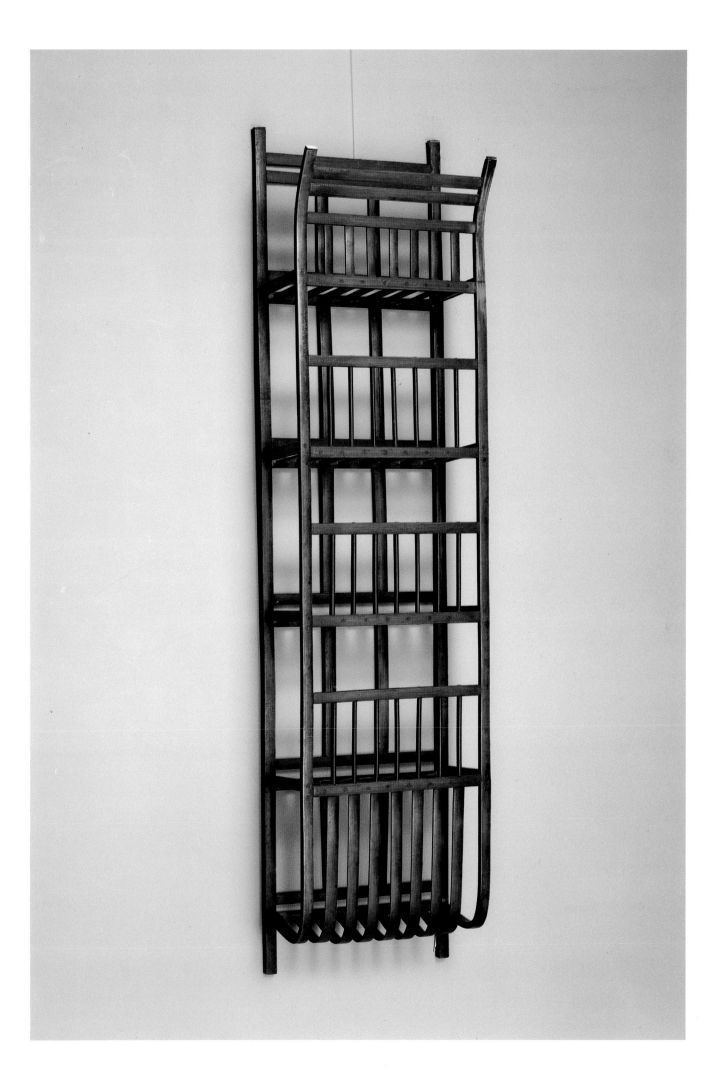

aspects of the ritual had become ossified by the eighteenth century, vessels were adapted to the modified Korean-style ceremony.

As varied as contemporaneous literature or painting, the writing accoutrements used by scholars and people of the upper classes took many different forms. Beautiful, high-quality inkstones, inksticks, ink jars, paper scroll stands, brush holders, brush washers, water droppers, and assorted other objects appeared in various types. For example, theretofore water droppers came in simple round, octagonal, and peach shapes, but now there were many different shapes and types of decoration. These included fireflies on peaches and blue or copper red painting (no. 69). Round water droppers became less common; flower-shaped and rectangular water droppers began to be made, and octagonal ones became more varied; iron brown and blue underglaze paintings were incorporated, including landscapes, flower paintings, and calligraphy; and animals, such as frogs and toads, were sculptured (nos. 44–46). Forms and decoration were changed from the ideal and inherited to new styles and patterns derived from Korean life and nature.

In the second half of the eighteenth century, stationery accoutrements developed in various ways, both in traditional forms and decoration and in new shapes and patterns based on native elements. They are humorous,

64. DOCUMENT CHEST
Late Chosŏn
Wood
11⅛ x 42⅝ x 8¾ in (28.2 x 108.2 x 22.1 cm)
National Museum of Korea, Seoul

bolder, and more concisely rendered than later examples. Simple, stable
forms of the brush case, brush rack, brush holder, brush washer, ink jar,
paper scroll stand, water dropper, incense stand, and basin with various
kinds of decoration were developed. These eighteenth-century prototypes
spawned nineteenth-century forms that had a smart appearance. The eigh-
teenth century concluded the classic and opened the modern phase of
ceramics.

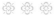

HOW DID THE EIGHTEENTH CENTURY lay the foundation for modern Korea and
modern Korean arts? After the ideological and political disputes of the sev-
enteenth century, philosophy and society stabilized in new forms that
emphasized Korea's intellectual self-sufficiency, and the artistic seeds of the
celebration of Korea and Korean life were built upon. In addition to the
innovations of Chŏng Sŏn in true-view landscape painting, Kim Hongdo
and Sin Yunbok in genre painting, and the previously discussed literati
painters who introduced Korean elements into their canon, Pyŏn Sang-
byŏk's Korean animal pictures and the depictions of Korean vegetables,
such as cabbages, radishes, and watermelons, by Ch'oi Buk and others
enlarged upon Korea's newly forged identity.

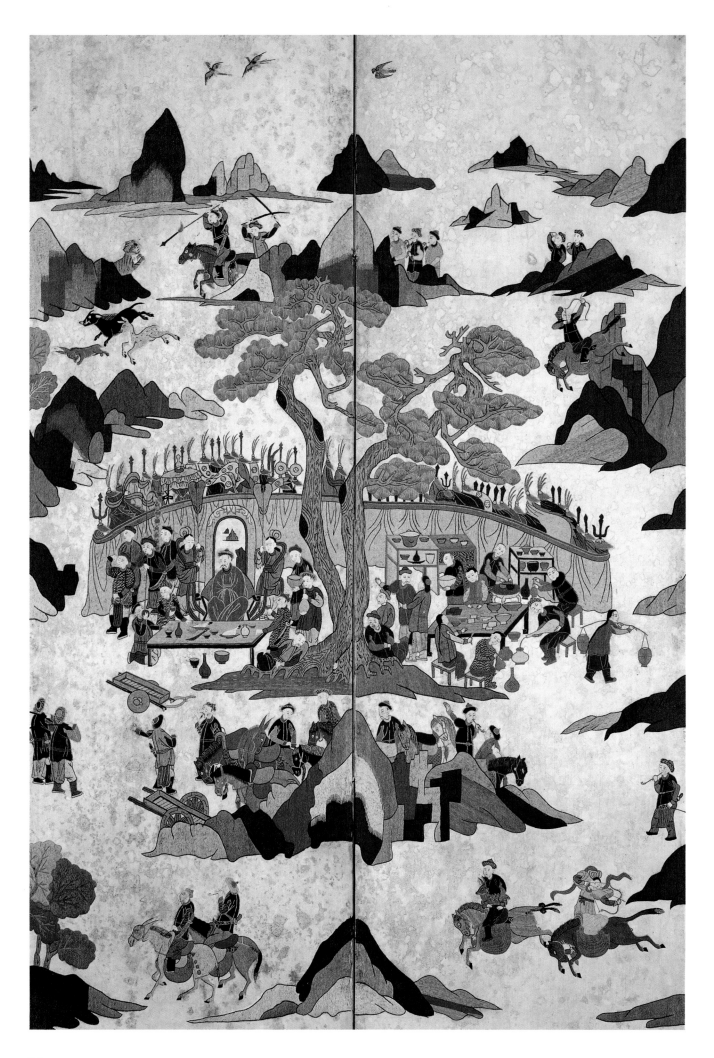

In the following century, these new subjects were further elaborated. For example, Chǒng Hwang (active nineteenth century), Chǒng Sǒn's grandson, rendered the beauty of the Korean landscape, and Kim Dǔksin and others painted genre pictures. Another nineteenth-century trend was the expression in painting of new philosophies of Neo-Confucianism by the likes of Ch'usa Kim Chǒnghǔi and Cho Hǔiryong. But whereas the rarefied paintings and achievement of these literati were opaque to the ordinary person and the productions of the Bureau of Painting were wholly conventional, the works of the prominent painters Kim Such'ǒl (active mid-nineteenth century; sobriquet Puksan) and Kim Changsu (active nineteenth century; sobriquet Haksan) formed a bridge between the nineteenth century and the future. Moreover, there were numerous anonymous painters who satisfied the public's need for images, and their pictures are called folk painting (minhwa). These paintings, which were based on the royal family's commemorative pictures, were highly accessible and were filled with joy, especially during the increasingly prosperous times that characterized the century. Their simplicity and joy were based in the art of the eighteenth century.

In ceramics, the eighteenth century saw the maturation of a new, pure white porcelain that was simple and refined in both form and decoration. Elegant vessels had thin walls, and, if embellished, had subtle, simple underglaze painting. In the later part of the century, forms became heavier, with more pronounced swelling and lower centers of gravity. After their introduction, faceted forms increased in popularity and type, the latter being marked by an increasing number of sides. Similarly, more of the surface was covered by painting. Increase was a hallmark of the late eighteenth century. Demand had been growing across society since the seventeenth century, and although the thrifty, Confucian aesthetic preferred by the nobility prevailed at first, as the century grew to a close, the increasing liberality of life was reflected in ceramics: the ideal of a temperate, spiritual inner beauty that was not outwardly expressed gave way to showier forms and more elaborate surface decoration. Nineteenth-century Korean ceramics are practical, liberal, stable, elegant, humorous, and romantic, but these aspects are built upon the moderate, refined inner beauty that characterized Korean eighteenth-century porcelain.

95. HUNTING SCENE
Late 18th-early 19th century
Two-fold screen; embroidery on silk
74¾ x 43¾ in (190.0 x 111.2 cm)
Huh Dong Hwa Collection, Seoul

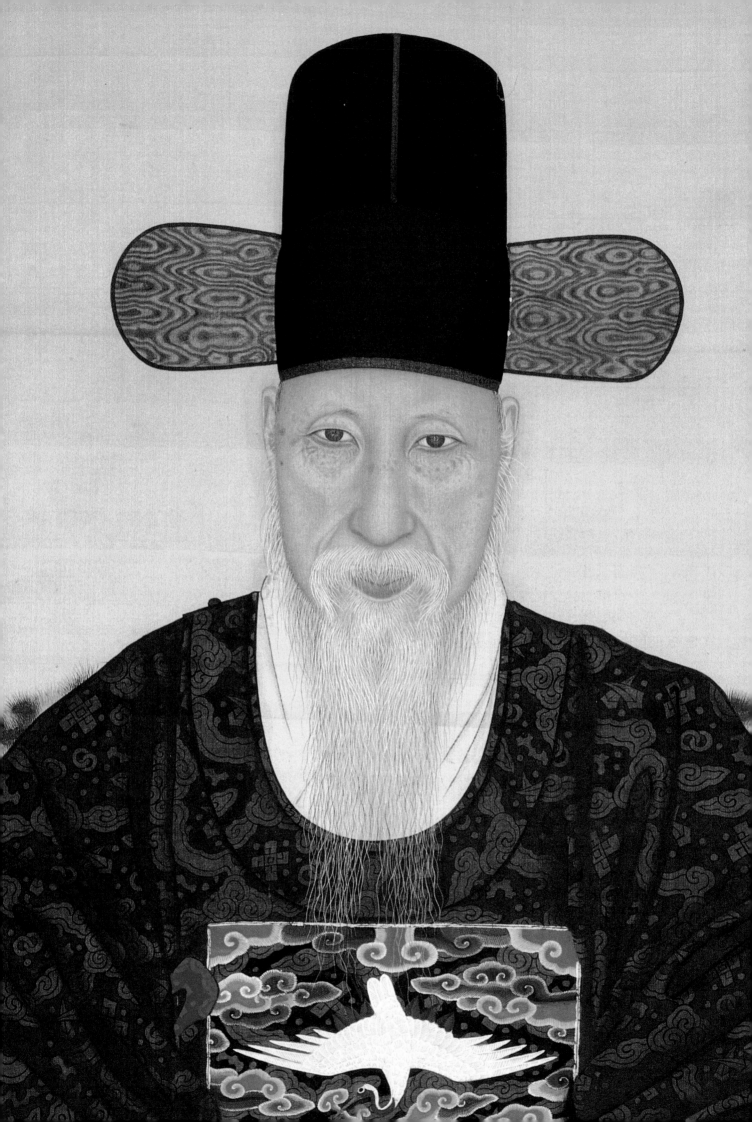

Ritual and Art During the Eighteenth Century

Kang Woo-bang

THE EIGHTEENTH CENTURY was a politically stable time which saw a remarkable flowering in all aspects of Korean culture. The majority of extant portraits in ancestral shrines and Buddhist paintings in temples date from this period. Confucianism, specifically the later variety known as Neo-Confucianism, had been the state-supported religion since the founding of the Chosŏn dynasty. By the eighteenth century, Buddhism, which had been the dominant religion under the preceding Koryŏ dynasty (918–1392), had substantially retrenched, partly because of severely anti-Buddhist Chosŏn state policies. Buddhism, in combination with Shamanistic elements, became a faith practiced principally by women and members of the lower classes. Despite the king's suppressive policies, Buddhist and Shamanistic religious practices became widely popular among women in the inner courts of the palace, namely the queen, and women of the aristocratic class. While Buddhist priests attempted to insinuate themselves into the *yangban* class by learning poetry, many Neo-Confucian literati scholars practiced the Buddhist faith. Such points of contact between the two religions allowed Buddhist ideas to permeate Confucian thought, which led to the development of a form of Neo-Confucianism unique to Korea.

Against this cultural and social background, the visual arts, including religious forms, underwent significant changes. Portraiture proliferated as a result of a combination of factors: ceremonial rituals gained prominence in everyday life, and there was a nationwide emergence of private academies. During a monarch's lifetime, formal portraits were painted, which would become enshrined in a memorial hall after his death (see fig. 6). Scholars

100. PORTRAIT OF OH JAESUN (DETAIL)

FIGURE 9. Detail of *Nectar Ritual Painting*, 1759, from Bongsŏ-am, no. 118.

also enshrined their ancestors' portraits (no. 100) and memorial tablets (nos. 104 and 105) in a family ancestral hall. With the development of blue-and-white porcelain, various forms of porcelain epitaphs, inscribed with locally produced blue pigment, were buried in the tombs of members of the upper classes (nos. 110 and 111).

Within the confines of the state suppression of Buddhism, the most noteworthy development in Buddhist art was the proliferation of hanging banners depicting scenes of the Nectar Ritual (no. 118). Buddhist paintings began to include depictions of Korean landscapes and commoners. Reflecting the hope of transcending the perpetual cycle of reincarnation and entering the Pure Land (Skt. Sukhāvatī), paintings related to universal salvation rites, such as those of the Amitābha Buddha (K. Amita), Kṣitigarbha (K. Chichang), and Avalokiteśvara (K. Kwanŭm), along with paintings of the Nectar Ritual, were profusely produced owing to their popularity among the lower classes.

Portraits of Buddhist priests were also produced in greater numbers as the Meditation School of Sŏn (Zen) Buddhism became widespread. A subtle, but distinct, difference between Confucian ancestral portraits and those of Buddhist priests was that the latter (nos. 123 and 124) were the objects of worship and not part of a sacrificial ritual.

Shamanistic elements also became incorporated into the artistic vocabulary of Buddhist temples, evidenced by depictions of mountain gods in all the temples. The correlation between Buddhist and Shamanistic sub-

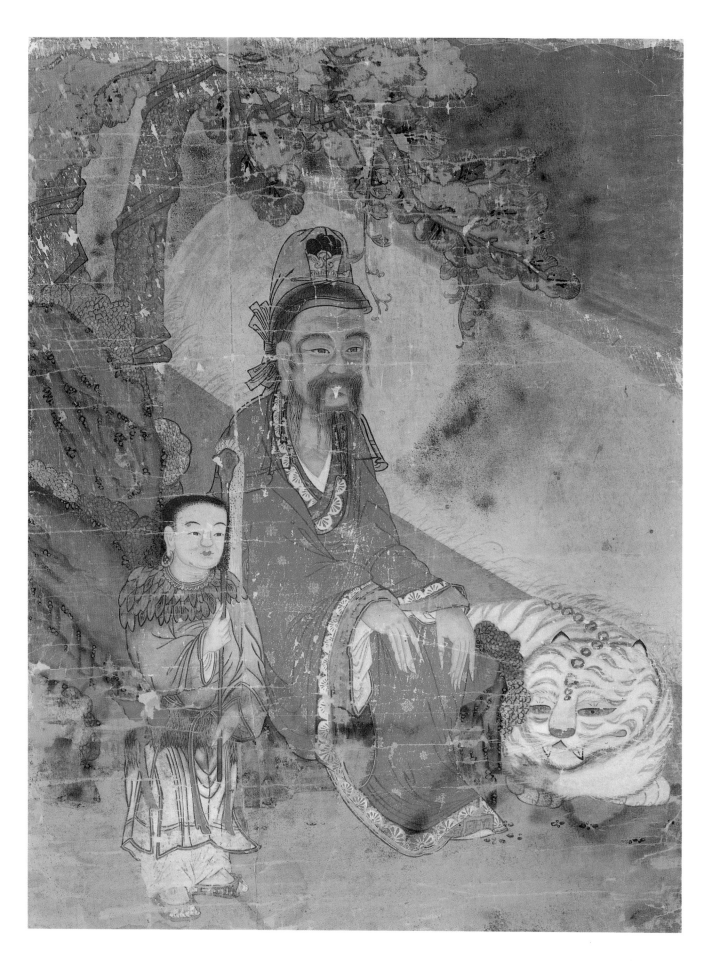

122. MOUNTAIN SPIRIT
Late Chosŏn
Hanging scroll; color on silk
37⅛ x 28½ in (94.3 x 72.4 cm)
Zozayong Collection, Po-Eun

jects increasingly deepened owing to a mutuality of influence. The visual arts of the times reflected the amalgamation of diverse elements from various religious origins, namely Neo-Confucianism, Buddhism, Daoism, Shamanism, and geomancy. This fusion of elements gave birth to a distinctive manifestation of the visual arts.

This eighteenth-century proliferation of the arts was, in part, recoupment for previous chaotic epochs ridden by invasions from China and Japan. The Japanese invasions led by Hideyoshi Toyotomi, which lasted from 1592 to 1598, literally wiped out the Korean arts treasury, temples, and palaces and account for the lack of art-historical information pertaining to the early Chosŏn period. Peacetime recuperation began in the mid-seventeenth century and sustained sufficient momentum to usher in a golden age of arts that flourished particularly during the reigns of Yŏngjo (r. 1724–76) and Chŏngjo (r. 1776–1800). With the stabilization of the livelihood of the masses, Confucianism took root in the value system of the populace. Throughout the country, Buddhist temples were built and paintings were produced.

Yŏngjo and his grandson and successor Chŏngjo, who was himself a proficient calligrapher and painter, were patrons of professional artists. Masters such as Kim Duryang, Kim Hongdo, Chŏng Sŏn, Sin Yunbok, Kang Sehwang, and Yi Inmun produced not only idealized landscapes but also true-view landscapes and genre paintings. Their works began to influence Buddhist paintings during the late eighteenth century.

While the king and literati scholars were learned Neo-Confucianists, the ladies in the inner courts embraced Buddhism and Shamanism for spiritual solace. Vestiges of Buddhism and Shamanism thus remained in various art forms, which provide documentation of the interaction between these two practices. Continuing the practice from the Koryŏ period, Buddhist temples were built near the royal tombs as branches of court buildings. Prayer temples were built throughout the nation. Since these were essentially sites of filial worship, the king could not prohibit their construction. At the same time that Yŏngjo adopted harsh measures against Buddhism, ordered the closing of prayer temples, and prohibited the entrance of monks into the city, he renovated Chinkwan-sa into a larger temple to ensure his mother's well-being. Chŏngjo built Yongju-sa in Suwŏn, then called Hwasŏng, Kyŏnggi Province, in memory of his father.

In general, the literati *yangban* class conducted Confucian funerary services, while the lower classes carried out Buddhist rituals. Buddhism, in fact, was the chief faith among the common people. Consequently, religious practice under the Chosŏn dynasty clearly became demarcated within a two-part structure based on class and gender: on the one hand, there were the males of the court and literati, who were trained in the Chinese classics and were practitioners of Neo-Confucianism; and on the other, there were the women and commoners, who used *han'gŭl* and were believers in Buddhism.

This dichotomy was engendered by conflicting forces in the nation's development. The Chosŏn dynasty was founded upon Confucian governing precepts, which made the country a truer Confucian state than China, the originator of Confucianism, had ever been. Nevertheless, the previous dynasties—Three Kingdoms, Unified Silla, and Koryŏ—had been governed by Buddhist religious ideology, and Buddhism continued to be a vital cultural force. Supported by the king and absorbed by the masses, including social outcasts, it had been the country's religious foundation and had formed its cultural basis. Therefore, its suppression on political and social

grounds was merely superficial. The notion of Buddhism's steady decline during the late Chosŏn dynasty stems from a policy stance rather than actual fact. Buddhist temple complexes and other architecture, sculpture, painting, and decorative arts were actively produced and underwent great development.

The Buddhist clergy formed private monetary organizations with the objective of promoting friendship within the Buddhist community and raising funds for the building of temples. Temples expanded their financial base without government support. Thus, monks became the key promoters of Buddhist affairs. Owing to the active role played by monks and the enthusiastic participation of the sharply increased nonelite population, Buddhist rituals became fully established during the eighteenth century. The Rites of Forty-nine Days, the Water and Land Assembly, and the Spirit Vulture Peak Rite included dynamic performatory rituals, such as the *daech'wit'a* (the sounding of horns and drums) and the *paramch'um* (literally, "dance of the wind" ceremonies), which contrasted sharply with the solemn Confucian rites.

Among commoners, these rituals were prevalent in areas where the dominion of Confucian culture was relatively weak and Buddhist influence was strong. Accordingly, Buddhist sculpture and the decorative arts incorporated substantial folkloric elements, but Buddhist painting preserved a relatively orthodox tradition. Concurrently, Shamanistic rituals became so fashionable among the populace that women of the *yangban* class would bring their ancestral tablets to shaman spirit houses in commemoration of their forebears.

The differences between the religious forms of Confucianism and Buddhism can best be assessed by comparing their divergent viewpoints on filial piety and ancestral worship. Filial piety is the underlying philosophical tenet of Confucianism as well as the basis of Confucian moral conduct

FIGURE 10. Scene of an offering ceremony (*chŏndojae*) at Bongŭn-sa, Seoul, showing a Nectar Ritual painting above the altar table, on which there are ancestral tablets.

and the source of all virtue. Confucian ethics emphasize filial conduct and piety not only toward the living but toward the dead as well. Of the four Confucian rites of passage—coming-of-age, marriage, funeral, and the ancestral memorial—two are concerned with death and ancestor worship. Mortuary rituals conducted as expressions of filial piety are thus Confucian rites of major importance.

Ancestor worship is founded on the family system. Ancestral spirits were believed to be suprahuman forces that oversaw their survivors. Their worship was thought to lead to abundant harvests and to ensure the financial and physical security of the family. The deified ancestors thus became protector-gods. At the same time, these spirits were believed to be capable of vengeful acts and were feared. Survivors allayed their fear by practicing funerary rituals to console the deceased. This cultist behavior toward the dead led to the development of ancestor worship.

Filial duties, performed regularly, for both the living and the dead, were an undisputable aspect of Confucian society. Buddhist philosophical tenets, which call for the abandonment of the secular world in order to attain personal enlightenment, would seem to have no point of conciliation with the rigid Confucian doctrine of filial piety. Ancestral worship, however, had been practiced in other civilizations. Systematized by the Chinese, it had formed the kernel of behavioral ethics in China and Korea since ancient times. Korea had also imported from China an extremely sinicized form of Buddhism, which had previously incorporated Confucian concepts of filiality and ancestor worship.

The concepts of filiality and ancestor worship found in Korean Buddhism, however, were fundamentally different from those defined by Confucianism. In its original form, Buddhism was not concerned with life after death or ancestor worship; however, because of the already firmly established Chinese belief in ancestor worship, Buddhism could not have taken root without adapting to local convention. From early on in China and Korea, at times of making a Buddhist statue or holding a festival, prayers were offered for seven generations of the emperor's deceased parents and all sentient beings. The fruition of this assimilation is in the *Sutra of Filial Piety* (*Fumu enzhong jing*), which originated in China and was widely read in Korea. In conjunction with such textual developments, Buddhist ancestral festivals became prevalent in both countries. The Rites of Forty-nine Days, the Water and Land Assembly, and the Festival of Hungry Ghosts held on the fifteenth day of the seventh lunar month are some examples.

Unlike Confucian ancestral rituals, which were strictly for the immediate family's patrilineal forebears, Buddhist festivals commemorated all sentient beings. This conclusion is logically derived from the Buddhist belief in the eternal cycle of reincarnation. (According to one's karma, one was believed to repeat the cycle of rebirth in the six possible paths—as a hell dweller, a hungry ghost, an animal, an *asura*, a human on earth, or a god in the heavens.) The following passage from the *Sutra of the Net of Brahman* (*Brāhmajāla sūtra*) accounts for this practice: "All men are my father and all women my mother. Throughout my endless lives of rebirth, I have received some force of life from all men and women; therefore, all sentient beings of the Six Paths of Rebirth are my parents." Consequently, Buddhist concepts of ancestor worship and filiality are fundamentally different from Confucian notions. Accordingly, Buddhist and Confucian rites for the dead represent divergent outlooks. While the Confucian stance cannot embrace the Buddhist viewpoint, the latter is not only inclusive of the former, it encompasses all humankind.

Another point of divergence is the attitude of each religious system toward social class. Confucian ceremonies centered around upper-class males, such as members of the court and the literati. Women and the masses were excluded from Confucian teachings. Buddhist tenets, on the other hand, had sprung from an egalitarian belief that all sentient beings embody the Buddha nature. This doctrine was not subject to such mitigating factors as wealth, class, gender, or age. The *Sutra of Filial Piety* and the *Ullambanapātra sūtra* contain vivid and emotional descriptions of a son's attempts to save his mother from hell. This emphasis on the mother figure as the object of filial piety contrasts with the Confucian focus on the father's lineage and might have occurred as a reaction against the patriarchal orientation of Confucian doctrines.

Ceremonial rites were equally divergent. Confucianist belief in the deceased parent as a sanctified spirit entailed the enshrinement of holy tablets in the ancestral hall. The term for the ancestral tablet, *wip'ae* (*en-lieu-de-corps*), signifies its importance. Focusing upon this symbolic embodiment of the deceased, the worshiper's attitude was as reverential as that toward a living parent.

Portrait halls housed images of ancestors, who were revered on occasions stipulated by the ceremonial calendar. These halls began to be built extensively during the Koryŏ period. In addition to portraits of ancestors, those of Koryŏ kings, which had usually been painted during his lifetime, were also enshrined in these portrait halls. A Koryŏ king would often designate a home-temple site and would build a separate structure within the

104. SPIRIT TABLET CASE
Late Chosŏn
Lacquered wood
12¼ x 9¼ x 5¼ in (31.0 x 23.5 x 13.2 cm)
Onyang Folk Museum, Onyang

complex to house his portraits. This practice was adopted by members of the scholarly elite during the early Chosŏn period, resulting in the proliferation of family shrines and portrait halls within the upper-class milieu.

The appropriation of portrait halls, however, was limited to members of the court and the elite. There seems to have been no clear-cut distinction between portrait halls and ancestral shrines. While portraits certainly occupied the former, there were instances in which both ancestral tablets and portraits could be found in the latter.

Ancestral shrines usually consisted of three rooms. People of limited means would build a one-room, scaled-down version. The shrine stood on the east side of the main household building. Inside, on the north wall, four tabernacles were built in which tables were placed. In each of the four tabernacles, a pair of tablets was enshrined, housed in a case and placed on a folding chair. The four pairs of tablets, representing the four preceding generations, would be placed in generational order from left to right. Blinds were hung on the front of each tabernacle, and a table, incense burner, and jar were placed in front of them. Most vessels used for the ceremonies were made of wood, while porcelain and brass vessels were few. The wine jar was usually porcelain (no. 116).

Ancestral shrines were considered to be ancestors' homes. As such, they were the spiritual anchor of the Korean household. After a death, the ancestor's tablet was enshrined in a tent in the main household building that served as a temporary shrine and was offered food every morning and evening for three years. After the three-year mourning period, the tent was eliminated and the sacred tablet was moved to the ancestral shrine. Descendants paid tribute to the deceased every morning at dawn by burning incense and bowing twice in front of the shrine.

When the head of the household or his wife exited from or returned to the house, he or she would burn incense and bow to the deceased. New Year's Day, Winter's Arrival, and the first and fifteenth days of each month were designated for ancestral ceremonies. On these occasions, the shrine doors were left open and plates of fruit were placed on the tables in front of the tabernacles. Cups of wine were placed in front of each tablet, and a wine jar and additional cups were placed on a table set up in addition to the incense table. A gathered family would remove the tablets from the chest, symbolically offer wine to its ancestors, and bow toward the tablets. Seasonal fish catches, fresh fruit, or food made from newly harvested crops were also offered to the deceased before being consumed by the family.

Ancestors were regularly "notified" of major events, such as a family member's successful completion of the civil service examination, appointment to a civil rank, or marriage, as well as less significant domestic incidents. News was related by the head of the household, who would offer wine and bow to the deceased.

Ceremonies marking the seasons were also conducted in the second, fifth, eighth, and eleventh months of the lunar calendar. For these ceremonies, the tablets were placed in the main hall of the house. Additionally, the anniversaries of the birth and death of the ancestor were observed in a ceremony in which the tablets were enshrined on a folding table in the main hall. A service dedicated to five generations of ancestors was held once a year. Services marking a deceased parent's birthday as well as a special ceremony for the sixtieth birthday of a deceased parent were also conducted. Ancestors were honored on holidays as well. Confucian rites of varying scale, centering around the ancestral shrine, were conducted by the family as a unit throughout the year.

FIGURE 11. Partial re-creation of a Confucian memorial altar showing (back to front) a spirit tablet case on an altar chair (no. 101), a folding table for the memorial service (no. 102), and a table (no. 103) with incense burner and incense case.

Buddhist rites were mostly performed in the temple. Although a ceremony might have been geared toward a particular family, its scope was always inclusive of the entire human race. The main hall of the temple complex, the usual site of a ceremony, was hung with the Nectar Ritual banner along with banners on which are written the names of Trikāya (the three bodies of the Buddha), the bodhisattvas Avalokiteśvara and Kṣitigarbha, and the Ten Kings of Hell. In front of these were offerings of various kinds of food. Services were also sometimes held in the Hall of the Underworld (dedicated to an intermediary realm), which was located to the right or left of the main hall. Hanging scrolls of Kṣitigarbha and statues of the Ten Kings of Hell were housed in this hall. Statues of boy servants were also placed in between those of the Ten Kings (no. 126).

Unlike Confucianists, Buddhists believed in the existence of an afterworld. Therefore, funerary rites were fundamentally different. In a Confucian rite, the soul of the deceased was worshiped only as a protector-god; there was no consideration of a hell or paradise. Buddhists believed that the evil went to hell and the good to paradise. There was a special domain for those who had engaged in both good and evil acts; they entered an intermediary realm of existence and wandered around for forty-nine days, after which their path of rebirth was decided. The Rites of Forty-nine Days is a ritual held by the survivors of a deceased parent on the forty-ninth day following his or her death and dedicated to the wandering spirits in the intermediate realm of existence. Sometimes, a living person would dedicate

such a rite to himself in advance. He would acquire the status of an ancestral spirit after having gone through this intermediate passage of forty-nine days following his death.

The Festival of Hungry Ghosts, or Ullambana Ritual, was dedicated to seven generations of living and deceased ancestors. *Ullambana* carries the symbolic meaning of truth, materialized in the form of an offering.

Dedicated to the hungry ghosts, who not only wandered about the land but also explored the waters, the Water and Land Assembly was observed by making offerings of food to these souls and is a representative example of the Festival for the Spirits of the Dead. During the Chosŏn period, the Water and Land Assembly was held outdoors on a nationwide scale. This festival was initiated by the state in order to express gratitude to ancestors and to console unfortunate, hungry souls without survivors to make them offerings.

The Spirit Vulture Peak Rite commemorated Śākyamuni Buddha's preaching at Vulture Peak and was conducted to lead all spirits to rebirth in the Western Paradise. On this day, a banner was hung in front of the main hall of a temple, and a colorful variety of food was prepared and offered to the Buddhas, bodhisattvas, Buddhist monks, and lonely spirits without offerings. Various musical compositions and dances were performed during this festive day.

As mentioned, Buddhist memorial festivals not only included one's family but embraced all sentient beings, including those without descendants. Unlike the solemn Confucian rites, Buddhist rituals invariably included musical and dance performances. Another point of divergence is that there was a difference between Confucian funerary and commemorative rituals; Buddhism made no such distinction.

In contrast to Confucian rituals, which sought protection from ancestral spirits, Buddhist rituals were acts of charity to the dead to alleviate the suffering of an intermediary existence. Therefore, the two religions embraced completely opposite points of view: in Buddhism, the living offered charity to the dead; in Confucianism, ancestral spirits were seen to secure the happiness and well-being of their survivors.

The two systems also had radically differing objects of worship. Only members of the patriarchal lineage of the family were the subject of worship in Confucianism. Buddhist ritual, from the earliest times, not only included individual ancestral tablets but also tablets representing all spirits on earth.

One form of Buddhist salvation entailed transcending the wheel of reincarnation and being reborn in the Western Paradise. As acts of filiality, appropriate rituals were dedicated to parents, striving toward their rebirth in the Western Paradise. In the historical process of dissemination of Buddhism to the masses, only the educated few could obtain enlightenment through an understanding of texts. Some forms of Mahāyāna Buddhism, which were aimed toward the salvation of the masses, suggested different paths, such as chanting and the offering of rituals.

The Nectar (Amṛta) Ritual—actually a cluster of rituals—emerged from the eighteenth-century synthesis of Confucianism and Buddhism. Paintings depicting scenes of the Nectar Ritual saw an unprecedented popularity during this period and represent the most characteristic form of eighteenth-century religious art. These paintings reflect the Buddhist concepts of filiality and ancestor worship formed under the influence of Confucianism. While most other Buddhist paintings were used as backgrounds to enhance the majesty of Buddhist statues, Nectar Ritual paintings were

116. RITUAL WINE JAR
18th century
Porcelain painted with underglaze blue
H. 14 in (35.5 cm)
Namkung Lyŏn Collection, Seoul

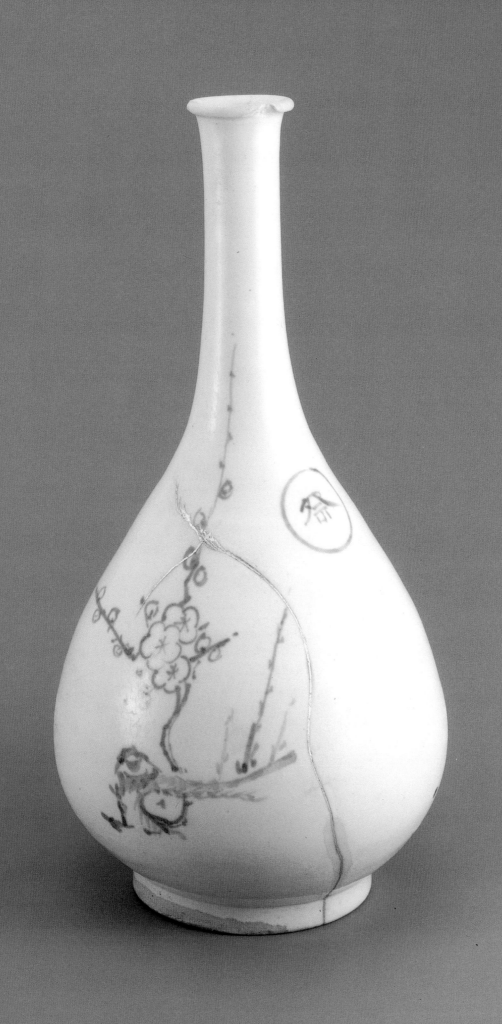

unusual in that they had a ritual function and depict the actual ceremony, of ritual offering, that they were intended to accompany.

Nectar Ritual paintings were most likely used during the universal salvation rites, among which were the Rites of Forty-nine Days, the Festival of Hungry Ghosts, the Water and Land Assembly, and the Spirit Vulture Peak Rite, all of which were related to filiality and ancestor worship. The strongest evidence for this is the presence of the seven Buddhas, including Amitābha, and three bodhisattvas in the upper part of the painting. Despite their presence, the painting was placed in the hierarchically low sacrificial platform of the temple. The interior of a temple was usually divided into high, middle, and low platforms. The high altar, adorned with a painting of the Buddha and a bodhisattva, was the focal point of all ceremonies conducted in the building. The middle altar, called the *sinchung-dan*, is on the left wall of the high altar and has enshrined at it a *sinchung* painting. Following the ceremony at the high altar, a ceremony was conducted at this altar. Such ceremonies at the high and middle platforms were carried out every morning and evening by monks. The low altar, also called the "spirit-altar," was on the right wall of the high altar and was used only on special occasions, such as the Rites of Forty-nine Days. It was decorated with a painting of the Nectar Ritual, and ancestral tablets were enshrined there as well.

These festivals required substantial financial support. They included a sumptuous banquet consisting of various kinds of fruit, chestnuts, and food—not only for the participating monks and believers but also for the high priests conducting the ceremony and the monks reciting the sutras and performing the rituals. The ladies of the court and the aristocracy would often sponsor a small-scale ritual at a temple and provide adequate food offerings, which were accompanied by *paramch'um* performances. Such private rituals were probably conducted inside the main hall.

State-sponsored festivals for the salvation of all souls, such as the Water and Land Assembly and the Spirit Vulture Peak Rite, were conducted on a grand scale in the spacious courtyard in front of the main hall. On these occasions, a gigantic image (thirty to fifty feet high) of the Buddha was hung, and numerous high priests, monks, dancers, and musicians, along with a large crowd of believers, participated in the festivities. For such large congregations, an enormous amount of food offerings had to be prepared. Nectar Ritual paintings depict the sumptuous festivities of the state-sponsored universal salvation rites.

Those who could not afford to sponsor large banquets substituted paintings for these live ceremonial scenes and held a modest ancestral ritual with simple offerings of food, candles, and incense. The proliferation of Nectar Ritual paintings in the eighteenth century was largely a result of the rapid increase in population and the rise of commoners. The simultaneous establishment of Confucian values, which emphasized the importance of ceremonial rites within the commoners' value system, also contributed to the spread of Nectar Ritual paintings throughout the nation.

The substitution of Nectar Ritual paintings for actual ritual scenes paralleled the use of Painted Spirit Houses (no. 108) by the lower classes in Confucian rites. Those without economic and social means could not afford to build an ancestral home or to host sumptuous banquets. The Painted Spirit House, Kammoyŏche-do in Korean, sprang from the need to conduct essential rituals within modest circumstances. *Kammo* means "to adore with deep emotion"; *yŏche* means "to respectfully address the spirits as if they were present at the ceremony"; and *do* means "painting." A Painted Spirit

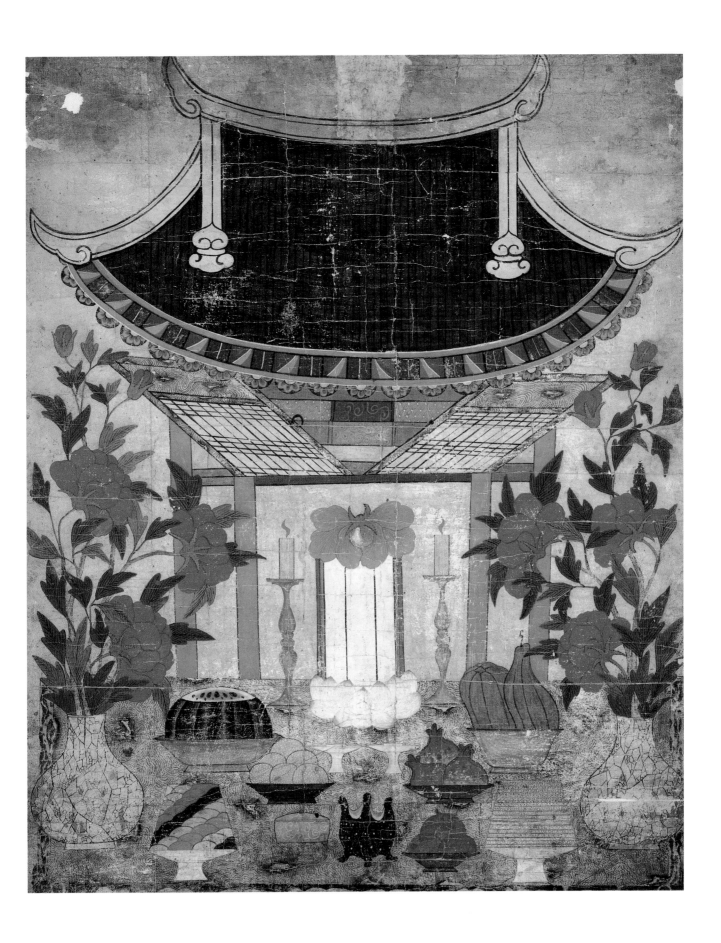

108. Painted Spirit House
Late Chosŏn
Hanging scroll; color on paper
45¼ x 36⅝ in (114.8 x 93.2 cm)
Lee Wŏn-ki Collection, Seoul

House depicts an ancestral shrine, inside of which are glued paper ancestral tablets. In replication of actual rituals, the foreground of the painting includes a sacrificial table adorned with various kinds of fruit and food, lighted candles, and burning incense. A simple ancestral ceremony in which the descendants would express their wishes for abundance and happiness would be conducted in front of these paintings. The Painted Spirit House has the effect of an actual ceremony being held in front of the memorial hall. Such paintings, I believe, began under the influence of Buddhism. Even if Confucian rituals were expanded to the lower strata of society, ancestral rituals were probably conducted by proxy in a Buddhist ceremony at a temple or in Shamanist spirit houses.

The Nectar Ritual hanging banner is a form of Buddhist painting unique to Korea. Unlike other Buddhist paintings, which tend to remain orthodox in style, Nectar Ritual paintings exhibit great variations in iconography and composition because they incorporate scenes from everyday life, which is susceptible to change. By the end of the eighteenth century, Nectar Ritual paintings began to include figures in Korean dress. In light of their importance, I would like to discuss at some length the characteristics of Nectar Ritual paintings and their evolution during the eighteenth century.

During the observance of the Rites of Forty-nine Days, the Water and Land Assembly, and the Festival of Hungry Ghosts, Nectar Ritual paintings were hung on the left or right wall of the temple's main hall; in front of them would be the ancestral tablets (or, in modern times, photographs of the ancestors) placed upon a high chair as well as a table of food offerings. A ceremony consisting of *paramch'um*, musical performances, or sutra recitation was conducted in front of this.

Nectar Ritual paintings are emblematic of a Mahāyānist teaching that every soul can be led into the Western Paradise through acts of ritual offering. The general composition of the paintings is fairly consistent. At the top are the seven Buddhas flanked by bodhisattvas who are pledged to saving souls. In the middle is a grotesque hungry ghost (or ghosts), representing suffering souls. The hungry ghost stands before an elaborately detailed scene of a Buddhist ceremony. Along the bottom, various small-scale scenes of death are laid out in panoramic fashion. This portion of the painting represents dramatic scenes of the secular world from which the path of rebirth in one of the Six Realms eventually will be determined. The three-part composition and its corresponding images convey the message that all sentient beings are caught in the eternal wheel of rebirth and that the living are to hold rituals for the deceased so that they may be led out by the seven Buddhas, Avalokitesvara, Kṣitigarbha, and the bodhisattva who leads the souls to the world of paradise. Such instruction is conveyed dynamically in three ascending stages up the surface of the painting.

Among the oldest surviving Korean Nectar Ritual paintings, two works from the end of the sixteenth century can be found in Japan, while the only surviving example from the seventeenth century is in the National Museum collection in Seoul. There are about twenty eighteenth-century examples—a number sufficient to allow the study of their stylistic development—as well as a few from the late nineteenth and early twentieth centuries.

The Nectar Ritual painting at Namjang-sa, Sang-ju, dated to 1701 (fig. 12), depicts the seven Buddhas in the upper center, flanked by scenes of the salvation of the dead by the bodhisattvas. On the left side is the bodhisattva who leads the souls of the deceased to paradise. On the right is the compassionate Avalokiteśvara, who attempts to save sentient beings; beside him stands Kṣitigarbha, who has sworn to save even those in hell. The

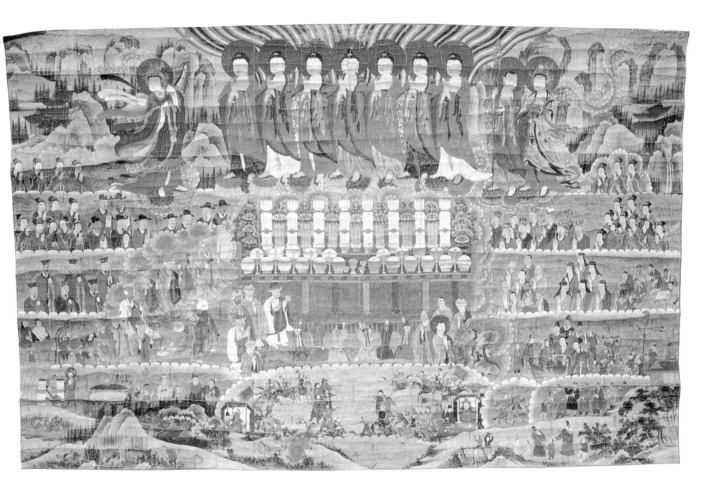

FIGURE 12. *Nectar Ritual Painting*, 1701. Namjang-sa, Sang-ju.

iconography and composition in the upper portion, which were introduced by this work, became the prototype for all subsequent Nectar Ritual paintings. The middle of the painting is occupied by a fairly large altar table, in front of which are numerous monks engaged in the ceremony. A hungry ghost stands slightly to the side, on the right. The scale of this scene indicates its importance. At the bottom are depictions of the secular world, with vignettes separated by contours of cloud patterns and described in writing. This is the first appearance of written descriptions of the secular scenes in Nectar Ritual paintings. Such inscriptions facilitate identification of the scenes, all of which are depictions of death by various means, including war, suicide, drowning, natural calamity, and homicide. There are also various scenes of hell. This painting represents an early attempt to systematize the iconography into clear-cut divisions.

Nevertheless, later paintings show variations in iconography and composition. The mid-eighteenth century saw another attempt at iconographic systematization. Generally, the upper portion of most works produced around this time would be occupied by figures of the Buddhas and bodhisattvas, the middle by the altar table and a gigantic hungry ghost, and the lower by scenes of hell.

The Nectar Ritual painting in this exhibition (no. 118; fig. 9), originally from a subtemple named Bongsŏ-am, is dated to 1759. It is a unique example of a vertical format. Other Nectar Ritual paintings are horizontal and rendered in a panoramic fashion. The vertical layout of this painting necessitated changes in composition. The Buddhist deities and hungry ghosts are less prominent than they are in the horizontal-format paintings. At the same time, the vertical format lends an elevating effect. Six of the seven Buddhas in this scene face toward the viewer's left; all hold their

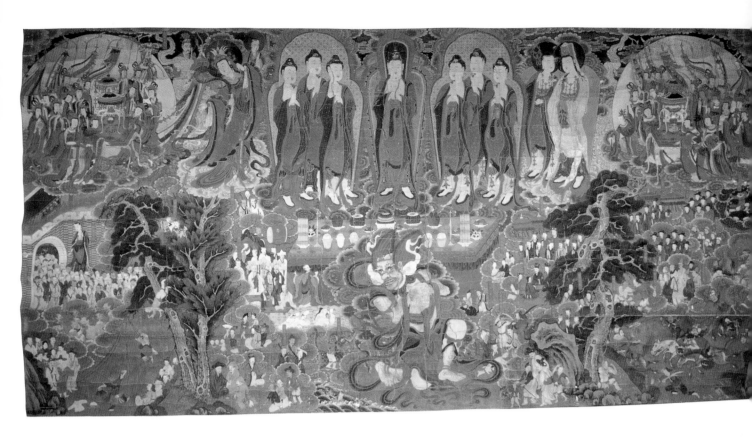

FIGURE 13. *Nectar Ritual Painting*, 1790, from Yongju-sa, Suwŏn. Present location unknown.

hands together in prayer. To the left is the figure of the leading bodhisattva, and on the right are Ksitigarbha and a white-robed Avalokiteśvara riding a jewel cloud.

The middle section consists of an altar table and two hungry ghosts, which are flanked by scenes of monks performing a ritual and a royal procession. In front of the audience are two sutra tables: a volume of the *Lotus Sutra (Saddharmapuṇḍarīka sūtra)* lies on one, and a volume of ritual texts is on the other. This provides information on which texts were read aloud on such ceremonial occasions. A curtain hangs behind some of the monks, and the floor is covered with a decorated mat.

A large expanse of the lower portion is given to depictions of secular scenes. This relative spaciousness is afforded by the vertical division of the picture into three equal registers. A row of needle-leaf trees and mountains separate the upper and middle divisions of the painting, while the middle and lower portions are on a continuous plane. Cloud patterns demarcate different occurrences in the lower section. A large pine tree, the roots of which extend through some rocky terrain to a river, is situated in the lower left corner. A pine tree in the lower register is characteristic of Nectar Ritual paintings; it and the rocky terrain are symbolic of the secular world.

A 1790 Nectar Ritual painting from Yongju-sa (present location unknown; fig. 13), rendered in an extremely horizontal format, provides a peculiar example of compositional modification. Instead of being clearly apportioned into three parts, this painting is generally divided into upper and lower portions. Among the Buddhas, the centrally placed Amitābha faces front, while the others, grouped in threes, face slightly left. The Buddhas are flanked by the three bodhisattvas, and at each side of the painting is a luxuriant scene of numerous celestial females carrying a lotus pedestal, upon which a soul will be transported to the Western Paradise. The upper part thus exhibits a completely symmetrical composition.

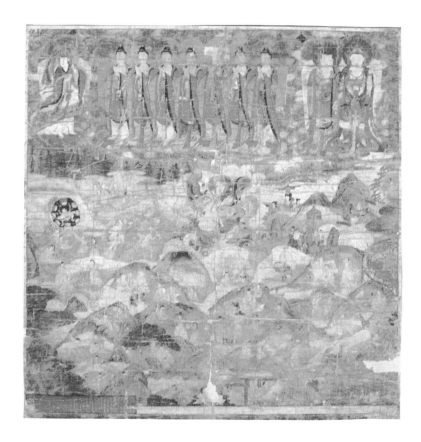

The altar table, a fairly large, grotesque, hungry ghost, and two gigantic pine trees are sharply delineated at the center of the lower part of the painting. In between these large elements are small scenes of various secular activities. At the sides of the altar table are a scene of monks performing a ritual and a scene of a royal procession. These are given relatively little prominence. Instead, scenes of the secular world occupy the majority of the lower part. At the left edge is a rare depiction of Kṣitigarbha leading a crowd through flaming gates, out of hell. In both lower corners are rocks, which, along with the two large trees and ghost figure at the center, echo the symmetricality of the composition of the upper part. Red is predominantly used for the bodhisattvas, celestial ladies, and the hungry ghost. Pine needles are rendered in a strong green. Overall, red and green constitute a vivid color scheme.

Significantly, even though the costumes worn by most of the figures in the lower part of this painting are Chinese, a few figures—the wandering family at the bottom in front of the rock and the group watching the entertainers at the bottom left—are distinctively dressed in Chosŏn native costume. Men wear *kats* (wide-brimmed hats made of horsehair) and *durumagis* (large overcoats); women are clad in *ch'imas* (full skirts) and *chŏgoris* (tight jackets). This marks the first appearance of native Korean costumes in a Nectar Ritual painting.

The extremely horizontal format of this painting led to the introduction of new motifs. The groups of pedestal-bearing celestial females, depicted in the outer reaches of the upper portion of the painting, are an important motif that signifies salvation through universal salvation rites. Previous Nectar Ritual paintings either did not contain such scenes or included only a small pedestal.

Yongju-sa, where this painting was originally housed, was built by King Chŏngjo in commemoration of his father. King Chŏngjo's visits to his

FIGURE 14. *Nectar Ritual Painting,* 1791, from Kwangyong-sa, South Kyŏnggi Province. Dongguk University Museum, Seoul.

father's tomb near the temple are recorded in many paintings (for example, nos. 7 and 8). On each visit, King Chŏngjo probably would have held universal salvation rites at the Buddhist temple on his father's behalf. In fact, it is highly probable that this painting was commissioned by King Chŏngjo. This would account for the unusually prominent pedestal motif and the enlarged pine trees, like those one actually encounters en route to the tomb. In addition, the inscription is in gold powder, further establishing a connection to the king. In 1796, King Chŏngjo donated a copy of the *Sutra of Filial Piety* to the temple in memory of his parents' benevolence. The tomb, located on a mountain, and the nearby Yongju-sa are testaments to Chŏngjo's touching filial emotions.

While the Yongju-sa painting synthesizes and culminates previous Nectar Ritual painting traditions in an exaggerated form, an example from Kwanyong-sa in South Kyŏnggi Province, dated 1791 (now at Dongguk University Museum; fig. 14), represents a dramatic departure. Not only are Avalokiteśvara and Kṣitigarbha depicted in larger scale than the seven Buddhas, the altar table in the middle section has been eliminated. Most significant is the presence of Koreans attired in national dress (*hanbok*).

Self-discovery and a newly emerged national identity, evident in other areas of culture, were finally beginning to influence the rather orthodox and formal Buddhist painting tradition. Unlike other Buddhist paintings, Nectar Ritual paintings underwent a process of Koreanization—delayed perhaps, but pronounced. The displacement of figures wearing Chinese costumes by those in Korean garb marks the expressive beginnings of Chosŏn's surrounding reality. The emergence of Sirhak philosophy, the popularity of genre and true-view landscape paintings, and the rise of vernacular literature all contributed to a change in the form and style of Nectar Ritual paintings by the end of the eighteenth century.

In the upper center of the Kwanyong-sa example is the customary row of seven Buddhas flanked on the left by the leading bodhisattva and on the right by Avalokiteśvara and Kṣitigarbha; the last-named two are rendered frontally and unusually large. Needle-leaf and blossoming peach trees and city walls divide the upper and middle parts, and the Daoist figure of the Queen Mother of the West of the Peach Blossom Land is to one side of the central hungry ghost.

The altar table, which heretofore had been an essential element in Nectar Ritual paintings, is absent, and no one is shown offering. Instead, a slightly transformed image of a hungry ghost sits in the center of the painting. The hungry ghost has no flames flaring out of his mouth but is holding a bowl in his left hand. Small figures of a king, queen, and aristocrats are wrapped in clouds on the left side.

Soft ridges, reminiscent of Korean mountains, appear in the lower half of the painting. Scenes from the secular world occupy the niches between these ridges. Approximately half the surface of the painting is filled with secular scenes. Most figures appearing in them are wearing clothing and hairstyles that are uniquely Korean. Even the police chief is wearing an official Korean outfit. Although some figures are depicted in light colors and are, therefore, less conspicuous, most wear ordinary Korean white clothing and are drawn in a linear fashion. These white clothes are suggestive of mourning. The preponderance of Korean figures in this depiction was unprecedented. These elements in the Kwanyong-sa painting are evidence of the Koreanization of Nectar Ritual paintings. This painting exhibits a dramatic transformation in its iconography and overall composition. This major stylistic shift was taken suddenly, without a transition period.

Eighteenth-century Nectar Ritual paintings were the most characteristically Korean and perhaps the most widely produced type of religious painting. They underwent the greatest change at the end of the eighteenth century. The 1790 Yongju-sa painting was the first to include figures wearing Korean garments. An example from Namsa-dang includes a depiction of a Korean mask dance performance. Most of the secular figures in the Kwanyong-sa painting of 1791 are depicted in Korean dress. After that time, paintings of the Nectar Ritual invariably had figures clad in Korean native garments. The appearance of such Korean genre scenes in Buddhist paintings can be attributed to the influence of contemporaneous trends in other types of painting. Nectar Ritual paintings thus underwent a unique artistic development within the parameters of the eighteenth-century Buddhist painting tradition.

UNDER THE CHOSŎN DYNASTY, Neo-Confucianism, adopted as the official state ideology, had its most significant impact on the upper classes, but its influence was evident beyond the political realm in the artistic and literary spheres. Buddhism lost the ruling-class patronage that it had enjoyed for centuries and developed into a religion of the ruled, the outcasts, and the weaker members of society. This inevitably led to changes in the Buddhist creed to better fit the needs of its followers, and it focused on providing the masses the promise of a happier life in the next world.

During the eighteenth century, Confucian principles took root in the popular consciousness, and Confucian behavioral guidelines for the rites of passage began to be followed by the masses. Since concepts of filiality and ancestor worship had been important in Sino-Korean Buddhism, and various rituals in that context had already been part of people's lives, the infiltration of Confucian rites into the commoners' life pattern created little conflict or contradiction with Buddhism. On the contrary, Buddhism offered spiritual salvation and the vision of rebirth in the Western Paradise, which could only attract the hearts of the populace. With the establishment of Confucian rites among commoners, the Buddhist religion began to emphasize areas of mutuality with Confucianism: filial piety and devotion to ancestors. The sometimes opposing, but somewhat convergent, tenets of Confucianism and Buddhism dynamically interacted to ease the tensions between the upper and lower classes by providing them with a common ground. The differences between the two religions became, in effect, pillars of support for the formation of Korean culture.

Such developments in religion naturally affected religious art. Nectar Ritual paintings that depict the universal salvation rites intended to help lead souls to the Western Paradise became popular. Until this time, Buddhist paintings had generally been produced as backgrounds and supplements to Buddhist statues to explain ideas that could not be conveyed in sculptural form. Their aesthetic purpose was to imbue the statues with a majestic aura. Within this function, the first appearance of secular scenes in Buddhist painting occurred in the Ten Kings of Hell paintings. These were, however, scenes of hell rather than scenes of everyday life. The first appearance of the secular world in the realistic sense occurred in Nectar Ritual paintings, where one finds scenes of sinful deeds and retribution depicted in plain detail. In Nectar Ritual paintings, salvific rituals are lavishly depicted in the middle of the painting with the figure of a hungry ghost, who exemplifies those who would be saved. The depictions of the Buddhist deities above feature those most important to salvation: Amitābha Buddha, Ava-

lokiteśvara, Kṣitigarbha, and the bodhisattva who leads the souls to paradise.

Nectar Ritual paintings show, for the first time in Buddhist art, genre scenes from everyday life, in which rebirth in paradise is emphasized, synthesizing not only the secular world and ritual but also the teachings of the many sutras that became important doctrinally. They can be used as visual tools for examining the period: they provide evidence of the symbiotic role played by Confucianism and Buddhism. Most notable, however, is the appearance of the populace as the subject of these paintings. The emergence of the populace in the social, economic, religious, and artistic realms may have been the primary trend of the eighteenth century.

SELECTED REFERENCES

Chang, Ch'ŏl-su. *Sadang ŭi yŏksa wa wich'i e kwanhan yŏngu (Study of the History of Confucian Shrines and Their Locations)*. Seoul: Agency for Protection of Cultural Properties, 1990.

Cho, Sunmie. *Han'guk ŭi ch'osanghwa (Portrait of Korea)*. Seoul: Sŏlhwadang, 1983.

Han'guksa: kunse hugi (History of Korea: The Later Modern Age). Seoul: Uryu munhwa-sa, 1965.

Hwang, Sŏn-myŏng. *Chosŏn-cho chonggyo sahoesa yŏngu (Study of the Socioreligious History of the Chosŏn Period)*. Seoul: Ilchi-sa, 1985.

Kim, Sung-hui. "Chosŏn sidae Kamro-do ŭi tosang yŏngu" (Study of the Iconography of Chosŏn-Period Nectar Paintings). *Han'guk misul sahak yŏngu (Journal of Korean Art History)* 196 (1992).

Oh, Hyŏng-gun. *Pulkyo ŭi yŏnghon kwa yunhoe-kwan (The Transmigration of the Soul in Buddhism)*. Seoul: Pulkyo sasang-sa, 1978.

Ryoshu, Michihata. *Bukkyō to Jyukyō rinri (Moral Principles of Buddhism and Confucianism)*. Kyoto: Heirakuji shoten, 1985.

PLATES

壽翰賀帝閜古十卍歲眞

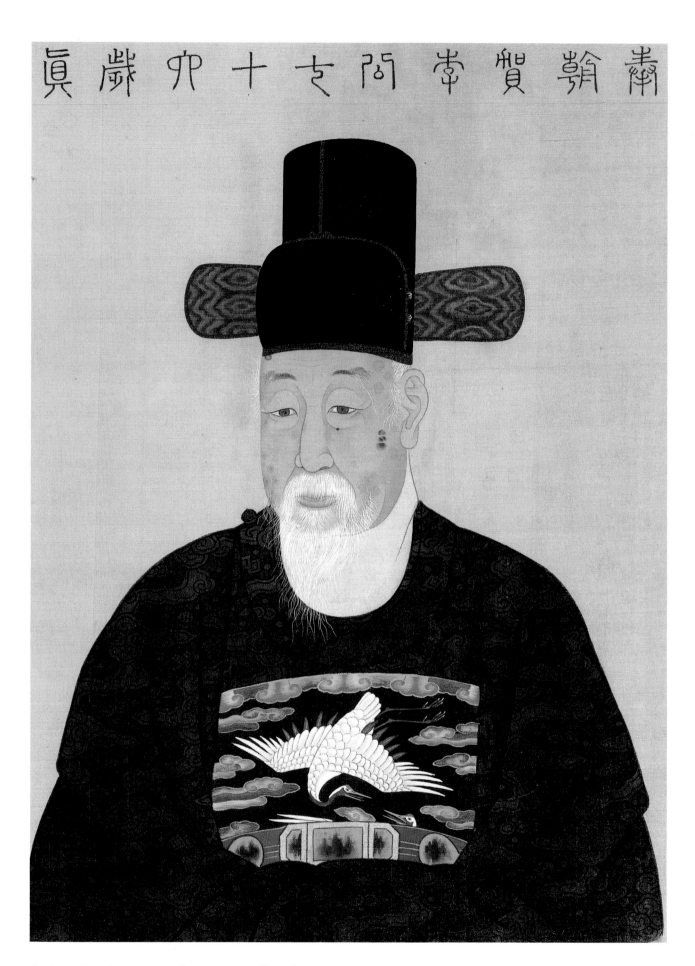

2. Album Commemorating the Gathering of the Elder Statesmen
1719–20
Kim Chinyŏ, Chang Dŭkman, Pak Dongbo
Album; color and ink on silk
17¼ x 26⅛ in (43.9 x 67.6 cm)
Ho-Am Art Museum, Yongin

100

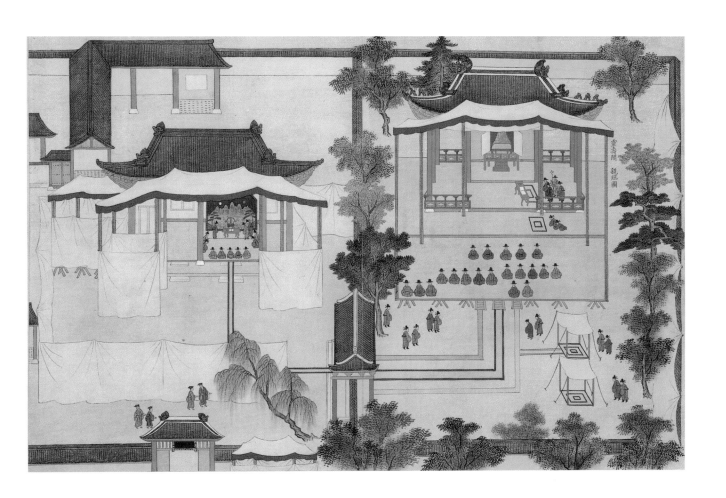

3. Album Commemorating the Gathering of the Elder Statesmen
1748
Album; color and ink on silk
17⅛ x 26⅞ in (43.5 x 67.8 cm)
National Museum of Korea, Seoul

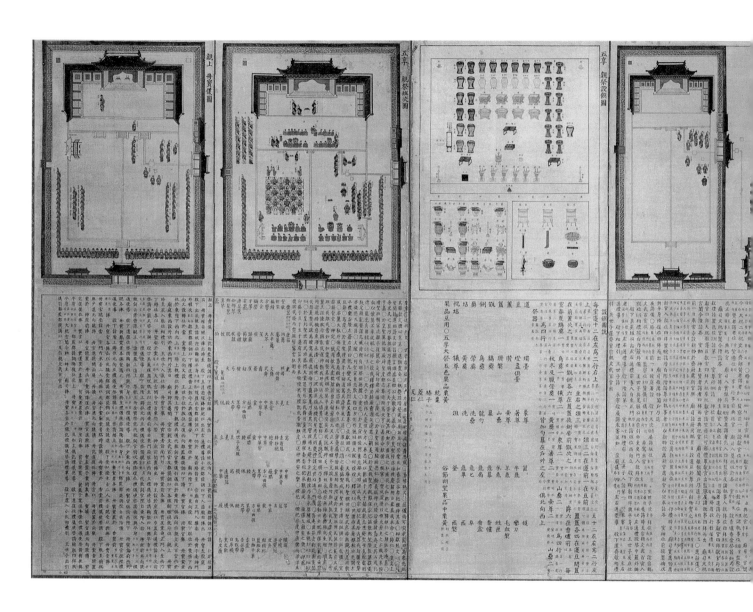

4. DIAGRAM FOR RITUALS AT THE ANCESTRAL TEMPLE
Late Chosŏn
Eight-fold screen; ink and color on silk
71¼ x 169⅝ in (180.9 x 431.0 cm)
The Royal Museum, Seoul

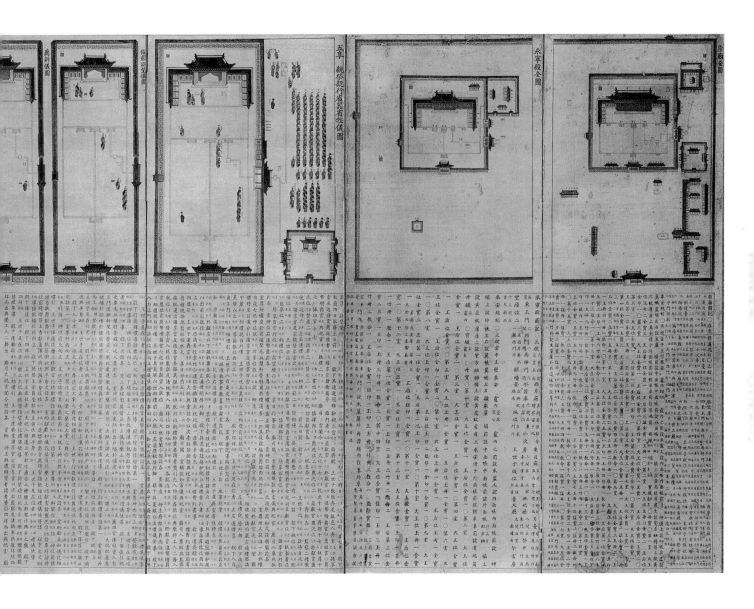

5. SEAL OF KING YŎNGJO
1776
Gold-plated tin
3⅛ x 3¾ x 4⅞ in (7.9 x 9.7 x 12.4 cm)
Jong-myo, Seoul

6. SEAL BOX WITH DOUBLE-DRAGON DESIGN
Probably late 19th–early 20th century
Sharkskin coated with lacquer and painted with gold; brass
inner box
9¾ x 9 x 9 in (25.0 x 22.9 x 23.1 cm)
Inner box, 6¼ x 6⅛ x 6⅛ in (15.90 x 15.6 x 15.7 cm)
The Royal Museum, Seoul

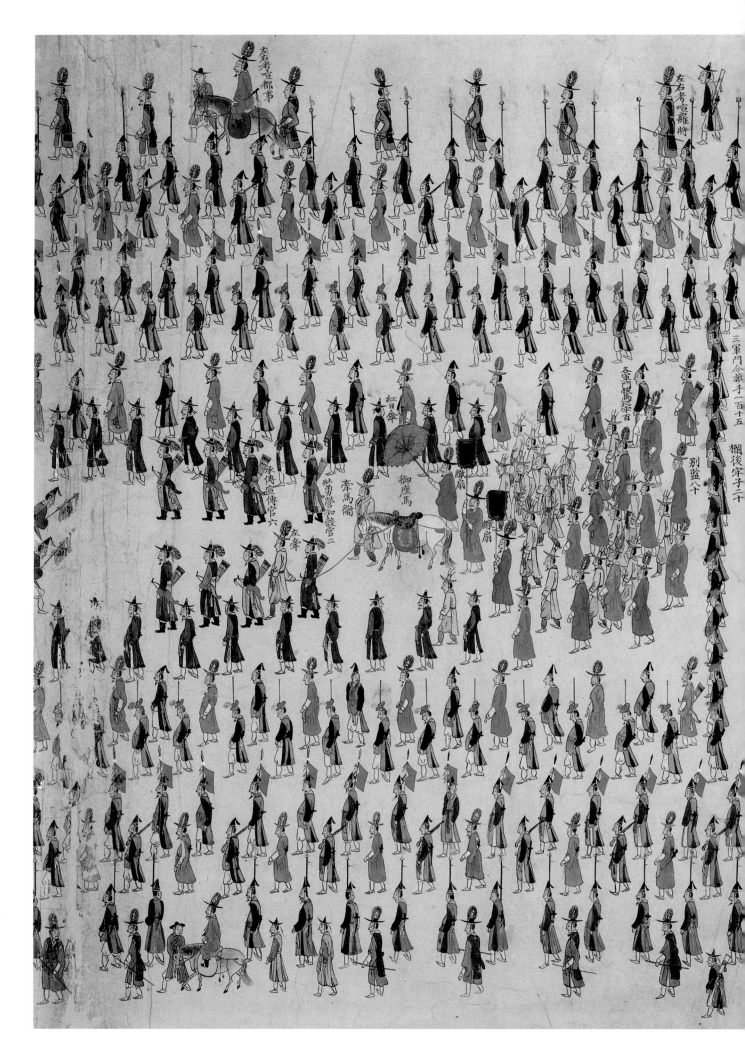

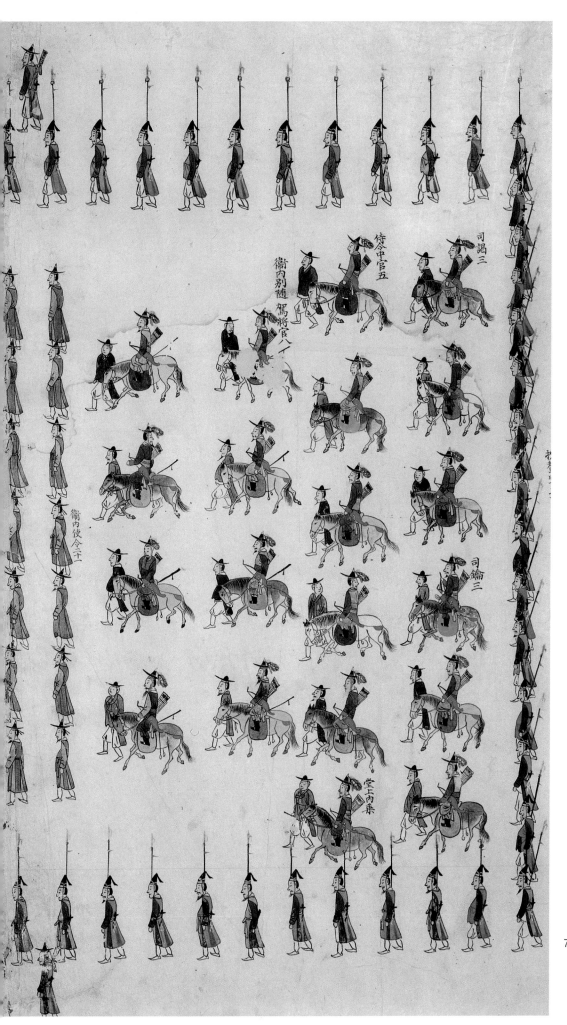

司謁三

侍令中官五

備內別隨 駕將官八

備內使令二十一

司鑰三

堂上內乘

7. ROYAL PROCESSION TO THE
CITY OF HWASŎNG
Late Chosŏn
Handscroll; color and ink on paper
19¾ x 1,811 in (50.3 x 4600.0 cm)
National Museum of Korea, Seoul

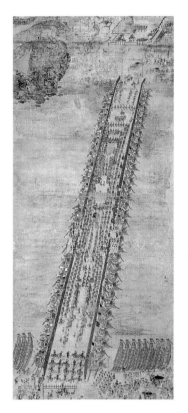 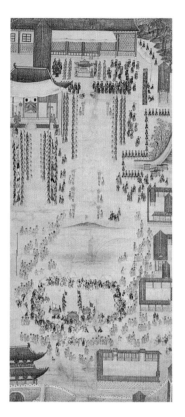 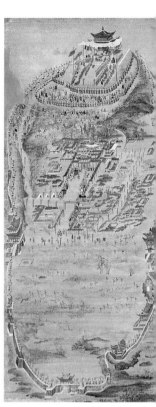

8. ROYAL VISIT TO THE CITY OF HWASŎNG
1790
Eight-fold screen; color and ink on silk
84⅞ x 240½ in (215.5 x 610.8 cm)
National Museum of Korea, Seoul

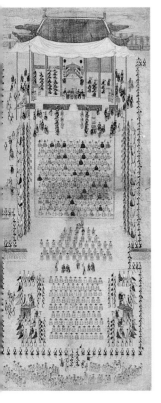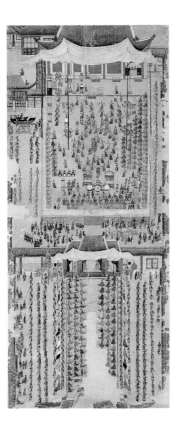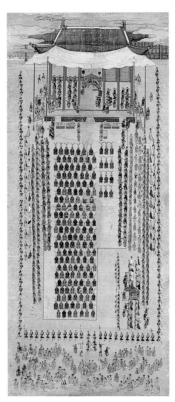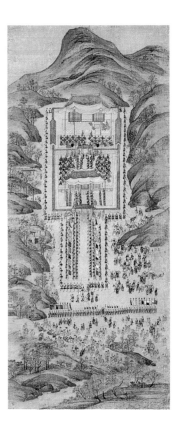

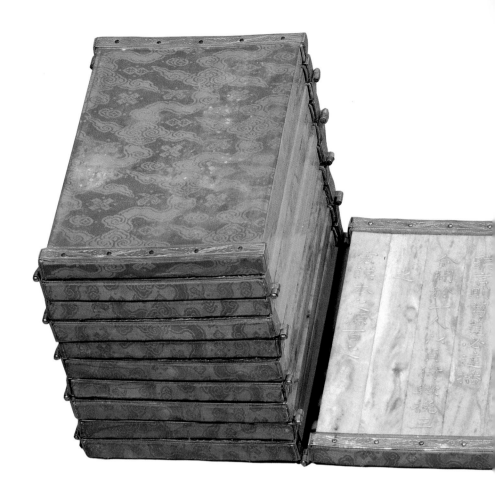

10. JADE BOOK FOR KING CHANGJO
 1795
 Jade with gold, metal and cloth binding
 9⅞ x 99⅛ in (25.2 x 251.8 cm)
 The Royal Museum, Seoul

11. BAMBOO BOOK FOR CROWN PRINCE ÜISO
 1752
 Bamboo with gold, metal binding
 9⅞ x 41⅜ in (25.2 x 105.0 cm)
 The Royal Museum, Seoul

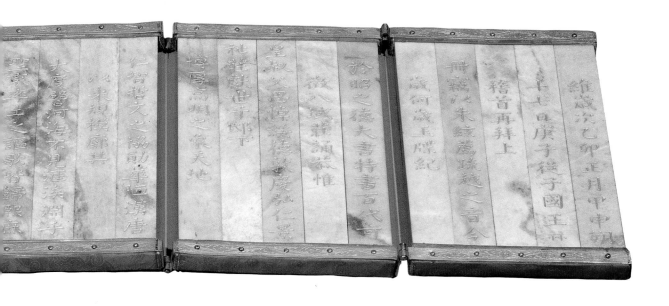

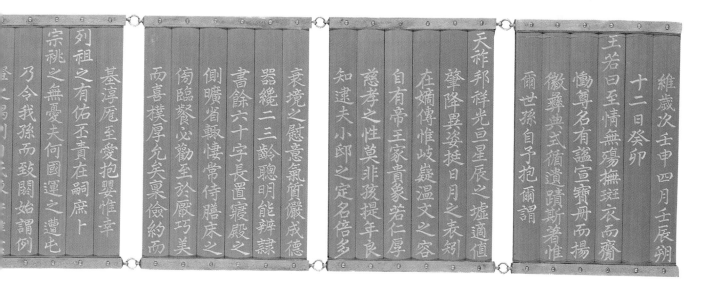

9. RECORD OF THE CONSTRUCTION OF
 THE ROYAL CITY AT HWASŎNG
 1801
 Printed by the order of King Chŏngjo
 Printed book, nine volumes; ink on paper
 Volume 1, 13⅜ x 8¾ x 1¼ in (34.1 x 22.2 x 3.3 cm)
 Changsŏgak Collection, The Academy of Korean
 Studies, Sŏngnam

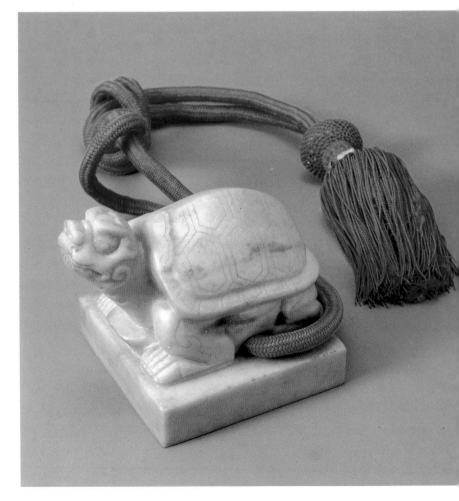

12. SEAL OF CROWN PRINCE MUNHYO
 Probably 1786
 Jade
 3⅞ x 4¾ x 3¾ in (9.9 x 12.2 x 9.7 cm)
 The Royal Museum, Seoul

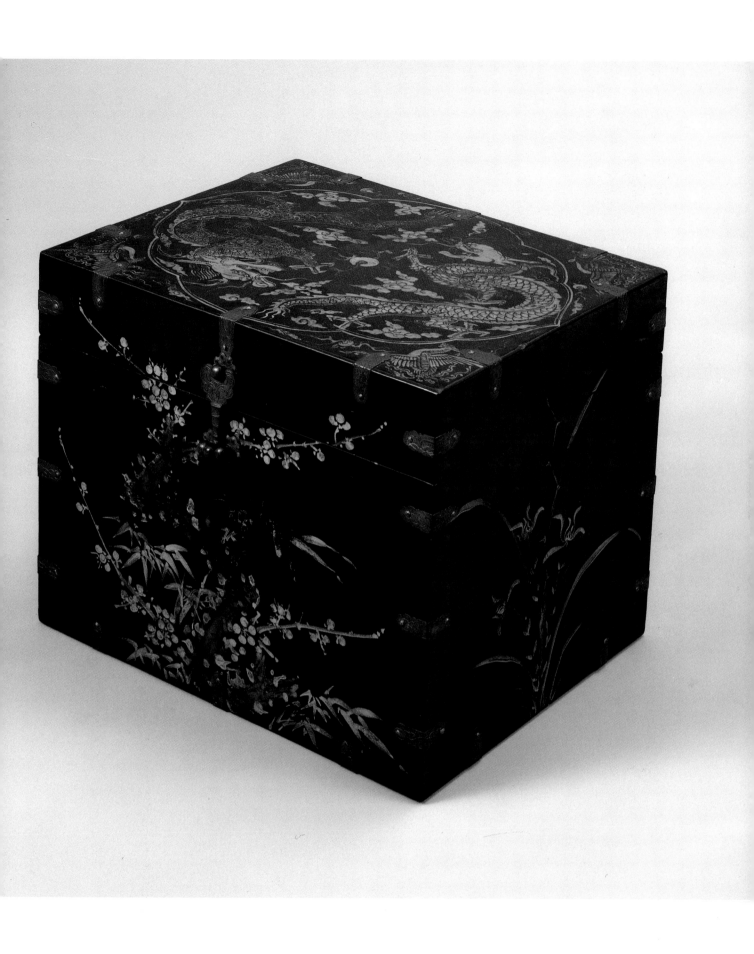

13. CASE FOR GOLD BOOK
1786
Lacquered wood painted with gold
10 x 10½ x 12⅝ in (25.4 x 26.7 x 32.1 cm)
The Royal Museum, Seoul

14. THE SEVEN STARS
 Late Chosŏn
 Color, gold leaf, and ink on silk
 28 x 94¾ in (71.2 x 240.8 cm)
 Onyang Folk Museum, Onyang

16. SUNDIAL
 Late Chosŏn
 Bronze with silver inlay
 D. 9½ in (24.2 cm)
 Sŏng-sin Women's University Museum, Seoul

17. BASE FOR SUNDIAL
18th century
Stone
34¼ x 14⅜ x 14⅜ in (87.0 x 36.5 x 36.5 cm)
Ch'angkyŏng Palace, Seoul

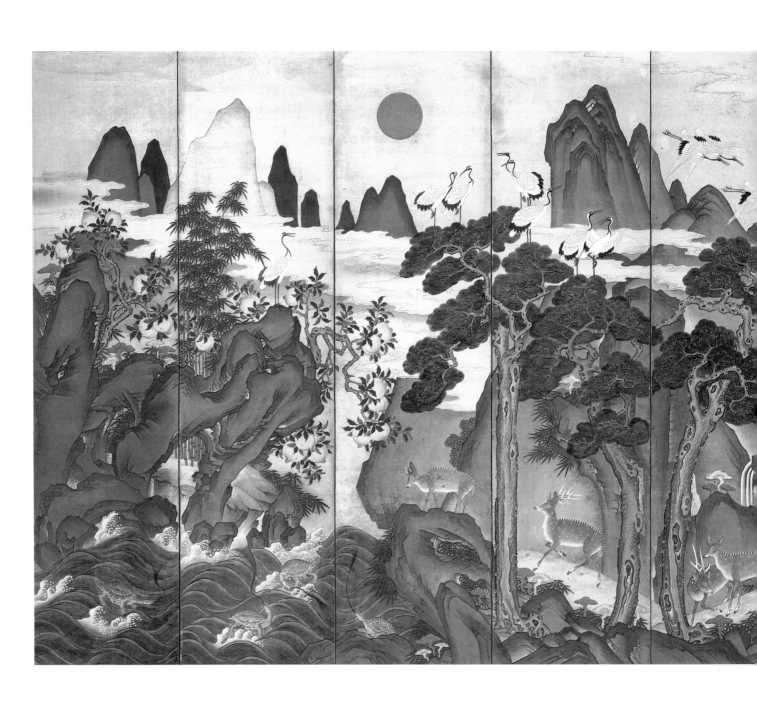

18. Ten Longevity Symbols
Late Chosŏn
Ten-fold screen; color on silk
98¼ x 232⅞ in (250.8 x 591.4 cm)
Ho-Am Art Museum, Yongin

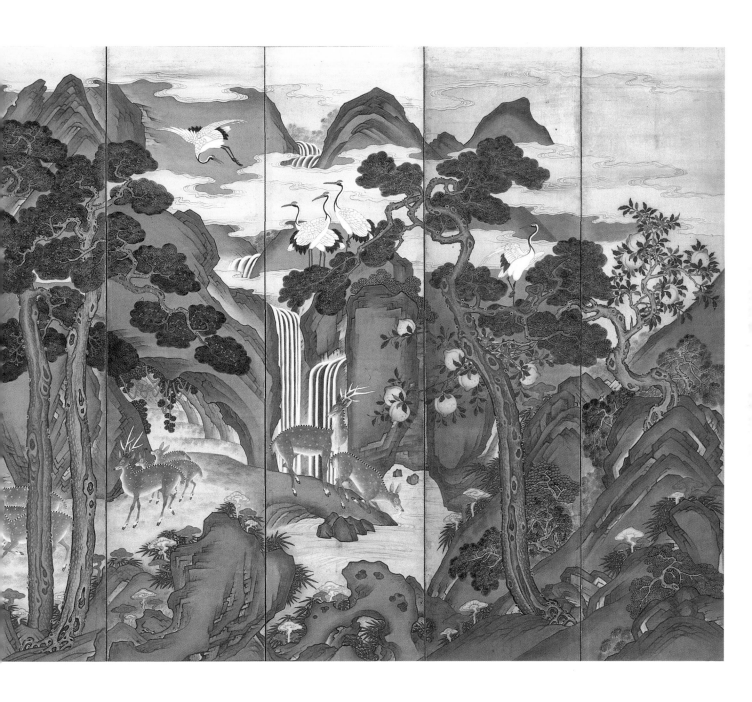

117

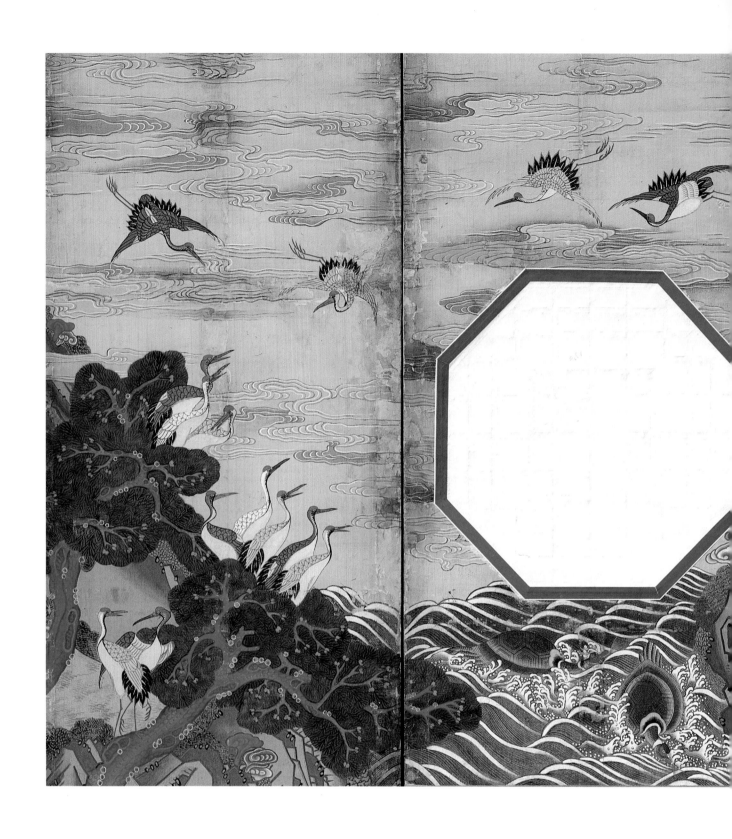

19. LONGEVITY SYMBOLS WITH CRANES
Late Chosŏn
Four-panel sliding door; color on silk
57 x 363¼ in (144.7 x 924.0 cm)
Ch'angdŏk Palace, Seoul

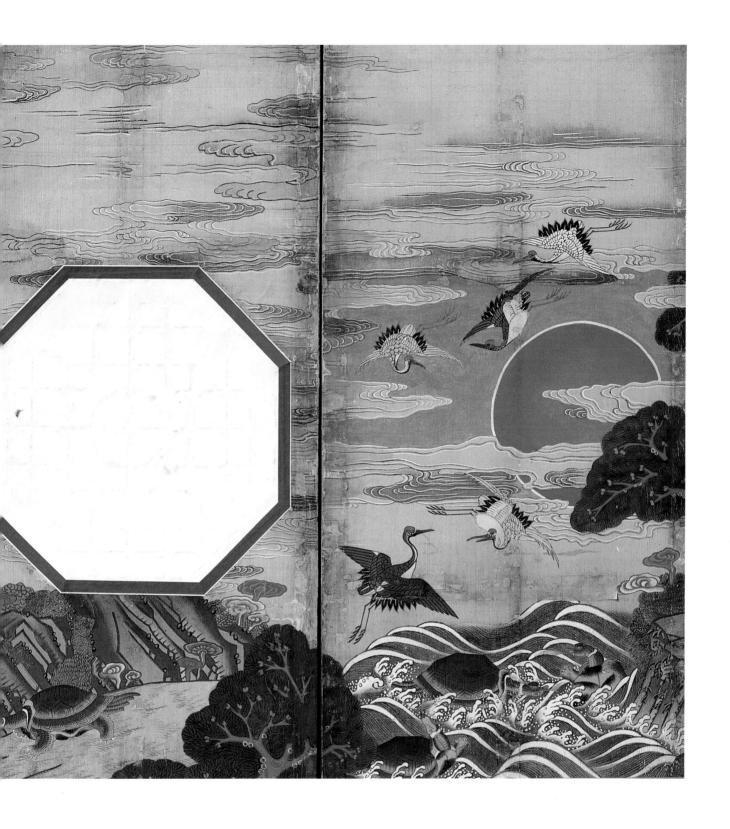

20. CHEST
 18th century
 Wood with red and black lacquer
 23¾ x 21 x 12⅞ in (60.4 x 53.4 x 32.7 cm)
 National Museum of Korea, Seoul

21. LANTERN
 Late Chosŏn
 Wood with red and black lacquer
 41⅞ x 12¾ x 12¾ in (106.4 x 32.5 x 32.4 cm)
 National Museum of Korea, Seoul

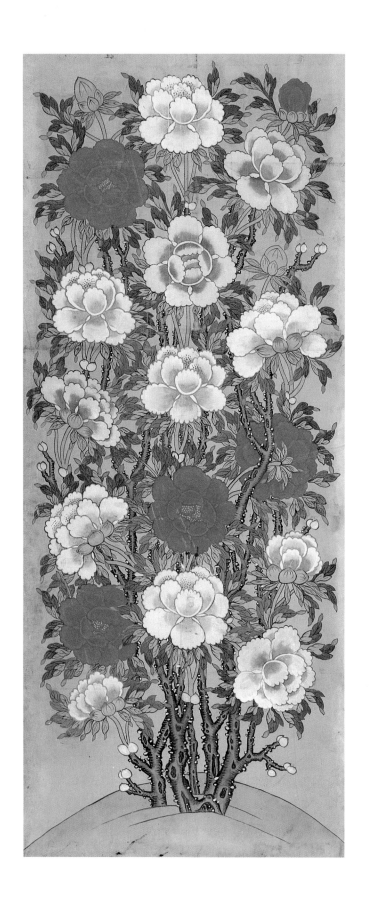
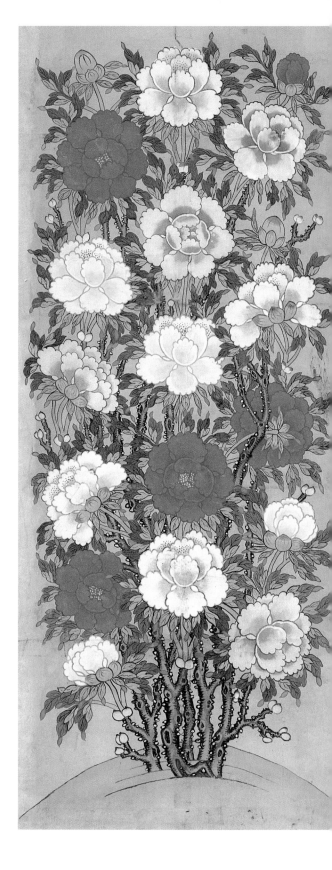

22. PEONIES
Late Chosŏn
Four-fold screen; color on silk
106½ x 156 in (270.5 x 396.0 cm)
Ch'angdŏk Palace, Seoul

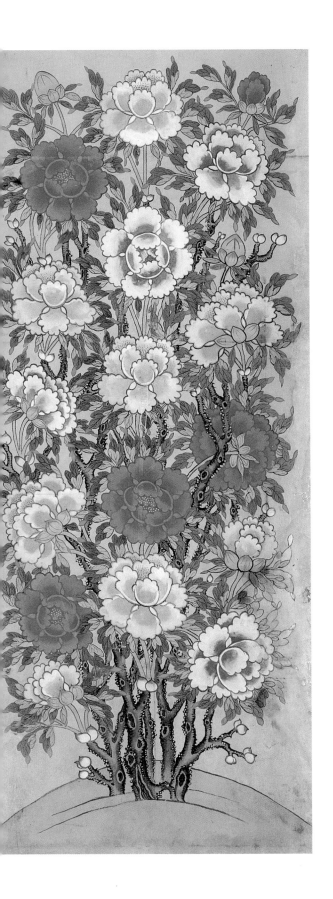

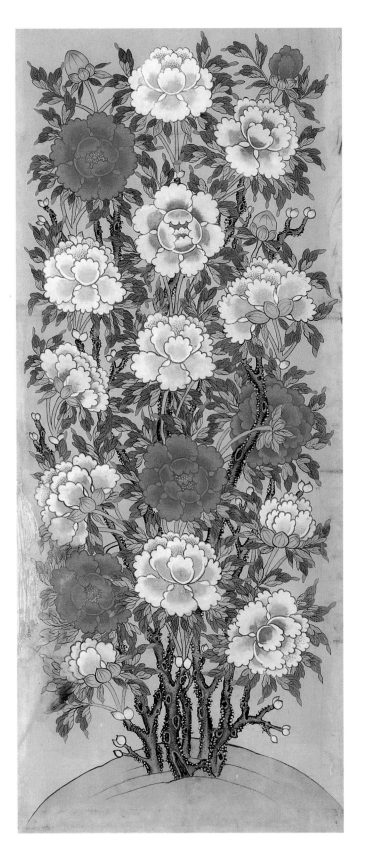

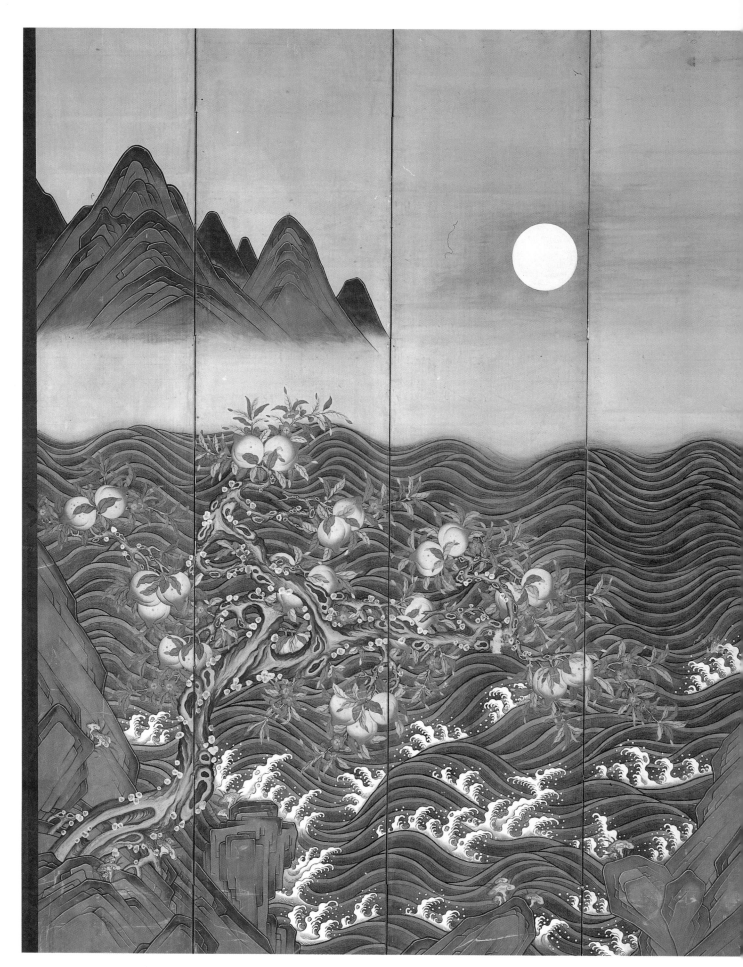

23. SUN, MOON, AND IMMORTAL PEACHES
Late Chosŏn
Pair of four-fold screens; color on silk
Each, 130 x 107⅝ in (330.3 x 273.4 cm)
The Royal Museum, Seoul

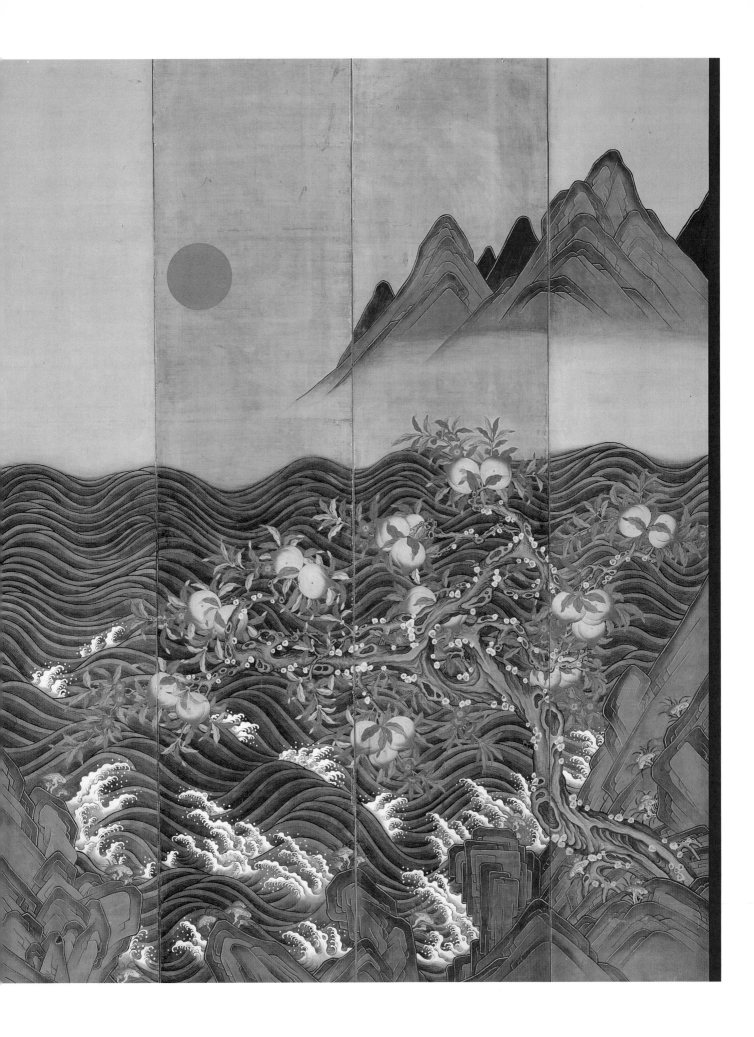

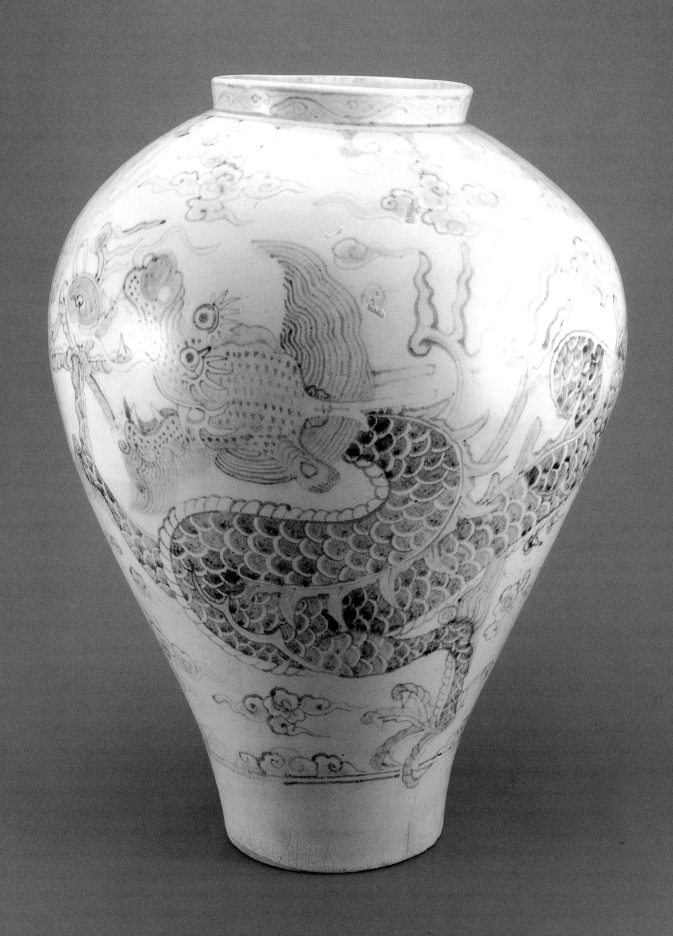

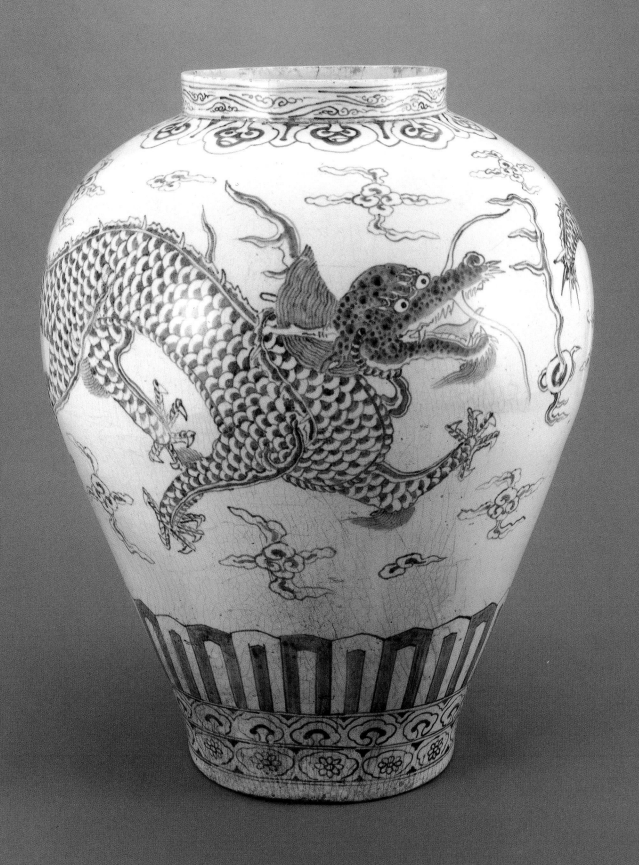

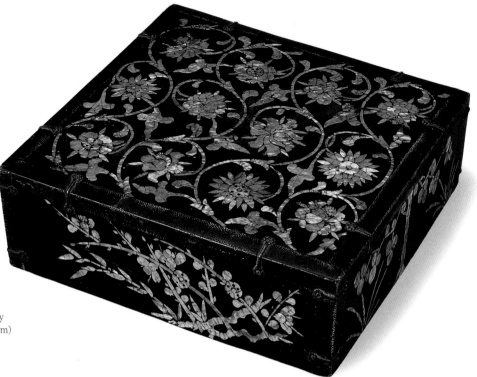

26. BOX
 18th century
 Lacquered wood with mother-of-pearl inlay
 4 ⅛ x 12 ½ x 12 ½ in (10.4 x 31.8 x 31.7 cm)
 National Museum of Korea, Seoul

27. CHEST
 Late Chosŏn
 Painted wood with flattened-ox-horn inlay
 6 x 8⅝ x 8⅝ in (15.2 x 21.9 x 21.9.cm)
 Florence and Herbert Irving Collection

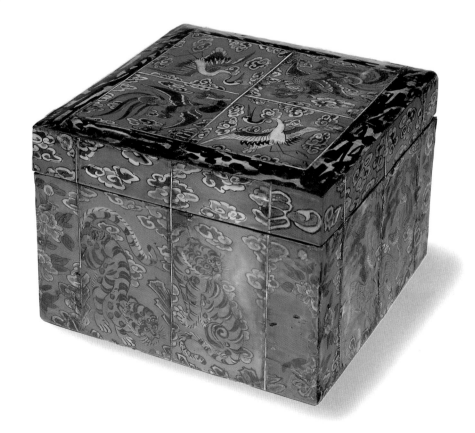

PAGE 126
24. JAR WITH DRAGON
 First half of the 18th century
 Porcelain painted with underglaze iron
 H. 23⅜ in (59.4 cm)
 National Museum of Korea, Seoul

PAGE 127
25. JAR WITH DRAGONS
 18th century
 Porcelain painted with underglaze blue
 H. 21½ in (54.6 cm)
 National Museum of Korea, Seoul

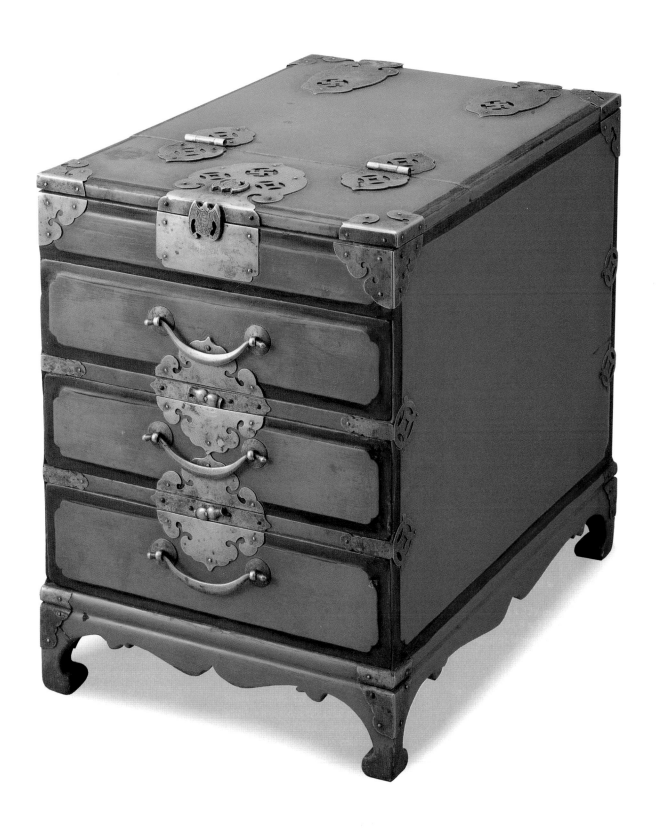

28. Cosmetics Chest with Mirror
18th century
Lacquered wood
12 x 12⅞ x 9¼ in (30.6 x 32.1 x 23.4 cm)
Chŏng So-hyon Collection, Seoul

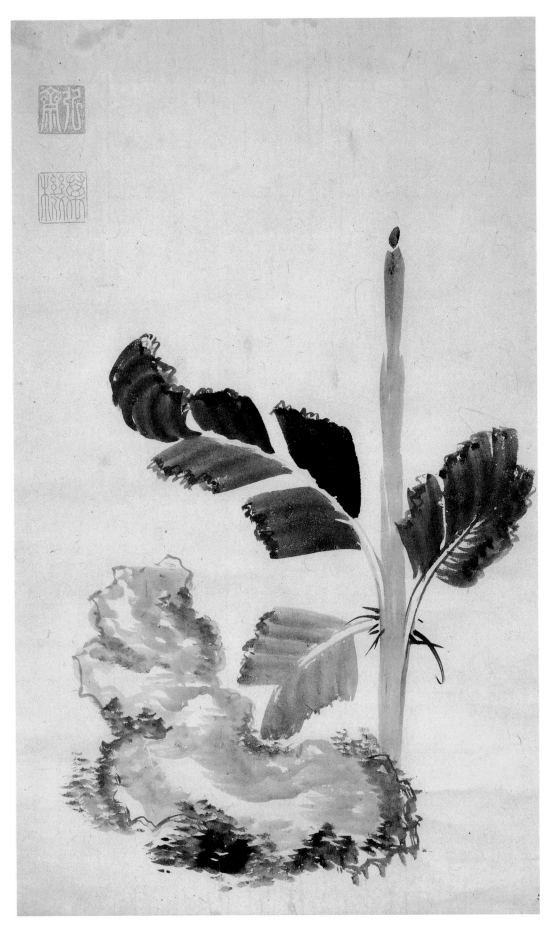

30. BANANA TREE
18th century
King Chŏngjo (1752–1800)
Hanging scroll; ink on paper
33¼ x 20¼ in (84.6 x 51.6 cm)
Dongguk University Museum, Seoul
Treasure no. 743

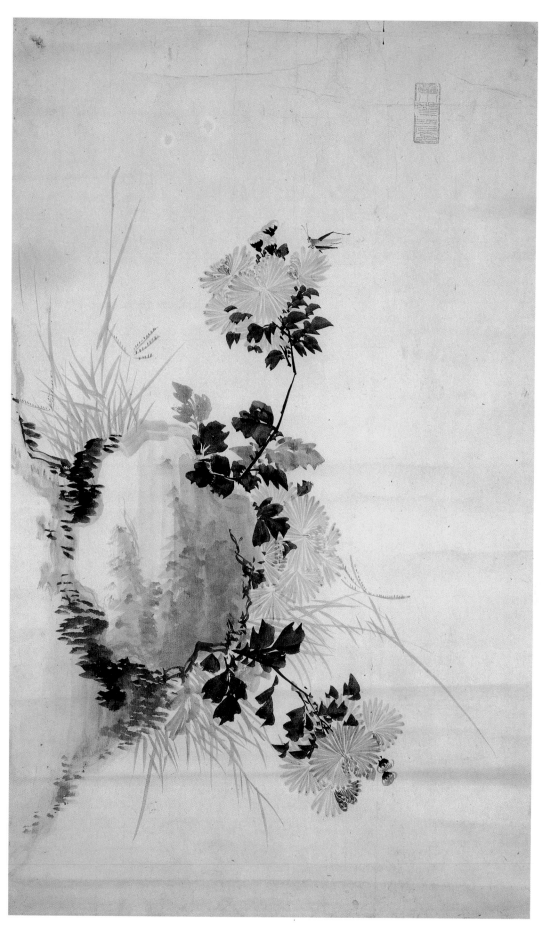

31. CHRYSANTHEMUM
 18th century
 King Chŏngjo (1752–1800)
 Hanging scroll; ink on paper
 33¼ x 20¼ in (84.6 x 51.6 cm)
 Dongguk University Museum, Seoul
 Treasure no. 744

33. LIST OF OBJECTS MADE FOR THE WEDDING OF A CROWN
PRINCE
Dated 1882
Ink on colored paper
90⅜ x 10⅛ in (229.7 x 25.7 cm)
Changsŏgak Collection, The Academy of Korean Studies,
Sŏngnam

35. CEREMONIAL CHANT FOR THE RITUAL OF THE
ROYAL VISIT TO THE YUKSANGGUNG SHRINE
18th century
Ink on paper
9¼ x 28¾ in (23.5 x 72.0 cm)
Changsŏgak Collection, The Academy of
Korean Studies, Sŏngnam

贈鋧瓷府伯赴任之行
萬丈霞標鋧瓷城城門高
闢使君程江東不遠成都
近熟路輕車遂此行
己未季夏之月

36. POEM BESTOWED ON THE MAGISTRATE OF
 CH'ŎRONG-SŎNG
 Dated 1799
 King Chŏngjo (1752–1800)
 Hanging scroll; ink on silk
 77⅜ x 34¼ in (196.5 x 88.2 cm)
 National Museum of Korea, Seoul

諭世孫書

王若曰嗚呼海東三百年朝鮮八十三

歲君其依於二十五歲孫今日正

宗統邦國有泰山磐石之安而且見陳

章辭嚴義正可垂千百世日記洗草

定循汝意且聞昨日墓上舉措聞者

可以浮沿導

國初造寶印故事欲以至孝賜爾爾師

領相忠言令予感動玆寢其命宣

可泯其跡於來後特以一孝字彰其

心於今世表其事於來世雖海東草

木昆虫就莫知也特爲臨殿宣諭仍

受其賀祖孫相依光明正大於今日

也嗟我我孫體祖意夙夜乾乾保我

三百年

宗社也夫予卽阼五十二年季八十三

示諭于二十五歲世孫

37. ROYAL EDICT: ADMONITION TO THE ELDEST
GRANDSON OF THE KING
Dated 1776
King Yŏngjo (r. 1724–76)
Handscroll; ink on paper mounted on silk
22⅞ x 47 in (58.0 x 119.4 cm)
The Royal Museum, Seoul

38. ROYAL EDICT CASE
18th century
Lacquered wood with lead
H. 32⅜ in (82.2 cm)
The Royal Museum, Seoul

39. Letter Rack
Late Chosŏn
Bamboo and wood partially decorated with red lacquer
20 x 9⅜ x 3 in (50.8 x 23.8 x 7.5 cm)
National Museum of Korea, Seoul

40. Bookcase
Late Chosŏn
Wood, paper, and silk
50¼ x 12⅜ x 19 in (127.6 x 31.3 x 48.2
The Royal Museum, Seoul

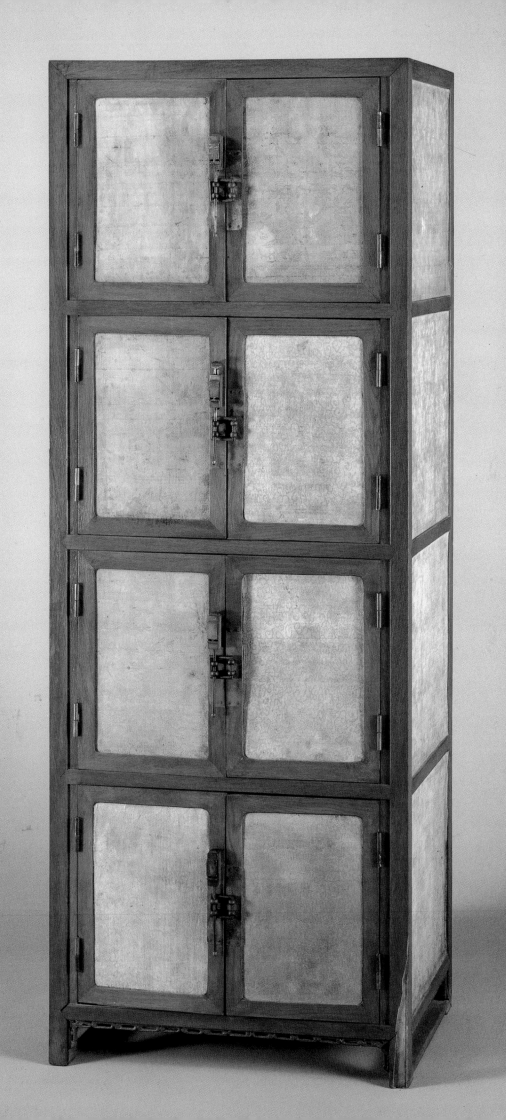

43. BOOKCASE WITH THREE SHELVES
 18th century
 Wood
 52⅛ x 14⅛ x 12¾ in (132.5 x 36.0 x 32.5 c
 Yun Hyong-kun Collection, Seoul

41. DOCUMENT BOX
 19th century
 Wood
 2 x 14⅜ x 8¼ in (5.0 x 36.6 x 21.0 cm)
 National Museum of Korea, Seoul

42. DOCUMENT CHEST
 Late Chosŏn
 Wood
 14¼ x 56⅝ x 8¾ in (36.3 x 144.0 x 22.2 cm)
 National Museum of Korea, Seoul

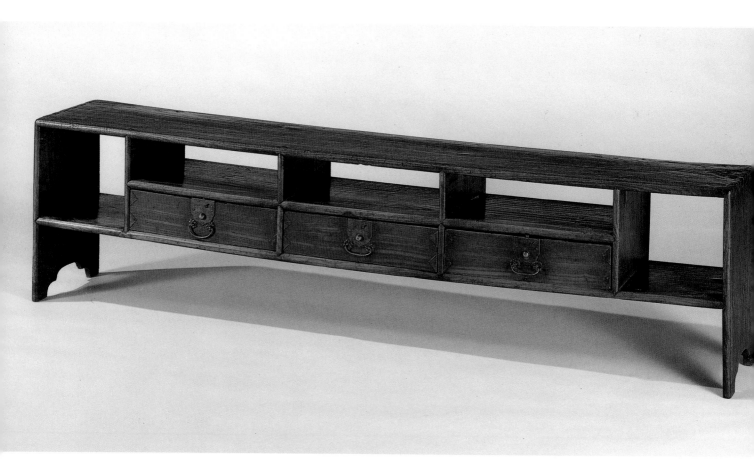

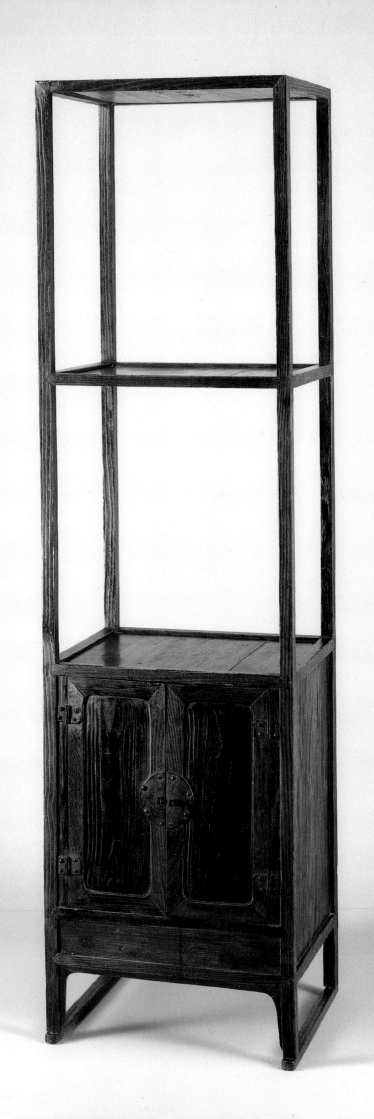

44. Inkstone in the Shape of a Boat
18th century
Stone
⅝ x 3½ x 8¼ in (1.5 x 9.0 x 21.0 cm)
National Folk Museum of Korea, Seoul

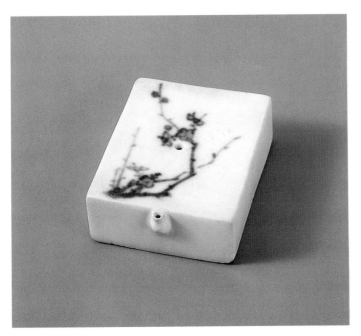

45. WATER DROPPER WITH PLUM BLOSSOM
 18th century
 Porcelain painted with underglaze blue
 ¾ x 1⅞ x 2½ in (2.0 x 4.8 x 6.3 cm)
 Dŏkwŏn Art Museum, Seoul

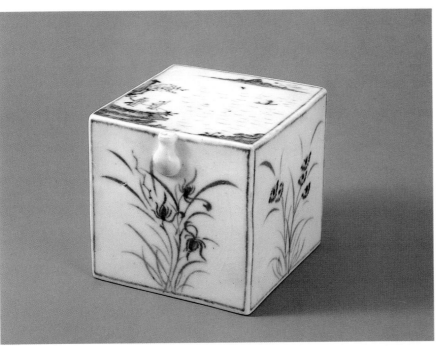

46. WATER DROPPER WITH LANDSCAPE
 18th century
 Porcelain painted with underglaze blue
 3 x 3¾ x 3⅜ in (7.5 x 9.5 x 8.6 cm)
 Dŏkwŏn Art Museum, Seoul

48. BRUSH WASHER
 18th century
 Porcelain
 2⅝ x 3⅞ x 3⅞ in (6.6 x 10.0 x 10.0 cm)
 Chŏng So-hyon Collection, Seoul

PAGE 142

49. OCTAGONAL VASE WITH ORCHID AND BAMBOO
 Early 18th century
 Porcelain painted with underglaze blue
 H. 11 in (27.9 cm)
 National Museum of Korea, Seoul

PAGE 143

50. OCTAGONAL VASE WITH PLUM BLOSSOMS AND BAMBOO
 18th century
 Porcelain painted with underglaze blue
 H. 15⅜ in (39.0 cm)
 Song-am Art Museum, Inch'ŏn

靈通洞口亂石
壯佛大如屋玉蒼蘚
覆之下見颼颼修傳
就起於颼庵未必信
趁三臠佛之親六所稱
有

51. Yŏngt'ong-dong, *from* Travel Sketches of Songdo
 1757
 Kang Sehwang (1713–91)
 Album leaf; ink and light color on paper
 13 x 21 in (32.9 x 53.4 cm)
 National Museum of Korea, Seoul

52. Valley of Ten Thousand Waterfalls
 About 1747
 Chŏng Sŏn (1676–1759)
 Album leaf; ink and light color on silk
 13 x 8⅝ in (33.0 x 22.0 cm)
 Seoul National University Museum, Seoul

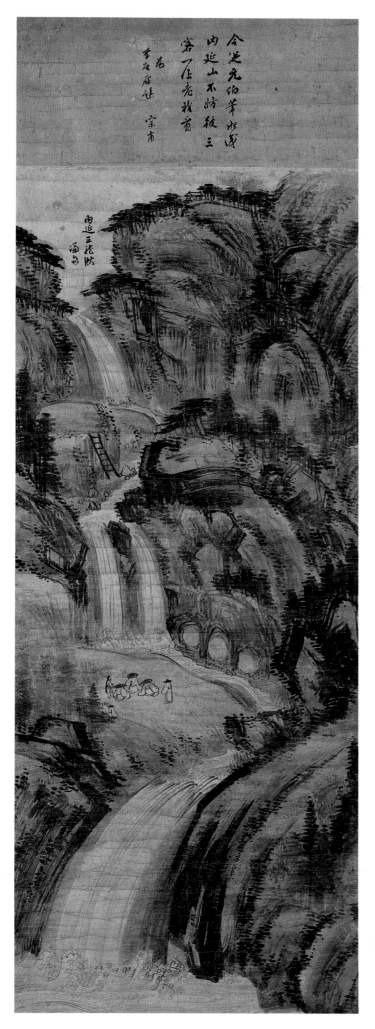

53. THREE-DRAGON WATERFALL, MOUNT NAEYŎN
18th century
Chŏng Sŏn (1676–1759)
Hanging scroll; ink on paper
62⅞ x 22⅛ in (159.8 x 56.2 cm)
Ho-Am Art Museum, Yongin

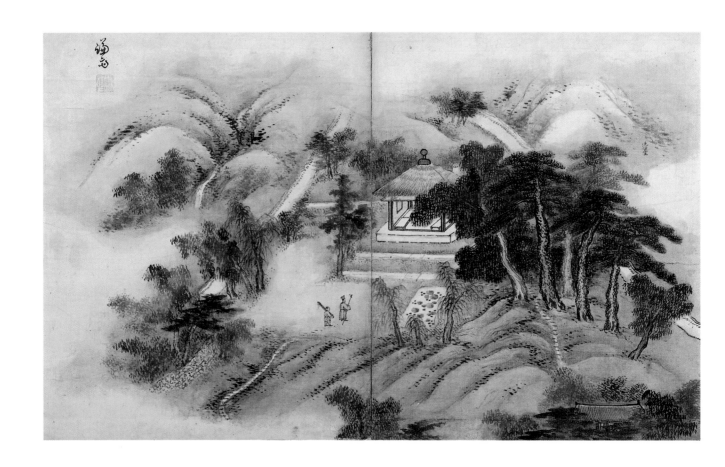

55. PAVILION IN THE WESTERN GARDEN
1740
Chŏng Sŏn (1676–1759)
Album leaf; ink and light color on paper
15¾ x 26¼ in (40.1 x 66.8 cm)
Chung Hwan-kook Collection, Seoul

56. LANDSCAPE WITH FISHERMEN
1796
Kim Hongdo (b. 1745)
Album leaf; ink and light color on paper
10½ x 12⅜ in (26.6 x 31.5 cm)
Ho-Am Art Museum, Yongin
Treasure no. 782

57. TILLING THE FIELD
1796
Kim Hongdo (b. 1745)
Album leaf; ink and light color on paper
10½ x 12⅜ in (26.6 x 31.5 cm)
Ho-Am Art Museum, Yongin
Treasure no. 782

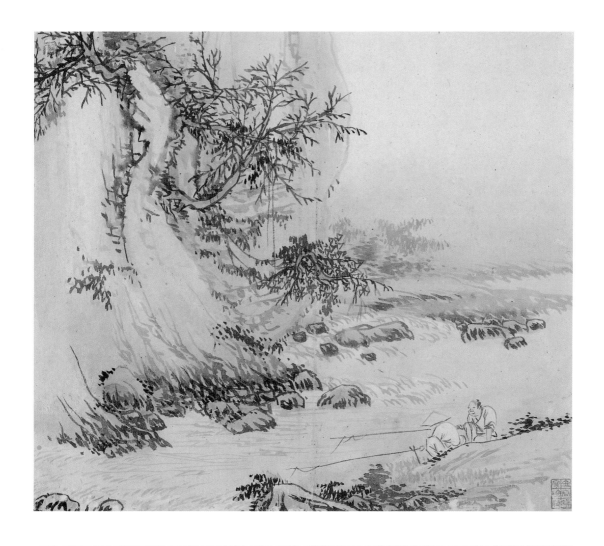

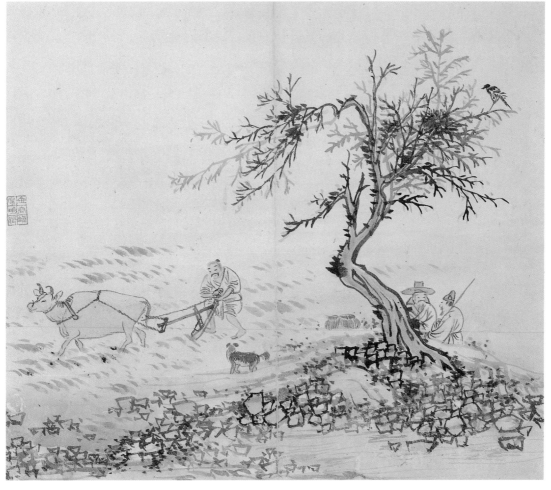

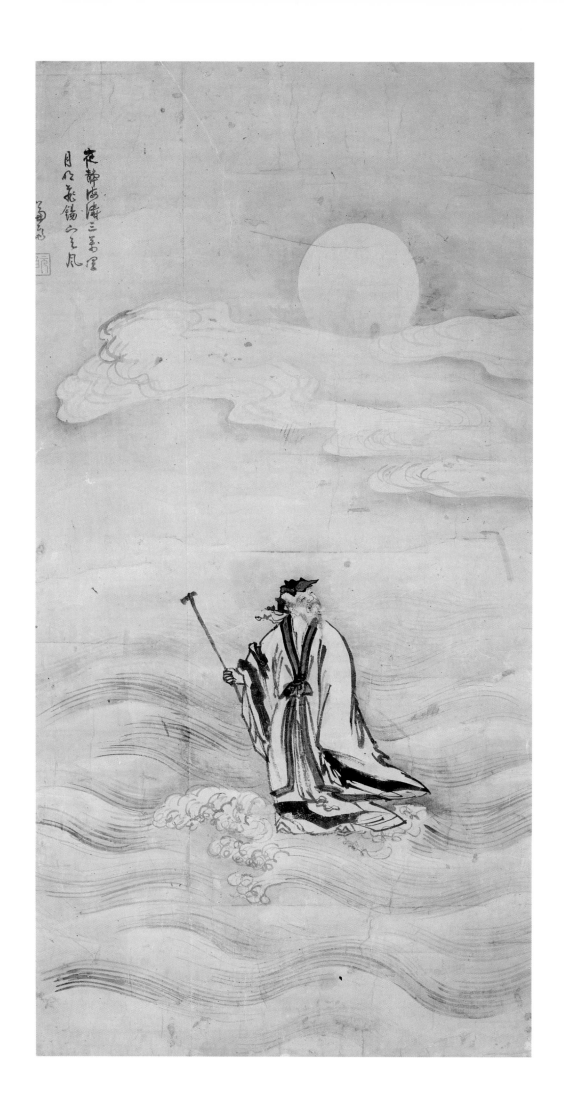

58. An Immortal Crossing the Ocean
18th century
Chŏng Sŏn (1676–1759)
Hanging scroll; ink on paper
48¼ x 26⅜ in (124.0 x 67.8 cm)
National Museum of Korea, Seoul

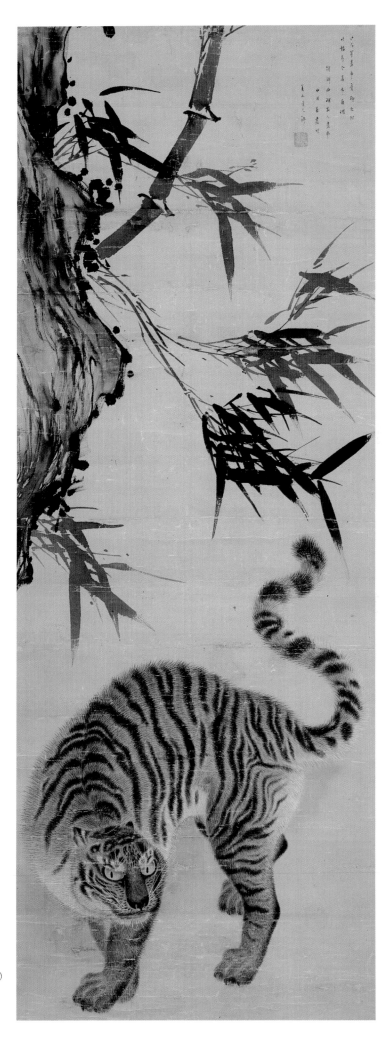

59. Tiger and Bamboo
Late Chosŏn
Kim Hongdo (b. 1745) and Im Hŭiji (b. 1765)
Hanging scroll; ink and light color on silk
35¾ x 13⅜ in (90.9 x 34.1 cm)
Dŏkwŏn Art Museum, Seoul

61. INKSTONE DECORATED WITH A RELIEF OF LOTUS LEAVES
18th century
Stone
1 x 8 x 4½ in (2.6 x 20.3 x 11.4 cm)
National Museum of Korea, Seoul

62. INKSTONE TABLE
Late Chosŏn
Wood
8¾ x 11⅞ x 7½ in (22.1 x 30.3 x 19.0 cm)
Im Kŭm-hŭi Collection, Seoul

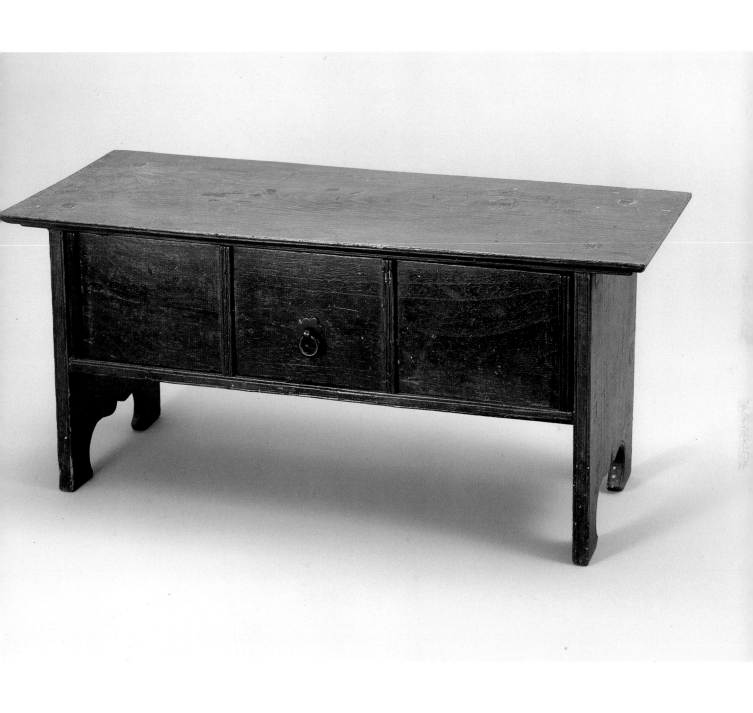

63. WRITING TABLE
Late Chosŏn
Wood
10⅝ x 23⅝ x 9⅝ in (27.0 x 60.0 x 24.5 cm)
Choi Su-jŏng Collection, Seoul

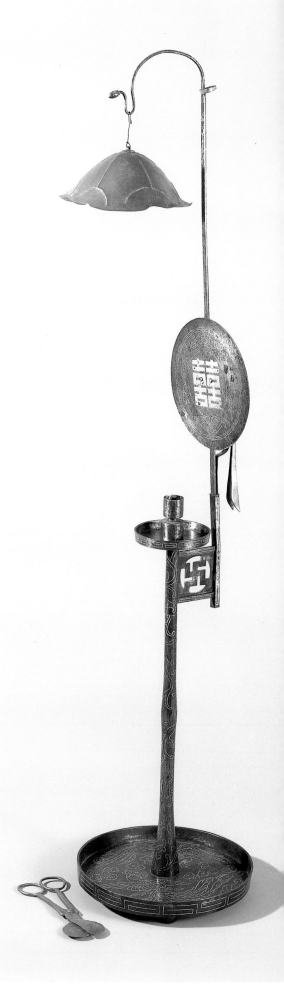

67. BRUSH HANGER
Late Chosŏn
Wood
6⅞ x 25½ x 1⅜ in (17.5 x 64.7 x 3.4 cm)
National Museum of Korea, Seoul

OPPOSITE

65. FOUR-SHELF DISPLAY STAND
Late Chosŏn
Wood
63⅞ x 16⅜ x 13⅜ in (162.3 x 41.5 x 34.0 cm)
National Museum of Korea, Seoul

66. CANDLESTICK
Late Chosŏn
Iron with silver and copper inlay
H. 42½ in (108.0 cm)
National Museum of Korea, Seoul

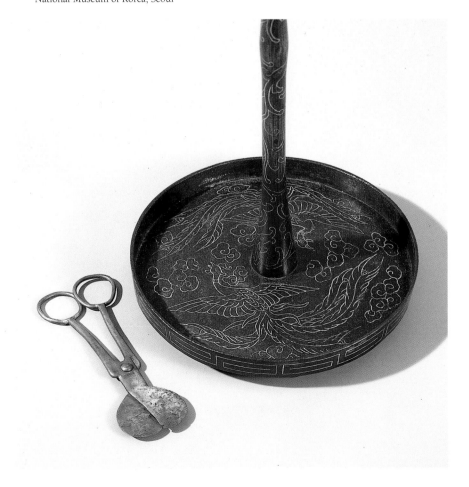

68. PAPER SCROLL STAND
 18th century
 Porcelain
 H. 4⅝ in (11.9 cm)
 Namkung Lyŏn Collection, Seoul

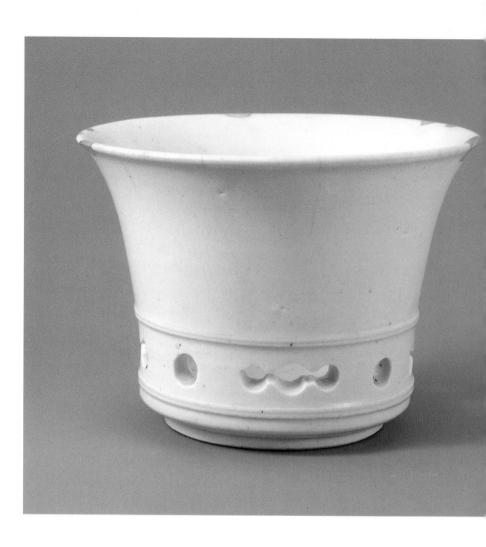

69. WATER DROPPER IN THE SHAPE OF A PEACH
 First half of the 18th century
 Porcelain painted with underglaze blue
 and copper
 H. 4⅛ in (10.5 cm)
 Ho-Am Art Museum, Yongin

OPPOSITE
70. SNOW-COVERED PINE TREES
 18th century
 Yi Insang (1710–60)
 Hanging scroll; ink on paper
 46⅛ x 20¾ in (117.3 x 52.7 cm)
 National Museum of Korea, Seoul

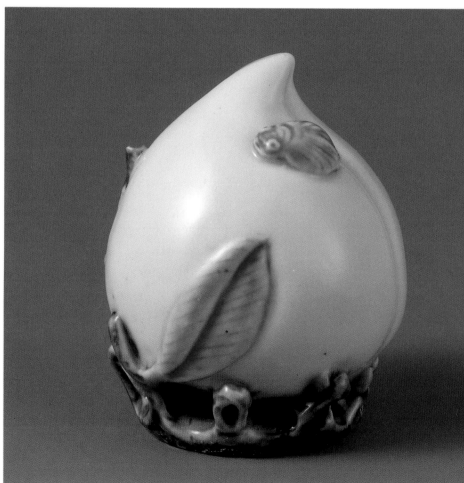

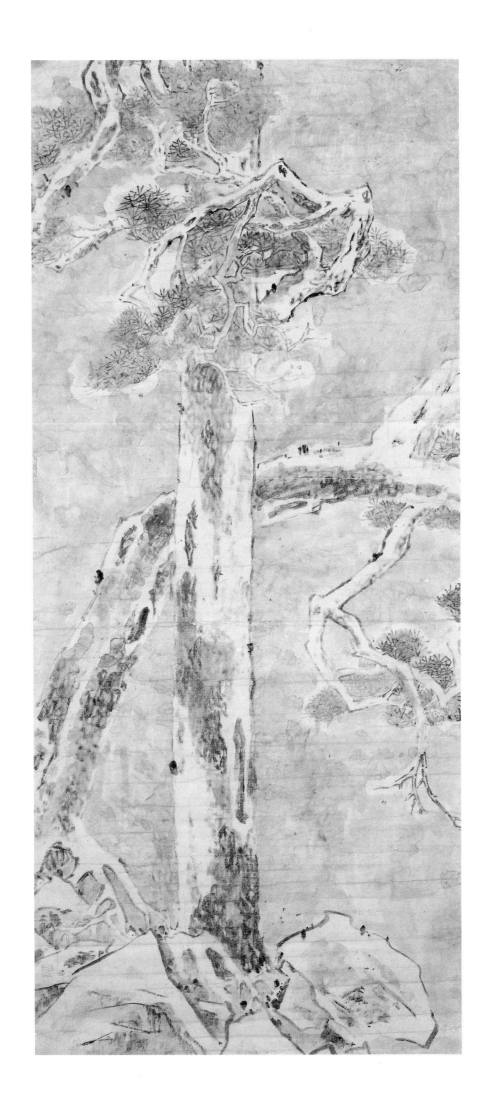

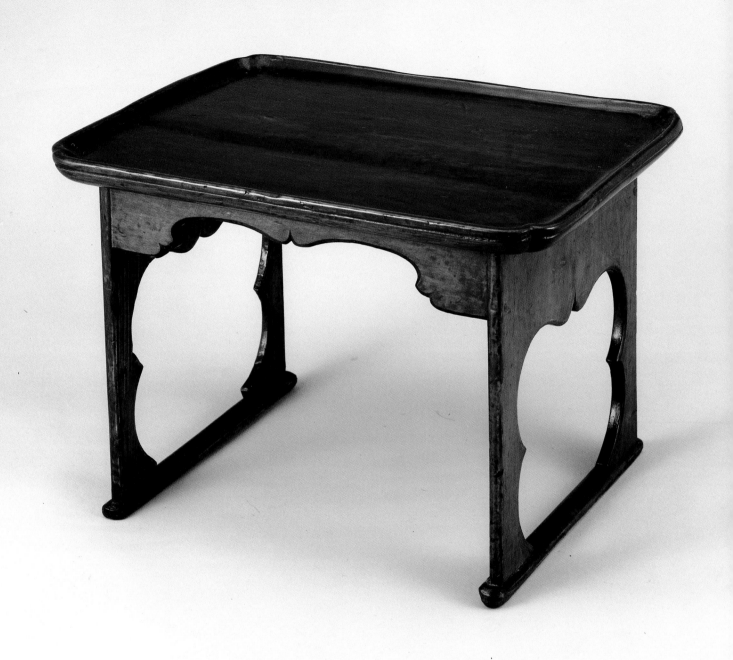

72. DINING TABLE
 Late Chosŏn
 Wood
 9¼ x 13⅜ x 9⅞ in (23.5 x 34.1 x 25.0 cm)
 National Museum of Korea, Seoul

74. THREE-SHELF CUPBOARD
 Late Chosŏn
 Wood
 62⅞ x 28¼ x 18⅜ in (159.7 x 71.7 x 46.7 cm)
 National Museum of Korea, Seoul

73. DOCUMENT CHEST
Late Chosōn
Wood
15½ x 74⅛ x 12 in (39.5 x 188.9 x 30.5 cm)
National Museum of Korea, Seoul

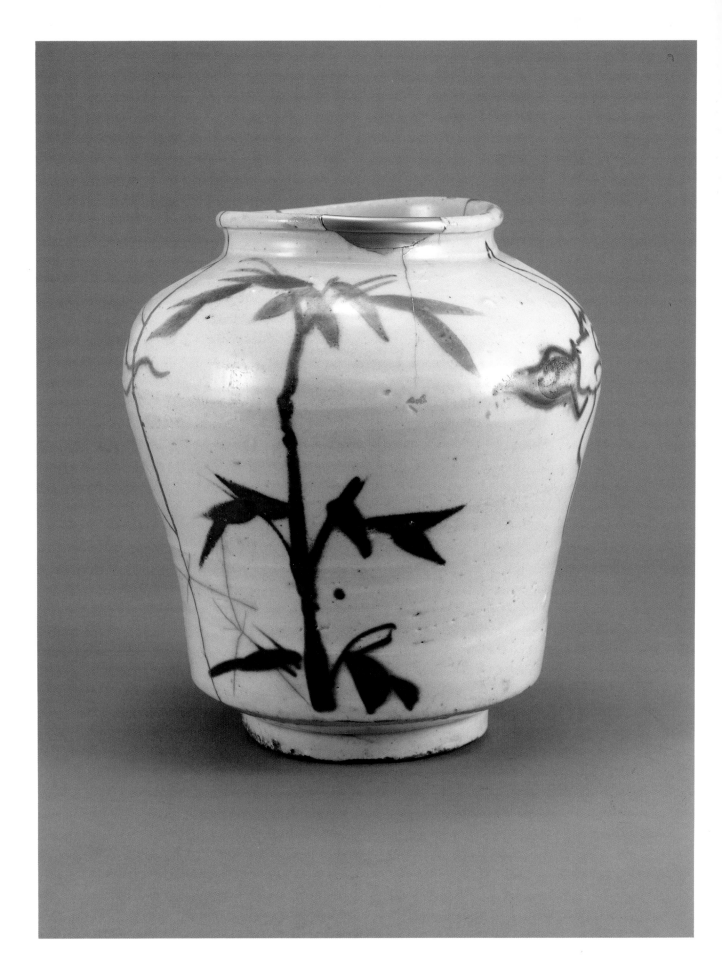

75. Jar with Bamboo
Late 18th century
Porcelain painted with underglaze copper
H. 8¼ in (20.9 cm)
National Museum of Korea, Seoul

76. Jar with Clouds and Dragon
Early 18th century
Porcelain painted with underglaze ir○
H. 14 in (35.8 cm)
Song-am Art Museum, Inch'ŏn

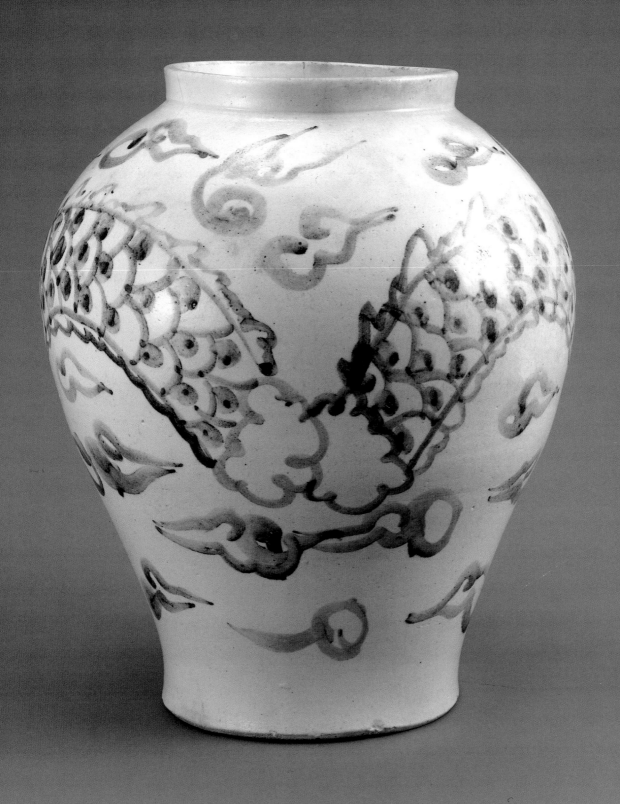

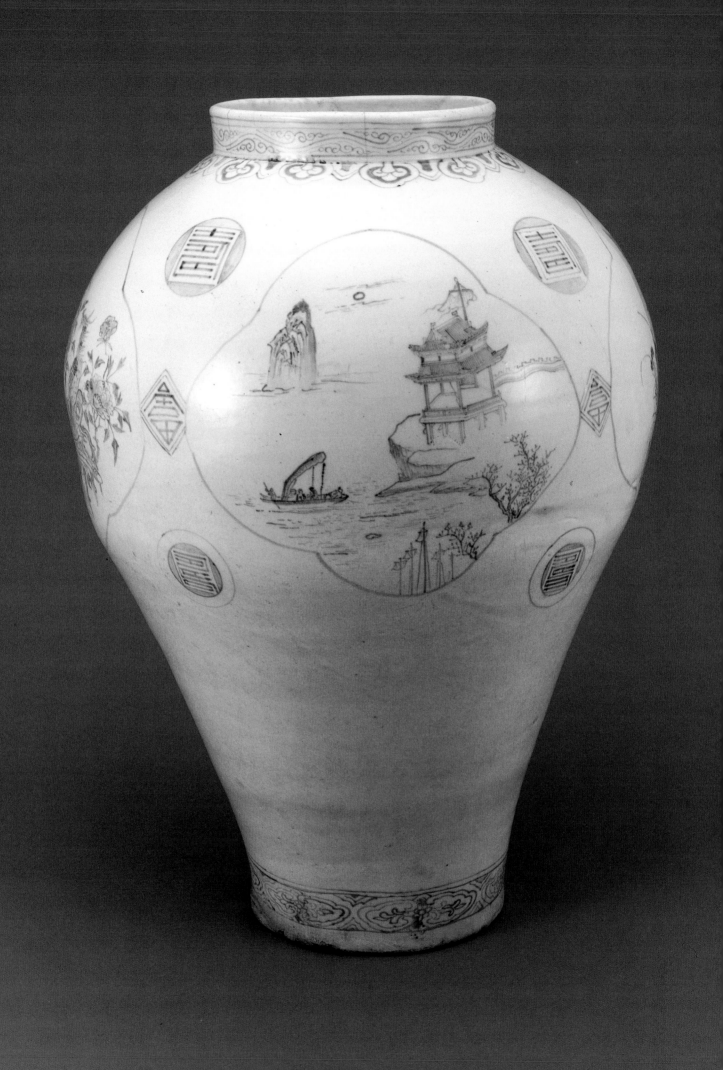

80. OCTAGONAL VASE WITH FLOWERS AND GRASS
 18th century
 Porcelain painted with underglaze iron
 H. 10⅜ in (26.4 cm)
 National Museum of Korea, Seoul

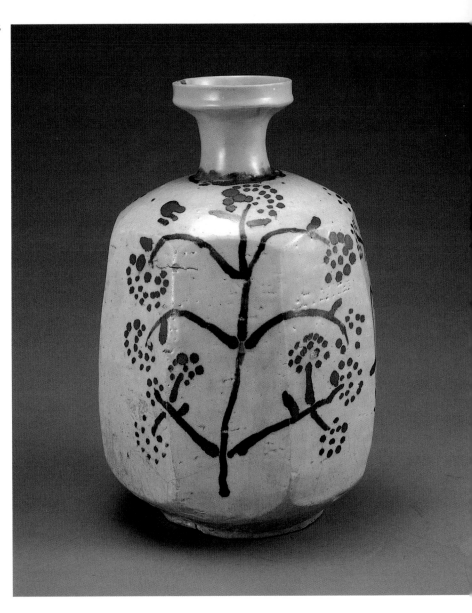

81. VASE WITH BUILDING AND LOTUS POND
 Late 18th century
 Porcelain painted with underglaze blue
 H. 8 in (20.2 cm)
 National Museum of Korea, Seoul

PAGE 162
77. JAR WITH LANDSCAPE
 18th century
 Porcelain painted with underglaze blue
 H. 21¾ in (55.2 cm)
 Lee Hak Collection, Seoul
 Treasure no. 263

PAGE 163
79. VASE WITH FLOWERS AND INSECTS
 Early 18th century
 Porcelain decorated in relief and painted
 with underglaze blue, copper, and iron
 H. 16⅝ in (42.1 cm)
 Kansong Art Museum, Seoul
 Treasure no. 241

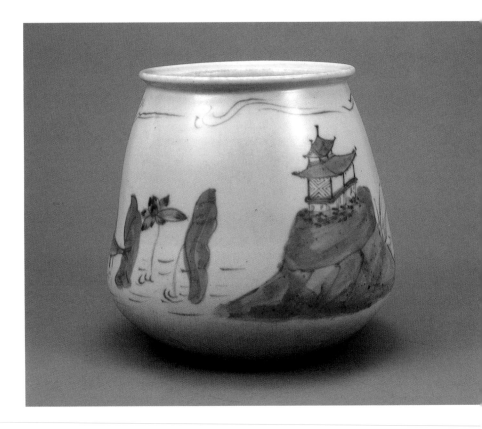

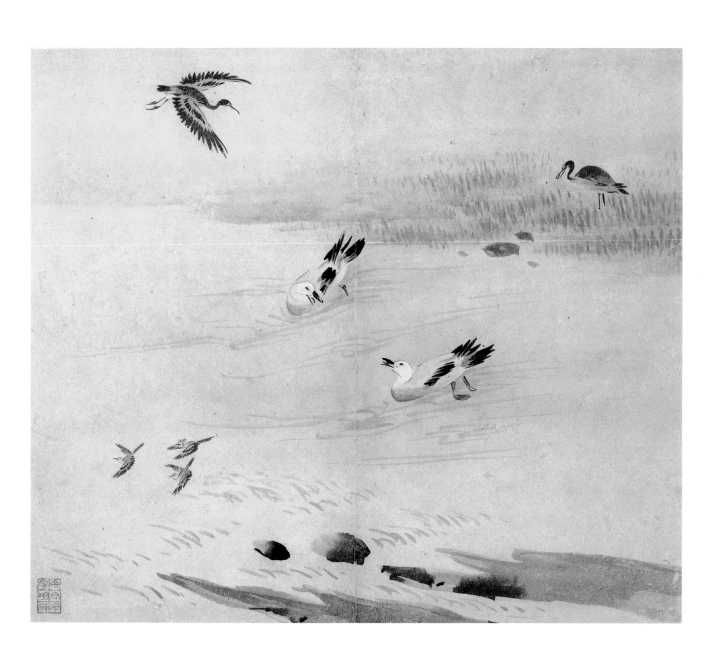

83. Ducks Playing
 1796
 Kim Hongdo (b. 1745)
 Album leaf; ink and light color on paper
 10½ x 12⅜ in (26.6 x 31.5 cm)
 Ho-Am Art Museum, Yongin
 Treasure no. 782

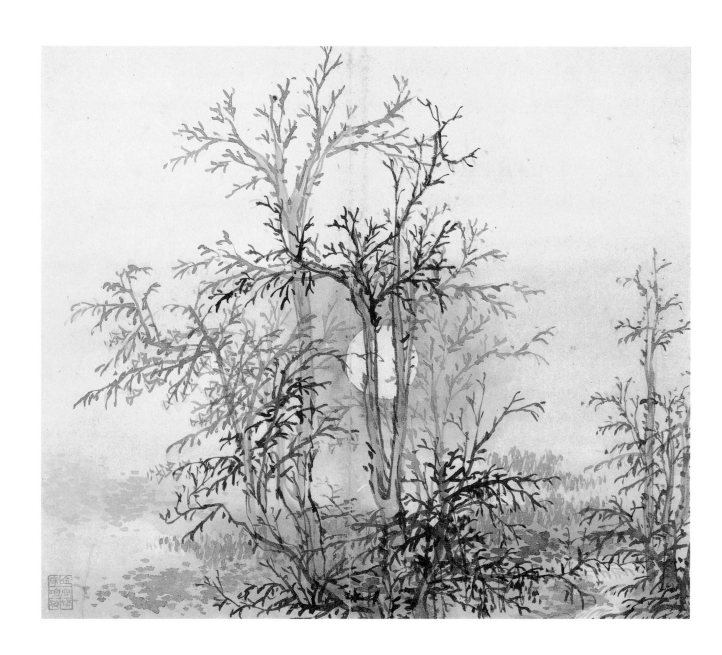

84. Full Moon Amidst Bare Trees
1796
Kim Hongdo (b. 1745)
Album leaf; ink and light color on paper
10½ x 12⅜ in (26.6 x 31.5 cm)
Ho-Am Art Museum, Yongin
Treasure no. 782

85. Cats and Sparrows
18th century
Pyŏn Sangbyŏk (active 18th century)
Hanging scroll; ink and color on sil
36⅞ x 16⅞ in (93.8 x 43.0 cm)
National Museum of Korea, Seoul

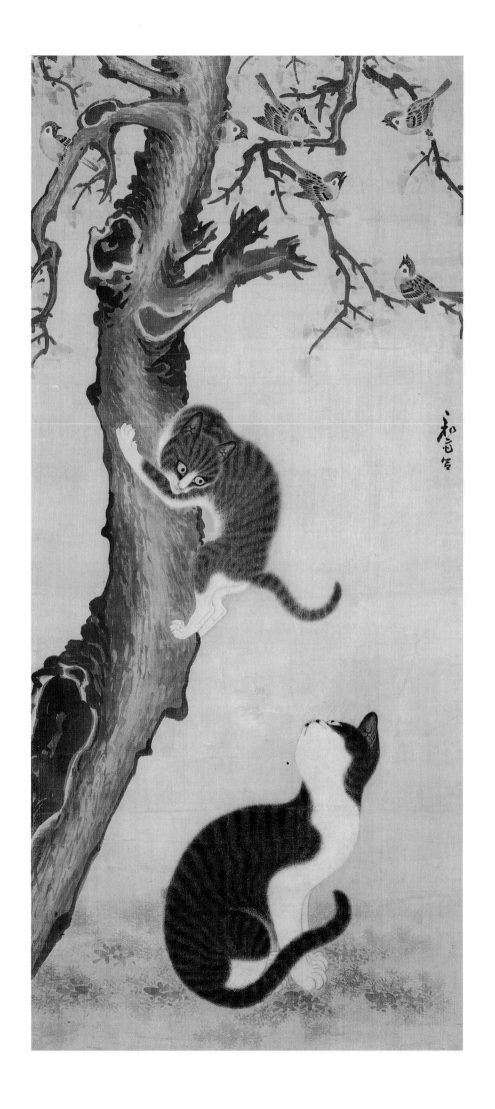

87. CHASING A CAT
Late Chosŏn
Kim Dŭksin (1754–1822)
Album leaf; ink and light color on paper
8⅞ x 10⅝ in (22.5 x 27.1 cm)
Kansong Art Museum, Seoul

88. ADMIRING THE SPRING IN THE COUNTRY
Late Chosŏn
Sin Yunbok (b. 1758)
Album leaf; ink and light color on paper
11⅛ x 13⅞ in (28.3 x 35.2 cm)
Kansong Art Museum, Seoul
Treasure no. 135

91. Women by a Crystal Stream
Late Chosŏn
Sin Yunbok (b. 1758)
Album leaf; ink and light color on paper
11⅛ x 13⅞ in (28.3 x 35.2 cm)
Kansong Art Museum, Seoul
Treasure no. 135

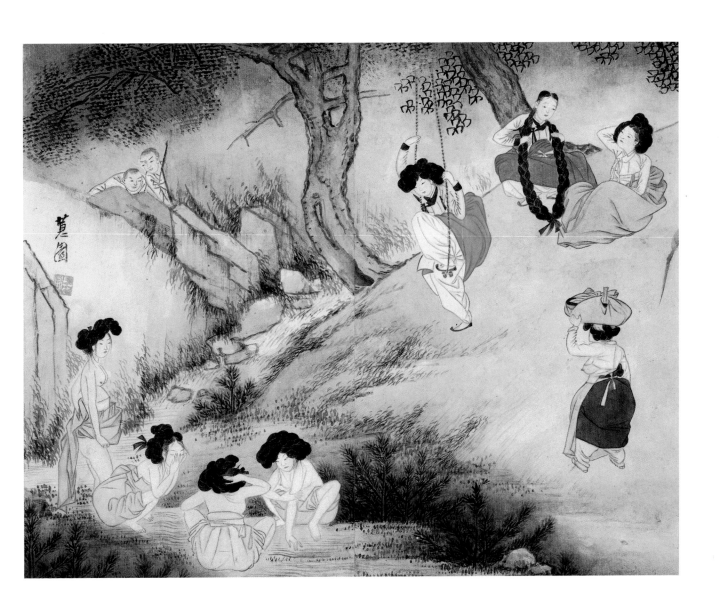

90. WOMEN ON DANO DAY
Late Chosŏn
Sin Yunbok (b. 1758)
Album leaf; ink and light color on paper
11⅛ x 13⅞ in (28.3 x 35.2 cm)
Kansong Art Museum, Seoul
Treasure no. 135

92. A COURTESAN (*KISAENG*)
About 1805
Sin Yunbok (b. 1758)
Album leaf; ink and light color on silk
11⅛ x 7½ in (28.4 x 19.0 cm)
National Museum of Korea, Seoul

93. WOMAN BY A LOTUS POND
Late Chosŏn
Sin Yunbok (b. 1758)
Album leaf; light color on silk
11¾ x 9¾ in (29.8 x 24.7 cm)
National Museum of Korea, Seoul

94. ROCK, GRASS, AND INSECT
18th century
Sim Sajŏng (1707–69)
Album leaf; ink and light color on paper
11⅛ x 8⅝ in (28.2 x 21.8 cm)
Seoul National University Museum, Seoul

96. WRAPPING CLOTH FOR BEDDING (*IBULPO*)
Late Chosŏn
Hemp
56¼ x 55⅛ in (143.0 x 140.0 cm); tying strings, 84¼ in, 57 in,
and 37⅜ in (214.0 cm, 145.0 cm, and 95.0 cm)
Huh Dong Hwa Collection, Seoul

97. WRAPPING CLOTH (*CHOGAKPO*) WITH
 FOUR TYING STRINGS
 Late Chosŏn
 Hemp
 35⅜ x 37⅜ in (90.0 x 95.0 cm); tying strings,
 approx. 35⅜ in (90 cm)
 Huh Dong Hwa Collection, Seoul

98. WRAPPING CLOTH (*CHOGAKPO*)
 Late Chosŏn
 Ramie
 28 x 28 in (71.0 x 71.0 cm)
 Huh Dong Hwa Collection, Seoul

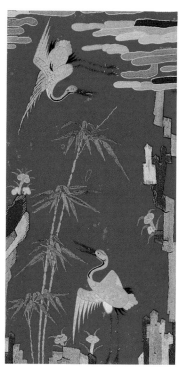
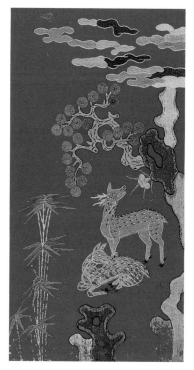

99. TEN LONGEVITY SYMBOLS
Late Chosŏn
Eight-fold screen; embroidery on silk
54⅝ x 134⅜ in (138.8 x 341.2 cm)
Huh Dong Hwa Collection, Seoul

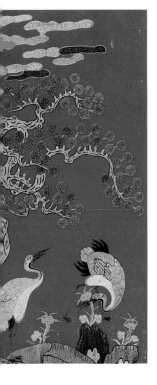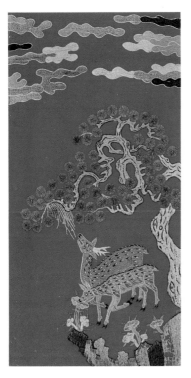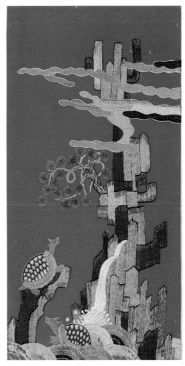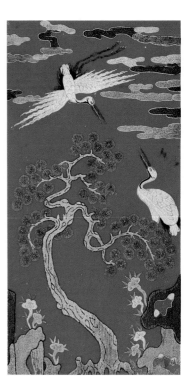

PAGE 178

99. TEN LONGEVITY SYMBOLS (Detail)

PAGE 179

100. PORTRAIT OF OH JAESUN
1791
Attributed to Lee Myongki (active late 18th-early 19th
century)
Hanging scroll; color on silk
59⅞ x 35¼ in (152.0 x 89.6 cm)
Kwŏn Ok-yŏn Collection, Seoul

177

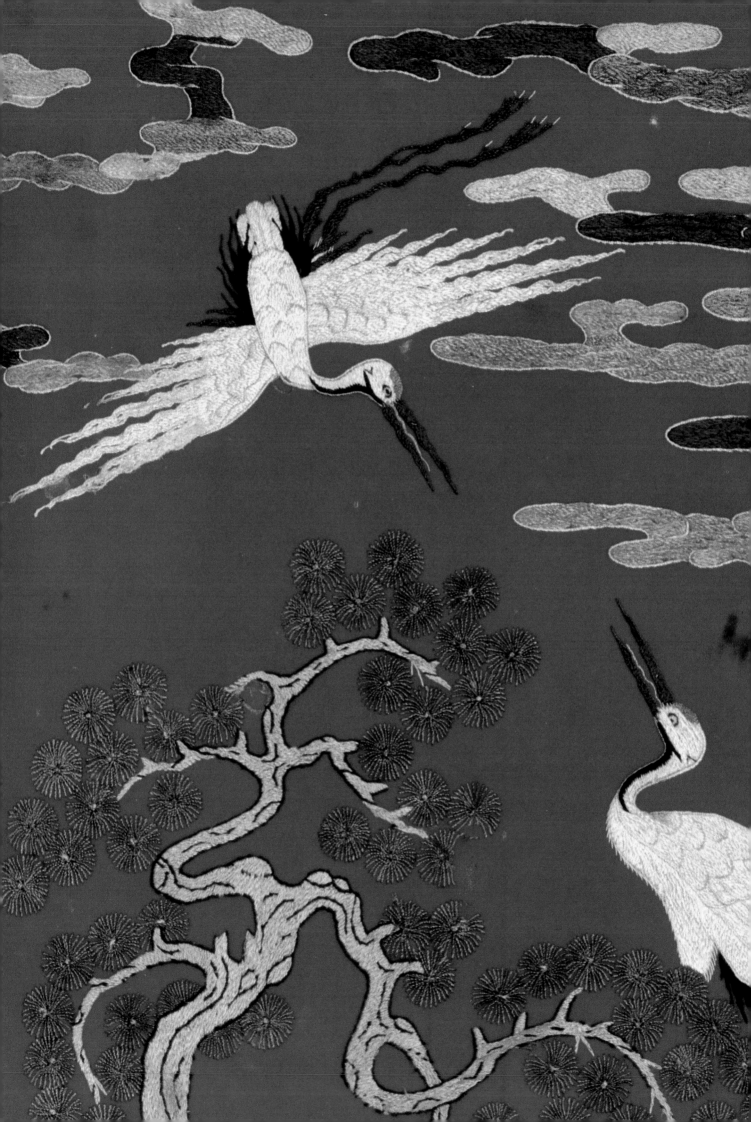

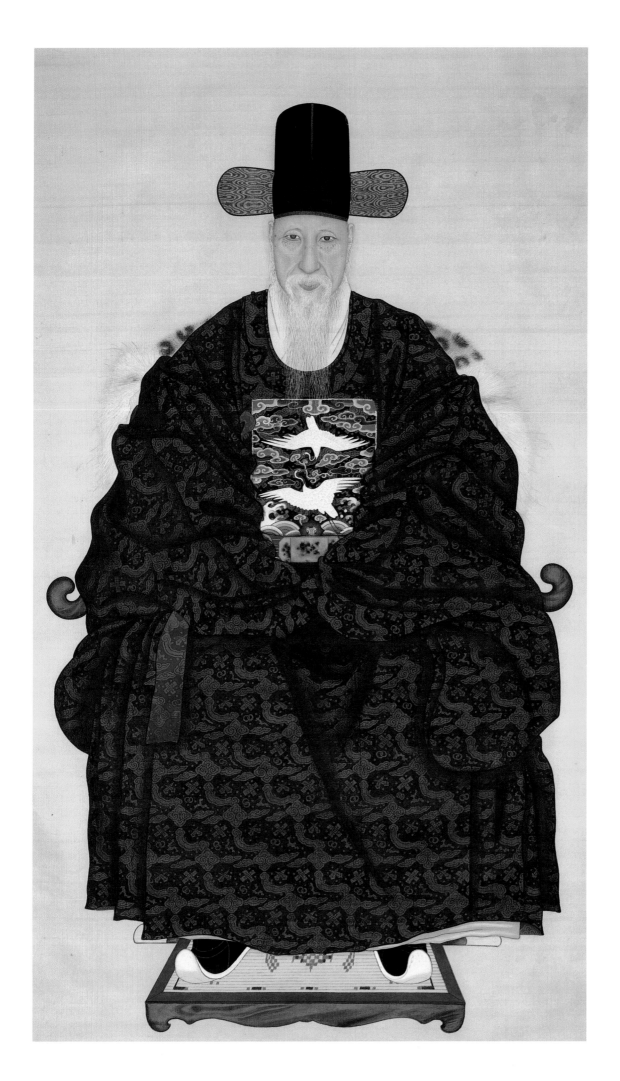

101. HIGH ALTAR CHAIR
Late Chosŏn
Wood
49⅛ x 24⅜ x 14 in (126.5 x 62.0 x 35.5 cm)
Onyang Folk Museum, Onyang

102. TABLE FOR MEMORIAL SERVICE
Late Chosŏn
Wood
31⅛ x 40⅜ x 31 in (79.8 x 102.5 x 78.9 cm)
Onyang Folk Museum, Onyang

103. Table for Incense Burner
Late Chosŏn
Wood
18¼ x 18⅛ x 12¼ in (46.4 x 46.0 x 31.0 cm)
Onyang Folk Museum, Onyang

105. Memorial Tablet Case
Late Chosŏn
Wood
23⅞ x 21¾ x 14⅛ in (60.8 x 55.2 x 35.8 cr
Lee Wŏn-ki Collection, Seoul

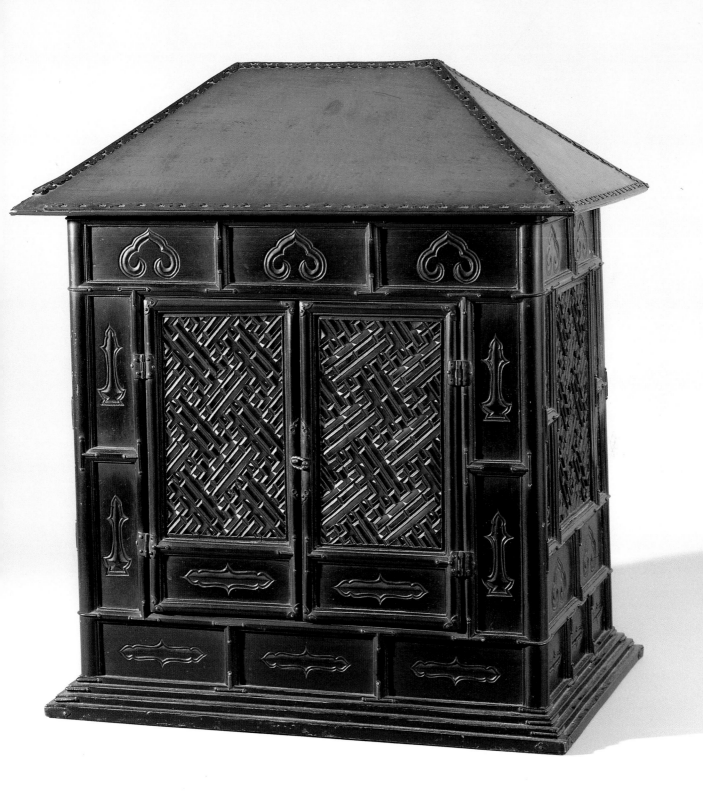

106. INCENSE BURNER
 18th century
 Porcelain
 H. 6½ in (16.4 cm)
 Chŏng So-hyon Collection, Seoul

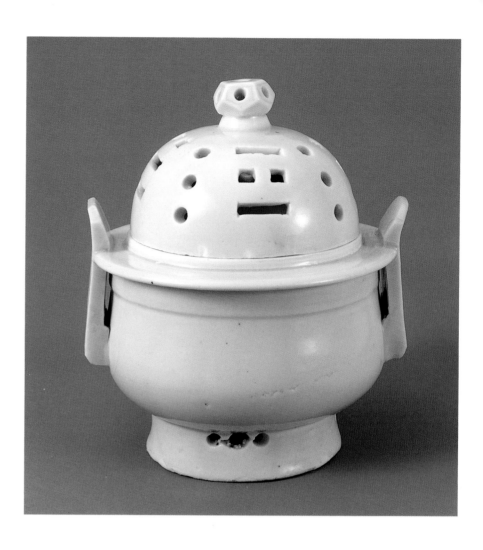

107. INCENSE CASE
 Late Chosŏn
 Porcelain
 H. 4½ in (11.6 cm)
 National Museum of Korea, Seoul

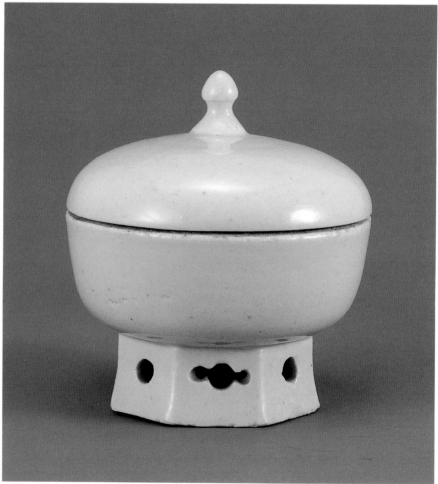

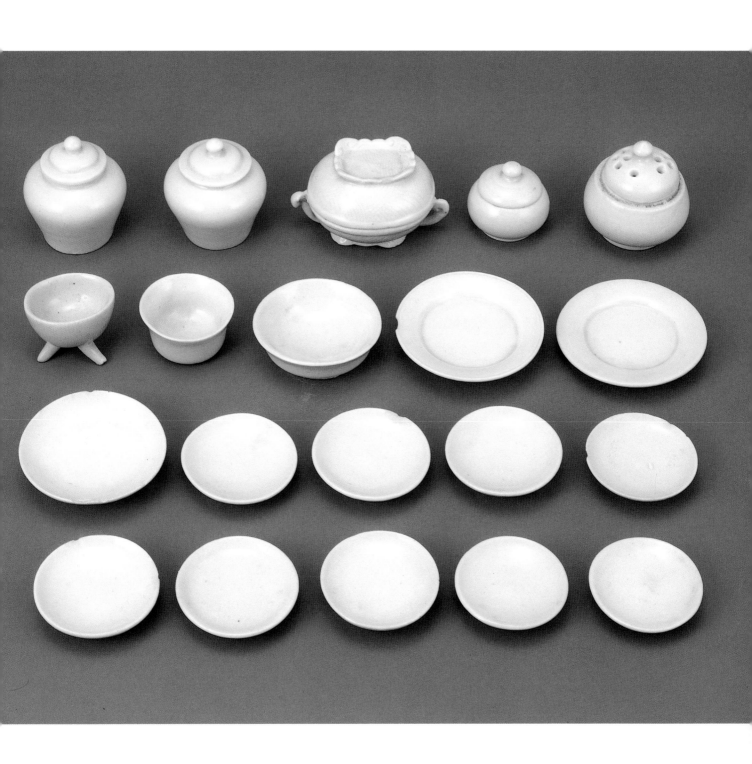

109. FUNERARY VESSELS
About 1764
Porcelain
Set of twenty vessels; largest, H. 2⅜ in (6.1 cm)
Yŏnsei University Museum, Seoul

110. EPITAPH TABLETS
Dated 1764
Porcelain painted with underglaze blue
Five pieces, each, 7½ x 6 x ⅜ in (19.1 x 15.1 x 1.6 cm)
Yŏnsei University Museum, Seoul

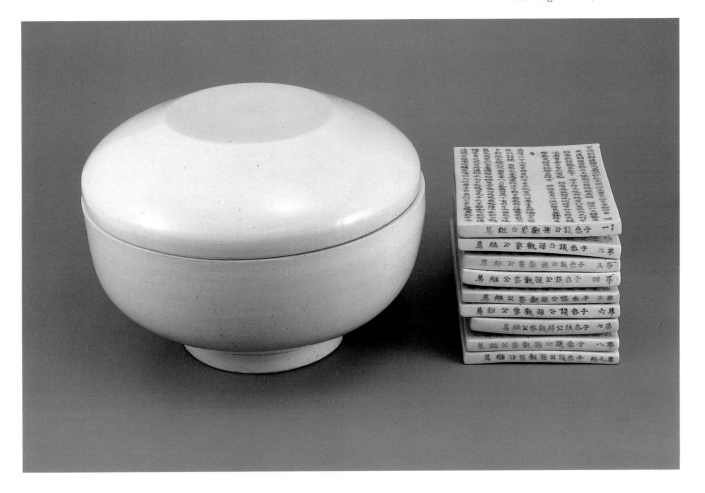

御製暎嬪李氏墓誌
暎嬪李氏即子後庭也本全義父贈賛
成榆蕃祖通訓英任曾祖學生正立外
祖學生金佑宗本漢陽生於丙子七月
十八日六歳入闕丙午初封淑儀又封
貴人伊後進封暎嬪女官極品也有一

111. EPITAPH TABLETS AND CONTAINER
Dated 1710
Tablets
Porcelain painted with underglaze blue
Nine pieces, each, 7⅝ x 5¼ x ⅜ in
(19.5 x 14.5 x 1.1 cm)
Container
Porcelain
D. 12½ in (31.9 cm)
Hae-kang Museum, Ich'ŏn

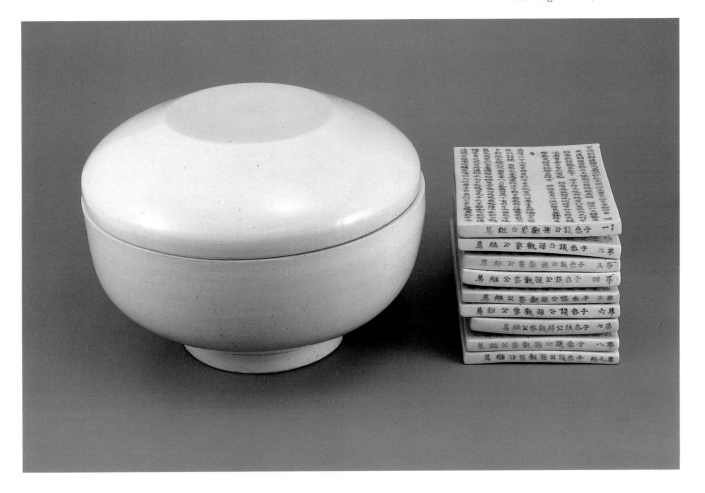

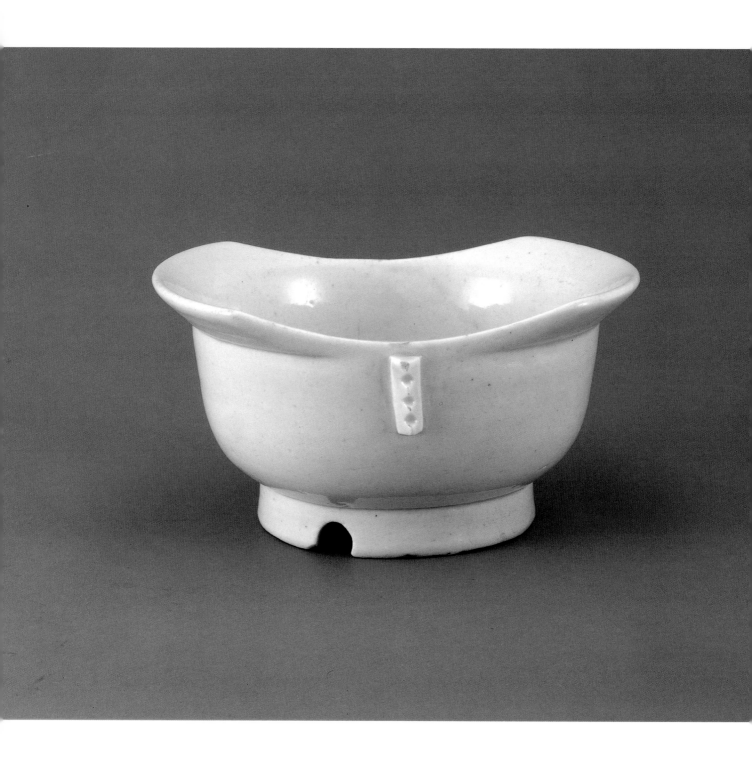

112. RITUAL DISH
Late Chosŏn
Porcelain
H. 3⅛ in (7.9 cm)
National Museum of Korea, Seoul

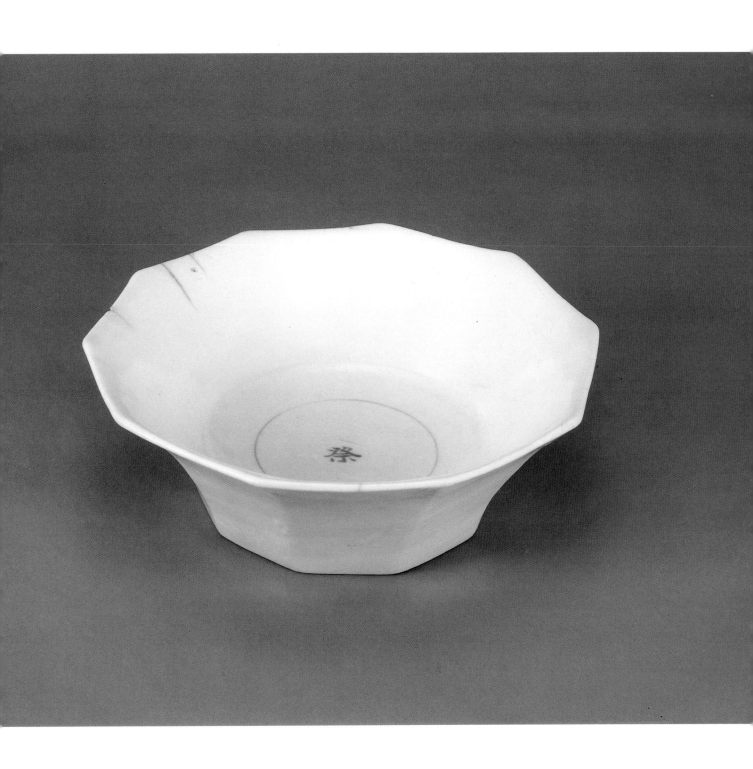

113. RITUAL DISH
 18th century
 Porcelain painted with underglaze blue
 D. 7⅜ in (18.7 cm)
 National Museum of Korea, Seoul

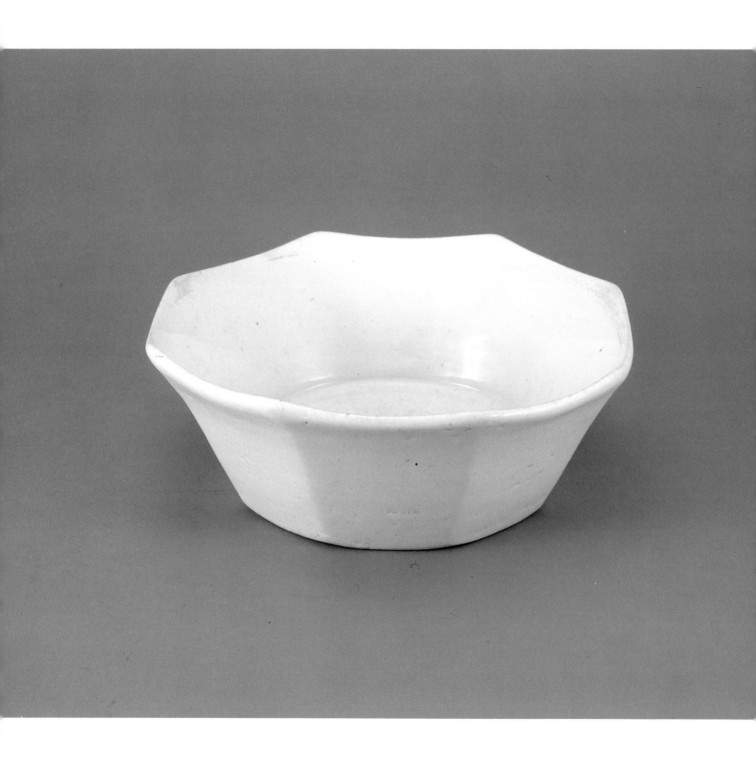

114. RITUAL DISH
18th century
Porcelain
D. 7¼ in (18.3 cm)
National Museum of Korea, Seoul

115. RITUAL DISH
18th century
Porcelain painted with underglaze blue
H. 3⅛ in (7.9 cm), W. 8¾ in (22.2 cm)
Chŏng Kap-bong Collection, Seoul

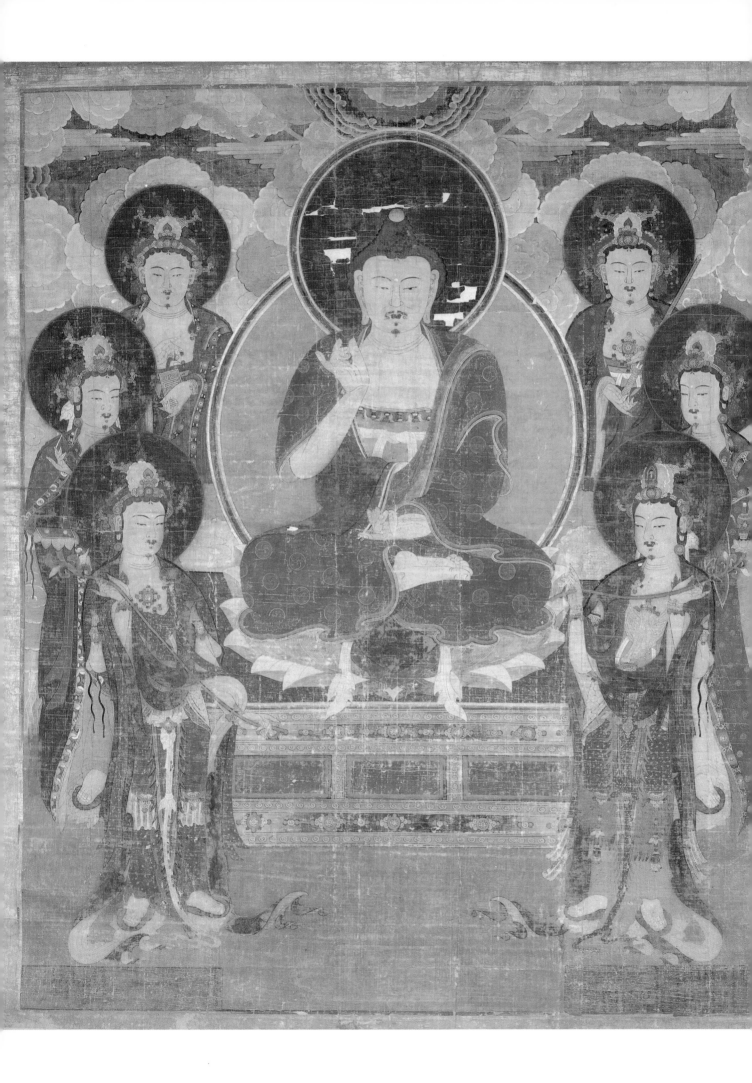

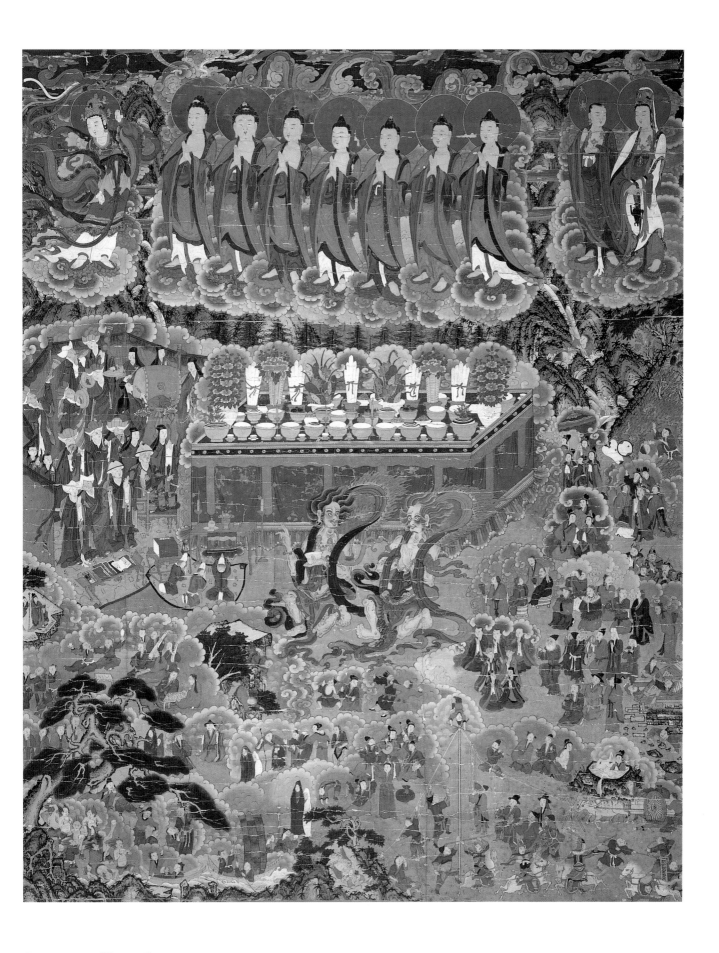

17. Assembly at the Western Paradise
 Dated 1703
 Hanging banner; color on silk
 120¾ x 99¼ in (306.8 x 253.3 cm)
 National Museum of Korea, Seoul

118. Nectar Ritual Painting
 Dated 1759
 Hanging banner; color on silk
 89¾ x 71⅝ in (228.0 x 182.0 cm)
 Ho-Am Art Museum, Yongin

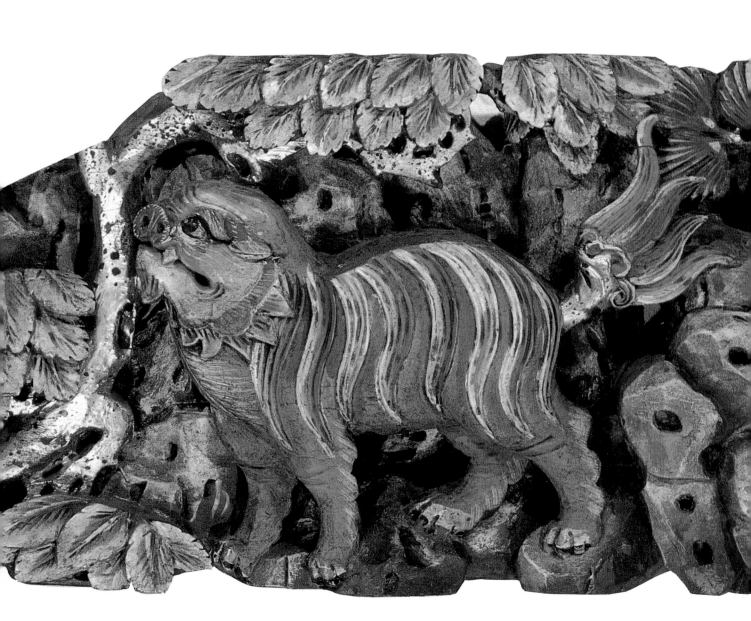

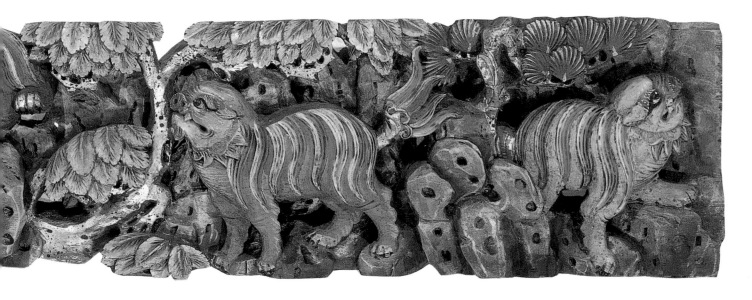

119. BUDDHIST ALTAR ORNAMENT
Late Chosŏn
Painted wood
9 x 59½ x 3¾ in (23.0 x 151.1 x 9.5 cm)
Lee Wŏn-ki Collection, Seoul

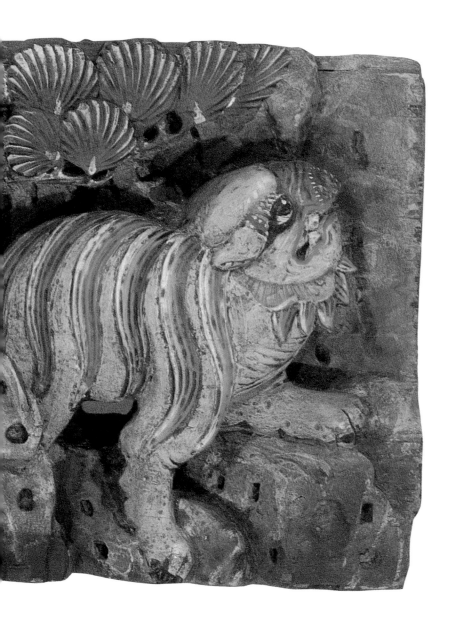

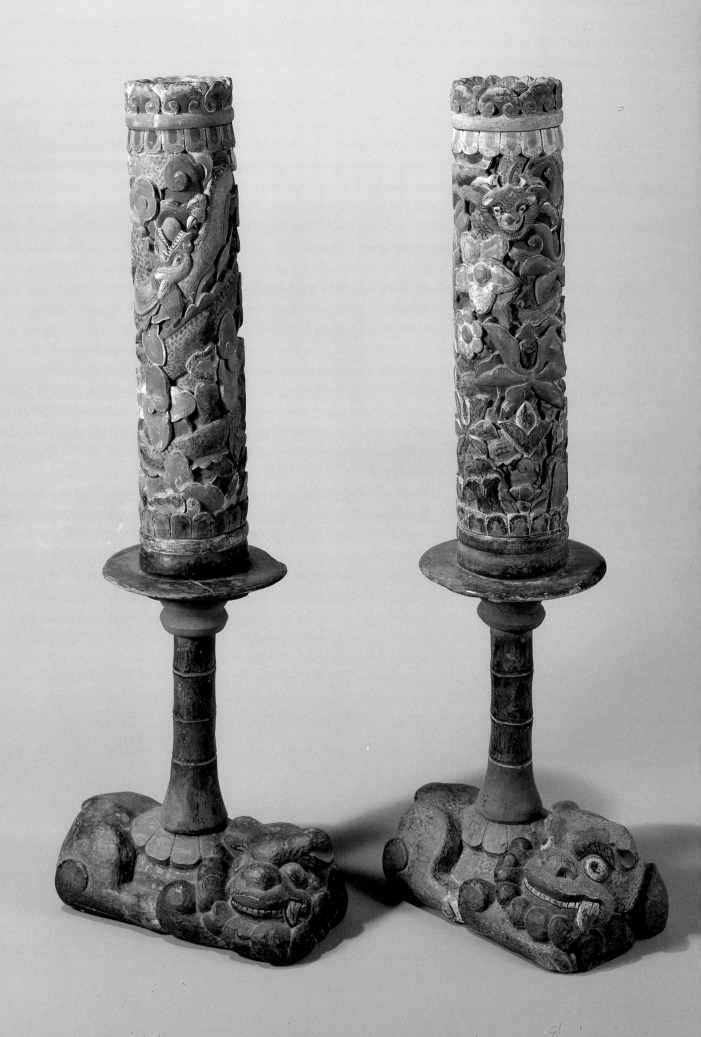

1. PAIR OF CANDLESTICKS
 Late Chosŏn
 Painted wood
 Each, H. 39¼ in (99.6 cm)
 Onyang Folk Museum, Onyang

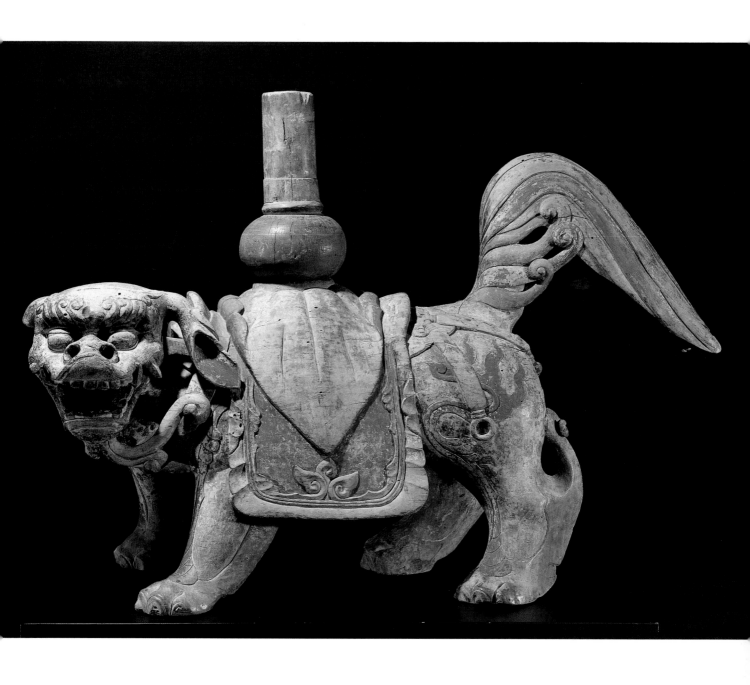

120. DRUM STAND
 Late Chosŏn
 Painted wood
 36⅝ x 54⅜ x 22 in (93.0 x 138.0 x 56.0 cm)
 Ho-Am Art Museum, Yongin

PAGE 198
123. PORTRAIT OF THE MONK SŎSAN DAESA
 Probably 18th century
 Hanging scroll; color on silk
 50⅛ x 31 in (127.3 x 78.7 cm)
 National Museum of Korea, Seoul

PAGE 199
124. PORTRAIT OF A MONK
 Late Chosŏn
 Hanging scroll; color and ink on silk
 45⅛ x 31⅜ in (114.7 x 79.7 cm)
 Cleveland Museum of Art, Mr. and Mrs. William H. Marlatt
 Fund, 90.16

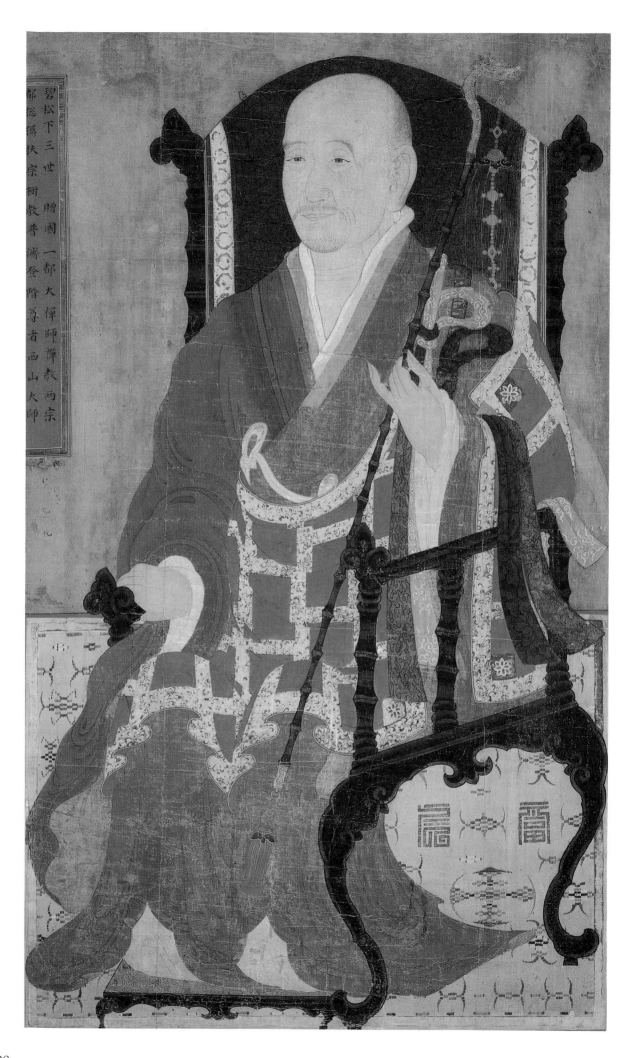

碧松下三世　贈國一都大禪師禪教兩宗
都總攝扶宗樹教普濟登階尊者西山大師

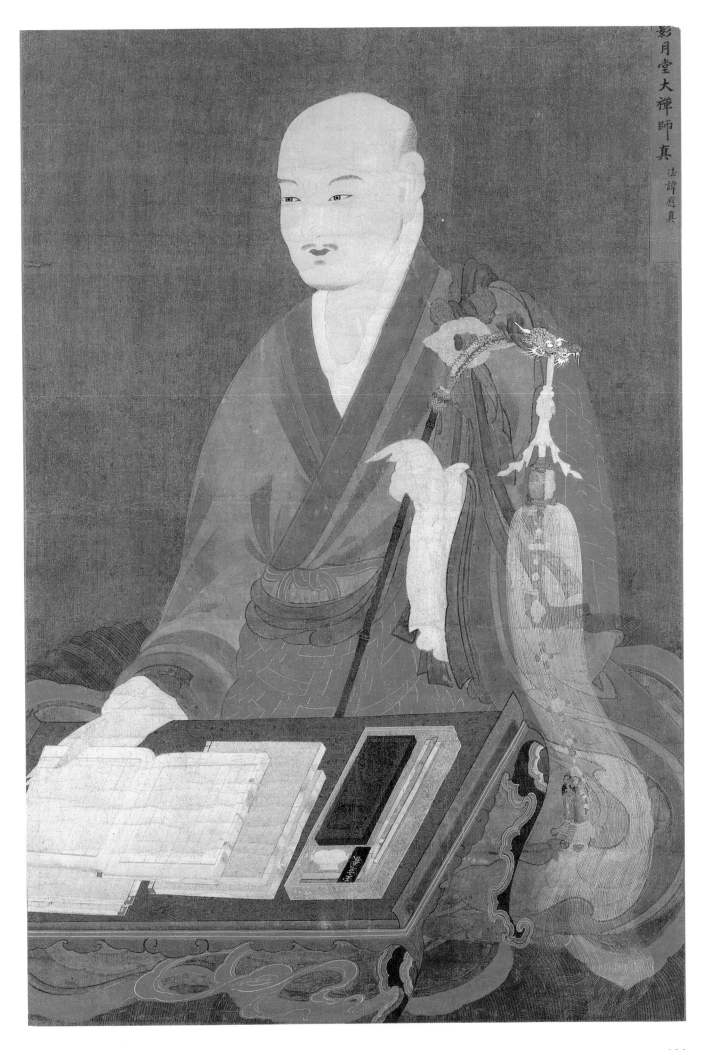

影月堂大禪師眞 法諱應眞

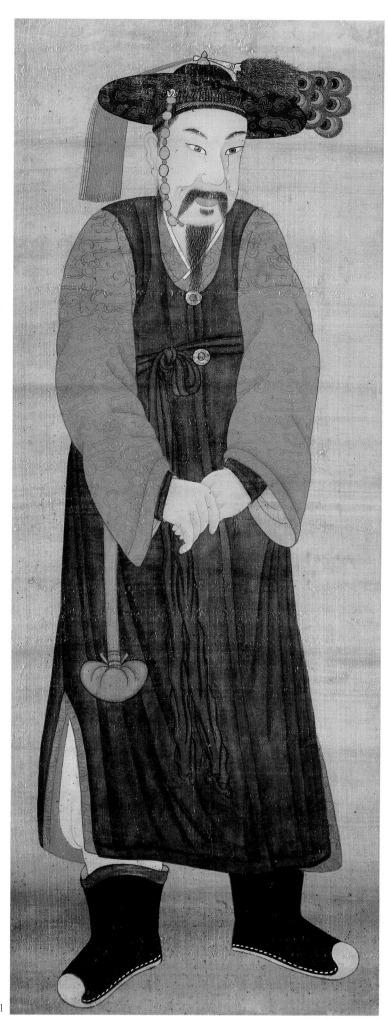

125. Portrait of a General
Late Chosŏn
Hanging scroll; color on silk
36¾ x 14⅜ in (93.3 x 36.4 cm)
National Museum of Korea, Seoul

200

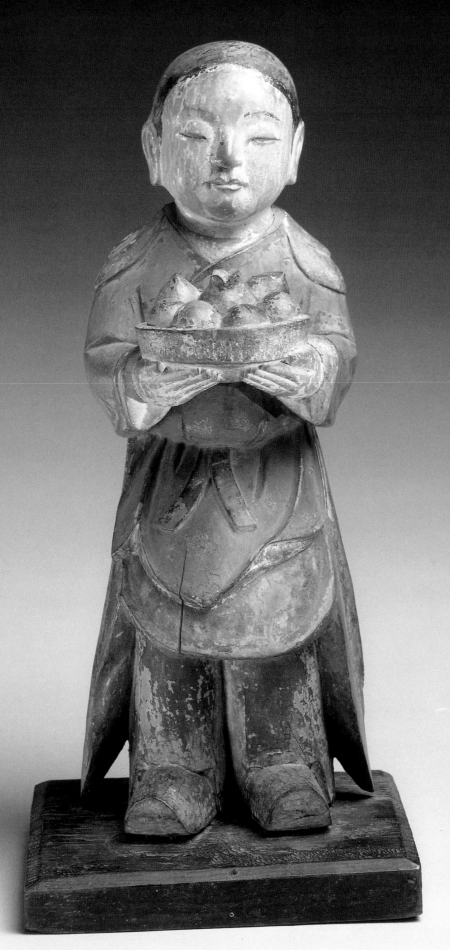

126. BOY ATTENDANT
Late Chosŏn
Painted wood
H. 13¼ in (33.6 cm)
Philadelphia Museum of Art, Purchased through Morris Fund

Checklist of the Exhibition with Selected Entries

AUTHORS OF ENTRIES

Cho Sunmie CS

Chung Yang Mo CYM

Hong Sun Pyo HSP

Kang Woo-bang KWB

Hongnam Kim HK

Park Young Kyu PYK

Yi Sŏng Mi YSM

NOTE

As the style of many types of artworks, particularly those produced for the court, remained virtually unchanged after the eighteenth century, some later works have been included when eighteenth-century examples were not extant or available for exhibition.

1. SUN, MOON, AND FIVE PEAKS

Late Chosŏn
Six-fold screen; color on silk
77¼ x 141¼ in (196.2 x 360.0 cm)
Ch'angdŏk Palace, Seoul

Traditionally placed behind the thrones of Chosŏn rulers, the Sun, Moon, and Five Peaks screen was the most crucial signifying element of the king as the nexus between the earthly and heavenly realms. As he sat on the throne, the king became the pivot of a balanced universe.

The screen format, called *pyongp'ung* (Ch. *pingfeng*, J. *byōbu*), is a significant archaic feature of Chosŏn court painting; it is among the oldest painting formats in the history of China, Japan, and Korea. In China, terminology referring to a type of screen painting called *fuyi* (literally, "a screen of axes"), which was used to symbolize the Son of Heaven, appears in the *Book of Rituals and Ceremonies* (datable to the late Zhou dynasty). Etymologically, the character *pyong* refers to an altar or worship before an altar, thus suggesting the screen's function as an altarpiece for ritual and worship in an ancient theocracy. In a Korean pictorial representation datable to the fifth century, a royal couple is seated in front of a screen; the screen format was probably introduced through the Han Colonies. The earliest written evidence for the use of a Sun, Moon, and Five Peaks screen in the Chosŏn palace dates from the mid-seventeenth century, although it could have been used earlier, as the Chosŏn court tried to establish an identity distinguishable from that of the Koryŏ court.

More than twenty examples of the Sun, Moon, and Five Peaks screen are extant, mostly in folding screen format. None bear artists' signatures; many generations of copies, to be used exclusively for ritualistic purposes at the court, were produced through the collective efforts of court painters.

Of the painting's many emblematic layers, the cosmological symbolism based on the Theory of Yin, Yang, and the Five Elements is undoubtedly most significant. This screen features the archetypal composition of the universe manifested in a highly formalized landscape setting. The sun and moon, portrayed in full disk above, symbolize the two opposing forces of yang and yin, the positive and negative, coming to rest in perfect equilibrium. Below are five peaks, representing the five elements, from which two waterfalls cascade into a pool of billowing waves. The movement of the waterfalls and waves may symbolize the constant churning of the five elements in creating the phenomenal world. The composition is closed off on both sides by two lush pine trees. The so-called red-and-blue color scheme of the painting is based

on the "five colors," further reinforcing the correspondence with the cosmological Theory of the Five Elements.

REFERENCES

Agency for Protection of Cultural Properties. *Kungjung yumul torok (An Illustrated Catalogue of Palace Relics)*. Seoul, 1986.

Han, Mi-ri. "Il-wol-o'ak-do ae kwanhan yŏngu—hyonjon Il-wol-o'ak-do rul chungsim uro" (A Study of the Painting of the Sun, the Moon, and the Five Peaks Based on the Extant Works). Master's thesis, Sŏng-sin Women's University, Seoul, 1983.

Son, Kwang-song. "Il-wol-o'ak-do ae taehan yŏngu" (A Study of the Painting of the Sun, the Moon, and the Five Peaks). Master's thesis, Dongguk University, Seoul, 1986.

HK

2. ALBUM COMMEMORATING THE GATHERING OF THE ELDER STATESMEN

1719–20
Kim Chinyŏ, Chang Dŭkman, Pak Dongbo
Album; color and ink on silk
17¼ x 26⅝ in (43.9 x 67.6 cm)
Ho-Am Art Museum, Yongin

The subject of this album and the next item, no. 3, is *kiro* (*ki*, "the age of sixty"; *ro*, "the age of seventy") gatherings. The greatest honor a scholar official could achieve was to become a *kiro*, and only a few distinguished persons over the age of seventy were permitted to join the Kiroso (the official agency for *kiro*), which held gatherings intended to strengthen friendships. *Kiro* gatherings originated during the Tang dynasty (618–906), and were introduced in Korea during the Koryŏ dynasty (918–1392). The Kiroso was established during the Chosŏn dynasty.

This album, which was produced to commemorate the sixtieth birthday of King Sukchong, depicts *kiro* gatherings held on April 17 and 18, 1719. Its fifty pages include a preface, a poem by His Majesty, scenes of banquet ceremonies, portraits of *kiros*, and a directory of members and their written works. Five banquet and ceremonial ritual scenes, meticulously drawn in dark colors, depict the participants and events. These are scenes of the enshrinement of poems by the king; the dedication of congratulatory poems to King Sukchong in front of Sŭngjŏngwŏn (the royal secretariat); the royal grant of silver cups to *kiros* at a banquet held by the king; the return to the Kiroso with the silver cups; and an additional, private *kiro* gathering held the next day. These scenes provide valuable information about eighteenth-century fashion, court customs, music, and dance.

The album also includes valuable portraits of ten *kiros*, including Hwanghŭm and Kanghyŭn. Records show that an eleventh *kiro*, who had to return to the countryside and could not sit for a portrait, also attended the ceremony. Kim Chinyŏ, Pak Dongbo, and Chang Dŭkman, who were among the most distinguished portrait painters and had been commissioned to paint the king's portraits, were selected to produce these works as well.

The sitters are presented with an almost full frontal view of the body and facing either fully front or to the right, which maintains uniformity. The *kiros* wear black *samos* (silk winged hats) and green *danryongs* (official robes for courtiers). *Hyungbaes* (the embroidered patches on the breast and back of the *danryong*) reflect the rank of the sitters before their retirement and elevation to the rank of *kiro*.

Though the drapery folds are unnaturally uniform, individual differences are represented in the angle of each of the sitter's shoulders and the posture of his folded arms. The painters' main efforts, however, were directed toward depicting facial features. In most cases, the sitter's complexion was first rendered using a brownish-yellow tone; then, by increasing the density of the brushstrokes, the painters replicated the relief of the facial structure. This style of portraiture is typical of the early eighteenth century.

CS

3. ALBUM COMMEMORATING THE GATHERING OF THE ELDER STATESMEN
1748
Album; color and ink on silk
17⅛ x 26⅞ in (43.5 x 67.8 cm)
National Museum of Korea, Seoul

4. DIAGRAM FOR RITUALS AT THE ANCESTRAL TEMPLE
Late Chosŏn
Eight-fold screen; ink and color on silk
71¼ x 169⅞ in (180.9 x 431.0 cm)
The Royal Museum, Seoul

Even though it has been repeatedly remodeled since 1395, the Ancestral Temple (Chongmyo or Jong-myo), featured on this screen, still stands on its original site, in a secluded garden that once adjoined the Ch'angdŏk Palace. Inside are nineteen cubicles, each of which is devoted to a significant Chosŏn king and his queen or queens, starting with the dynastic founder in the extreme left cubicle and ending with the twenty-seventh king. Three eighteenth-century kings—Sukchong, Yŏngjo, and

Chŏngjo—are enshrined here. Unlike the royal portrait shrines, the Ancestral Temple enshrined spirit tablets only.

The upper half of each panel of this screen consists of an illustration and the lower half of a lengthy inscription. The first panel on the right exhibits a full view of the main compound of the temple, the Chŏng-jŏn, and provides information on the geography of the entire temple complex, the names of all buildings within the compound, the interior details, as well as the manner by which each of its seventeen shrines were set up, along with a list of items enshrined. The second panel provides similar information for the detached secondary compound that houses fourteen shrines, the Yongnyong-jŏn. The third illustrates and explains the personal inspection of the ritual vessels and the offerings for the five annual sacrifices by the king, who would be accompanied by his retinue. The fourth is concerned with two different types of offerings: the tea ceremony on the first and fifteenth of each lunar month and an auspicious day of each season as well as the offering ceremony of newly harvested grains and fruit. The fifth panel illuminates a sacrificial procedure that requires the royal person to kneel, touching the ground with his forehead. The sixth illustrates and explains the layout of the ritual vessels on altar tables. The seventh charts all sorts of musical instruments, ritual dances, and ritual dress for the king and performers. The eighth panel elucidates a type of ceremony that entailed bestowing posthumous titles upon the deceased, as well as its detailed procedure.

REFERENCES

Kim, Dong-wook. *Chongmyo wa Sajik-dan (The Royal Ancestral Shrine and the Altar of Soil and Grain)*. Seoul: Daewon-sa, 1990.

Lee, Kyong-mee. "Chongmyong konch'uk ae kuanhayo" (A Study of the Royal Ancestral Shrine). Master's thesis, Ewha Women's University, Seoul, 1989.

HK

5. SEAL OF KING YŎNGJO
1776
Gold-plated tin
3⅛ x 3¾ x 4⅞ in (7.9 x 9.7 x 12.4 cm)
Jong-myo, Seoul

This is one of several seals that belonged to King Yŏngjo (r. 1724–76). Royal seals were usually made of green jade, gold-plated tin, or sometimes crystal. The upper part is a replica of a tortoise, around which is looped a tasseled red cord tied loosely in a *maedŭp* knot.

The legend on the seal reads: *Ingmun sŏnmu hŭigyŏng hyŏnhyo taewangjibo*, which

can be translated as "The seal of the great king who promoted culture, propagated military virtue, illuminated reverence, and displayed filial piety." This title was posthumously bestowed upon King Yŏngjo by his grandson, King Chŏngjo (r. 1776–1800), upon the latter's ascension to the throne in March 1776. The last character of the seal's legend, *po* ("treasure"), is interchangeable with the character *sae* ("royal seal"). However, the character *po* is preferred because the pronunciation of the character *sae* in Chinese is close to that of the character *sa* ("death").

The seal is carved in relief in *mujŏn*, which is a type of seal script with meandering strokes that are used to fill the square space of a large seal face.

REFERENCES

Chŏngjo sillok (Veritable Records of King Chŏngjo) 1, in Committee on Compilation of National History. *Chosŏn wangjo sillok (Veritable Records of the Chosŏn Dynasty)*. Seoul, 1955–58.

The National Museum of Folklore. *Han'gugŭi injang (Korean Seals)*. Seoul: Samhwa Book Co., 1987.

YSM

6. SEAL BOX WITH DOUBLE-DRAGON DESIGN
Probably late 19th-early 20th century
Sharkskin coated with lacquer and painted with gold; brass inner box
9¾ x 9 x 9 in (25.0 x 22.9 x 23.1 cm)
Inner box, 6¼ x 6⅛ x 6⅛ in (15.90 x 15.6 x 15.7 cm)
The Royal Museum, Seoul

This seal box (*inhap* or *twiung'i*) is the second in a series of three containers designed for protecting a royal seal. Because such a seal was a symbol of royal status, it was impeccably stored. It was first placed into a smaller, more simply designed metal box (*int'ong*), shown in the illustration. The more elaborate outer box was used for both additional protection and to signify authority and was, in turn, placed into one of two identical, slightly larger protective cases (*hogap*), connected to each other by a metal loop handle. The twin container held the red-ink paste used for impressing the seal.

This box is constructed of pine, and the entire surface is covered with a layer of sharkskin, which is lacquered in red. On all four sides, there are drawings in gold dust of a pair of dragons—the symbol of royalty. Their heads turn toward each other in confrontation.

The upper half of the lid has four slanting sides and a flat, square top, making the box resemble an Egyptian mastaba. A

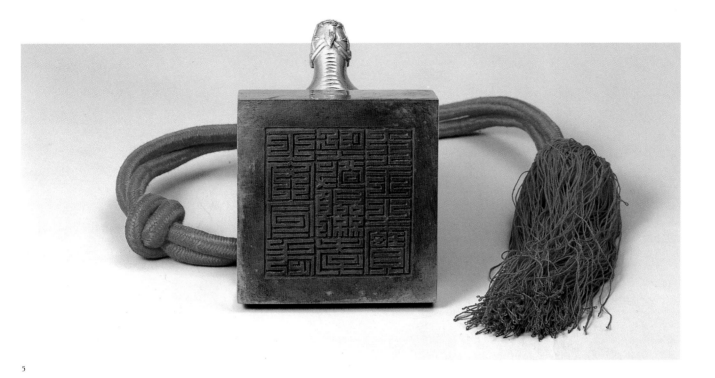

5

small, twelve-sided metal knob on a floral-shaped base is in the center of the flat top. Decorative metal sheets cover all four vertical corners; on the horizontal corners are flat metal strips that terminate in lotus-bud shapes. On the front of the box is a hasp for a now missing lock. On either side are metal ring handles to which a sash could be tied. The abundance of hardware makes this box appear to be tightly constructed.

In the numerous *Karye togam uigwae* (*Records of the Royal Wedding Ceremonies of the Chosŏn Period*), there are detailed descriptions of these containers and instructions for their construction. According to these records, however, none of the seal boxes has the dragon-pair motif that appears on this box. Only in the 1906 records does the dragon motif appear on seal boxes and other boxes for ceremonial objects. Therefore, it seems that the motif began to be used after the Chosŏn kingdom declared itself an empire in 1897, and this box probably was made during the late nineteenth or early twentieth century.

REFERENCES

Agency for Protection of Cultural Properties. *Kungjung yumul torok (An Illustrated Catalogue of Palace Relics)*. Seoul, 1986.

Karye togam uigwae (Records of the Royal Wedding Ceremonies of the Chosŏn Period). Manuscripts, 1759, 1769, 1802, 1837, 1866, 1882, and 1906. Kyujanggak Library of Seoul National University, Seoul; Changsŏgak Library of the Academy of Korean Studies, Sŏngnam.

YSM

7. ROYAL PROCESSION TO THE CITY OF HWASŎNG

Late Chosŏn
Handscroll; color and ink on paper
19¾ x 1,811 in (50.3 x 4600.0 cm)
National Museum of Korea, Seoul

Perhaps the most celebrated ceremonial events of the eighteenth-century Chosŏn court were King Chŏngjo's visits to his father's tomb in Hwasŏng (present-day Suwŏn, south of Seoul). Chŏngjo's father, Crown Prince Sado, met a tragic death under the order of his own father, King Yŏngjo. As Chŏngjo ascended the throne, he bestowed the posthumous title of Crown Prince Changhŏn on his father and a new honorific title on his living mother. He moved his father's tomb to an elaborate mausoleum that he built in Hwasŏng in 1789. Thereafter, he made annual visits to Hwasŏng until he died in 1800. Of the twelve, the 1795 visit, upon which he was accompanied by his aged mother, Hyegyŏnggung Hongssi, was the grandest, since it coincided with his mother's sixtieth year.

A special project office to organize the 1795 visit was established two years in advance. This was followed by the founding of an office to prepare illustrated records of rituals (*uigwae*) after the completion of the event. The *uigwae* for Chŏngjo's Hwasŏng visits took the form of hand-produced books, woodblock prints, and painted screens. This scroll was done by hand. Such documentary paintings were often produced in multiple copies, at times printed with woodblocks and finished off by hand. *Royal Visit to the City of Hwasŏng* (no. 8) is from another set of paintings commemorating this particular visit, while *Record of the Construction of the Royal City at Hwasŏng* (no.

9) celebrates another of King Chŏngjo's Hwasŏng projects.

This long handscroll, which was originally a book-format illustration, depicts the king and his mother accompanied by a retinue of more than 6,100 people and 1,400 horses. The sheer number of figures, horses, and paraphernalia engendered a fair amount of repetition. Yet, monotony has been avoided by the depiction of various postures and a wide spectrum of physical attributes. Details and walking postures are rendered in a concise, decisive manner, indicating the involvement of high-level figure painters from the Bureau of Painting.

REFERENCES

Agency for Protection of Cultural Properties. *Kungjung yumul torok (An Illustrated Catalogue of Palace Relics)*. Seoul, 1986.

Park, Pyong-son. *Chosŏn cho ŭi uigwae (Ritual Records of the Chosŏn Dynasty)*. Sŏngnam: The Academy of Korean Studies, 1985.

HK

8. ROYAL VISIT TO THE CITY OF HWASŎNG

1790
Eight-fold screen; color and ink on silk
84⅞ x 240½ in (215.5 x 610.8 cm)
National Museum of Korea, Seoul

This sumptuous screen illustrates eight commemorative events that took place during the 1795 visit of King Chŏngjo to his father's mausoleum (see previous entry). Starting from the right, they are: the visit to the Confucian shrine at Hwasŏng, the taking of the special civil and military examination,

the banquet in honor of Chŏngjo's mother at Long Life Hall (Pongsu-dang), the reception for the elders at Hall of South-of-Han-River (Nak'nam-hon), the military drill at West General Fort (Sojang-dae), nighttime military training by torchlight, the return procession to Seoul by way of the countryside, and the crossing of the Han River via the pontoon bridge.

All details are superbly rendered with individual touches and the sense of humor that was typical of contemporaneous genre painting. There is an unmistakable touch of "true-view" naturalism in the depiction of particular scenery. Therefore, it is not surprising to find the name of Kim Dŭksin (1754–1822), a leading court painter famous outside of the court for his genre scenes (see nos. 86 and 87), included in the official record that lists the group of artists responsible for this series of paintings. There is an increased sense of depth but not so great as to divert focus from the subject matter. This sense of space frees the subject from the flat picture plane and places the activity of the figures in their surroundings. With its superb rendering of landscape and architectural backgrounds, this painting set the standard for the Chosŏn uigwae-do ("illustrations for the records of rituals") tradition. Three complete versions of the screen and one partial one are extant, all eighteenth-century originals.

When the king wished to commemorate special events by means beyond the uigwae-do of a documentary nature, he appointed court painters to render the best scenes of any given event in albums, handscrolls, hanging scrolls, or folding screens to be distributed among appropriate palace buildings. In addition to direct royal commissions, such paintings were also customarily commissioned and collectively financed for presentation to the king by government officials involved in a given project. Folding screens appear to have been the most popular painting format for both aesthetic and practical reasons during and following the eighteenth century; this idea is supported by written records and extant objects. In fact, such screens provide the most vivid evidence of the solemnity, majesty, and florid style of Chosŏn rituals.

REFERENCES

Lee, Hong-yul. "Suwŏn nonghaengdo ae kwanhayo" (On the Royal Visit to the Suwŏn Mausoleum). Kogo misul (Archaeology and Art), no. 95 (1968).

Park, Jong-hye. "A Study of a Screen Painting, Suwŏn Nunhaeng-do Pyong." Misulsa yŏn'gu (Korean Journal of Art History), no. 189 (March 1991).

HK

9. RECORD OF THE CONSTRUCTION OF THE ROYAL CITY AT HWASŎNG

1801
Printed by the order of King Chŏngjo
Printed book, nine volumes; ink on paper
Volume 1, 13⅜ x 8¾ x 1¼ in
(34.1 x 22.2 x 3.3 cm)
Changsŏgak Collection, The Academy of Korean Studies, Sŏngnam

This work documents another of King Chŏngjo's Hwasŏng activities (see nos. 7 and 8). Hoping to retire near his father's tomb with his widowed mother, Chŏngjo made the city the southern capital. A special office for this project, which was unsurpassed in scale and expense during the eighteenth century, was formed. Construction began in the first lunar month of the eighteenth year of King Chŏngjo's reign (1794) and ended in the eighth lunar month of the twentieth year (1796). This book is the first of a nine-volume, fully illustrated record, one of the important uigwae of the period, providing all related information in minute detail, including a statement of purpose of the construction, all royal decrees and edicts, governmental correspondence, a daily record of the construction work, lists of participating offices, names of officers and workers as well as their awards, all related rituals and ceremonies held, along with illustrations for all types of walls and buildings, construction materials, machinery, and tools. It was published in limited editions in 1801, one year after the king's death. The pages illustrated here show an overview of the inside of the Gate of Eight Directions (P'aldal-mun), the main southern gate of the city.

The book set a high standard for printing technology. It is considered to be an important source of information for scholarly research on scientific knowledge of the period and the state administration of construction projects. It is also used as a primary source by socioeconomic historians.

REFERENCES

The Academy of Korean Studies. Han'guk minjok munhwa taebaekkwa sajŏn (Encyclopedia of Korean Culture), s.v. "Record for the Construction of the City of Hwasŏng." Seoul: Samhwa Publishing Co., 1992.

Yang, Yun-sik. "Hwasŏng yong'gon ae kwanhan yŏngu—Hwasŏng songyuk uigwae ae natanan konch'uk saengsan ch'aejae rul chungsim uro" (A Study of the Construction of Hwasŏng Castle through the Analysis of the Hwasŏng-songyuk-ūkwe). Master's thesis, Seoul National University, Seoul, 1989.

HK

10. JADE BOOK FOR KING CHANGJO

1795
Jade with gold, metal and cloth binding
9⅞ x 99⅛ in (25.2 x 251.8 cm)
The Royal Museum, Seoul

A "jade book" (okch'aek) is a series of flat pieces of jadeite placed side by side, in groups of five or seven, bound on the top and bottom by metal strips and nails in a form resembling that of the ancient Chinese bamboo book (compare no. 11). Jade books were used to record royal edicts upon the investiture of kings, crown princes, and royal consorts or upon the endowment of higher or posthumous royal titles. The text is inscribed in regular script and contains eulogistic remarks about the newly titled person.

King Changjo (1735–62) is the highest posthumous title bestowed upon the second son of King Yŏngjo, who was the father of King Chŏngjo. Better known in Korean history as Sado Seja, "Crown Prince Sado," he was crowned prince when he was only two years old, upon the death of his elder brother in 1736. Later, however, he incurred the king's wrath by leading a life unsuitable for a crown prince. King Yŏngjo finally locked him up in a large, wooden storage container for rice (twiju), where he was starved to death. Yŏngjo later regretted his cruelty and posthumously bestowed upon his son the title Sado, which means "thinking of one in grief." The tragic life and death of Crown Prince Sado was recorded by his wife, Hyegyŏnggung Hongssi. This account is the famous literary piece Hanjung rok.

Upon accession to the throne in 1776, King Chŏngjo conferred the title Crown Prince Changhŏn on his father, Crown Prince Sado. This jade book of seventy pieces of stone was made in 1795 when King Chŏngjo bestowed an additional title, which consists of eight characters, upon his father.

REFERENCES

Agency for Protection of Cultural Properties. Kungjung yumul torok (An Illustrated Catalogue of Palace Relics). Seoul, 1986.

Han'guk inmyŏng taesajŏn (Dictionary of Korean Biography). Seoul: Shingu munhwa-sa, 1980.

YSM

11. BAMBOO BOOK FOR CROWN PRINCE ŬISO

1752
Bamboo with gold, metal binding
9⅞ x 41⅜ in (25.2 x 105.0 cm)
The Royal Museum, Seoul

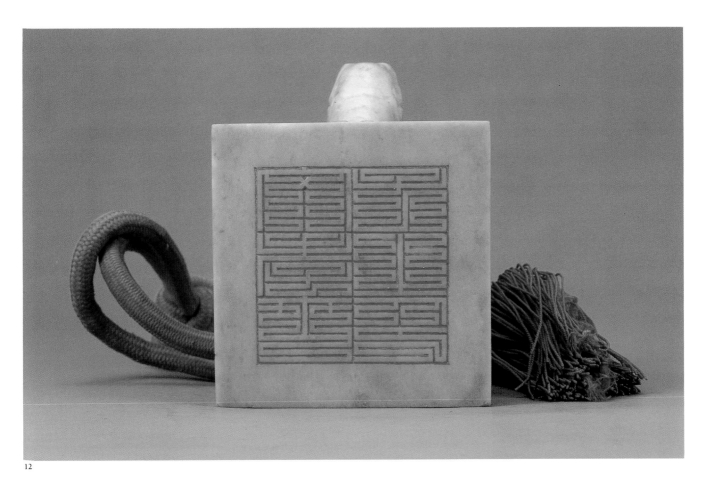

12

12. SEAL OF CROWN PRINCE MUNHYO

Probably 1786
Jade
3⅞ x 4¼ x 3¾ in (9.9 x 12.2 x 9.7 cm)
The Royal Museum, Seoul

Crown Prince Munhyo (1782–86) was the first son of King Chŏngjo, born of his concubine Sŏng Ŭibin. He died when he was only four years old, and King Chŏngjo posthumously bestowed upon him the title of Munhyo Seja, Crown Prince Munhyo, in 1786, on the occasion of the tenth anniversary of the king's coronation. This seal seems to have been made for that occasion.

The seal is carved in relief in the *mujŏn* seal script, a style usually employed in carving official seals, which is characterized by meandering strokes that create mazelike lines to fill the square space of the large seal face. There are two vertical rows of three characters each, reading *Munhyo sejaji in*, "the seal of Crown Prince Munhyo."

The upper part of the seal is a replica of a tortoise, which was a common design for royal seals. A decorative red cord terminating in a thick tassel is looped around the tortoise and is tied in a loose *maedŭp* knot.

REFERENCES

Agency for Protection of Cultural Properties. *Kungjung yumul torok (An Illustrated Catalogue of Palace Relics)*. Seoul, 1986.

Chŏngjo sillok (Veritable Records of King Chŏngjo) 14 (Sept. 1782) and 21 (May 1786), in Committee on Compilation of National History. *Chosŏn wangjo sillok (Veritable Records of the Chosŏn Dynasty)*. Seoul, 1955–58.

YSM

13. CASE FOR GOLD BOOK

1786
Lacquered wood painted with gold
10 x 10½ x 12⅝ in
(25.4 x 26.7 x 32.1 cm)
The Royal Museum, Seoul

This handsome box was made to store the gold book (*kŭmch'aek*) of Crown Prince Munhyo (1782–86). He was given the title posthumously by his father, King Chŏngjo, on the tenth anniversary of the king's coronation in 1786. When a member of the royal family was awarded a title posthumously, it was customary to have a gold book made in order to record the eulogy. At the same time, a seal inscribed with the new title was carved, and boxes were made to store these newly crafted royal objects. This box, therefore, can be dated to 1786, when the title of Crown Prince Munhyo was bestowed.

A gold book is made of sheets of gold-plated tin placed side by side and bound on the sides by two silk cords. This box is made of pine and is lacquered in black. The motifs of the four gentlemen—plum, orchid, chrysanthemum, and bamboo—on the sides of the box are painted in gold dust. A cloud dragon (*unyong-mun*) occupies the center of the lid, and on each of the four corners there is a phoenix. On the front hangs a hasp for the now missing padlock.

REFERENCE

Agency for Protection of Cultural Properties. *Kungjung yumul torok (An Illustrated Catalogue of Palace Relics)*. Seoul, 1986.

YSM

14. THE SEVEN STARS

Late Chosŏn
Color, gold leaf, and ink on silk
28 x 94¾ in (71.2 x 240.8 cm)
Onyang Folk Museum, Onyang

This painting of the Seven Stars, or the Big Dipper (*Ursa Major*), features seven large disks of gold leaf and two tiny gold disks branching from the fourth star from the left,

all united by crimson lines on a dark blue ground. A long inscription in standard script on the far right has not been deciphered. Although the painting's origin and production date will remain uncertain until the inscription is read, it is undoubtedly a work of court art, considering its fine quality and manner of execution, the use of gold and crimson, its extraordinary scale, and the prominent location of the orderly formation of vertical text columns inscribed in disciplined standard script. The purity of concept and form is striking: the luminous golden disks appear on a single, flat picture plane, at once iconic, luxurious, and decorative.

In ancient Korea, the North Pole was believed to be the center of the earth, and the Big Dipper, shining against the dark sky, was seen as the pivot of Heaven, controlling its mysteries and making the celestial sphere revolve around it. Worship of the Big Dipper had been established by the seventh century as an integral part of Korean Shamanism (both official and private), religious Daoism, and Buddhism, under the continuous influence of the evolving cult in China. During the Chosŏn period, a large number of Buddhist and Shamanist paintings representing the seven corresponding Buddhas or shaman figures were produced, and shrines devoted to the Seven Stars were built independently or at various temples.

Given the presence of a depiction of the Big Dipper, along with the sun and the moon, on a wall behind the throne hall at the Ch'angdŏk Palace, we cannot completely exclude the possibility that this iconic painting could have originally come from a Chosŏn palace hall. It may well have been an icon used for Daoist or Shamanic rituals practiced unofficially on behalf of the Chosŏn royal family. Tradition has it that this painting was used by the shamans of Seoul for a ritual performed on behalf of the last king of Korea, Sunjong (1874–1926; r. 1907–10), to exorcise evil spirits and to pray for his long life.

Although one source refers to the development of a nine-star cult in the late Chosŏn period, it fails to clarify the names and symbolism of the two small stars. The character of the cult itself remains unclear and awaits further study.

REFERENCES

Ch'a, Chae-son. "Chosŏn cho ch'ilsong pulhwa ŭi yŏngu" (Seven-star Buddhist Paintings of the Chosŏn Dynasty). *Kogo misul* (*Archaeology and Art*), no. 186 (1990).

Lee, Yong-bum. "Popjusa sojang ŭi sinbup ch'onmun dosol ae taehayo" (On the New Astronomical Chart in the Collection of the Popju Temple). *Yoksa hakbo* (*Historical Studies*), no. 31 (August 1966).

McCune, Evelyn B. *The Inner Art: Korean Screens*. Berkeley and Seoul: Asia Humanities Press and Po Chin Chai Co., Ltd., 1983.

HK

15. MAP OF THE CAPITAL CITY

Late Chosŏn
Color and ink on paper
51 x 40¼ in (129.5 x 103.5 cm)
Ho-Am Art Museum, Yongin

Among the largest extant maps of the mid-eighteenth century Chosŏn capital, Hanyang (present-day Seoul), this map represents the city as viewed from south to north. Produced for administrative purposes by the government, it includes all surrounding mountains, city gates, waterways, avenues and streets, districts, villages, palaces, state temples and shrines, and major government offices, some of which are depicted with some degree of realism and labeled with their names while others are represented by their names only. The large, tree-filled, walled-in compounds in the upper half are the two major palaces of the dynasty. On the left is Kyŏngbok Palace, built in 1395, and on the right, Ch'angdŏk Palace, built in 1405 as the eastern detached palace. The latter is connected to the Ancestral Temple of the royal Yi family (Chongmyo) to its south, and another Chosŏn detached building (Ch'angkyŏng Palace, built in 1484) adjoins the temple on the east. To the west of Kyŏngbok Palace stands a walled-in compound of the Altar of Soil and Grain (Sajik-dan), one of the first buildings to have been built after the new capital was founded. The main Kyŏngbok Palace stood in the northern center of the city under the geomantically auspicious Mount Pukhan, flanked by the Ancestral Temple and the Altar of Soil and Grain; all three face south.

A ten-mile wall with nine city gates was constructed, and the four main gates are at the cardinal points. Along the main avenue, on the north-south axis from Kyŏngbok Palace stood orderly rows of government buildings, including the Office of Three Consuls and six ministries on both sides, ending where the avenue met an east-west crossroad leading to the market toward the east. Right outside of the main city gates, particularly the eastern and southern, bustling markets gradually developed. Not only in layout but also in architecture, Confucian ethics and morality were manifested with the highest standard of architectural workmanship and formality.

In this map, the depiction of the northern mountains is based on natural observation, and the surface treatment entailed the extensive use of texture strokes. Four different viewpoints were used to render the four quarters of the city, an archaistic convention of court painting, which requires the rotation of the map for reading.

REFERENCES

Huh, Young-hwan. *Seoul ŭi kochido* (*Old Maps of Seoul*). Seoul: Samsung Publishing Co., 1989.

Seoul yukpaek nyun sa (*Six Hundred Years of Seoul*). Seoul: City of Seoul, 1992.

HK

16. SUNDIAL

Late Chosŏn
Bronze with silver inlay
D. 9½ in (24.2 cm)
Sŏng-sin Women's University Museum, Seoul

This sundial type is named *angbu ilgu* or *angbu ilyong*, both of which literally mean "shadow of the sun on a legged cauldron." According to the *Veritable Records of the Chosŏn Dynasty*, this type of sundial was invented in 1434 by the country's foremost scientist, Chang Yongsil, by the order of Sejong (r. 1418–50), the fourth Chosŏn king. Although there were other types of sundials—flat and standing—mostly made of stone, this is by far the most elegant and refined, although it may not be the most accurate. During Sejong's reign, a sundial was installed within the palace Office of Astronomy and two large ones were placed on the main avenues. By the eighteenth century, a large number of them seem to have been produced and placed at various locations inside and outside the palaces.

This example was cast in bronze and coated in black lacquer pigment. The inscription around the rim and all lines in the concave portion were incised after the metal cooled and then inlaid with silver strips. Within the bowl are the so-called shadow-point (its tip is oriented from south to north), twelve main vertical lines to mark time, and thirteen horizontal lines (perpendicular to the angle of the shadow point) to mark seasons. The twelve main vertical lines increase where they crisscross the thirteen seasonal lines to divide one hour into four quarters.

The inscription identifies the position of the capital city, where this instrument was to be set up, at an angle relative to the Seven Stars (Big Dipper) that corresponds to 37.39"15', the present-day calculation of the latitude of Seoul. Since this calculation of angle replaced an earlier measure of 37.20" in 1713, this sundial certainly dates from no earlier than that year; it is probably an eighteenth-century product.

REFERENCES

The Academy of Korean Studies. *Han'guk minjok munhwa taebaekkwa sajŏn (Encyclopedia of Korean Culture)*, s.v. "Sundial." Seoul: Samhwa Publishing Co., 1992.

Agency for Protection of Cultural Properties. *Kungjung yumul torok (An Illustrated Catalogue of Palace Relics)*. Seoul, 1986.

HK

17. BASE FOR SUNDIAL

18th century
Stone
34¼ x 14⅜ x 14⅜ in
(87.0 x 36.5 x 36.5 cm)
Ch'angkyŏng Palace, Seoul

18. TEN LONGEVITY SYMBOLS

Late Chosŏn
Ten-fold screen; color on silk
98¾ x 232⅞ in (250.8 x 591.4 cm)
Ho-Am Art Museum, Yongin

This painting makes a pointed reference to a land of immortals where one finds the ten auspicious symbols, which originated in the Daoist cult of immortality. The red sun, auspicious clouds, and immortal cranes are depicted against the golden sky in the upper part of the picture. The other immortality symbols—the mountains, water, rocks, pines, fungus, deer, and turtles—occupy the lower portion.

Although all motifs are drawn with a linear clarity and there is little atmospheric effect, the painting exhibits a certain sense of spatial depth, internal unity, and naturalism that allows the viewer to discern each motif's individual nature. Painted in luminous mineral pigments of red, golden-yellow, white, silver-gray, and blue-green, the setting appears to be otherworldly, a divine realm of mineral luxury.

Because of their magical efficacy, the ten longevity emblems naturally enjoyed tremendous popularity in all strata of Chosŏn society. They appear in all the Chosŏn decorative arts, including ceramics, paintings, furniture, and architectural details. Although the Daoist immortality cult and its iconography, including these ten symbols, were developed in China during the Han dynasty (206 B.C.E.–220 C.E.), this particular grouping of ten in a single work appears to have been unique to Korea.

REFERENCE

Ho-Am Art Museum. *Minhwa koljakjon (Masterpieces of Folk Painting)*. Seoul, 1983.

HK

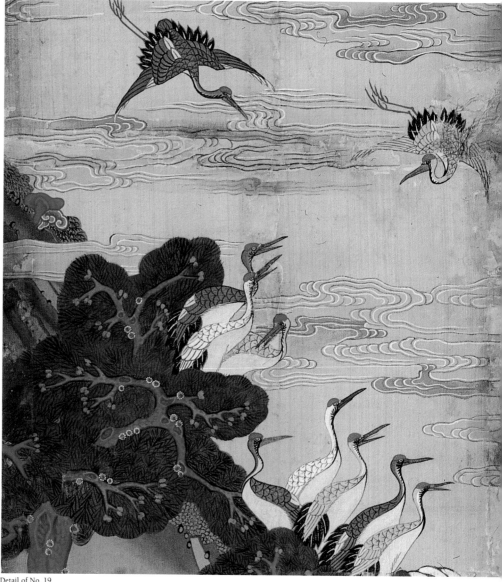

Detail of No. 19

19. LONGEVITY SYMBOLS WITH CRANES

Late Chosŏn
Four-panel sliding door; color on silk
57 x 363¾ in (144.7 x 924.0 cm)
Ch'angdŏk Palace, Seoul

This painting from the late Chosŏn period was used to embellish a four-paneled closet door in a Chosŏn palace. Everyday wear and tear is visible on the leather handles and along the edges of the frequently used inside panels. These two panels have octagonal lattice windows covered with the traditional translucent white paper for both aesthetic reasons and for practical lighting purposes. The octagonal windows strike an interesting contrast to the richly painted surface of mineral colors, fine lines, and meticulous details.

The painting is a variation of the longevity theme. Of the ten longevity symbols (see no. 18), only the deer and mountains are missing. This land of

immortality is devoid of human figures, as is usually the case in such longevity screens. Most prominently featured are nineteen cranes, in contrast to another popular variation that highlights deer. The bird was firmly established as a symbol of immortality in the Daoist pantheon of spirits and deities during the Han dynasty of China. This picture features the black and the yellow Manchurian crane. (Additional varieties are the white and the blue.)

Nearly as decorative as Japanese gold screens, the composition is dominated by the expanse of luminous sky, while all earthbound elements are compressed into the extreme bottom and lower corners. This resulted in a considerably lowered horizon and required a bold cropping of the bottom portion of the composition. The sky is covered by auspicious clouds outlined in black ink and painted in golden yellow and silver-gray tinged with light pink. The large,

red disk of the setting sun is partly veiled by clouds. Silhouetted against this seemingly unlimited luminous space are the seventeen cranes, gracefully posed in flight or perched on the pine trees. A black crane and a yellow crane stand between the red trunks of the pine trees in the left corner. Above, other cranes perform a dance of eternal joy. Below, six handsome turtles playfully ride the waves. Cinnabar reds are used for the sun, the tree trunks, the birds' crests, the fungus, and the turtles. The rocks and pine needles are painted in greens and blues of malachite-azurite, while the soft earth is painted in golden yellow. The lustrous mineral white accentuates the waves and the sun.

Highly refined contour lines effectively and elegantly describe and support forms with a great degree of precision. The clouds seem to be moving rather than static. The curvilinear rhythms of their movement not only imbue the forms with a sense of life but also emphasize their own aesthetic presence. These clouds and the immortal cranes merge in harmony, signifying their divine nature and characterizing a supernatural realm. The painting represents the best of the decorative arts tradition of the Chosŏn court and is reminiscent of some of the great mural paintings from the Koguryŏ tombs of the Three Kingdoms period (57 B.C.E.–668 C.E.).

REFERENCES

Agency for Protection of Cultural Properties. *Kungjung yumul torok (An Illustrated Catalogue of Palace Relics)*. Seoul, 1986.

Williams, C. A. S. *Chinese Symbolism and Art Motifs*. Rutland, VT: Charles E. Tuttle Co., 1989.

HK

20. CHEST

18th century
Wood with red and black lacquer
23¼ x 21 x 12⅞ in
(60.4 x 53.4 x 32.7 cm)
National Museum of Korea, Seoul

21. LANTERN

Late Chosŏn
Wood with red and black lacquer
41⅞ x 12¾ x 12¾ in
(106.4 x 32.5 x 32.4 cm)
National Museum of Korea, Seoul

Several types of traditional lighting devices—candlesticks, oil lamps with ceramic or brass reservoirs, hanging lanterns, and floor lanterns—served various purposes, whether general illumination or lighting a specific area. This example is typical of Chosŏn-period lanterns except

that the silk that would have enclosed it is no longer present. Such lanterns were used to provide reading or sewing light and were usually placed in the corner of a room, where they could provide warmth as well. A candle or oil lamp was placed inside; if more light was needed, the front would be opened to increase its intensity and range.

In the top is a metal plate that contains a cutout, which in this example is in the shape of a swastika. The opening facilitates the circulation of air within the lantern as well as casts the shadow of the cutout form. Often the form would be the character for "Asia" or "happiness," and might be deliberately matched to a character on the door to the room in which the lantern would be placed. On this lantern, lotus designs are carved in the panels above the windows; below are panels with relief-carvings of arabesques and, below them, chrysanthemums. There is a small drawer in front for the storage of small ornamental tools and utensils. A base with four sturdy legs, of a type often seen in Chinese furniture, supports the lantern. The main posts are lacquered in black and the floral designs are lacquered in red, imparting a rich effect and a distinctive imperial dignity.

PYK

22. PEONIES

Late Chosŏn
Four-fold screen; color on silk
106½ x 156 in (270.5 x 396.0 cm)
Ch'angdŏk Palace, Seoul

Probably the best-loved flower at the Chosŏn court, this "flower of riches and honor" appears in all mediums and categories of art, for both ritual and decorative purposes, including architectural ornamentation. Its popularity began in the Koryŏ period (918–1392) and extended to the Buddhist architecture of the late Chosŏn period.

A large number of peony screens was produced at the Chosŏn court as they were a crucial element to such major rituals and ceremonies as weddings and the rites of ancestral worship. This is evidenced by the presence of a peony screen in each of the twelve cubicles at the portrait shrine in the Ch'angdŏk Palace. Customarily a single four-panel folding screen was used for ancestral worship, while a pair of such screens was used for wedding ceremonies. Screens that were not meant to be paired feature unusually wide, tall panels, which is true of those at the Ch'angdŏk portrait shrine and this one.

With its bold motifs and striking graphic stylization, the peony screen is the

most dramatic example of the category of bird and flower paintings. The interlaced manipulation of floral form somewhat corresponds to the stroke manipulation found in the type of Chinese paleography called tangled-seal (*miuzhuan*) script, the talismanic efficacy of which has allowed its survival in both China and Korea. The totemlike column of peonies is repeated at the same scale and height on each panel of a screen, whether one of four panels or one of a pair of four-fold screens.

REFERENCE

Agency for Protection of Cultural Properties. *Kungjung yumul torok (An Illustrated Catalogue of Palace Relics)*. Seoul, 1986.

HK

23. SUN, MOON, AND IMMORTAL PEACHES

Late Chosŏn
Pair of four-fold screens; color on silk
Each, 130 x 107⅞ in (330.3 x 273.4 cm)
The Royal Museum, Seoul

The picture plane is composed of eight tall panels. A great expanse of deep blue-green water with billowing waves occupies more than half of the picture. Above and beyond the horizon on the right are the white disklike moon and a group of distant mountain peaks; in perfect symmetry on the left are the red disklike sun and a group of distant mountain peaks. Rooted in the jagged, angular rocks on the shore in the foreground is an equally symmetrical pair of peach trees, bearing their immortal fruit at the stage of perfect ripeness. They seem to reach out to each other over an intervening rock, the only singular element in this picture. The horizon line and this centrally positioned rock appear to provide a sense of unity to this otherwise extremely bifurcated composition. Growing all over the rocks is the red *yŏngji* (Ch. *lingzhi*) fungus, basis of an elixir of immortality.

A mysterious world, maintaining an absolute equilibrium of yin and yang forces, a pivot of Heaven and earth, where abundant water and rich minerals nourish fungi and trees producing a life-sustaining elixir, is depicted. This screen thus possesses a magical efficacy to transform the royal palace into a sacred land of eternity and immortality. This is made clear by the screen's pictorial language: the isolation of iconic motifs, the deliberate preclusion of an illusionistic space, the quintessential portrayal of forms, and the use of auspicious mineral colors. Graphic exaggeration, such as the zoomorphic depiction of the waves and foam, is employed to intensify the potency of this scene. Nevertheless, there is

a certain naturalism, particularly in the rendering of the peach trees, the key motif of the picture, as well as in the light-gray shading of the sky around the moon. However, the impossibly perfect state of the fruit underscores its symbolic nature.

The peach had an important place in Chinese and Korean popular beliefs and held high aesthetic appeal. Although a popular emblem of springtime and marriage, it was as a symbol of immortality that it appealed most, and it was frequently portrayed as such in the fine arts.

These audaciously rendered motifs and their exaggerated stylization are as striking as those in the *Sun, Moon, and Five Peaks* screen (no. 1) and closely relate to those in the rest of the longevity screens in this exhibition, which served to create regal authority and were emblematic of heavenly blessings on the dynasty.

This immortality screen was executed at the Bureau of Painting, probably sometime later than the eighteenth century, in faithful adherence to existing models.

REFERENCES

Agency for Protection of Cultural Properties. *Kungjung yumul torok (An Illustrated Catalogue of Palace Relics)*. Seoul, 1986.

Williams, C. A. S. *Chinese Symbolism and Art Motifs*. Rutland, VT: Charles E. Tuttle Co., 1989.

HK

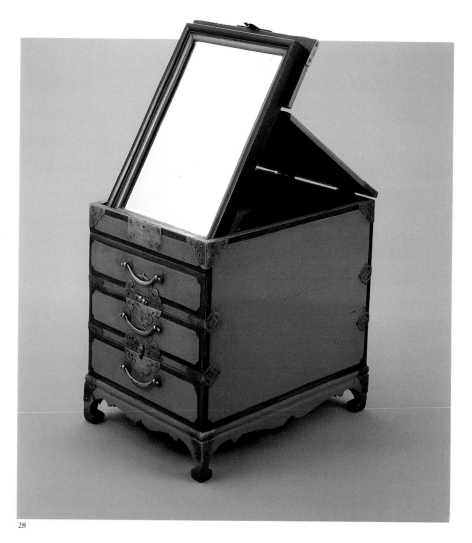

28

24. JAR WITH DRAGON

First half of the 18th century
Porcelain painted with underglaze iron
H. 23⅜ in (59.4 cm)
National Museum of Korea, Seoul

During the Chosŏn period, porcelain jars decorated with dragons, popularly known as dragon jars, were made for the royal family. This is the largest extant iron-brown painted dragon jar from the first half of the eighteenth century. During the seventeenth century (considered the end of the early Chosŏn period), tastes in underglaze-iron-decorated ceramics were changing. A new white clay jar with a clearer glaze and less refined underglaze-iron decoration was becoming more popular toward the beginning of the eighteenth century. The pure white clay, transparent glaze, and style of painting of this jar are exemplary of the middle of the Chosŏn period. The painting of the single dragon amid clouds marks a transition between earlier and later styles. The neck of the jar is surrounded by various decorative patterns, and there are two horizontal lines at the bottom of the painted portion.

CYM

25. JAR WITH DRAGONS

18th century
Porcelain painted with underglaze blue
H. 21½ in (54.6 cm)
National Museum of Korea, Seoul

As royal insignia, dragons are usually emblematic of power and dignity; however, Korean depictions are characterized by a sense of intimacy because the drawing is schematized and lacks detail. The body of this jar has a dragon painted on the front and one on the back. Numerous clouds surround both. Their legs and bodies are fluid, and each plays with a "flaming pearl" among the clouds in a relaxed, blissful manner. The various features of both heads—mane, eyebrows, eyes, horn, and beard—represent dreams, modesty, and children's sensibilities, aspects other than dignity. Various patterns encircle the neck and foot of the jar.

This jar was made with smooth clay, and the glaze, which is clear and clean, is thoroughly melted and crackled over the whole surface. The broad foot lends the jar stability. The shape of the jar, the nature of the pattern, and the color place this jar in the later part of the mid-Chosŏn period. Iron-painted dragon jars were produced less

frequently as the eighteenth century progressed, and blue dragon jars became characteristic of the period.

CYM

26. BOX

18th century
Lacquered wood with mother-of-pearl inlay
4⅛ x 12½ x 12½ in
(10.4 x 31.8 x 31.7 cm)
National Museum of Korea, Seoul

27. CHEST

Late Chosŏn
Painted wood with flattened-ox-horn inlay
6 x 8⅝ x 8⅝ in (15.2 x 21.9 x 21.9 cm)
Florence and Herbert Irving Collection

28. COSMETICS CHEST WITH MIRROR

18th century
Lacquered wood
12 x 12⅞ x 9¼ in (30.6 x 32.1 x 23.4 cm)
Chŏng So-hyon Collection, Seoul

29. Dining Table

18th century
Lacquered wood with mother-of-pearl inlay
H. 10 in (25.5 cm), D. 12½ in (31.7 cm)
Chŏng So-hyon Collection, Seoul

30. Banana Tree

18th century
King Chŏngjo (1752–1800)
Hanging scroll; ink on paper
33¼ x 20¼ in (84.6 x 51.6 cm)
Dongguk University Museum, Seoul
Treasure no. 743

31. Chrysanthemum

18th century
King Chŏngjo (1752–1800)
Hanging scroll; ink on paper
33¼ x 20¼ in (84.6 x 51.6 cm)
Dongguk University Museum, Seoul
Treasure no. 744

King Chŏngjo (1752–1800; r. 1776–1800), the twenty-second king of the Chosŏn dynasty, sought a dynastic revival through a literary movement. He achieved this by establishing a royal research institute called Kyujanggak, which mobilized the publication of scholarly works. A man of simplicity who distanced himself from extravagance at an early age, King Chŏngjo was, to a greater degree than any other Korean monarch, a born scholar and a lover of books. Like other scholars of the time, he pursued painting and calligraphy as hobbies.

The first painting depicts a banana tree in juxtaposition with an oddly shaped stone; the other features chrysanthemums—both being traditional literati subjects. These two works were executed during the king's leisure hours and reflect his cultured tastes. The simple, clean compositions, against plain, spacious backgrounds, along with the unostentatious, unrestrained brushwork and the refined combination of dark and light ink tones exude scholarly cultivation and exemplify literati virtuosity. The elegant figure of the erect banana tree with its large, vital leaves and the natural beauty of the grasshopper perched upon the chrysanthemum demonstrate the king's unaffected, taintless character, which was very much in keeping with that of his fellow scholars. Moreover, these paintings evidence King Chŏngjo's aim to heighten national morale by infusing the public conscience with the spirit of the scholar.

HSP

32. Books and Scholar's Utensils

19th century
Lee Hyŏngrok (b. 1808)
Eight-fold screen; color on paper
79½ x 172½ in (202.0 x 438.2 cm)
Ho-Am Art Museum, Yongin

This eight-fold screen belongs to an extremely popular genre of late Chosŏn decorative painting called *ch'aekkori*, a type of screen painting depicting an array of items from the scholar's studio with traditional cases of books as the main motif. This screen features such standard literati items as books, the "four treasures of the scholar's studio" (brush, paper, inkstone, and inkstick), scrolls of paintings and calligraphy mounted in beautiful embroidery, and an assortment of seals.

Admiration for things Chinese is apparent by the prominent display of painstakingly detailed Chinese porcelains and metal objects, some of which are used here for holding rocks and auspicious flowers and fruit, as well as brushes and scrolls. In reality, such rare, luxurious items were fit only for royalty, indicative of the palatial origin of this genre of painting. In the Confucian-dominated Chosŏn culture, screens showing scholarly paraphernalia had come to symbolize culture and learning and served both aspirational and decorative purposes in the homes of the educated as well as becoming status symbols for all sorts of well-to-do patrons in the eighteenth century. The qualitative variety found among the large number of extant scholar's studio screens suggests that production was executed by artists of varying proficiency—ranging from court painters to folk artists.

By the end of the eighteenth century in Korea, there were a great many variants of this subject. Even though they were produced simultaneously, they are indicative of stylistic evolution. There are four major types (presented in possible order of development). The first type exhibits a separate composition for each panel displaying a limited set of scholar's studio motifs against a neutral background, as was common in comparable Chinese paintings. Each motif is realistically rendered, and motifs are grouped to occupy a section of the painting as a unified whole structurally and spatially. The second type is the same as the first, with repeated motifs placed over a neutral background with little connection to each other and an increased sense of design. This second type was made in many embroidered versions by women. The third type exhibits a much bolder, abstract, and decorative variation of the theme. Like the first two types, each composition for a panel is complete in itself, but each fills the picture plane nearly completely. Stacks of books, colorful and

varied in size and shape, are profusely piled, often askew and in a precarious manner, to form a jagged, mountainlike mass. Other motifs, such as vessels and flowers, are placed at various locations, at times half hidden by books. The fourth is the bookcase type represented by this screen, the development of which was probably contemporaneous with the third. Its composition of a display bookcase spreads across all panels with a close-up view of shelves with bilateral perspectives. Shelves are filled with the aforementioned literati items in a more orderly fashion.

In the last two types, the subject is transformed into one of the most dazzlingly picturesque, decorative, and unique idioms ever created by Chosŏn court artists that included the incredibly bold two-dimensional schematization of forms, the free control of perspectives and viewpoints, the dramatic composition, the graphic juxtaposition of strong flat colors, and the stylistic qualities that seem to have been generated by forces more internal than external. This characterizes the best of eighteenth-nineteenth century Korean decorative painting. It can be said that while China developed the literati art of painting on the level of fine art, Chosŏn Korea managed to create an extraordinarily beautiful equivalent on the level of decorative art.

REFERENCES
Agency for Protection of Cultural Properties. *Kungjung yumul torok (An Illustrated Catalogue of Palace Relics)*. Seoul, 1986.

McCune, Evelyn B. *The Inner Art: Korean Screens*. Berkeley and Seoul: Asia Humanities Press and Po Chin Chai Co., Ltd., 1983.

Moes, Robert. *Auspicious Spirits: Korean Folk Paintings and Related Objects*. Washington, D.C.: The International Exhibitions Foundation, 1983.

HK

33. List of Objects Made for the Wedding of a Crown Prince

Dated 1882
Ink on colored paper
90⅜ x 10⅛ in (229.7 x 25.7 cm)
Changsŏgak Collection, The Academy of Korean Studies, Sŏngnam

This object list was made for the wedding of the crown prince who later became King Sunjong (1874–1926; r. 1907–10), the last king of the Chosŏn dynasty. The date is shown on the reverse side of the scroll as *imo ch'ŏnmanse tonggung mama karyesi*. The cyclical date of the wedding is indicated as

imo, which fell in 1882. The term *tonggung mama* ("Master of the Eastern Palace") refers to the crown prince whose residence, during the Chosŏn period, was in the palace east of the main palace of the king. Another Chosŏn-period royal wedding had taken place during the cyclical year *imo*, which fell in 1702—that of King Sukchong (r. 1674–1720).

The object list includes three sets of dragon rank-badges for the crown prince as well as another set for the bride to wear on her *chŏggŭi* (a ceremonial robe embroidered with peacock patterns). The list also cites two types of pendant ornaments to be worn by the bride—one consisting of small openwork containers for fragrance and another called *norigae*—as well as embroidered screens of heavy silk, bedding, and embroidered pillows. Most items listed come in several pairs or groups of ten to twenty, making the total number of items several hundred. The list provides testimony to the sumptuousness of the royal weddings of the Chosŏn dynasty. During the reign of King Yŏngjo (1724–76), the court ordered that spending on royal weddings be reduced and issued a book called *Kukhon chŏngrye* (*Regulations on Royal Weddings*), in which quantities to be used for each wedding were severely limited. It seems, however, that subsequent weddings were not orchestrated within these strict guidelines, as evidenced by this object list.

The scroll is made up of four different colors in the following order: pink, sky blue, yellow, sky blue, green, yellow, and green. Pink is called azalea color in Korea, and green is called green bean. These colors are juxtaposed so that each looks brilliant.

The object list is written in semicursive palace style (*kung-ch'e*) *han'gŭl* calligraphy, which is easy to decipher, yet exhibits beautiful fluency. The language used is somewhat different from modern Korean, especially some of the vowel sounds.

REFERENCES

Mun-su, Pak, et al., eds. *Kukhon chŏngrye* (*Regulations on Royal Weddings*). 7 vols. 1749. Changsŏgak Library, The Academy of Korean Studies, Sŏngnam.

Yi, Sŏng-mi. "Changsŏgak sojang karye togam uigwae yŏngu" (A Study of the Records of the Royal Weddings Preserved in the Changsŏgak Library). Sŏngnam: The Academy of Korean Studies. Forthcoming.

YSM

34. STRANGE ENCOUNTER AT MOUNT HWA

Late Chosŏn
Handwritten book, thirteen volumes; ink on paper
Volume 1, 13 x 8⅝ x ¼ in
(31.6 x 21.8 x 0.8 cm)
Changsŏgak Collection, The Academy of Korean Studies, Sŏngnam

This is the first book of the thirteen-volume novel entitled *Strange Encounter at Mount Hwa* (*Hwasan kibong*). It is handwritten in a somewhat cursive form of palace style (*kung-ch'e*) *han'gŭl* calligraphy. This novel is one of many anonymously written works of Korean literature from the late Chosŏn period written in *han'gŭl* rather than Chinese. Although the exact date of the novel is not known, the eighteenth century saw the rise of this genre of Korean literature and the palace style of *han'gŭl* calligraphy. The novel was first published in 1917.

The palace style of calligraphy developed shortly after the invention of *han'gŭl* in the mid-fifteenth century. It quickly gained acceptance because the first style of *han'gŭl* calligraphy, called printing style (*p'anbonch'e*), was difficult to execute. Each stroke had to contain the hidden brush tip, which took very deliberate, time-consuming effort. The palace style was first used for letter writing and for literary works composed by women in the palace. There are several famous palace ladies who contributed greatly to the formation and development of the palace style.

This script is more cursive than the regular *han'gŭl* script used for the ceremonial chant in the next item (no. 35). One can sense the movement and speed of the brush. There is also a greater variety of ink density, which can be seen especially in the finely tapered vertical strokes that tend toward the left and often form slanting strokes that blend into the next character. This produces an overall visual effect of fluency and suppleness.

The story of *Strange Encounter at Mount Hwa* is set in Tang China. It unfolds with the birth of the hero, Yi Sŏng, the son of Yŏngch'un. Yi Sŏng's mother's sudden death starts a chain of tragic events within the family. When Yi Sŏng's stepmother gives birth to her own son, she tries to get rid of Yi Sŏng, who somehow avoids the misfortune and takes first place in the state examination. This family feud eventually becomes enmeshed with a series of palace plots involving the Tang imperial family by which the hero is forced to expel his beloved wife and remarry a princess. In the end, however, he is cleared of all accusations and lives happily with two wives—the princess and his first.

The efflorescence of vernacular literature in the late Chosŏn period, especially during the reigns of Yŏngjo and Chŏngjo, should be considered in conjunction with the contemporaneous development of genre painting. There are numerous anonymously written *han'gŭl* novels that have such themes as familial conflict, love, social satire, and heroes of humble origin. After *han'gŭl*'s invention, more than three centuries were to pass before it was successfully appropriated as a means of Korean literary expression. The larger cultural context of the eighteenth-century Korean renaissance fostered this movement.

REFERENCES

Kim, Ki-dong. *Han'guk kojŏn sosŏl yŏngu* (*A Study of Korean Classical Novels*). Seoul: Kyohak-sa, 1981.

Pak, Pyŏng-ch'ŏn. *Han'gŭl kungch'e yŏngu* (*A Study of Palace Style Korean Calligraphy*). Seoul: Ilchi-sa, 1983.

Skillend, W. E. *Kodae Sosŏl: A Survey of Korean Traditional Style Popular Novels*. London: School of Oriental and African Studies, University of London, 1968.

YSM

35. CEREMONIAL CHANT FOR THE RITUAL OF THE ROYAL VISIT TO THE YUKSANGGUNG SHRINE

18th century
Ink on paper
9¼ x 28¼ in (23.5 x 72.0 cm)
Changsŏgak Collection, The Academy of Korean Studies, Sŏngnam

The title of this text can be translated as *The Ritual for a Visit to the Yuksanggung Shrine* (*Yuksanggung Myohyŏnŭi*). The Yuksanggung Shrine, located in Kungjŏng-dong in Seoul, is a shrine for the memorial tablet of Lady Ch'oe, the concubine of King Sukchong (r. 1674–1720) and mother of King Yŏngjo. The shrine was established in 1725, the second year of the reign of King Yŏngjo, and was called the Yuksang-myo or "Yuksang Shrine." In 1753, however, it was elevated to the status of palace, *kung*, and has since been called the Yuksanggung. Here, however, it is being referred to as a shrine to distinguish its meaning from that of a king's residential palace.

The language of the chant is classical Korean, which is very different from modern Korean. The text starts with the phrase "*Sanggung kwegye chung'ŏm*," which

means, "Palace Attendant Lady, please kneel and bow with the utmost respect [to the king and queen]." This is followed by a series of instructions to the palace attendant. First she must lead the visiting king and queen out of their tent and into the shrine. Then they must stand facing north, bow to the tablet twice, and straighten themselves. In the last two lines of the chant, the palace lady is instructed to tell the king and queen to go back to their tent for their return journey to the palace. Even though the text is written in *han'gŭl*, or the phonetic Korean alphabet, it is a mere transcription of words and phrases of Chinese origin.

The style of calligraphy employed here is called the palace style (*kung-ch'e*), so named because it was the style mainly used in the palace. It is characterized by supple, round forms ending with delicate vertical strokes. This particular piece is an example of the most noncursive palace style. The preceding item, no. 34, provides the most cursive example of *han'gŭl* calligraphy in this exhibition.

REFERENCES

The Academy of Korean Studies. *Han'guk minjok munhwa taebaekkwa sajŏn (Encyclopedia of Korean Culture)*, s.v. "Yuksanggung." Seoul: Samhwa Publishing Co., 1992.

Pak, Pyŏng-ch'ŏn. *Han'gŭl kungch'e yŏngu (A Study of Palace Style Korean Calligraphy)*. Seoul: Ilchi-sa, 1983.

YSM

36. POEM BESTOWED ON THE MAGISTRATE OF CH'ŎRONG-SŎNG
Dated 1799
King Chŏngjo (1752–1800)
Hanging scroll; ink on silk
77⅜ x 34¼ in (196.5 x 88.2 cm)
National Museum of Korea, Seoul

King Chŏngjo (r. 1776–1800) was one of the two central figures of the eighteenth-century Korean cultural efflorescence. The other was his grandfather, King Yŏngjo (r. 1724–76). King Chŏngjo's numerous cultural achievements included the establishment of the Kyujanggak Library in the palace; the promotion of the School of Practical Learning; the creation of several new metal types that facilitated the publication of books; and the sponsorship of encyclopedias on Korean history, geography, law, and literature. He was himself an accomplished painter and calligrapher, as represented by several works of each genre.

During the first half of the eighteenth century, Korean calligraphy was dominated by two figures: Paekha Yun Sun (1680–1741) and his disciple Wŏngyo Yi

Kwangsa (1705–77). They mostly worked in the Wang Xizhi (321–79) style, using old printed model books, which probably were not truly representative of the originals due to numerous recarvings and reprintings. Wŏngyo Yi Kwangsa was acutely aware of this problem and tried to work within the pre-Wang Xizhi stele (*pi*) tradition. It was not until the late eighteenth century, however, that Korean scholar-calligraphers were exposed to the new trend of Qing calligraphy that had developed along with the new study of epigraphy. Korean scholars of the School of Northern Learning, such as Pak Chega, visited Peking and introduced the prevailing Qing style in Korea. The Korean synthesis of the new Chinese calligraphic style was brought to fruition by Ch'usa Kim Chŏnghŭi (1786–1856), the most prominent statesman-calligrapher-painter in Korean history. King Chŏngjo's calligraphy must be considered within this late eighteenth-century context.

On the upper part of this large hanging scroll, there is a letter in small, regular script. The main part of the scroll consists of a septisyllabic truncated verse in large running script. In the letter, the king expresses his sorrow because his trusted subject is leaving the palace for his new post as magistrate in Ch'ŏrong-sŏng (present-day Yŏnghŭng-gun in South Hamgyŏng Province, North Korea). King Chŏngjo also tries to console himself by saying that the magistrate will be welcome in Ch'ŏrong-sŏng and instructs him to make the defense of the region and the plight of the people suffering from poverty and hunger his priorities. King Chŏngjo also advises him to apply unequivocal rules in governing. Wishing him a pleasant stay, the king concludes his letter with a list of gifts to the magistrate—mainly Korean medicines used for alleviating the summer heat and thirty fans to help him spend a cool summer.

The verse can be translated as follows.*

Ch'ŏrong-sŏng, flying in the sunset ten thousand feet high
The fortress gate opens high to welcome you, the magistrate
Jiangdung is not far, Chengdu also close
Familiar roads, light carriage to send you off.
In the summer month [June] of the *kimi* year [1799]

Following the date, there appears an impression of a square intaglio seal reading *Manch'ŏnmyŏng chuinong*, which was the king's pen name.

* My English translation of the letter and the poem on this scroll is based on Mr. Yi Wan-wu's unpublished Korean translation.

REFERENCES

Han'guk inmyŏng taesajŏn (Dictionary of Korean Biography). Seoul: Shingu munhwa-sa, 1980.

Yi, Wan-wu. "Wŏngyo Yi Kwangsa's Theory of Calligraphy" (in Korean). *Kansŏng munhwa* 38 (1990).

YSM

37. ROYAL EDICT: ADMONITION TO THE ELDEST GRANDSON OF THE KING
Dated 1776
King Yŏngjo (r. 1724–76)
Handscroll; ink on paper mounted on silk
22⅞ x 47 in (58.0 x 119.4 cm)
The Royal Museum, Seoul

The title of this edict (*yusŏ*) is Admonition to the Eldest Grandson of the King (Yu seson sŏ). It was composed by King Yŏngjo, at the age of eighty-five, in 1776, for his twenty-four-year-old grandson, who would soon succeed him to become King Chŏngjo, the twenty-second king of the Chosŏn dynasty. As stated at the beginning of the document, this was the first time in the three-hundred-year history of the Chosŏn dynasty that a king was to directly succeed his grandfather. Chŏngjo's father, Crown Prince Sado, had been put to death by King Yŏngjo (see no. 10).

In this edict, King Yŏngjo entrusts the peace of the nation and the righteousness of the government to his grandson for thousands of generations to come. He also advises the heir apparent to follow the words of his loyal ministers and praises the young prince's widely known filial piety. The king concludes by entreating his royal ancestors to protect Chŏngjo from any hardships that he might encounter.

The edict is written in handsome regular script and has nine impressions of the square seal that reads *yusŏjibo*, "royal seal of the edict."

REFERENCE

Agency for Protection of Cultural Properties. *Kungjung yumul torok (An Illustrated Catalogue of Palace Relics)*. Seoul, 1986.

YSM

38. ROYAL EDICT CASE
18th century
Lacquered wood with lead
H. 32⅜ in (82.2 cm)
The Royal Museum, Seoul

This large, cylindrical case for storing a royal edict (*yusŏ*; see no. 37) is made of wood and covered with a layer of thick paper that is lacquered in brown. It has a hasp for a now

missing padlock as well as two rings on the back through which a sash could be looped to enable one to carry the case across his back. A royal edict would be loosely rolled and stored inside.

Just below the rectangular hardware are four vertically ordered bronze characters ŏ, je, yu, sŏ that read "edict composed by the king." On each side, spanning the height of the cylinder, are two dragons with twisted bodies, painted in gold dust. Scattered cloud patterns act as filler, and stylized waves are painted along the lower edge of the case.

YSM

39. LETTER RACK
Late Chosŏn
Bamboo and wood partially decorated with red lacquer
20 x 9⅜ x 3 in (50.8 x 23.8 x 7.5 cm)
National Museum of Korea, Seoul

40. BOOKCASE
Late Chosŏn
Wood, paper, and silk
50¼ x 12⅜ x 19 in
(127.6 x 31.3 x 48.2 cm)
The Royal Museum, Seoul

41. DOCUMENT BOX
19th century
Wood
2 x 14⅜ x 8¼ in
(5.0 x 36.6 x 21.0 cm)
National Museum of Korea, Seoul

During the Chosŏn period, various types of boxes and chests were made for different purposes, such as the storage of inksticks, personal ornaments, heirlooms, official outfits, and documents. Boxes were made of various materials, including wood, sharkskin, paper, and woven bamboo; some were inlaid with mother-of-pearl. Storage boxes were usually small and light so they could be easily transported on horseback and short so they could be stored under dressers or easily placed in a room.

Metal braces reinforce the corners and bracket the top and bottom of this sturdy box. The lid occupies roughly two thirds of the top and is typical of the period. Lock sets resembling inkstones, which are pushed up to open the lid, were common. Document boxes such as this were highly appropriate and handsome appointments of gentlemen's *sarangbangs*.

PYK

42. DOCUMENT CHEST
Late Chosŏn
Wood
14¼ x 56⅝ x 8¾ in
(36.3 x 144.0 x 22.2 cm)
National Museum of Korea, Seoul

Because scholars' lives were centered around learning, they spent a great deal of time in their studies, or *sarangbangs*, where they meditated, read and wrote poetry, and taught their students. The *sarangbang* was also a favorite gathering place for politicking as well as socializing among the literati.

Sarangbangs were usually small, simple rooms, which were geared to the comfort of the occupant and guests. Unadorned furniture and fixtures, whose beauty came from their proportion and linear design, were made of humble types of wood. Designed to accommodate the persons sitting on the floor, these pieces were also intended to be viewed from such a position as well—an important feature of Korean traditional furniture.

Long, low document chests were used for storing papers or vessels, and sometimes brush holders, incense burners, and other ornaments were placed atop them. The document chest was an important element of the *sarangbang*. This particular piece, which is low and conveys an impression of expansiveness, exemplifies the pleasant proportions appropriate to a man's study. Its simple structure provides a perfect setting for such scholarly implements as an ink container, brushes, or a brush holder. It is composed of plain wooden planks, and great attention was paid to detail. The profile and line are articulated by the side and top panels that frame the internal structure and are joined by dovetails. The other planks are inserted with forty-five-degree-angle joints. The joinery and the pepper-leaf-shaped decorations in the middle of the drawers are important design elements. Locks were put on the drawers to secure the documents stored within.

PYK

43. BOOKCASE WITH THREE SHELVES
18th century
Wood
52⅛ x 14⅛ x 12¼ in
(132.5 x 36.0 x 32.5 cm)
Yun Hyong-kun Collection, Seoul

Bookcases are exemplary pieces of Korean wood furniture. In keeping with the aesthetic appropriate to a literatus's *sarangbang*, they tend toward rational structure, plain lines, and fine proportions. Light, thin uprights and crossbars form the main frame, and the predominantly open

frame conveys an impression of lightness. Three-shelf bookcases were used for storing books, and ceramics were displayed on them as well. The panels and doors enclosing the bottom shelf afforded the storage of a variety of items, such as tools, utensils, or clothing. Sometimes drawers were installed behind the doors.

The pine used for this bookcase was smoothed using a hot iron, which darkened it, and then scrubbed and polished with a brush of rice straw to bring out the grain. Other woods used for bookcases included *Cedrela sinensis* and pear; shelves were made of dark persimmon; zelkova, which has a beautiful grain; and paulownia.

Hardware on bookcases was usually brass, but iron decorations, which hark back to an older style, are occasionally seen. This has a round lock that fastens with a pin rather than a ring, and the metal fittings coordinate well with the piece.

PYK

44. INKSTONE IN THE SHAPE OF A BOAT
18th century
Stone
⅝ x 3½ x 8¼ in
(1.5 x 9.0 x 21.0 cm)
National Folk Museum of Korea, Seoul

This inkstone, which is thinner and proportionally longer than most, is in the shape of a Chosŏn-period ferryboat. The rimless prow gives the impression of speed. A frog sits in the upward-sloping bow area, which rises above the concave ink-containing portion of the vessel. Frogs were more commonly depicted in sedentary positions on lotus leaves (compare no. 61). This frog is poised to spring, which vests this otherwise unembellished inkstone with a striking artistic effect. But the frog is not only decorative, it can be used to straighten the brush tip. It is made of a special stone, which is striated and has reddish veins, traces of which are visible on the upper surface.

CYM

45. WATER DROPPER WITH PLUM BLOSSOM
18th century
Porcelain painted with underglaze blue
¾ x 1⅞ x 2½ in (2.0 x 4.8 x 6.3 cm)
Dŏkwŏn Art Museum, Seoul

This elegantly proportioned rectangular water dropper is shorter than most. The spout protrudes from one of the narrow

sides, and a hole, which facilitates the displacement of air by water, is in the center of the top. A blossoming plum branch is painted in dark blue, and the clear overglaze has a slight bluish cast. The contrast of the blue painting, concisely rendered with a light touch, with the white body imbues this piece with a quiet dignity.

CYM

46. WATER DROPPER WITH LANDSCAPE

18th century
Porcelain painted with underglaze blue
3 x 3¾ x 3⅜ in (7.5 x 9.5 x 8.6 cm)
Dŏkwŏn Art Museum, Seoul

The top and sides of this nearly cube-shaped water dropper feature various motifs, which are surrounded by borders and are painted in blue. A landscape occupies the top and an orchid is on the front. Depicted on the

other sides are a china pink, another type of orchid, and wildflowers. The landscape is sharp and the flowers full of life. The combination of the painter's expertise and neat shape of the vessel result in a work of notable elegance. A glaze with a light bluish cast and a dim gloss evenly coats the surface. After glaze was wiped from the bottom, the vessel was fired on sand.

CYM

47. PAPER SCROLL STAND WITH ORCHIDS

18th century
Porcelain painted with underglaze blue
H. 6¼ in (16.0 cm)
Ho-Am Art Museum, Yongin
Treasure no. 1059

This cylindrical vessel is painted with three groups of orchids that rise as if from the ground of a line that circles the vessel. This

device was popular at the end of the seventeenth century, and the spare use of rare blue pigments on white clay produces a simple, neat effect that is particularly Korean. Judging from the glaze style, this stand may have been fired at the Kumsari kiln in Kwangju, Kyŏnggi Province.

CYM

48. BRUSH WASHER

18th century
Porcelain
2⅝ x 3⅞ x 3⅞ in
(6.6 x 10.0 x 10.0 cm)
Chŏng So-hyon Collection, Seoul

Writing accoutrements performed certain functions, which placed certain constraints on the makers' creativity. This brush washer is completely original in style and is a peerless example of eighteenth-century Korean porcelain. Its utilitarian suitability and simplicity of expression place it in a class by itself.

The form is rectangular and the mouth circular; the slight rim at the opening and the six sides are superbly joined. The corners are softly rounded. Its harmony of just proportions and simple details makes it quintessentially eighteenth century.

The white clay body was coated with a light blue-cast glaze, and after the glaze was wiped from the bottom, it was fired evenly.

CYM

49. OCTAGONAL VASE WITH ORCHID AND BAMBOO

Early 18th century
Porcelain painted with underglaze blue
H. 11 in (27.9 cm)
National Museum of Korea, Seoul

The shape of this vase, which consists of a bulging body culminating in a long neck with rimmed mouth is a common form of mid-eighteenth-century vases. This shape provided a "canvas" for spare, detailed paintings.

With its simple decoration and apt use of space, this vase is a typical work of the eighteenth century, a remarkable period in which Korean style and culture flourished. On one side is a drawing of a single stalk of bamboo, on the other is a flowering orchid. The clean blue used for depictions harmonizes with the light blue tint of the glaze that thickly coats the surface, and has no crackling.

This product of the Kumsari kiln in Kwangju exhibits the beauty of Chosŏn-period blue-and-white vases.

CYM

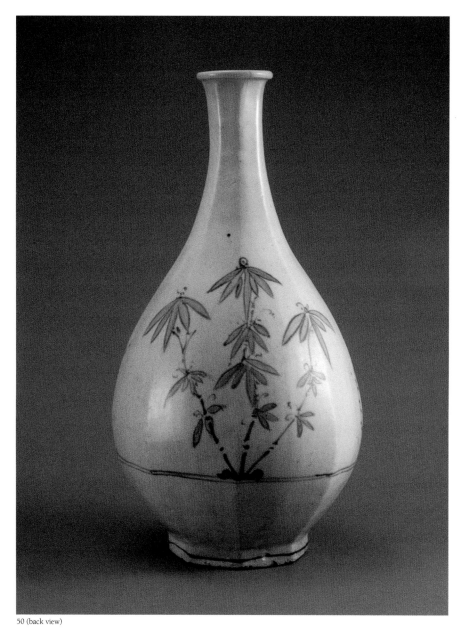

50 (back view)

50. OCTAGONAL VASE WITH PLUM BLOSSOMS AND BAMBOO

18th century
Porcelain painted with underglaze blue
H. 15⅜ in (39.0 cm)
Song-am Art Museum, Inch'ŏn

Octagonal vases featuring plum blossoms and bamboo were popular from the end of the seventeenth to the middle of the eighteenth century. Within this time span, they can be dated according to the manner of the painting. This example is a masterpiece of the mid-eighteenth century. The old trunk of the plum tree conspicuously contrasts with its new branches. Single lines are incised in the bamboo stems, and double incisions mark the wide leaves. There is a double horizontal line beneath the plum and bamboo.

The clay body is pure white, and the blue-tinged transparent glaze has tiny crackles. Following the form of the body, the foot is octagonal. The vessel was fired on sand.

CYM

51. YŎNGT'ONG-DONG, FROM TRAVEL SKETCHES OF SONGDO

1757
Kang Sehwang (1713–91)
Album leaf; ink and light color on paper
13 x 21 in (32.9 x 53.4 cm)
National Museum of Korea, Seoul

Kang Sehwang (1713–91) was renowned as the most accomplished literati artist of the second half of the eighteenth century. He not only distinguished himself in poetry, calligraphy, and painting, he also achieved prominence as a critic of the latter two arts.

Kang Sehwang consistently strove, in his art, to escape mere imitation and to achieve the essence of the literatus spirit by basing his works on his personal experience and sensibility. His artistic theories, which emphasized the artist's practical consciousness and empirical emotions as the basis of creativity, were strongly influenced by the School of Practical Learning (Sirhak) led by the eminent scholar Yi Ik, who lived next door to Kang on Mount An. Kang's ideology played a crucial role in the development of late eighteenth-century painting, including that of his student Kim Hongdo (see no. 56).

Yŏngt'ong-dong was the seventh work in *Travel Sketches of Songdo*, which Kang executed during his 1757 journey through Songdo (present-day Kaesŏng), the capital city of the Koryŏ dynasty. These travel sketches are depictions of the sixteen sites of Mount Ch'ŏnma, located north of Songdo. *Yŏngt'ong-dong* aptly illustrates the essence of Kang's artworks. As we can infer from the

painting's title, which the artist inscribed on the upper left corner, this is a depiction of the magnificent spectacle of the moss-covered rocks—the scale of which rivals that of houses—intruding upon the entrance to the Yŏngt'ong-dong Valley.

To present the scenery of Yŏngt'ong-dong in its entirety, Kang painted the foreground from a bird's-eye view while depicting the main hill from the viewpoint of the traveler who rides the donkey in the lower right. This dual perspective effectively conveys a sense of realism as well as the pleasure derived through the artist's senses. The colossal rocks, which were amazing to the artist and are the focus of his inscription, are situated prominently and haphazardly in the center of the painting. They are depicted more realistically than are the surrounding mountains, whose shadowing is merely alluded to by dotting the indentations. In order to convey the volume of the rocks, Kang eliminated the traditional method, opting, instead, to apply a thin wash and shade with ink. This novel approach, prefiguring modern watercolor technique, is a notable example of the Western painting method adopted by Korean artists in the early eighteenth century.

Nevertheless, this painting makes it clear that Kang was not fully satisfied with the Western method. He not only accentuated the beauty of the brush lines by outlining the rocks (thereby incorporating the traditional method of outlining and filling in with light color) but also created an ambience of simplicity and naivete particular to works of literati artists. By including himself as the traveling figure, Kang not only emphasized the massiveness of the rocks but created a memento as well.

HSP

52. VALLEY OF TEN THOUSAND WATERFALLS

About 1747
Chŏng Sŏn (1676–1759)
Album leaf; ink and light color on silk
13 x 8⅝ in (33.0 x 22.0 cm)
Seoul National University Museum, Seoul

Chŏng Sŏn (1676–1759) developed and made popular the true-view landscape (*chin'gyŏng sansu*) style of the late Chosŏn period. This accomplishment was highly notable because of its reorientation of contemporaneous artists who had imitated the traditional themes and methods of Chinese landscape painting without developing an individual style. Chŏng regarded the existing style of landscape painting stereotyped and artificial and strove

to render nature's essence and mysterious inner harmony as he had personally experienced it. In other words, he sought to achieve the original spirit and ideal of landscape painting through portraying reality. Based on this belief, Chŏng Sŏn executed many depictions of the famous scenic spots of Korea through which he traveled, using original techniques appropriate to each scene.

This hanging scroll, whose subject is Mount Kŭmgang—the most famous sight in the country, which is in present-day North Korea and was considered to be a fairyland by some—is a fitting example of Chŏng Sŏn's artistic accomplishment. Judging from its style and the form of the seal on the left, this work appears to have been executed during Chŏng's third excursion to the mountain in 1747. The compositional focus is on the scholar-sightseers and the boy who stand on the broad, flat rock, appreciating the beauty of the water that cascades down the various valleys to converge in the foreground. Mountain peaks and rocks envelop the center of the painting. The artist's visual experience is rendered appealingly by means of the straight lines that demarcate the angle of the mountains and through the sketch technique he developed. In particular, the confidently quick, rhythmic, and energetic brushstrokes communicate the beauty of the scenery as well as the sound of the wind and the water. Moreover, by applying a light blue wash over the entire picture and by including mists in the valleys, Chŏng conveyed both the energy and the mood of the mountain's unfathomable essence.

On the top right corner of the scroll is transcribed a poem by the Chinese Western Qin artist, Gu Kaizhi (344?–406?), that describes the scenery of Mount Huiji in Zhejiang Province. By including the poem, Chŏng equated the magnificence of Mount Huiji with that of the Valley of Ten Thousand Waterfalls.

> The myriad mountain peaks contest in beauty
> From all the valleys flow waters as if in competition—
> A majestic scenery with clouds casting above the misty trees.

HSP

53. THREE-DRAGON WATERFALL, MOUNT NAEYŎN

18th century
Chŏng Sŏn (1676–1759)
Hanging scroll; ink on paper
62⅞ x 22⅛ in (159.8 x 56.2 cm)
Ho-Am Art Museum, Yongin

This painting portrays the Mount Naeyŏn waterfall at Ch'ŏngha in Yŏng'il-gun, North Kyŏngsang Province, and was probably

Detail of No. 56

painted while the artist was serving as the leading official of Ch'ŏngha. Chŏng Sŏn's name, which he inscribed to commemorate his trip, is on the cliff rock of the actual waterfall. The artist included his own figure, intoxicated with the splendor of the scenery.

The grandeur of the earth-shaking waterfall, changing directions at several points, is conveyed all the more realistically and majestically by combining two viewpoints, looking down at the foreground and up at the rest of the landscape. To emphasize the magnitude of the rocks, Chŏng Sŏn used dark ink and strong brushstrokes that seem to be an adaptation of his frequently used *pu'gam* technique. Such brushstrokes effectively render the powerful bearing of the mountain and the beauty of nature. Through the rapid, unhesitating strokes, we can experience the emotions instilled in the artist by the grand scenery.

HSP

54. TWELVE THOUSAND PEAKS OF MOUNT KŬMGANG

1734
Chŏng Sŏn (1676–1759)
Hanging scroll; ink and light color on paper
51½ x 37 in (130.7 x 94.1 cm)
Ho-Am Art Museum, Yongin
Treasure no. 217

From ancient times, Mount Kŭmgang (sometimes called Diamond Mountain) was widely known—even in China and Japan. It inspired the Chinese to remark, "To be born in Koryŏ and see Mount Kŭmgang is our dream." From the late Koryŏ through early Chosŏn period, paintings of Mount Kŭmgang were commissioned by the government to be sent as gifts to Yuan and Ming rulers. Paintings of Mount Kŭmgang for appreciation were made, albeit rarely, starting from around the seventeenth century. But it was not until the eighteenth century that such works were fully developed by Chŏng Sŏn, and a new style emerged.

This hanging scroll presents a view of Mount Kŭmgang in its entirety and includes, on the top right corner, a poem written in the winter of 1734. To afford a view of the whole, Chŏng Sŏn constricted

the spaces among the mountain peaks and painted from a bird's-eye perspective. In the center is located the Valley of Ten Thousand Waterfalls (see no. 52), the point of convergence of various streams. Below, the artist depicted the rainbow bridge of Chang'an-sa—the starting point for the exploration of Mount Kŭmgang—and above, the highest peak, Pirobong, along the vertical axis. On the right side of the painting, Chŏng abstracted the acute rock peaks with sharp, straight lines and, in this way, depicted the bold and elegant outlines. To the left, he painted the earthen peaks with dark points. These contrasting effects highlight the distinctive features of the mountain.

Such illustrations, presenting clear views of the whole mountain and its special characteristics, seem to have been painted as mementos for those who had traveled there and as substitute pictures for those who were not able to personally view the scenery. In compositional approach, these paintings appear to have taken inspiration from painted maps. Chŏng Sŏn's style greatly inspired other late Chosŏn depictions of Mount Kŭmgang and even influenced the Nanga artists of Edo-period Japan.

HSP

55. PAVILION IN THE WESTERN GARDEN

1740
Chŏng Sŏn (1676–1759)
Album leaf; ink and light color on paper
15¾ x 26¼ in (40.1 x 66.8 cm)
Chung Hwan-kook Collection, Seoul

This painting was executed in 1740 at the request of Yi Chunghui, the minister of finance. Yi asked his old friend Chŏng Sŏn to paint the scene to commemorate the building of a small pavilion in the western garden of his home, which was located on the east hill of Mount Inwang (to the west of the modern-day presidential residence, the Blue House).

In a commissioned literary work, Yi's friend Cho Hyŏnmyŏng, the minister of defense, named this simple and elegant parlor the "three firsts pavilion" as it was in the most scenic spot, was painted by the most famous painter, Chŏng Sŏn, and was commemorated in a poem by the most famous poet of the day, Yi Byonyon. It is situated in an ideal, open location, overlooking Seoul. In addition to building the small, rectangular pond adorned with water lilies to add to the aesthetic appeal of the garden, Yi Chunghui preserved the ambient natural scenery, in accordance with the Korean dislike for artificiality. Chŏng Sŏn conveyed the quiet atmosphere of the garden by using smooth, calm brushstrokes and a wash of light ink and colors. He painted a dense row of pine trees in dark ink, heightening the refined quality of the composition. The mist that appears to be enveloping the scene manifests the break with worldly thoughts, by which noblemen hoped to attain enlightenment and cultivate their minds.

HSP

56. LANDSCAPE WITH FISHERMEN

1796
Kim Hongdo (b. 1745)
Album leaf; ink and light color on paper
10½ x 12⅜ in (26.6 x 31.5 cm)
Ho-Am Art Museum, Yongin
Treasure no. 782

57. TILLING THE FIELD

1796
Kim Hongdo (b. 1745)
Album leaf; ink and light color on paper
10½ x 12⅜ in (26.6 x 31.5 cm)
Ho-Am Art Museum, Yongin
Treasure no. 782

These two leaves are from an album painted by Kim Hongdo in 1796, the *Byŏngjinnyŏn Album*. This album comprises two books,

each containing ten leaves. One consists of landscapes; the other contains bird and flower paintings (see nos. 83 and 84). The books are similar in size, paper quality, coloring, and brushwork. Each leaf bears the seal of the collector Kim Yongjin; however, only one bears the date of production and the seal of Danwŏn, the sobriquet of Kim Hongdo, which would make it appear that these two books originally constituted one album. The album was produced when Danwŏn was fifty-two, a year before he retired from the position of county magistrate (*hyŏn'gam*), the sixth civil service rank.

After the age of fifty, Danwŏn developed a unique painting style, especially in true-view landscape and genre painting. Drawing upon the establishment of true-view landscape painting by his predecessor, Chŏng Sŏn (see no. 52), Danwŏn realized the essence of Korea's unique landscape.

Landscape with Fishermen
Set in a typical Korean rural landscape, this painting depicts two men fishing peacefully in a stream near a mountain. The mountain and stream contrast in their respective verticality and horizontality, however, they are also in harmony due to the soft projection of the mountain and the slightly slanted flow of the current. Naturally positioned trees dot the mountainside.

Among Korea's most celebrated and prolific painters, Danwŏn captured the candid emotion of common people in actual Korean surroundings through his innate sense of discrimination and masterly brushwork. This is a striking example of the realistic style attained over the course of his long and arduous career.

Tilling the Field
Like *Landscape with Fishermen*, this leaf depicts a common rural scene. On the right is a tree that illustrates Danwŏn's unique brushstroke style; under it are two men chatting. The posture of the farmer plowing, along with the cow's stride, conveys a sense of unhurried or easy labor. The dog in the middle of the field and the bird in the upper right corner near the nest complete the peaceful mood of the scene. The masterly rendering of light and dark tones of ink make this scene relaxing to the viewer.

By departing from the use of the well-known, scenic areas of Korea as settings for his paintings, Danwŏn advanced the technique of depicting common, modest landscapes without resorting to affected or overly deliberate compositions. This album not only exemplifies his achievement, it provides indication that Danwŏn brought the true-view landscape genre into a more mature phase.

CS

58. AN IMMORTAL CROSSING THE OCEAN

18th century
Chŏng Sŏn (1676–1759)
Hanging scroll; ink on paper
48¾ x 26⅜ in (124.0 x 67.8 cm)
National Museum of Korea, Seoul

This work is an example of Daoist-Buddhist figure painting, a type which Chŏng Sŏn rarely painted. On the top left corner, the artist included a relevant poem:

> While the mountain is still, the waves of the ocean seem to stretch eternally, and the moon shines brightly, I came down, riding on the heavenly winds and waving a staff.

Chŏng Sŏn signed the poem with his sobriquet, Kyŏmjae, and under that impressed a seal with his alternative sobriquet, Wŏnpaek.

As we can infer from the poem, this painting depicts an immortal who, having descended from heaven, flies above the waves on a moonlit night. The dancing waves against the large, empty space, along with the simple rhythm of the foam and clouds, suggest delicate movement. In contrast to the immortal's clothing— accentuated by dark ink and rough brushstrokes—his face is painted with delicate lines. A peaceful expression and an unmistakable dignity grace his countenance. In this figure, we catch a glimpse of the artist's Daoist tendencies and are presented with an idealized depiction of nobility.

HSP

59. TIGER AND BAMBOO

Late Chosŏn
Kim Hongdo (b. 1745) and Im Hŭiji (b. 1765)
Hanging scroll; ink and light color on silk
35¾ x 13⅜ in (90.9 x 34.1 cm)
Dŏkwŏn Art Museum, Seoul

It is evident from the small inscription by Hwang Kich'ŏn on the upper right corner— *Chosŏn Sŏho inwaho Suwŏl onghwachuk*— that this painting was a collaborative work by Kim Hongdo, whose sobriquet, besides Danwŏn, was Sŏho, and Im Hŭiji (b. 1765), who was known as Suwŏl. That the name of the country, Chosŏn, was included and that this work was once in a Japanese collection indicate that it may have been created as a gift, upon the request of Tokugawa Bakufu of Japan.

This painting provides evidence that compositions that use both bamboo trees and tigers as motifs predate those that use pine trees. The former motif is based on the Buddhist scripture, *Pulsolkumgwang myongch'oesung'wanghyong*, and was more

commonly used in Japan than in Korea. The bamboo in this painting symbolizes "peace through the four seasons," as it does in various other themes, such as bamboo and rooster, bamboo and hawk, bamboo and crane, and bamboo and cat, which include birds or animals that signify longevity and the defeat of evil spirits. Tigers were believed to be protective animals who would chase away the three natural disasters as well as attack and destroy evil spirits. Therefore, this work reflects the hope of averting catastrophe and misfortune all year long.

The tiger, with piercing gaze, assumes a contorted stance beneath the cliff from which the bamboo grows. The pose is standard, as can be seen in the extreme foreground of the Buddhist Nectar Ritual painting of 1759 (no. 118). Judging from the turn of the tiger's body, it seems that it was customary to produce double sets of such works because many paintings show it in mirror image. The tiger's alert stare and lifelike expression, along with the thin strokes that delineate each strand of fur and create a pattern of horizontal lines across his body and the realistic texture of his features, lend tension to the painting. Moreover, these details are indicative of Kim Hongdo's virtuosity. The perfect rendering of each strand of hair is accounted for by the fact that Kim Hongdo was thrice appointed court painter—a position that demanded a high degree of realism. It is interesting to compare this painting with Kang Sehwang's *Pine Trees and Tigers* in the Ho-Am Art Museum. The two works differ only in the turn of the tigers' bodies. They closely resemble each other in method and detail—even down to the number of stripes on each tiger—and are considered to be the superlative examples of Chosŏn-period tiger painting.

Im Hŭiji, who painted the bamboo, was a middle-class literati artist who once worked as a government translator. Like Kim Hongdo, he was active in the Songsŏk-wŏnsisa. An enthusiastic collector of antiques, such as knives, mirrors, and Korean lutes (*gŏmun'go*), he was nearly as celebrated as Kang Sehwang because of his ability to depict bamboo and orchids. In this painting, the bamboo is rendered with forceful brushstrokes, complementing the imposing figure of the tiger. Such force was symbolic of the middle class's emergence as the new social, economic, and literary power.

HSP

60. SELF-PORTRAIT

18th century
Yun Dusŏ (1668–1715)
Hanging scroll; ink and light color on paper
15⅛ x 8 in (38.4 x 20.4 cm)
Yun Yŏng-sŏn Collection, Haenam
Treasure no. 240

Self-portraits were not produced as abundantly in the East as they were in the West. In China, however, as early as the Han dynasty, Zhaoqi, a famous scholar-official, had painted a self-portrait for his own tomb. Since then, a significant number of painters have portrayed themselves. Korean records reveal that King Kongmin (1330–74) of the Koryŏ dynasty painted a self-portrait; and Kim Sisŭp, the outstanding figure of the early Chosŏn dynasty, painted portraits of himself as a young and old man. Particularly notable are Lee Kwangjua's and Kang Sehwang's extant eighteenth-century self-portraits.

Yun Dusŏ, who was the great grandson of Yun Sŏndo—a famous poet who was the maternal great grandfather of Chŏng Yagyung, the famous scholar of the School of Practical Learning—passed the state examination to attain a doctorate at the age of twenty-six but never pursued an official career. Instead, he devoted himself to writing poems and prose and to calligraphy and painting. He excelled in painting animals, plants, and figures. Nevertheless, he did not consider a work to be successful until he had captured the essence of the object he was painting. Known by the sobriquet Kongjae, he was one of the famous Three Jae (along with Kyŏmjae and Hyŏnjae) of the Chosŏn dynasty.

This self-portrait is the most distinctive work of its kind. Only the face of the painter is portrayed. His direct gaze challenges the viewer to return his stare. Verisimilitude permeates the entire painting. The painter used a mirror to squarely confront himself as the subject. This was related to the Practical-Learning approach that entailed seeing oneself and one's surroundings realistically. The revelation of self-awareness is reflected in the composition. The brushstroke technique used is typical of eighteenth-century portraiture. His naturalistic facial structure and countenance were produced by shading, which was achieved by using increasingly dark brushstrokes. Punctilious detail and the vivid expression of the eyes, especially the pupils, successfully achieve the transmission of the subject's soul. His beard seems to raise his face from the surface.

Yun Dusŏ once painted a portrait of Sim Dŭkyung, his deceased best friend, completely from memory. Upon seeing the portrait, Sim's family was overcome by its accuracy. Through this self-portrait, Yun Dusŏ expanded his genius to display verisimilitude and provided the genre of portrait painting with a masterpiece.

CS

61. INKSTONE DECORATED WITH A RELIEF OF LOTUS LEAVES

18th century
Stone
1 x 8 x 4½ in (2.6 x 20.3 x 11.4 cm)
National Museum of Korea, Seoul

This rectangular inkstone is made of Namp'o hard stone, but the rounded corners yield a softening effect. It is rare to see the whole surface of an inkstone decorated as this one is, to represent a single lotus leaf. The slightly raised edge of the leaf furnishes a prop for the inkstick. The veins of the leaf and the stem are realistically depicted.

A small frog, which appears to have just alighted, sits near the edge of the leaf. There is a slight depression on that side for the water into which the inkstick is ground, while the opposite side has a deeper hollow to contain the ink. Such slight variations allowed the artisan a range of nuance.

CYM

62. INKSTONE TABLE

Late Chosŏn
Wood
8¾ x 11⅞ x 7½ in
(22.1 x 30.3 x 19.0 cm)
Im Kŭm-hŭi Collection, Seoul

Along with the writing table used by a literatus, a table for the storage of inkstones was part of the standard furniture of a *sarangbang*. These tables are solid boxes on a simple stand. Large ones would sometimes have a two-piece lid. Lids were typically made of zelkova or paulownia wood, and some had colorful designs on them, such as floating clouds, dragons, or flying tigers; sometimes they were adorned with bamboo mosaics or mother-of-pearl inlays.

The sides of this box are persimmon panels, and the stand is pine. Persimmon was used for its color and grain. There is a drawer on one side, the front of which is cut on a forty-five-degree angle so that it fits flush.

PYK

63. Writing Table

Late Chosŏn
Wood
10⅝ x 23⅜ x 9⅝ in
(27.0 x 60.0 x 24.5 cm)
Choi Su-jŏng Collection, Seoul

A table of this type, used for writing and reading, was a core element of the study of a Chosŏn literatus. Rather than being placed against the wall as were storage and display furniture, writing tables were used in the middle of the room and therefore had to be low, narrow, and easily movable. When guests visited the *sarangbang*, the writing table would be placed between the host or elders, who sat near the wall toward the kitchen, and the visitors.

This table's main features are a long plank for the working surface and a deep drawer that spans the entire front. The front panel of the drawer is paulownia. The beautifully worked tenons of the joints in the side panels and top were left visible. Subtle decoration is provided by the incised lines around the cutouts at the feet, on the front of the side panels, and on the vertical strips applied to the front of the drawer. The brass drawer pull, which is almost as small as possible to be serviceable, completes the spare decoration.

PYK

64. Document Chest

Late Chosŏn
Wood
11⅛ x 42⅜ x 8¾ in
(28.2 x 108.2 x 22.1 cm)
National Museum of Korea, Seoul

65. Four-Shelf Display Stand

Late Chosŏn
Wood
63⅞ x 16⅜ x 13⅜ in
(162.3 x 41.5 x 34.0 cm)
National Museum of Korea, Seoul

Stands like this were used for display rather than storage, and favorite inkstones, ceramics, ornaments, and potted plants would be exhibited on them. Made simply of four thin framing elements, shelves, and a top, these stands are very compact and accommodating to small rooms.

Usually shelves are inserted into the posts with forty-five-degree-angle joints, but in this stand the shelf corners were cut out before they were fit into the posts atop the side supports.

PYK

66. Candlestick

Late Chosŏn
Iron with silver and copper inlay
H. 42½ in (108.0 cm)
National Museum of Korea, Seoul

67. Brush Hanger

Late Chosŏn
Wood
6⅞ x 25½ x 1⅜ in (17.5 x 64.7 x 3.4 cm)
National Museum of Korea, Seoul

Chosŏn-period furniture was scaled appropriately to small, low-ceilinged rooms. Subtle landscapes or bird and flower paintings were hung on the walls, partly to alleviate the possibility of a closed-in feeling. Otherwise, decoration was sparse, and furniture was limited to a few pieces in order to maximize space. Accordingly, wall-hung brush racks such as this and letter racks (for example, no. 71) served ornamental as well as functional purposes.

Brush racks hold one of the so-called four treasures of the literatus: ink, inkstone, paper, and brush. Ordinarily brushes were kept in ceramic, wood, or stone brush holders; but for the cultured gentleman, hanging brushes of various sizes from a rack would have provided a pleasing decorative accent. Quite a few brushes could be hung from this rack. The evenly spaced wooden pegs divide the rectangular space into equal units, creating an abstract rhythm. Brushes neatly hung from such a rack were an indicator of scholarly character.

PYK

68. Paper Scroll Stand

18th century
Porcelain
H. 4⅝ in (11.9 cm)
Namkung Lyŏn Collection, Seoul

Ceramic writing implements were not made in great quantities, and many show the creativity of the artisan. The form of this paper scroll stand is very simple and direct. In profile it curves from a wide mouth to a narrower circular base, and it sits atop a foot ring. At the base, between two raised ridges with incised lines, are alternating circular and modified cloud-shaped perforations.

The clay is white and delicate. A glaze with a very light green cast, which was well melted and did not crackle, covers the entire surface. There is some vertical cracking around the mouth. Glaze was wiped from the bottom before this piece was fired on a sand strut.

CYM

69. Water Dropper in the Shape of a Peach

First half of the 18th century
Porcelain painted with underglaze blue and copper
H. 4⅛ in (10.5 cm)
Ho-Am Art Museum, Yongin

This water dropper takes the form of a peach resting on a cushion of branches. Its quality resides in the way the leaves and branches harmonize with the shape of the fruit and the fact that one of the branches forms the spout. The white clay body has been left plain for the peach, while the branches have been painted golden green, and the leaves and the firefly that sits on the peach are blue. Fine pieces, such as this, would sometimes be placed on a document chest or table for admiration rather than actual use.

CYM

70. Snow-Covered Pine Trees

18th century
Yi Insang (1710–60)
Hanging scroll; ink on paper
46⅛ x 20¾ in (117.3 x 52.7 cm)
National Museum of Korea, Seoul

Yi Insang (1710–60) was an exemplary mid-eighteenth-century literatus who was accomplished in poetry, calligraphy, and painting. A man of integrity, in 1752 he resigned from the government position he had held for eighteen years because of an argument with a senior official. Thereafter, he retired to Sŏlsong, Umjuk District, where he spent his remaining years.

This painting expresses the artist's proud solitude and transcendental sentiments of his late life. The tall, erect pine tree extending from the top to the bottom of the painting contrasts with the tree that sways to the right to exude a noble quality. The quiet dignity of the snow-covered pine trees weathering the winter—the season of extreme hardship for plants—is emblematic of Yi's lifelong integrity and devotion to the philosophy of *sungmyŏng-baech'ŏng sasang*. (When the Ming dynasty, who had aided the losing Chosŏn kingdom during its invasion by Japan [1592–98], was defeated by the Manchus, many Koreans chose not to recognize the new Qing dynasty set up by the conquerors.) The skillful, cleanly executed, and unostentatious brushstrokes and the intellectual, noble nature of the subject are further manifestations of the artist's character and

life-style. This type of self-portraiture affords a glimpse of the dignified inner world of the artist, who lived according to his beliefs.

Yi Insang's style was based on that of Wen Zhengming (1470–1559) of the Ming dynasty as well as that of the Ming-style folk artists of the early Qing dynasty. He pioneered the literati style of the late Chosŏn period and especially influenced the intellectual artists.

HSP

71. LETTER RACK
18th century
Bamboo
32½ x 8¼ x 4⅜ in
(82.6 x 21.1 x 11.1 cm)
Kim Ki-su Collection, Seoul

Letter racks, in which writing paper of various colors was stored, were one of the few items hung on the walls of *sarangbangs*. Because they had to be harmonious with the rest of the room's furniture, their design was simple. Generally a scholar's letter rack would be made of paulownia wood embellished with iron decorations or impressed with designs of plum blossoms, bamboo, orchids, or chrysanthemums (four motifs that represent virtues of the scholar). In contrast, letter racks for a woman's *anbang*—the room in the inner part of the house where women worked and socialized among themselves—were decorated with brightly colored paper-cut decorations, birds or flowers, or the characters for "Asia" or "happiness"—expressive individualistic embellishments, which contrasted sharply with the Confucian literati ideal of austere, humble beauty appropriate to a *yangban's sarangbang*.

The frame of this rack is made of thin bamboo, which conveys a sense of lightness; it has a dramatic silhouette and casts a striking shadow on a white wall. Bent splines and round pieces of bamboo provide a counterpoint of thick and thin lines and emphasize the fine proportions. This letter rack beautifully embodies the simple aesthetic atmosphere of the *sarangbang*.

PYK

72. DINING TABLE
Late Chosŏn
Wood
9¼ x 13⅜ x 9⅞ in (23.5 x 34.1 x 25.0 cm)
National Museum of Korea, Seoul

In a traditional Korean house, meals were carried from the kitchen, across a yard, and through the front hall of the house to the room where the meal was eaten. The food

was carried on individual dining tables, and, as it was transported in heavy brass or ceramic containers, light materials were used to construct these tables. The ergonomic design of these tables facilitated their conveyance.

Traditional Korean custom dictated that males and females dine separately and that persons be treated in accordance with their age. A dining table's particular function —as the setting for the serving of liquor, tea, or fruit or as an essential part of a wedding banquet or a funeral ceremony— also influenced its design. Therefore, it was absolutely necessary for a Korean household to have a large variety and number of such small tables.

There is a great range of regional variation in the design of dining tables and cabinetry. This particular table is in the style characteristic of the Haeju area of Hwanghae Province. It differs from the most common design, which features four identical legs. The legs of Haeju tables are formed from two side panels that cant outward; the legs are called *pan kak*. Such outwardly tilting legs are more stable and can support much more weight than straight legs. *Pan kak* are supported by runnerlike members called *ŭn kak*. Usually the side panels were cut out to make them appear lighter.

PYK

73. DOCUMENT CHEST
Late Chosŏn
Wood
15½ x 74⅜ x 12 in
(39.5 x 188.9 x 30.5 cm)
National Museum of Korea, Seoul

This type of document chest was normally placed on the wall near the kitchen, and often two units were placed side by side, as in this example. Since they are completely enclosed on the front by doors and do not contain open areas or drawers, they were sometimes called mute or toad document chests. The fact that they can be opened only by inserting a key into one door—here, the third from the left—and removing it before sliding the others into the same position in order to remove them makes the chests quite secure.

Chests of this type were made for the woman's *anbang* as well as the man's *sarangbang* and differed accordingly in material and decoration. *Anbang* chests were made of bright zelkova, dark persimmon, or ash, all of which have exquisitely patterned grains that were left untouched. The doors were decorated in a number of ways: those

of so-called *nanjun* document chests were inlaid with landscape designs of mother-of-pearl or tortoiseshell. Others had bamboo mosaics. *Sarangbang* chests of this type were generally made of thick pine panels with paulownia or dark persimmon inside the chests.

PYK

74. THREE-SHELF CUPBOARD
Late Chosŏn
Wood
62⅞ x 28¼ x 18⅜ in
(159.7 x 71.7 x 46.7 cm)
National Museum of Korea, Seoul

This is a kitchen cupboard that was used both to house kitchenwares and to store food. The bottom shelf has side and back panels to provide the safe storage of piles of dishes. The middle shelf, on which food would have been stored, is the only shelf with doors. The upper shelf is open to allow air to circulate among the washed, but not towel-dried, dishes that were placed there.

To accommodate their function, kitchen cupboards were made of thick boards of moisture-resistant pine that enabled them to support heavy brass and ceramic wares. The cupboard doors were made of *Cedrela sinensis* and often had latticed windows backed with a fine cloth, often decorated with the character "Asia," to facilitate air flow. The hardware on kitchen furniture was generally iron, but on this example it is brass. Such pieces are much taller than they are wide, but normally a pair of cupboards was placed side by side.

PYK

75. JAR WITH BAMBOO
Late 18th century
Porcelain painted with underglaze copper
H. 8¼ in (20.9 cm)
National Museum of Korea, Seoul

This jar from an unknown kiln has a unique beauty. The mouth features a rolled, chubby rim, and the shapely, plump shoulder narrows to a slender waist that dramatically gives way to a much smaller foot ring. This elegant harmonizing of mouth, body, and base is uniquely Korean, and, although this jar may not be immediately striking, appreciation of its character and the skill of the craftsman grow with time. The composition of the bamboo is bold and informal and the modified cloud motifs are freely painted. Both are well integrated with the shape of the jar.

A hint of tan permeates the clear glaze; the vessel was fired on a sand support.

CYM

76. JAR WITH CLOUDS AND DRAGON

Early 18th century
Porcelain painted with underglaze iron
H. 14 in (35.8 cm)
Song-am Art Museum, Inch'ŏn

Jars are central to Chosŏn-period ceramics. There are two main forms—one with a moonlike round body and one with a bulging upper body. This example of the latter type has a large mouth and a gently bulging shoulder that curves to a low waist; there is a slight outward flare at the foot. Its elegant silhouette, along with the pale color of the underglaze decoration and the mildness of the painting style, creates a gentle effect.

The dragon on this jar floats peacefully among the clouds, which cover its head. The bulging eyes, horns, and exposed teeth characteristic of dragons have been obscured to emphasize a gentle quality. The jar's shape, clay color, and pellucid glaze, combined with underglaze iron, are indicative of an early eighteenth-century date.

CYM

77. JAR WITH LANDSCAPE

18th century
Porcelain painted with underglaze blue
H. 21¾ in (55.2 cm)
Lee Hak Collection, Seoul
Treasure no. 263

On the upper body of this jar are four cartouches, each of which encloses a fine drawing of a landscape or flowers. Connecting the cartouches are diamond shapes bounding the character for "wealth." Above and below the diamonds are circles containing the characters for "longevity" and "strength." The neck rim is decorated with a stylized scroll and the shoulder with a Chinese *ruyi*-cloud pattern, and the foot is decorated with a different pattern.

In the middle of the jar, a trace of paste reveals where the upper and lower parts of the body were joined. The glaze is even, glossy, and has no trace of crackling. The landscape painting especially is harmonized by the use of a dim blue. The jar was set on sand during firing. It may have been made during the eighteenth century at Kumsari.

CYM

78. LARGE JAR

18th century
Porcelain
H. 19 in (48.2 cm)
Lee Hak Collection, Seoul
Treasure no. 262

Jars of this size, whether of the so-called moon shape of which this is an example or the more elongated style (such as no. 77), were hard to form and fire. After having been formed, the upper and lower halves were joined together.

This unusually large jar is characteristic of Chosŏn-period monochrome porcelains in its mild white color, elegant shape, and natural appearance. Gentle curves projecting from the everted neck rim and the foot rim form the round shape that makes this a "moon jar."

The clay body is milk white, and the glaze has a subtle blue cast. The jar was glazed inside and out but not evenly: some thick runnels and an unglazed patch, which are visible in the illustration, show the glaze and clay colors. The lower portion has some spots of yellowish red caused by dirt in the clay, and there is a scratch across the surface. Glaze was removed from the bottom, and fireproof clay was applied to it before firing.

Even though the surface is not unblemished, this is an unusually handsome piece. It is representative of the round jars produced at a government kiln near Kwangju in Kyŏnggi Province.

CYM

79. VASE WITH FLOWERS AND INSECTS

Early 18th century
Porcelain decorated in relief and painted with underglaze blue, copper, and iron
H. 16⅝ in (42.1 cm)
Kansong Art Museum, Seoul
Treasure no. 241

Both sides of this vase feature a composition of flowers and insects, an unusual subject to find on a Korean ceramic. On the convex surface are painted depictions—which exhibit a refined use of the three colors of blue, red, and brown—of chrysanthemums and orchid plants, butterflies and bees. The long, slim neck terminates in a neat, plain mouth. Over the warm white body, glaze was applied heavily, resulting in a netlike pattern of crackling, which harmonizes well with the colors. This jar is a masterpiece of its kind.

CYM

80. OCTAGONAL VASE WITH FLOWERS AND GRASS

18th century
Porcelain painted with underglaze iron
H. 10⅜ in (26.4 cm)
National Museum of Korea, Seoul

During the middle Chosŏn period, up to about 1850, iron glaze was used as an alternative to blue for ceramic painting at the government kilns in Kwangju and elsewhere.

After being formed on the wheel, the body of this vase was trimmed to make it octagonal. It is slightly narrower at the top and sits on a wide, stable base. Golden tan clay was used, and the thickly applied glaze melted well and crackled. The hexagonal base was placed on clay struts for firing.

The painting of flowers and grass is divided into large compositions on the front and back with small ones in between. The execution is free and strong. The loose drawing, rough shape, gray-white color, and nature of the foot suggest that this was made at a country kiln.

The neck is a modern replacement.

CYM

81. VASE WITH BUILDING AND LOTUS POND

Late 18th century
Porcelain painted with underglaze blue
H. 8 in (20.2 cm)
National Museum of Korea, Seoul

The painting on this vase is placed between the projecting rim at the mouth and the point at which the outwardly bulging body tapers into the base. There are truncated representations of clouds at the top. In quite different scales are painted a building on a rock or mountain, lotuses, three fish, and a boat.

The clay is white and covered with a glossy, bluish glaze. Glaze was wiped off the bottom, and it was placed on sand during the firing.

CYM

82. ROOF TILING

18th century
Kim Hongdo (b. 1745)
Album leaf; ink and light color on paper
11 x 9½ in (28.0 x 24.0 cm)
National Museum of Korea, Seoul
Treasure no. 527

This is a leaf from the twenty-five-leaf *Danwŏn Genre Painting Album*, which consists of paintings that depict ordinary people engaged in such activities as mat

weaving, rice threshing, tobacco cutting, dancing, and wrestling. The workers in this painting have already erected the pillars, set the beams, and kneaded balls of clay. They are ready to tile the roof. Two people are on the roof; one crouches and is ready to pull the string attached to a ball of clay, while the other prepares to catch a tossed tile. The standing figure in the middle checks the alignment of the pillar. In the lower right corner, the motion of the carpenter using a plane is vividly captured. The man on the right appears to be an overseer, given his attire and posture.

Kim Hongdo, widely known by the sobriquet Danwŏn, was a master of Korean landscape painting as well as this type of genre painting. His paintings highlight the humor and warmheartedness of the ordinary people who lived simply but honestly. Danwŏn's figures have round, flat faces and wear white clothes, which marks them as being truly Korean. Danwŏn and Hyewŏn (the sobriquet of Sin Yunbok) brought to maturity the genre painting movement, which was made possible by the social and economic circumstances as well as the cultural climate of the eighteenth century.

CS

Detail of No. 83

83. DUCKS PLAYING
1796
Kim Hongdo (b. 1745)
Album leaf; ink and light color on paper
10½ x 12⅜ in (26.6 x 31.5 cm)
Ho-Am Art Museum, Yongin
Treasure no. 782

84. FULL MOON AMIDST BARE TREES
1796
Kim Hongdo (b. 1745)
Album leaf; ink and light color on paper
10½ x 12⅜ in (26.6 x 31.5 cm)
Ho-Am Art Museum, Yongin
Treasure no. 782

Kim Hongdo (b. 1745), who was active during King Chŏngjo's reign (1776–1800), was one of the four greatest men of the Chosŏn period as well as its most widely known artist. The king favored Kim to such an extent that he was entrusted with all matters related to art. Kang Sehwang, his teacher (see no. 51), hailed him as "the new brush in the world." Although Kim is best known as a genre painter, he also exhibited a unique touch in landscape and bird and flower paintings.

The album from which these two paintings come, the *Byŏngjinnyŏn Album*, was assembled in the spring of the *byŏngjin* year 1796 and is also called the *Danwŏn Album*, after the artist's sobriquet. The album is now

divided into two booklets—landscape and bird and flower paintings—each of which consists of ten leaves (see also nos. 56 and 57).

Ducks Playing
This painting is included in the bird and flower booklet. Centered around two ducks facing each other as they play on a stream that ripples softly to the right, this realistic bird and flower painting portrays a peaceful and cozy scene. The charming and ingenuous ducks, along with the combination of translucent pale green and orange pigments, heighten the bucolic scenery, evoking a lyrical sensation that is one aspect of the Korean sensibility. Although it illustrates only a fragment of a stream, this painting succeeds in conveying a sense of expanded space through the fact that the heron in the upper left corner and the small

water birds in the lower left corner appear to be flying in and out of the picture frame.

Full Moon Amidst Bare Trees
This painting, which appears in the landscape booklet of the album, captures the solitude of a defoliated forest in the autumn moonlight. The simplicity of the scene is manifested by the trees in the foreground, through which the full moon radiates, that feature the unique Danwŏn technique. Unlike his predecessors, the true-view landscape artists, who painted famous scenic spots, Kim valorized the ordinary, yet romantic, scenery around him. Effectively conveying particular regional and seasonal attributes, this work also communicates the lyricism of eighteenth-century Koreans, who favored life in harmony with nature. Particularly notable are the smooth, yet character-revealing, thin lines of Kim's mature brushstroke; the refined, liberal use of light and shade; and the light shades of ink that create a sense of depth and the prosaic mood.

HSP

85. CATS AND SPARROWS

18th century
Pyŏn Sangbyŏk (active 18th century)
Hanging scroll; ink and color on silk
36⅞ x 16⅞ in (93.8 x 43.0 cm)
National Museum of Korea, Seoul

Pyŏn Sangbyŏk was a member of the Bureau of Painting and was appointed to paint royal portraits in 1763 and 1773. As a reward for his fine portraits of the king, he was granted the position of county magistrate (*hyŏn'gam*). Aside from being a portraitist, he was particularly skilled in drawing cats and merited the nickname Pyŏn Koyang'i, which means "Pyŏn Cat." This work, which the artist signed with his sobriquet, Hwaje, is a prime example of the type of painting that brought him unrivaled fame.

The Korean pronunciation of the characters for "cat" and "sparrow"—*myo* and *chak*—resemble *mo*, meaning an aged person, and *chak*, meaning the long-lived magpie. Thus, cats and sparrows were representative of the bliss of longevity. Such subjects not only reflected popular taste, they also signified the increasing wealth and life span of members of the nonelite classes. This painting gives life to such a subject through its simple but tension-filled composition. The aged, twisting form of the tree is painted roughly in ink. In contrast, the chirping sparrows, perched on the small branches, and the expression and movement of the two cats, exchanging looks with each other, are treated with remarkably fine, delicate brushstrokes that exemplify the artist's superior skill. The ability to draw based on sharp observation and the accurate realism manifested in this painting evidence the dexterity of the artists of the time. Furthermore, the newly emerging energy of the period is represented in the vivacity of the cats.

HSP

86. BLACKSMITH'S SHOP

Late Chosŏn
Kim Dŭksin (1754–1822)
Album leaf; ink and light color on paper
8⅞ x 10⅞ in (22.5 x 27.1 cm)
Kansong Art Museum, Seoul

This leaf depicts blacksmiths, who were among the lowest class of people of the Chosŏn period, at work. There is a forge in the middle of the picture, and four people are centered around a piece of heated iron. In the lower right, a young man, stripped to the waist, stretches back preparing to strike the iron. Behind him, a middle-aged man beats the iron with a hammer. Another young man, seated at the left, performs the critical task of holding the iron with tongs, but he pointedly looks away from the scene toward the viewer. Behind this man, an apprentice thoughtfully watches the blacksmiths. Kim Dŭksin depicted the movement and drapery of the figures with an economy of brushstrokes, and the scene vividly conveys the atmosphere of the workplace.

A similar composition of the subject can be found in a painting by Kim Hongdo, who was nine years older than Kim Dŭksin. Kim Dŭksin eliminated the blacksmith sharpening a knife on a whetstone in the foreground of Kim Hongdo's painting and replaced him with a thatched shed. This serves to enhance the reality of the scene. Yet, the similarity among the figures' postures and the motifs illustrate Kim Hongdo's direct influence upon Kim Dŭksin.

A number of painters of the late eighteenth century were involved in this type of genre painting—every facet of the daily lives and jobs of common people was reproduced pictorially. This trend is connected to the temper of the time, in which painters were encouraged to reassess the reality of their environment and to sympathize with common people. A professional painter, Kim Dŭksin was a nephew of Kim Ŭngwhan, who was supposedly a teacher of Kim Hongdo. Kim Dŭksin did not attain the prominence of his contemporaries Kim Hongdo and Sin Yunbok. Nevertheless, he was noted for his fidelity in the portrayal of his surroundings, as this picture illustrates.

CS

87. CHASING A CAT

Late Chosŏn
Kim Dŭksin (1754–1822)
Album leaf; ink and light color on paper
8⅞ x 10⅞ in (22.5 x 27.1 cm)
Kansong Art Museum, Seoul

This leaf vividly captures a frenetic scene that has suddenly erupted around an elderly couple who had been calmly weaving a mat. A striking story is told with simplicity. A cat, holding a chick in his teeth, escapes as the old master, who cannot match the cat's speed, attempts to reach him with a long pipe. The old woman, barely on her feet, is startled to see her husband falling off the porch along with his indoor headgear (*t'anggon*, visible at the foot of the pillar) and the frame for the mat. The artist clearly conveys his sympathetic observation.

The diagonal thrust of the old woman in the upper right corner of the picture, along with the old man, and the mother hen and chicks in the lower left, heightens the dynamic motion of the moment. Eye contact between the cat and the master evokes a state of tension and complication. To transfer a scene of daily common life into a narrative pictorial composition is the charm of genre painting.

Kim Dŭksin, whose sobriquet was Kŭngjae, was employed by the Bureau of Painting. Unlike Kim Sŏksin, his younger brother, who specialized in landscape painting, Kŭngjae specialized in genre painting. The influence of Kim Hongdo is especially evident in Kŭngjae's choice of subject matter, the humorous expressions of his figures, and his style of depicting trees.

CS

88. ADMIRING THE SPRING IN THE COUNTRY

Late Chosŏn
Sin Yunbok (b. 1758)
Album leaf; ink and light color on paper
11⅛ x 13⅞ in (28.3 x 35.2 cm)
Kansong Art Museum, Seoul
Treasure no. 135

89. AMOROUS YOUTHS ON A PICNIC

Late Chosŏn
Sin Yunbok (b. 1758)
Album leaf; ink and light color on paper
11⅛ x 13⅞ in (28.3 x 35.2 cm)
Kansong Art Museum, Seoul
Treasure no. 135

Sin Yunbok, better known by his sobriquet Hyewŏn, and Kim Hongdo, also known as Danwŏn, were the two foremost practitioners of genre painting during the latter part of the Chosŏn dynasty. Hyewŏn's painting style differed from that of Danwŏn, who depicted various facets of daily life and low-echelon jobs vividly and humorously. Hyewŏn preferred depicting the tender feelings between men and women with erotic overtones as well as the coquettish behavior of women and the proclivities of the young dandies of the upper-class *yangban*. In contrast to most of Danwŏn's genre paintings, which give priority to figures and include simple surroundings, Hyewŏn's paintings include various backgrounds—such as landscapes, gardens, and streets—that convey the feeling of the actual location. Occasionally, this approach proves to distract more from the figures than does Danwŏn's.

These two paintings and the next two (nos. 90 and 91) are from an album of thirty leaves; each pair is bound so they face each other. They illustrate the life and environment of the wealthy *yangban* and high-class *kisaeng* entertainers. The album provides fascinating glimpses of eighteenth-

century Korean clothing and customs as well as illustrates the basis for Hyewŏn's artistic acclaim.

Admiring the Spring in the Country
Against a background of rocky mountains and scattered blooming azaleas, *yangban* men and *kisaeng* courtesans enjoy a spring day while listening to music. A man on the left intently listens to the music; however, the woman beside him, holding a long pipe, is inattentive and looks away. Another woman sits in a relaxed, but prim, position, clasping her knee. Beside her, in a mostly frontal view, a serenely posed man with a thick beard holds a thin belt in one hand and leans on matting with the other. These two men sit against bolsters. At the right stand two young men, who are naturally posed. Three musicians perform in the foreground. In the lower left corner, a servant carries a drinking table. The men have settled in this pleasant spot to enjoy a picnic while listening to music.

This painting illustrates the unlabored technique used by Sin Yunbok to render aspects of real life. By taking a slightly elevated viewpoint, he created ample space for the characters in this scene. His descriptive style—varied but never mannered—along with the subtle expressions of the figures, results in a satisfying depiction of the pleasures had by members of the *yangban* class of the Chosŏn dynasty on a spring day.

Amorous Youths on a Picnic
The three women on horseback in this painting are *kisaeng* courtesans. They are accompanied along a mountain road by four *yangban* dandies, as well as a child servant, and appear to be out to enjoy the season. Blooming azaleas on the cliff signify that it is spring. The women's features typify Sin Yunbok's style: oval faces adorned with fashionable wigs (*raches*), suggestive eyes, narrow shoulders, tight jackets, slim waists, and voluminous skirts. One woman has covered her head with a long capelike outer garment (*chang'ot*) to protect herself from both the cold and the prying eyes of others. The shape of the garment conveys the bluster of the spring wind. A second woman, raising a hand to her wig, adopts a flirtatious pose. The third has azaleas in her hair and holds a long pipe to her lips. The men have hitched up their outer garments (*dopos*), exposing their undergarments and tobacco pouches. Hyewŏn's delicate, sophisticated brushwork and the suggestive poses illustrate the mood of his subjects. Moreover, the colorful clothing and the pink flushes of the azaleas diffuse visual charm throughout the painting.

CS

90. WOMEN ON DANO DAY
Late Chosŏn
Sin Yunbok (b. 1758)
Album leaf; ink and light color on paper
11⅛ x 13⅞ in (28.3 x 35.2 cm)
Kansong Art Museum, Seoul
Treasure no. 135

91. WOMEN BY A CRYSTAL STREAM
Late Chosŏn
Sin Yunbok (b. 1758)
Album leaf; ink and light color on paper
11⅛ x 13⅞ in (28.3 x 35.2 cm)
Kansong Art Museum, Seoul
Treasure no. 135

These two paintings by Sin Yunbok, known as Hyewŏn, come from the same album as the pair in the preceding entry (nos. 88 and 89).

Women on Dano Day
Although this painting has no inscription, it clearly depicts the amusements of women of the Chosŏn period on Dano Day, which was a traditional festival held on the fifth day of the fifth month of the lunar year. Women would enjoy the warmth of this early summer day by bathing, taking herbal shampoos, and playing on a Korean swing (*kunae*). Men would engage in Korean wrestling (*ssirŭm*) and other pursuits.

The scene includes slightly more female nudity than is typical of Hyewŏn. A woman wearing bright clothing is on the swing, revealing her undergarments. Another woman, preparing to don her wig, lets her hair down. Her companion tilts her head to gaze vacantly at the sky. One carries a package of clothing on her head, while, on the left, seminude women bathe in a stream. Even though these virtually nude women convey an erotic appeal, the most decisive erotic motif is provided by the child monks who steal a glance at them from behind a rock. Hyewŏn often inserted figures of men into his paintings to imply sensuality. His refined, sophisticated brushstrokes are appropriate to the feminine poses and subtlety of the mood. Moreover, the purple ribbons, jade-green skirts, and yellow jacket lend charm to the figures against the natural background of the summer scenery. The painter's wit is expressed through his use of red to highlight the bathers' nipples.

Hyewŏn's predilection for erotic motifs is said to have resulted in his expulsion from the Bureau of Painting. He came from

a family of painters; however, he was the last member to paint professionally—a fact that makes the account credible.

Women by a Crystal Stream
This leaf, which depicts a scene that takes place by a stream, is less familiar to the public than are others from Hyewŏn's album of genre paintings. The sideways U-shaped configuration of the rocks and the stream results in an extraordinary composition not usually seen in Sin Yunbok's paintings. Four figures engaged in different actions complete the scene. A woman with a large, braided wig (*rache*) squats as she washes clothes; another, preparing to don a wig, lets her hair down; and a third, seminude, woman stands on the knoll, drying her clothes. Across the stream, a male passerby, carrying a bow and arrow, is distracted by the women.

Hyewŏn's genre paintings often focus on flirtation, and this scene is typical. By introducing a man to an otherwise ordinary scene of women washing and dressing, the artist infuses a subtle tension and evokes the viewer's curiosity. Other leaves of the same album contain more blatant depictions, including a view of a *kisaeng*'s private room and a young widow watching coupling dogs. Nevertheless, Hyewŏn's erotic motifs remain suggestive and indirect—in contrast to the more graphic and intense scenes of sexuality found in some Japanese wood-block prints. Showing indirect, more subtle, erotic overtones are one characteristic of Hyewŏn's work. His natural brushwork, exemplified by the grass between the rocks and the light blue current, demonstrates his virtuosity.

This leaf lacks the intensity of the bright accents used in *Women on Dano Day*; however, its appeal lies in its realistic rendition of women's modest, casual dress and common gestures.

CS

92. A COURTESAN (KISAENG)
About 1805
Sin Yunbok (b. 1758)
Album leaf; ink and light color on silk
11⅛ x 7½ in (28.4 x 19.0 cm)
National Museum of Korea, Seoul

The woman in this picture is wearing a *jeon-mo*, a large hat made of oiled paper worn outdoors by women during the Chosŏn dynasty, especially when they rode horses. It was sometimes decorated with beautiful patterns; this one has been left plain. The woman appears to be walking—a figure in motion against a neutral

background is rare among Hyewŏn's genre paintings. The influence of Hyewŏn's predecessor, Danwŏn, or Kim Hongdo, is evident in this painting. The dark and slightly intense brushstrokes exhibit Danwŏn's stylistic flavor, marking a departure from the light, tender strokes usually favored by Sin Yunbok in feminine portraiture. Several characteristics, however, remain unique to Hyewŏn's style: the slender figure; the countenance; the wisps of hair around her ears; the short, fitted jacket (chŏgori); and the hitched-up skirt, revealing her undergarments. These were among his favorite elements of depiction of kisaeng entertainers.

The inscription on the upper right reads "Predecessors thus far have not shown such a class as this, this could be considered quite new and unique." The painting is also inscribed with the sign of Hyewŏn as well as his seal.

Two additional genre paintings of similar size and brushwork are in the National Museum of Korea. It is believed that they are from the same album as this one. Among them, A Woman Wearing a Cloak bears the inscription 1805. Therefore, it is presumed that this picture was also painted around that time.

CS

93. WOMAN BY A LOTUS POND

Late Chosŏn
Sin Yunbok (b. 1758)
Album leaf; light color on silk
11¾ x 9¾ in (29.8 x 24.7 cm)
National Museum of Korea, Seoul

This noted painting exhibits the true character of Hyewŏn. The woman is seated on a narrow wooden porch (toetmaru) by a lotus pond. Presumably it is midsummer, because the lotuses are in full flower. The woman's dress and pose lead to the conclusion that she is a kisaeng courtesan. She wears a large, braided wig (kache) on top of her own neatly combed hair. Wigs are said to have been a highly fashionable luxury item of the time. In one hand she holds a pipe and in the other a reed instrument.

One foot rests on the cornerstone, exposing the woman's undergarments. Her pose seems to indicate an inadvertent moment of contemplation. The full wig, adorned with purple ribbon, which stands out in contrast to the plain jade-green skirt and white jacket (chŏgori), provides an

accent to the scene. The naturalistically rendered folds of the undergarments are Sin Yunbok's favorite erotic motif.

The slightly distanced perspective captures the pond, yard, and wooden porch accurately. Horizontal, vertical, and diagonal lines provide the rough suggestion of a house. Skillful brushwork and the combination of dark and light ink tones, along with light colors, successfully convey the serene atmosphere of the backyard of a kisaeng house as well as the erotic overtone of the female figure.

CS

94. ROCK, GRASS, AND INSECT

18th century
Sim Sajŏng (1707–69)
Album leaf; ink and light color on paper
11⅛ x 8⅝ in (28.2 x 21.8 cm)
Seoul National University Museum, Seoul

Sim Sajŏng and Chŏng Sŏn were regarded as the greatest literati artists during the reign of King Yŏngjo (1724–1776). Sim's family had, for generations, produced high government officials, but after the execution of his grandfather for treason, members of succeeding generations were excluded from politics. Thus, in an attempt to submerge his unfortunate circumstances into his passion for art, Sim spent his life in a lonely valley outside the present-day Seoul West Gate, devoting himself to painting. Because he was a deeply serious and honest individual, he had no children of his own and died alone in extreme poverty.

One of the leaders in establishing in Korea the "Southern School" along the model of the Wu School of the Ming dynasty, Sim Sajŏng was a renowned landscape artist. But he also created many superior portraits as well as bird and flower and insect paintings. His friend Kang Sehwang once ranked his depictions of flowering plants and insects higher than his landscape paintings.

This small scene is composed of flowers, grass, and an insect centered around an oddly shaped rock. Without becoming encumbered by detail, Sim faithfully conveyed the scene's distinctive aspects. The lyrical and sentimental mood embodied by the lonely grasshopper on the rock communicates the artist's affection for insignificant wildlife. The odd form of the rock—softly delineated by short, rhythmic brushstrokes—parallels the configuration of flowers and grass. Furthermore, the contrasting effect of red and green provides a refreshing visual experience in addition to conveying nature's dormant vitality.

HSP

95. HUNTING SCENE

Late 18th-early 19th century
Two-fold screen; embroidery on silk
74¾ x 43¾ in (190.0 x 111.2 cm)
Huh Dong Hwa Collection, Seoul

As distinguished from multipanel screens, two-fold screens such as this are called karigae, "screens to block one's view." They were used to demarcate smaller, more private spaces within a room. Today, modern versions of such screens are widely used in offices to block the view of the entrance from inside.

This type of scene is commonly called horyŏpto, or "picture of the Manchu Chinese hunting." Hunting scenes were depicted in the mural paintings of tombs from the Koguryŏ dynasty (37 B.C.E.–688 C.E.). They can still be seen in the P'yŏngyang area of North Korea and Jilin Province in Manchuria, which was once a part of the Koguryŏ kingdom. In these Koguryŏ murals, the hunting scenes are an integral part of the scenes of the daily life of the tomb's occupant. During the late Chosŏn period, however, folk-painting screens depicting hunting scenes invariably showed hunters in Chinese costumes and are properly called horyŏpto. This embroidered screen follows the folk-painting tradition in both iconography and design.

In designing the screen, the artist made one unified field of the two panels and placed two large pine trees in the center as the focal point of the composition. A broad yellow military tent forms a wall behind the pine trees, creating a stagelike space in which a banquet scene for the tribal chieftain unfolds. On the left side, against a tall landscape screen, the chieftain is seated in front of a table surrounded by male and female servants. On the right side, there are tables and cupboards, filled with kitchen utensils, and busy servants preparing food and drink. Immediately below this central group are a series of small hills in different colors that form a shield for horses, grooms, and their carts. Smaller hills and hunters are scattered around this central group, forming a larger circle or enclosure to complete the overall composition.

The hunters and hills on this screen are depicted in a style similar to that used in the Dunhuang cave paintings of the Northern Wei period (386–534). Each unit of the composition consists of a few elements, such as hills and figures or hills and trees. These units are carefully placed to avoid overlapping one another. As a result, the space is read from bottom to top as foreground, middle ground, distant

Detail of No. 95

mountains, and sky. This primitive mode of depicting pictorial space has been perpetuated fairly consistently in Korean folk painting, and this embroidery follows the same design principle.

Except for the pine trees, the bright yellow tent, and some of the ceremonial flags and weaponry, whose tips emerge above the tent, most elements in this embroidery are depicted in subdued colors. The juxtaposition of indigo blue and violet or wine colors creates an atmosphere quite different from most other embroidered screens of the period, such as item no. 99. The outlines are done in a chain stitch, while the broad areas of colors are done in a satin stitch.

REFERENCE

Huh, Dong Hwa. *Han'gugŭi chasu (Korean Embroidery)*. Seoul: Samsung Publishing Co., 1978.

YSM

96. WRAPPING CLOTH FOR BEDDING (*IBULPO*)

Late Chosŏn
Hemp
56¼ x 55⅛ in (143.0 x 140.0 cm); tying strings, 84¼ in, 57 in, and 37⅜ in (214.0 cm, 145.0 cm, and 95.0 cm)
Huh Dong Hwa Collection, Seoul

97. WRAPPING CLOTH (*CHOGAKPO*) WITH FOUR TYING STRINGS

Late Chosŏn
Hemp
35⅜ x 37⅜ in (90.0 x 95.0 cm); tying strings, approx. 35⅜ in (90.0 cm)
Huh Dong Hwa Collection, Seoul

98. WRAPPING CLOTH (*CHOGAKPO*)

Late Chosŏn
Ramie
28 x 28 in (71.0 x 71.0 cm)
Huh Dong Hwa Collection, Seoul

Pojagi, "wrapping cloths," are used to wrap things to be carried or protected. They are made in many different sizes, usually square, with or without ties attached to the corners to secure the package after wrapping. In addition to this primary function, they also acquired ceremonial and decorative functions. Wedding and engagement gifts are traditionally wrapped with beautifully embroidered and lined wrapping cloths. Cotton, hemp, silk, ramie, and pongee are used as materials for making *pojagi*. *Pojagi* are named according to their use, structure, design, and function. The first example here is used to wrap bedding, *ibul*, and is made by using the patchwork method. Therefore, it is called *ibulpo*, "pojagi for wrapping or covering bedding," and *chogakpo*, "patchwork wrapping cloth."

228

Cloths can be classified as *minbo* or *pojagi* when used by people other than royalty, as opposed to *kungbo* or *pojagi* when used by members of the royal family. The character for *pojagi* is *pok*, which is homophonic with another character meaning "happiness." For this reason, it is believed that happiness is trapped or preserved inside wrapping cloths.

Patchwork Wrapping Cloth for Bedding (Ibulpo)
This large patchwork wrapping cloth, or *chogakpo*, is an example of the ingenuity of Korean housewives who created beautiful compositions from scraps of cloth. Many pieces of hemp of various shapes and sizes were sewn together to form a large, nearly square, wrapping cloth. Long, rectangular strips of hemp are placed along the border, while the central portion is made up of odd-shaped pieces. The woman who designed this tried to fashion either squares or rectangles using two odd-shaped pieces, which were then assembled into larger squares or rectangles, resulting in a neat and orderly composition. When a patchwork wrapping cloth is made from semi-transparent material, such as hemp or ramie, the seams assume a strong linear design function. Three wide straps are attached to three reinforced corners.

Patchwork Wrapping Cloth (Chogakpo)
This hemp *chogakpo* could have been used to wrap clothing to be stored in a chest. It is a relatively large *pojagi* but not large enough for wrapping bedding. It is made of many odd-shaped hemp cloth pieces sewn together in a design that closely resembles crazy paving. Wide straps are attached to all four reinforced corners.

Patchwork Wrapping Cloth (Chogakpo)
The smallest of the three examples in this exhibition, this hemp *chogakpo* was constructed mostly from rectangular or square pieces of cloth, along with a few odd-shaped pieces. The four double-layered corners are particularly outstanding, and the geometric patterns and subtle colors might bring to mind the paintings of Piet Mondrian or Paul Klee.

REFERENCES

Huh, Dong Hwa. *Traditional Wrapping Cloth: An Exhibition Catalogue.* English version by Sheila Middleton. Seoul: Museum of Korean Embroidery, 1990.

Yi, Sŏng-mi. *Korean Costumes and Textiles.* Seoul: Korean Overseas Information Service and IBM, 1992.

YSM

99. Ten Longevity Symbols
Late Chosŏn
Eight-fold screen; embroidery on silk
54⅞ x 134⅜ in (138.8 x 341.2 cm)
Huh Dong Hwa Collection, Seoul

The ten symbols of longevity (*Sipchangsaeng*) is one of the most popular themes in Korean painting, embroidery, and other crafts. The ten symbols are the deer, the crane, the tortoise, the sun, clouds, water, rock, pine, bamboo, and the *yŏngji* (Ch. *lingzhi*, mushroom of immortality).

On each of the panels of these embroideries, on brilliant red backgrounds, is a pair of cranes, deer, or tortoises, which constitute the dominant element of the composition, while the remaining symbols are subordinate. On the first panel, reading from the right, a pair of cranes is posed on the rock in the foreground from which a few stalks of *yŏngji* grow. A large pine tree, with meandering branches, and multicolored clouds fill the space above them. The second panel depicts a pair of tortoises posed among rocks and stylized waves. On the third panel, a buck and a doe are placed under a pine tree; the buck exhales toward the pine branch, while the doe grazes on the *yŏngji*. The fourth panel has a pair of cranes under a pine with rocks and *yŏngji*. Four additional panels follow about the same iconography as the first four.

The embroidery technique utilized here is somewhat unusual in that the threads are loosely woven. The satin stitch is also intentionally loose, making the ten motifs appear ancient. The red woolen material used for the ground looks brilliant against the blue, green, and yellow of the embroidery.

Screens such as this were used on many auspicious occasions, such as weddings and birthday celebrations, in traditional Korea. Today, they are used to decorate large wedding and banquet halls. Smaller scale screens are also used in many private homes for decoration as well as for blocking winter drafts. The word for screen in Korean is *pyong p'ung*, which means "windshield."

REFERENCE

Huh, Dong Hwa. *Han'guggŭi chasu (Korean Embroidery).* Seoul: Samsung Publishing Co., 1978.

YSM

100. Portrait of Oh Jaesun
1791
Attributed to Lee Myongki (active late 18th-early 19th century)
Hanging scroll; color on silk
59⅞ x 35¼ in (152.0 x 89.6 cm)
Kwŏn Ok-yŏn Collection, Seoul

Oh Jaesun (1727–92), sobriquet Sunam, posthumous name Munch'ŏng, was a civil officer during the reign of King Chŏngjo (1776–1800). Having passed the civil service examination at the age of forty-six, he served as *daejehak*, the highest officer of the Board of Literary Counselors (Hongmun'gwan). He rose to the level of minister of the Yi-Jo, a civil board, and became the first-ranking officer (*panjungchubusa*) in the Jungchubu, the government office that managed the king's ordinance and military affairs. Oh maintained an excellent reputation as a scholar and was well versed in contemporary philosophy and literature. The anthology of his writings, *Sun Am Jip*, is a valuable collection.

This is a full-length portrait in frontal presentation. The subject is wearing a black *samo* (silk winged hat) and a *danryong* (official robe for courtiers). This type of portraiture, which depicted meritorious retainers in dignified poses and attire, was prevalent during the reigns of King Yŏngjo and King Chŏngjo. The animal-skin chair and position of the sitter's feet are typical attributes of this type of portraiture, and the deep, scooped neckline of the *danryong* exemplifies late eighteenth-century attire. The embroidered double-crane patch and buffalo buckle signify that Oh's rank was *il pum*, the highest rank of the court.

The most crucial feature of the portrait, the carefully studied face, was rendered skillfully by means of delicate brushstrokes. Oh's complexion, particularly the dark spots, and sparse eyebrows are depicted realistically. The keen eyes, looking straight out, succeed in "transmitting the soul," which was the prerequisite for excellent portraiture, and the treatment of his beard is exquisite. On the precept that the beard is a natural extension of the face, the artist first flesh-tinted the area and then meticulously drew each hair, strand by strand. In spite of the frontal presentation, the seated pose is well balanced, and the shaded folds of drapery convincingly convey the frame and bulk of the sitter's body.

The portrait is ascribed to Lee Myongki, a well-known portraitist who had been commissioned to paint the king's portrait. During the Chosŏn dynasty, portraits of famous scholars and officials were often commissioned by their descendants and Confucian scholars to be enshrined in *samyo* (places of enshrinement in memory of ancestors and teachers).
CS

101. HIGH ALTAR CHAIR

Late Chosŏn
Wood
49½ x 24⅜ x 14 in
(126.5 x 62.0 x 35.5 cm)
Onyang Folk Museum, Onyang

102. TABLE FOR MEMORIAL SERVICE

Late Chosŏn
Wood
31⅜ x 40⅜ x 31 in
(79.8 x 102.5 x 78.9 cm)
Onyang Folk Museum, Onyang

103. TABLE FOR INCENSE BURNER

Late Chosŏn
Wood
18¼ x 18⅛ x 12¼ in
(46.4 x 46.0 x 31.0 cm)
Onyang Folk Museum, Onyang

104. SPIRIT TABLET CASE

Late Chosŏn
Lacquered wood
12¼ x 9¼ x 5¼ in
(31.0 x 23.5 x 13.2 cm)
Onyang Folk Museum, Onyang

105. MEMORIAL TABLET CASE

Late Chosŏn
Wood
23⅞ x 21¼ x 14⅛ in
(60.8 x 55.2 x 35.8 cm)
Lee Wŏn-ki Collection, Seoul

106. INCENSE BURNER

18th century
Porcelain
H. 6½ in (16.4 cm)
Chŏng So-hyon Collection, Seoul

This utensil for religious services has
numerous holes in its domed lid that allow
incense smoke to escape. The knob on top
of the lid is pierced on each pentagonal
facet. The handles on the body also have
holes along their vertical faces, and at the
base are perforations in the shape of
modified clouds.

The clay is a delicate white, and it is
thickly coated inside and out with a highly
glossy, blue-tinted glaze. The contacting
surfaces of the lid and body were coated
with alum powder. Glaze was wiped off the
bottom, which was coated lightly with white
fireproof clay before firing.

This piece is typical of utensils made
during the later Chosŏn period.

CYM

107. INCENSE CASE

Late Chosŏn
Porcelain
H. 4½ in (11.6 cm)
National Museum of Korea, Seoul

Incense cases such as this one were placed
with incense burners on low tables before
the main table of an ancestral shrine (see fig.
11, p. 87). These cases are used to store
wood chips from the incense tree. The lid of
this example is topped by a bead knob,
which has two incised lines around it. The
high, broad octagonal base is decorated with
alternating round and cloud-shaped
perforations.

The clay is a slightly dark white, and it
is coated with a transparent glaze. The foot
was wiped, and it was fired on sand.

CYM

108. PAINTED SPIRIT HOUSE

Late Chosŏn
Hanging scroll; color on paper
45¼ x 36⅞ in (114.8 x 93.2 cm)
Lee Wŏn-ki Collection, Seoul

The head of a family becomes an ancestor
upon his or her death. A memorial service
dedicated to this ancestor, as well as his or
her elders of three generations, is then
conducted regularly throughout the year: on
the memorial day of each ancestor; lunar
New Year; and Ch'usŏk, or Harvest Moon
Day. Ancestors from earlier generations are
venerated at other times, usually in the
tenth or third month of the lunar calendar.
Descendants gather to carry out these rituals
at a Confucian family shrine.

As bearers of the ancestors' spirits,
tablets are inscribed with the sobriquets the
ancestor used in life and are treated with
reverence. Ancestral tablets are housed in a
family memorial shrine. As embodiments of
the ancestors, these tablets reside with the
descendants. This painting is a two-
dimensional representation of an altar
prepared for a memorial service. Such
paintings were used as replacements for
actual shrines by the lower classes, who
could not afford to build a family shrine, or
by the middle classes as temporary
substitutes when official appointments
required them to relocate.

The ancestral tablet is located at the
center of the painting. It has been placed in
front of the open doors of a one-story
building. On the table, ritual vessels of
various shapes hold fruit and rice cakes; red
peonies are contained in beautiful crackled-
glazed vases standing on both sides of the
table. Flanking the ancestral tablet are
lighted candles—symbols of the heartfelt
sentiments of the descendants.

While this painting depicts an ancestral
altar fashioned after a Confucian shrine,
Buddhist decorative elements, such as the
lotus-blossom shape of the tablet's base, as
well as various expressive features found in
late Chosŏn folk paintings are combined in
an interesting configuration. The depiction
of wood patterns and the partial use of
perspective convey a limited sense of
realism. Nevertheless, the overarching
tendency toward simplification and
abbreviation situates this work within the
stylistic parameters of eighteenth-century
folk paintings.

KWB

109. FUNERARY VESSELS

About 1764
Porcelain
Set of twenty vessels; largest,
H. 2⅜ in (6.1 cm)
Yŏnsei University Museum, Seoul

Vessels such as these were used in funerary
and memorial services. This set was found
in a marble case during the 1974 excavation
of the grave of a concubine of King Yŏngjo
in Wonkyung Garden at Yŏnsei University.
As this was the grave of the mother of
Crown Prince Sado, the vessels are of the
highest quality. One vessel with legs, one
jar, and one bowl suffice for most services,
but this is an unusually large set.

The vessels are made of carefully
refined white clay and were coated with a
thick glaze that melted completely and did
not crackle. Glaze was wiped off the bottom
of each piece, which was then fired on a
sand strut. The color of the surface is a
slightly blue snow white. The only
decoration is an intaglio wave design on
one vessel.

CYM

110. EPITAPH TABLETS

Dated 1764
Porcelain painted with underglaze blue
Five pieces, each, 7½ x 6 x ⅝ in
(19.1 x 15.1 x 1.6 cm)
Yŏnsei University Museum, Seoul

Epitaphs chronicling the birthday, origins, and achievements of a deceased person were written on tablets and placed in front of the grave. Made of stone or ceramic, the tablets varied in number, depending on the importance of the person eulogized. Writing may be intaglio or inlay on stone, or painted in blue or iron brown on ceramic. Because they are dated, epitaphs provide important information on ceramic manufacture.

This five-tablet example was excavated from the same site as the funerary vessels in the preceding item (no. 109) and was contained in the same marble case. The epitaph is written in blue, and a standard tablet has nine columns of fifteen characters. One edge of each tablet is numbered (from one to five), and the opposite side notes that there is a total of five. On the fourth tablet is the date of manufacture, 1764.

Like the funerary vessels, a well-refined white clay was used; the calligraphy is in cobalt blue. The glaze coating is thick and melted well. The backs were wiped before firing took place on sand.

CYM

111. EPITAPH TABLETS AND CONTAINER

Dated 1710
Tablets
Porcelain painted with underglaze blue
Nine pieces, each, 7⅝ x 5¾ x ⅜ in
(19.5 x 14.5 x 1.1 cm)
Container
Porcelain
D. 12½ in (31.9 cm)
Hae-kang Museum, Ich'ŏn

This epitaph of nine tablets was buried in a white case. It is the epitaph of one Hong Sungmin (1536–94), and the ninth tablet states that it was made in 1710.

A standard tablet has twelve columns of twenty-four characters written in blue,

the intensity of which varies and is darker on the edges than the faces. The glaze was removed from the back of the tablets before firing.

The case has a deep, wide body on a high base and is topped by a lid with a flat area in the center. The white clay is coated inside and out with a glaze that has a light golden cast, and it crackled on the outside. The rims of the lid and body were wiped and coated with fireproof clay, and the foot was wiped before firing on sand.

CYM

112. RITUAL DISH

Late Chosŏn
Porcelain
H. 3⅛ in (7.9 cm)
National Museum of Korea, Seoul

Ceramic ware began to be used in religious services during the Koryŏ period (918–1392). From the early Chosŏn period until the seventeenth century, certain

complex shapes for ritual use were restricted to the royal family, government offices, and schools.

This late Chosŏn dish is a smaller, simpler version of a type used by the royal family; its shape is called a *koe*. It was used for offerings of mixed rice. Ritual dishes typically bear an inscription on each side.

The clay is a delicate light tan, and the glaze snow white. The foot was wiped, and it was fired on sand.

CYM

113. Ritual Dish

18th century
Porcelain painted with underglaze blue
D. 7⅜ in (18.7 cm)
National Museum of Korea, Seoul

This ritual utensil was used on a memorial table as a prop for a spoon and chopsticks. Upon addressing the ancestors, before making the first bow, the celebrant would tap this dish three times with the metal chopsticks to alert the spirit and then begin the service.

After being formed on the wheel, this dish was trimmed to form a decagon; such trimming is characteristic of the middle and late Chosŏn periods and is especially common in ritual utensils. The walls are thin near the rim. Evidence of cutting is visible in the interior where the walls adjoin the bottom. The character *che*, meaning "offering," is inscribed within a circle in blue.

The pure white clay was well refined, and the bluish cast glaze is even. The interior of the base was deeply cut, and the glaze was wiped off the bottom before the dish was fired on sand.

CYM

114. Ritual Dish

18th century
Porcelain
D. 7¼ in (18.3 cm)
National Museum of Korea, Seoul

After being thrown, the body and lip of this dish were cut to form an octagon. The light-gray clay was not well refined, and the large proportion of sand gives the body a rough texture. The glaze is thick and even, and the firing method was the same as that used for the previous example.

CYM

115. Ritual Dish

18th century
Porcelain painted with underglaze blue
H. 3⅛ in (7.9 cm), W. 8¾ in (22.2 cm)
Chŏng Kap-bong Collection, Seoul

Ceramic ritual utensils for Confucian shrines and services were usually simply shaped and often made of pristine white porcelain. This dish is composed of a nearly square slab that features upward-curving sides and is mounted on a high octagonal base. Notches are cut into the corners of the square, which is rimmed by an incised line. The character *che* ("offering") is inscribed in thin strokes within a circle in blue.

The white clay body was thickly coated inside and out with a slightly greenish glaze. Glaze was wiped from the bottom, and it was fired on sand.

CYM

116. Ritual Wine Jar

18th century
Porcelain painted with underglaze blue
H. 14 in (35.5 cm)
Namkung Lyŏn Collection, Seoul

The increasing cultivation of the self was an important part of eighteenth-century Korean culture, having begun during the seventeenth century and being well established by the nineteenth. One aspect of this process was the development of ritual utensils for use in private homes, and this ritual wine jar is an example of a Korean form. The rim at the mouth of the long neck is unusual.

The painting shows a blossoming plum and the character *che* ("offering"). The plum was painted with a soft touch and is well integrated with the shape and silhouette of the vessel. The details of the plum are carefully represented, and the painting bears the mark of an intelligent, able man. By the nineteenth century, the character *che* was put on such wine vessels, but pictures, such as this plum, were decreasingly common.

The pure white clay is covered with a glaze that has a slight blue tint.

CYM

117. Assembly at the Western Paradise

Dated 1703
Hanging banner; color on silk
120¾ x 99¾ in (306.8 x 253.3 cm)
National Museum of Korea, Seoul

Many adherents of Mahāyāna Buddhism in East Asia practice a form that is sometimes called "salvationist" and hope to be reborn after death in the Western Paradise (Sukhāvatī), which is presided over by the Buddha Amitābha. People worship Amitābha in preparation for rebirth in the next life. One of the easiest and most popular methods of worship is the recitation of the incantation, in Korean, *Namu Amit'abul Kwansaeŭmbosal*. While Amit'abul, or Amitābha Buddha, is called upon for benediction in the world to come, Kwansaeŭmbosal, or the bodhisattva Avalokiteśvara, is evoked for blessings in this world. Buddhist monks and adherents believe that calling upon these deities will procure rebirth in the Western Paradise and guarantee happiness in this world.

Avalokiteśvara is a Buddhist deity of miraculous virtue who offers compassionate salvation from all kinds of afflictions. Legends related to this favorite deity of Korean Buddhism still circulate the country.

The compassion of Amitābha (who leads souls from the nine stages of birth into the Western Paradise) toward sentient beings is magnanimous and deep. The *mudrā*, or gesture, of Amitābha is consequently called the "*mudrā* of the nine stages." In this painting, Amitābha's gesture signifies one of the stages of rebirth.

Amitābha is always accompanied by Avalokiteśvara. In this painting, Amitābha is seated in the center, and Avalokiteśvara stands on his left in the front, holding the stem of a lotus, upon which sits a bottle of nectar (Skt. *amṛta*). The bodhisattva who mirrors Avalokiteśvara is Mahāsthāma-prapta. Late Chosŏn dynasty paintings with similar subjects, however, often replace Mahāsthāmaprapta with the image of Kṣitigarbha, savior of the hell dwellers. This painting pairs Avalokiteśvara with Mahāsthāmaprapta, Samantabhadra with Mañjuśrī, and Vajragarbha with an unidentified bodhisattva. These figures surround Amitābha in a circular configuration. This circular composition, which is less rigid than the hierarchical composition of paintings from earlier periods, was widely used at the end of the Chosŏn period. Three-color jewel clouds, symbols of the Western Paradise, gently envelop the foreground figures, beyond which dimly appear the borders of the Western Paradise, which are painted in umber tones.

KWB

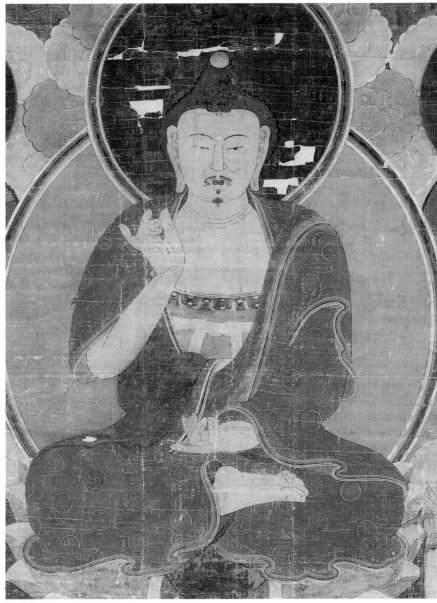

Detail of No. 117

who represent the souls to be saved. In the foreground are various scenes of the secular world, including calamities. The three-part structure of deities, ritual offering, and secular scenes is reflected in Nectar Ritual paintings' tripartite compositions, and while there is a clear demarcation between the top two portions in this example, the offering scenes and the smaller-scale secular scenes are joined by a continuous ground plane; different vignettes of the secular world are separated by clouds. The pine tree on the rocky terrain in the lower left corner is symbolic of the mundane world. The rich, vivid colors of this large banner painting are typical of Buddhist paintings.

According to the inscription, this painting was originally commissioned by Bongsŏ-am; yet the exact location of this subtemple is unclear. Nonetheless, the fact that even a small temple would commission a Nectar Ritual painting reveals the wide popularity of universal salvation rites.

KWB

119. BUDDHIST ALTAR ORNAMENT

Late Chosŏn
Painted wood
9 x 59½ x 3¾ in
(23.0 x 151.1 x 9.5 cm)
Lee Wŏn-ki Collection, Seoul

This is believed to have ornamented the altar of a Buddhist temple. Made of wood approximately four inches thick, various images of lions and *haet'aes*, mythological protective animals, were carved against images of rocks and pine trees. The successfully rendered depth and perspective on such a small surface impart a dimensionality close to that of freestanding sculpture.

On the far left soars a pine tree, beneath which three lions, who are perched upon rocks, roar fiercely. Underneath the oak tree in the center, two *haet'aes* with porcine snouts, protruding eyeballs, and long manes sit facing each other. On their right are two similar beasts, who turn their backs and climb the rocks to gaze upward. The varying degrees of depth within which these animals are rendered impart a lively sense of distance and space. Their spontaneous poses and intersecting gazes also convey a spirit of animation akin to that seen in a painting.

On a layer of pale green are leaves of varying shades of dark green and brown; gold powder sumptuously decorates the tree trunk and branches. A light green pigment covers the rocks, and an alternating color

118. NECTAR RITUAL PAINTING

Dated 1759
Hanging banner; color on silk
89¼ x 71⅝ in (228.0 x 182.0 cm)
Ho-Am Art Museum, Yongin

During the Chosŏn period, especially the eighteenth century, certain forms of painting developed in conjunction with the spread of Buddhist rites for ancestors. Among them was the Nectar Ritual painting, a form unique to Korea, which was apparently related to the group of rituals known as the universal salvation rites. Related Buddhist texts include the *Nectar Sutra* (Skt. *Amṛta sūtra*), the *Ullambanapātra Sūtra*, the *Sutra of Filial Piety* (Ch. *Fumu enzhong jing*), and the *Lotus Sutra* (Skt. *Saddharmapuṇḍarīka sūtra*). Nectar (Skt. *amṛta*) is the sweet dew of immortality.

As the rituals are concerned with helping souls to be reborn in the paradisal Pure Land (Sukhāvatī), over which the Buddha Amitābha presides, Nectar Ritual paintings include depictions of deities who help in this process. At the top of this unusual vertical-format example are the seven Buddhas, among whom only Amitābha looks toward the viewer. The Buddhas are flanked on the viewer's right by the bodhisattvas Kṣitigarbha, who holds a staff, and Avalokiteśvara, who is wearing a white robe, and on the left by the bodhisattva who leads souls to paradise, who is depicted with flying scarves. Below them is an altar table as it appears during the ritual ceremony, with spirit tablets, flowers, and food offerings. Around the table are depicted scenes of the ritual, such as monks making offerings and a royal procession, as well as two hungry ghosts,

scheme of red, blue, and dark green, against a light green background, is applied to the beasts' manes. This magnificent fragment testifies to the sophistication of the wood-carving technique that was achieved during the Chosŏn period.

KWB

120. DRUM STAND

Late Chosŏn
Painted wood
36⅛ x 54⅛ x 22 in
(93.0 x 138.0 x 56.0 cm)
Ho-Am Art Museum, Yongin

This wooden sculpture in the form of a lion and the wooden pole that protrudes from its back originally were used to support a Buddhist temple drum. With four firmly positioned paws and a head that is turned to emit a fearsome roar, this lion exudes unrestrained liveliness. Long, drooping ears, bulging eyes, and wave-patterned eyebrows mark the proportionately large head. The stubby, wrinkled nose features large nostrils, and the open mouth reveals rather blunt teeth. Below the jaw and behind the nearly invisible neck are schematized renderings of a beard and mane. The legs seem somewhat short to support such a massive body. Four toes are delineated on each paw. A large saddle, draped with a lotus leaf, covers the lion's back and extends to his knees. Such lotuslike pedestals are believed to have been directly derived from the turtle-shaped decorations found on pagoda bases.

In the center of the lotus leaf is a separately carved wooden cylindrical pole atop a spherical base. The tail, also a separate piece, projects upward then suddenly bends down. The schematic, yet lively, rendering of the curly hair of the tail accords well with the exuberant spirit of the lion.

Red tinges the legs, saddle, pole, and parts of the tail; traces of green can be detected on the mane, inside the mouth, and on the lotus leaf. Most of the color, however, has deteriorated.

The lion's size suggests that it might have been housed in a separate structure for temple drums. Though the loss of the drum is quite regrettable, this stand is an excellent example of the remarkable wooden sculpture of the late Chosŏn period.

KWB

121. PAIR OF CANDLESTICKS

Late Chosŏn
Painted wood
Each, H. 39¼ in (99.6 cm)
Onyang Folk Museum, Onyang

These candlesticks, made entirely of wood and of similar size and style, are believed to have been produced as a pair. The base of each pedestal is in the form of a crouched lion turning its head toward one side. The toothy grin of the lion on the right, along with the series of round knobs that suggest a beard beneath the chin, evokes a waggish mythical animal rather than a lion. A pedestal, in the form of lotus petals, rests on each animal's back, atop of which stands a cylindrical strut carved to resemble bamboo. On top of each strut sits a candlestick plate, upon which stands the tall, cylindrical candle holder, which is proportionately larger than the strut.

Noteworthy are the slightly differing decorations on the two candlesticks. The lotus-petal patterns around the lower and upper edges and the schematized cloud designs on the uppermost edge are similar, but the designs of the middle sections exhibit slight variations: one is encircled by a dragon amidst clouds, and the other is a dragon amidst lotus flowers. The two designs seem to represent a cloud dragon and a sea dragon.

The pervasive polychrome suggests that these were used in a Buddhist temple. These candlesticks are rare survivals since most extant examples from the Chosŏn period are brass or iron. The large, yet intricately carved, designs make these outstanding works.

KWB

122. MOUNTAIN SPIRIT

Late Chosŏn
Hanging scroll; color on silk
37⅛ x 28½ in (94.3 x 72.4 cm)
Zozayong Collection, Po-Eun

The Mountain Spirit is a Shamanistic deity. The objects of Shamanistic worship include elements from nature—such as the sun, moon, stars, mountains, wind, trees, and the cardinal directions—as well as human figures, such as generals, kings, high officials, and brides. Belonging to the category of nature deities, the Mountain Spirit reflects the popular reverence toward mountains as they offer many benevolent features and inspiration. The Mountain Spirit has been widely adored by the populace as a merciful, protective god.

Worship of the Mountain Spirit had long been a native religious practice in Korea. During the late Chosŏn period, the Mountain Spirit entered the realm of Buddhist religious practice in the role of Buddhism's protector. Most temple complexes, therefore, came to include an independent hall for the Mountain Spirit (sansin-gak), within which a painting of the subject was enshrined. Mountain Spirit paintings were also a crucial element of iconography of a shaman's spirit house.

In the center of the painting is an aged figure representing the Mountain Spirit, flanked by an extremely ancient tiger on the right and a young boy attendant on the left. This representation is typical of Mountain Spirit paintings of the late Chosŏn period. Except for the boldly colored rocks and pine trees in the background, the surrounding space is plain, which enhances the presence of the key figures in the foreground.

Wearing a long, red robe, the Mountain Spirit is seated with both hands on his knees. Particularly notable are the use of shading on the face, which reinforces the dimensionality of its features; the realistic depiction of the eyes; and the minutely depicted strands of facial hair. These features place this work above similar depictions, which generally exhibit a rough and crude style.

The boy attendant, who holds a staff, wears draped clothing, has grape leaves around his neck and shoulders, and has a gourd vessel attached to his belt. The relaxed tiger is drowsing. Echoing the tradition that the Mountain Spirit was transformed into a tiger, the pose of the tiger seems to reflect the tranquil world of the Mountain Spirit.

KWB

123. PORTRAIT OF THE MONK SŎSAN DAESA

Probably 18th century
Hanging scroll; color on silk
50⅛ x 31 in (127.3 x 78.7 cm)
National Museum of Korea, Seoul

Hyujŏng (1520–1604) was more widely known by his Buddhist name Sŏsan Daesa. During the 1592 Japanese invasion of Korea, when Hyujŏng was seventy-two years old, he raised an army of fifteen hundred men and assumed the role of commander in chief. In the following year, he retook the capital city with the aid of Ming armies for which King Sŏnjo endowed him with a eulogistic title. Sŏsan Daesa, however, is more commonly remembered as the monk who revived Buddhism, which had undergone a steady decline, and established the Chogye orders, or Korean Meditation Schools, in Korean Buddhism.

In this full-length portrait, the subject is seated in a chair, facing slightly right. He wears a monk's gray robes and red *kaṣāya* (a piecework garment symbolic of the first Buddhist monks' robes). In his left hand he holds a bamboo staff topped by a carved dragon's head; the right grasps the arm of the chair. The floor is covered with matting woven in elaborate patterns, which is depicted as if viewed from above, and the shape of the chair is distorted. In contrast, the facial treatment is fully realized. Against a pale foundation, the painter outlined the features with thin, even brushstrokes. Even though no shading was employed, the subject's character of gentle firmness is conveyed clearly.

This style is typical of the religious portraiture that originated during the late Koryŏ period. Most monks' portraits were enshrined in temples dedicated to that purpose (*josakaks*). The deterioration of the portraits brought about by burning incense necessitated the production of copies. This portrait is thought to be a duplicate made during the later Chosŏn period. Nevertheless, the style of brushwork exhibits fidelity to the original.

CS

124. PORTRAIT OF A MONK

Late Chosŏn
Hanging scroll; color and ink on silk
45⅛ x 31⅛ in (114.7 x 79.7 cm)
Cleveland Museum of Art, Mr. and Mrs. William H. Marlatt Fund, 90.16

Buddhism in the Chosŏn dynasty is roughly classified into the Orthodox School, *kyochong*, and the Sŏn Meditation School (Skt. *dhyana*, Ch. Chan, J. Zen). While most temples in Korea did not distinguish themselves as proponents of a particular sect, the Orthodox School preferred to enshrine paintings that illustrated the contents of the Buddhist scriptures. Followers of the Sŏn School, seeking illumination only within their own spiritual experience, emphasized the teachings and deeds of the masters over the scriptures. Portraits of former masters, who were living embodiments of enlightenment, were thus revered by disciple monks. This practice led to the proliferation of portrait paintings of Buddhist priests.

"True-image" (*chinyŏng*) portraits not only record a priest's outward appearance but also encapsulate his enlightened spiritual mind. Apart from the sitter's individual features, these portraits were extremely formulaic.

Even though the figure in this painting has not been identified, he is certainly a high priest of the Sŏn sect, active during the late Chosŏn period. In his left hand he holds a Buddhist staff of a type that was exclusively used by high priests when preaching to the masses. Wearing a green monk's robe and an elaborate, gold-brocaded red *kaṣāya* draped from his left shoulder, he is seated cross-legged on the floor. An open copy of a scripture and a brush and ink set lie on the table in front of him. A departure from the earlier format of depicting such subjects in chairs, a practice based on Chinese prototypes, this floor-seated pose became widespread in eighteenth-century true-image portraits.

Suspended from the golden dragon's-head finial of the staff falls a long, white tassel rendered in punctilious detail, which, together with the minutely expressed countenance, constitute the key points that make this a moving painting. The face is cast with the insight and dignity found only in those who have attained enlightenment.

KWB

125. PORTRAIT OF A GENERAL

Late Chosŏn
Hanging scroll; color on silk
36¾ x 14⅜ in (93.3 x 36.4 cm)
National Museum of Korea, Seoul

Since early times, Shamanism has been Korea's channel of transmission of popular beliefs to new generations. The principal priest (or priestess), generally referred to as *mudang*, of a Shamanistic ceremony used paintings of various deities in conducting rituals. This portrait is one such example. Sacred elements from nature or human figures, such as this general, constitute the majority of the numerous deities in the Shamanistic pantheon.

Shamanistic paintings were generally painted by the shamans themselves, based on their religious vision or experience. These paintings tend to exhibit, therefore, a rather rough and amateurish style. Powerful shamans, however, could engage the services of independent commercial painters or professional Buddhist monk painters.

This painting is distinguished from other Shamanistic paintings by its elegant quality. In contrast to a color scheme dominated by strong primary colors, this portrait is characterized by soft, intermediate tones, which, together with the rather realistic rendering of the figure's costume, suggest a professional hand. The quality of this portrait indicates that the shaman who commissioned this work probably had connections, albeit informal, to the court or to an aristocratic family. This assumption is based on the fact that the activities of the shaman mainly centered around the Sŏngsu-ch'ŏng (Star-Dwelling Office) until the early Chosŏn period.

The subject of this painting is a military officer deified as a general. His costume signifies that he was a military officer whose main duties involved soldiering and who also served as a police officer during the late Chosŏn period. The figure's stance denotes confidence and pomp, while his neatly clasped hands and slightly bent head suggest modesty. His faint smile and arching eyebrows are characteristic features of Shamanistic paintings of the late Chosŏn period.

KWB

126. BOY ATTENDANT

Late Chosŏn
Painted wood
H. 13¼ in (33.6 cm)
Philadelphia Museum of Art, Purchased through Morris Fund

The figure of a boy attendant usually accompanies a main figure either in the Hall of Lohans or in the Hall of Kṣitigarbha of a Chosŏn temple. Extant boy attendant sculptures found in Korean temples include figures scattering flowers in honor of Buddha or Sudhana, attendants to Mañjuśrī or Samantabhadra, or attendants found in the Hall of Lohans and the Hall of Hell. These figures date mostly from the late Chosŏn dynasty. This particular figure is surely a boy attendant for one of the Ten Kings of Hell.

Similar figures generally hold a tray of peaches, pomegranates, and melons—sometimes in combination with auspicious symbols, such as the lotus, turtle, or , phoenix. The hair is usually straight but sometimes it is braided and secured by a pair of tight knots. This figure has straight hair and is holding a tray of peaches. The thick, simplified clothing; round, even body; and the rather precocious expression are the dominant characteristics of this figure. Such style can be understood in relation to Buddhist sculptures from the late Chosŏn period, while the rather rough finish is exemplary of the wood-carved works of Chosŏn folk art.

The entire body was carved from a single piece of wood and was affixed to a separate square pedestal. Green, red, black, blue, and yellow were applied to the entire surface, and gold powder was used in etched decorative patterns.

Boy attendant figures were widely produced as the cult of Kṣitigarbha became widespread. Wood was the most commonly used material as it was easily accessible and inexpensive. Apart from being a religious work, this sculpture expresses the humor and intimacy of the folk decorative arts.

KWB

Select Bibliography

Acker, William, trans. *Some T'ang and Pre-T'ang Texts*. 2 vols. Leiden: E. J. Brill, 1954 and 1974.

Adams, Edward B. *Palaces of Seoul: Yi Dynasty Palaces in Korea's Capital City*. 2d ed. Seoul: Seoul International Tourist Publishing Co., 1982.

_____. *Korean Ceramics of the Koryŏ Dynasty*. Korea's Pottery Heritage, vol. 2. Seoul: Seoul International Publishing House, 1990.

_____. *Korean Ceramics of the Chosŏn Dynasty*. Korea's Pottery Heritage, vol. 3. Forthcoming.

Ahn, Hwi-joon. *Korean Landscape Painting in the Early Yi Period: The Kuo Hsi Tradition*. Ph.D. dissertation, Harvard University, Cambridge, MA, 1974.

_____. "An Kyŏn and 'A Dream Visit to the Peach Blossom Land.'" *Oriental Art* 26, no. 1 (Spring 1980).

Buswell, Robert. "Buddhism under Confucian Domination: The Synthetic Vision of Sŏsan Hyujŏng (1520-1604)." Paper presented to the Conference on Confucianism and Late Chosŏn Korea, University of California, Los Angeles, January 1992.

Choe, Ching Young. "Kim Yuk (1580-1658) and the *Taedongpŏp* Reform." *The Journal of Asian Studies* 23 (Nov. 1963).

Cox, Susan. "An Unusual Album by a Korean Painter, Kang Se-hwang." *Oriental Art* 19, no. 2 (1973).

d'Argencé, René-Yvon Lefebvre, ed. *5,000 Years of Korean Art*. Exh. cat. San Francisco: Asian Art Museum of San Francisco, 1979.

Deuchler, Martina. *The Confucian Transformation of Korea*. Cambridge, MA: Harvard University Press, 1993.

Gompertz, G. St. G. M. *Korean Celadon and Other Wares of the Koryŏ Period*. London: Faber and Faber, 1963.

_____. *Korean Pottery and Porcelain of the Yi Period*. London: Faber and Faber, 1968.

Griffing, Robert P. *The Art of the Korean Potter: Silla, Koryŏ, Yi*. Exh. cat. New York: The Asia Society, 1968.

Haboush, JaHyun Kim. "The Sirhak Movement of the Late Yi Dynasty." *Korean Culture* 8, no. 2 (Summer 1987).

_____. *A Heritage of Kings: One Man's Monarchy in the Confucian World*. New York: Columbia University Press, 1988.

_____. "The Confucianization of Korean Society." In *The East Asian Region*. Princeton: Princeton University Press, 1991.

_____. "Dual Nature of Cultural Discourse in Chosŏn Korea." Vol. 4 of *Proceedings of 33d International Congress of Asian and North African Studies*. Queenston, Ontario: Edwin Mellen Press, 1992.

_____. "Public and Private in the Court Art of Eighteenth-Century Korea." *Korean Culture* 14, no. 2 (Summer 1993).

_____. *The Memoirs of Lady Hyegyŏng*. Forthcoming.

Huh, Dong Hwa. *Traditional Wrapping Cloth*. English version by Sheila Middleton. Exh. cat. Seoul: Museum of Korean Embroidery, 1990.

A Hundred Treasures of the National Museum of Korea. Seoul: National Museum of Korea, 1972.

Itoh, Ikutaro, Yutaka Mino, Jonathan Best, et al. *The Radiance of Jade and the Clarity of Water: Korean Ceramics from the Ataka Collection*. Exh. cat. Chicago and New York: The Art Institute of Chicago and Hudson Hills Press, 1991.

Kalton, Michael. "An Introduction to Sirhak." *Korea Journal* 15, no. 5 (May 1975).

_____. "Horak Debate." Paper presented to the Conference on Confucianism and Late Chosŏn Korea, University of California, Los Angeles, January 1992.

Kawashima, Fujiya. "The Local Gentry Association in Mid-Yi Dynasty Korea: A Preliminary Study of the Ch'angnyŏng Hyangan 1600-1839." *The Journal of Korean Studies* 1 (1980).

Kim, Chewon, and G. St. G. M. Gompertz. *Korean Arts*. Ceramics, vol. 2. Seoul: Ministry of Foreign Affairs, Republic of Korea, 1961.

Kim, Chewon, and Lena Kim Lee. *Arts of Korea*. Tokyo, New York, and San Francisco: Kodansha International, 1974.

Kim, Chewon, and Wŏn-yong Kim. *Treasures of Korean Art: 2000 Years of Ceramics, Sculpture, and Jeweled Arts*. New York: Harry N. Abrams, 1966.

Korean Paintings Selected from the Collection of the National Museum—To Be Shown for the First Time to the Public. Seoul: National Museum of Korea, 1977.

Lee, Ki-baik. *A New History of Korea.* Translated by Edward W. Wagner with Edward J. Shultz. Cambridge, MA: Harvard University Press, 1984.

Lee, Lena Kim. "Chŏng Sŏn: Korean Landscape Painter." *Apollo* (August 1968).

Masterpieces of 500 Years of Korean Painting. Seoul: National Museum of Korea, 1972.

Masterpieces of Korean Art. Exh. cat. Boston: Museum of Fine Arts, 1957.

McCune, Evelyn B. *The Inner Art: Korean Screens.* Seoul: Asia Humanities Press and Po Chin Chai Co. Ltd., 1983.

Moes, Robert. *Auspicious Spirits: Korean Folk Paintings and Related Objects.* Washington, D.C.: The International Exhibitions Foundation, 1983.

National Museum of Korea. Oriental Ceramics, the World's Great Collections, vol. 2. Tokyo: Kodansha International, 1976.

Pak, Young-sook. *The Cult of Kṣitigarbha: An Aspect of Korean Buddhist Painting.* Ph.D. dissertation, University of Heidelberg, Heidelberg, 1981.

⸻. "Internationalism in Korean Art." *Orientations* 15, no. 1 (1984).

Palais, James B. *Politics and Policy in Traditional Korea.* Cambridge, MA: Harvard University Press, 1975.

Pihl, Marshall. *The Korean Singer of Tales.* Cambridge, MA: Harvard University Press. Forthcoming.

Seckel, Dietrich. "Some Characteristics of Korean Art, part 2: Preliminary Remarks on Yi Dynasty Painting." *Oriental Art* 25, no. 1 (Spring 1979).

Shaw, William. *Legal Norms in a Confucian State.* Berkeley: Institute of East Asian Studies, University of California, 1981.

Skillend, W. E. *Kodae Sosŏl: A Survey of Korean Traditional Style Popular Novels.* London: School of Oriental and African Studies, University of London, 1968.

Thorp, Robert L. *Son of Heaven: Imperial Arts of China.* Seattle: Son of Heaven Press, 1988.

Wagner, Edward. "The Ladder of Success in Yi Dynasty Korea." *Occasional Papers on Korea* 1 (April 1974).

Walraven, Boudewijn. "Popular Religion in a Confucianized Society." Paper presented to the Conference on Confucianism and Late Chosŏn Korea, University of California, Los Angeles, January 1992.

Whitfield, Roderick, ed. *Treasures from Korea: Art Through 5000 Years.* Exh. cat. London: British Museum Publications, 1984.

Williams, C. A. S. *Chinese Symbolism and Art Motifs.* Rutland, VT: Charles E. Tuttle Co., 1989.

Yi, Sŏng-Mi. *Korean Costumes and Textiles.* Exh. cat. Seoul: Korean Overseas Information Service and IBM Corporation, 1992.

Index of Works Illustrated

Admiring the Spring in the Country, Sin Yunbok (no. 88), 169

Album Commemorating the Gathering of the Elder Statesmen, Kim Chinyŏ, Chang Dŭkman, Pak Dongbo (no. 2), 27, 49, 100

Album Commemorating the Gathering of the Elder Statesmen (no. 3), 42 (detail), 101

Amorous Youths on a Picnic, Sin Yunbok (no. 89), 67

Assembly at the Western Paradise (no. 117), 192, 233

Bamboo Book for Crown Prince Ŭiso (no. 11), 110-11

Banana Tree, King Chŏngjo (no. 30), 130

Base for Sundial (no. 17), 115

Blacksmith's Shop, Kim Dŭksin (no. 86), 66

Bookcase (no. 40), 137

Bookcase with Three Shelves (no. 43), 139

Books and Scholar's Utensils, Lee Hyŏngrok (no. 32), 52-53

Box (no. 26), 128

Boy Attendant (no. 126), 201

Brush Hanger (no. 67), 153

Brush Washer (no. 48), 141

Buddhist Altar Ornament (no. 119), 194-95

Candlestick (no. 66), 152, 153 (detail)

Case for Gold Book (no. 13), 113

Cats and Sparrows, Pyŏn Sangbyŏk (no. 85), 167

Ceremonial Chant for the Ritual of the Royal Visit to the Yuksanggung Shrine (no. 35), 132

Chasing a Cat, Kim Dŭksin (no. 87), 168

Chest (no. 20), 120

Chest (no. 27), 128

Chrysanthemum, King Chŏngjo (no. 31), 131

Cosmetics Chest with Mirror (no. 28), 129, 211

Courtesan (Kisaeng), A, Sin Yunbok (no. 92), 172

Diagram for Rituals at the Ancestral Temple (no. 4), 102-03

Dining Table (no. 29), 45

Dining Table (no. 72), 156

Document Box (no. 41), 138

Document Chest (no. 42), 138

Document Chest (no. 64), 74-75

Document Chest (no. 73), 158-59

Drum Stand (no. 120), 197

Ducks Playing, Kim Hongdo (no. 83), 165, 224 (detail)

Epitaph Tablets (no. 110), 186-87

Epitaph Tablets and Container (no. 111), 187, 231

Four-Shelf Display Stand (no. 65), 152

Full Moon Amidst Bare Trees, Kim Hongdo (no. 84), 166

Funerary Vessels (no. 109), 185

High Altar Chair (no. 101), 180

Hunting Scene (no. 95), 76, 228 (detail)

Immortal Crossing the Ocean, An, Chŏng Sŏn (no. 58), 148

Incense Burner (no. 106), 184

Incense Case (no. 107), 184

Inkstone Decorated with a Relief of Lotus Leaves (no. 61), 150

Inkstone in the Shape of a Boat (no. 44), 140

Inkstone Table (no. 62), 150

Jade Book for King Changjo (no. 10), 110-11

Jar with Bamboo (no. 75), 160

Jar with Clouds and Dragon (no. 76), 161

Jar with Dragon (no. 24), 126

Jar with Dragons (no. 25), 127

Jar with Landscape (no. 77), 162

Landscape with Fishermen, Kim Hongdo (no. 56), 147, 218 (detail)

Lantern (no. 21), 121

Large Jar (no. 78), 69

Letter Rack (no. 39), 136

Letter Rack (no. 71), 73

List of Objects Made for the Wedding of a Crown Prince (no. 33), 132

Longevity Symbols with Cranes (no. 19), 118-19, 209 (detail)

Map of the Capital City (no. 15), 50

Map of the Eastern Palace (fig. 1), 36-37

Memorial Tablet Case (no. 105), 183

Mountain Spirit (no. 122), 81

Nectar Ritual Painting, 1701 (fig. 12), 93

Nectar Ritual Painting, 1759 (no. 118), 80 (detail), 193

Nectar Ritual Painting, 1790 (fig. 13), 94

Nectar Ritual Painting, 1791 (fig. 14), 95

Octagonal Vase with Flowers and Grass (no. 80), 164

Octagonal Vase with Orchid and Bamboo (no. 49), 142

Octagonal Vase with Plum Blossoms and Bamboo (no. 50), 143, 216

Painted Spirit House (no. 108), 91

Pair of Candlesticks (no. 121), 196

Paper Scroll Stand (no. 68), 154

Paper Scroll Stand with Orchids (no. 47), 61

Pavilion in the Western Garden, Chŏng Sŏn (no. 55), 146

Peonies (no. 22), 122-23

Poem Bestowed on the Magistrate of Ch'ŏrong-sŏng, King Chŏngjo (no. 36), 133

Portrait of a General (no. 125), 20-21 (detail), 200

Portrait of a Monk (no. 124), 199

Portrait of King Yŏngjo (fig. 6), 43

Portrait of Oh Jaesun, attributed to Lee Myongki (no. 100), 78 (detail), 179

Portrait of the Monk Sŏsan Daesa (no. 123), 198

Record of the Construction of the Royal City at Hwasŏng (no. 9), 112

Ritual Dish (no. 112), 188

Ritual Dish (no. 113), 189

Ritual Dish (no. 114), 190

Ritual Dish (no. 115), 191

Ritual Wine Jar (no. 116), 89

Rock, Grass, and Insect, Sim Sajŏng (no. 94), 173

Roof Tiling, Kim Hongdo (no. 82), 31

Royal Edict: Admonition to the Eldest Grandson of the King, King Yŏngjo (no. 37), 134

Royal Edict Case (no. 38), 135

Royal Procession to the City of Hwasŏng (no. 7), 106-07

Royal Visit to the City of Hwasŏng (no. 8), 108-09

Seal Box with Double-Dragon Design (no. 6), 105

Seal of Crown Prince Munhyo (no. 12), 112, 207

Seal of King Yŏngjo (no. 5), 104, 205

Self-Portrait, Yun Dusŏ (no. 60), 58

Seven Stars, The, (no. 14), 114-15

Snow-Covered Pine Trees, Yi Insang (no. 70), 155

Spirit Tablet Case (no. 104), 85

Strange Encounter at Mount Hwa (no. 34), 29

Sundial (no. 16), 114

Sun, Moon, and Five Peaks (no. 1), 38-39

Sun, Moon, and Immortal Peaches (no. 23), 34 (detail), 124-25

Table for Incense Burner (no. 103), 182

Table for Memorial Service (no. 102), 181

Ten Longevity Symbols (no. 18), 116-17

Ten Longevity Symbols (no. 99), 176-77, 178 (detail)

Three-Dragon Waterfall, Mount Naeyŏn, Chŏng Sŏn (no. 53), 145

Three-Shelf Cupboard (no. 74), 157

Tiger and Bamboo, Kim Hongdo, Im Hŭiji (no. 59), 22 (detail), 149

Tilling the Field, Kim Hongdo (no. 57), 147

Twelve Thousand Peaks of Mount Kŭmgang, Chŏng Sŏn (no. 54), 65

Valley of Ten Thousand Waterfalls, Chŏng Sŏn (no. 52), 144

Vase with Building and Lotus Pond (no. 81), 164

Vase with Flowers and Insects (no. 79), 163

Water Dropper in the Shape of a Peach (no. 69), 154

Water Dropper with Landscape (no. 46), 141

Water Dropper with Plum Blossom (no. 45), 141

Woman by a Lotus Pond, Sin Yunbok (no. 93), 172

Women by a Crystal Stream, Sin Yunbok (no. 91), 170

Women on Dano Day, Sin Yunbok (no. 90), 171

Wrapping Cloth (Chogakpo) (no. 98), 175

Wrapping Cloth (Chogakpo) with Four Tying Strings (no. 97), 175

Wrapping Cloth for Bedding (Ibulpo) (no. 96), 174

Writing Table (no. 63), 151

Yŏngt'ong-dong, from *Travel Sketches of Songdo*, Kang Sehwang (no. 51), 144

Contributors

Cho Sunmie is director of the Museum of Sung Kyun Kwan University, Seoul. Dr. Cho has extensively studied portrait painting of the Chosŏn period; she contributed entries on paintings.

Chung Yang Mo is director general of the National Museum of Korea. Mr. Chung, a specialist in Chosŏn-period ceramics, wrote an essay as well as the entries on ceramics.

JaHyun Kim Haboush is associate professor of East Asian Languages and Cultures at the University of Illinois. Dr. Haboush, a historian of royal institutions of the Chosŏn period, contributed an introductory essay.

Hong Sun Pyo is curator of the Hong Ik University Museum, Hong Ik University, Seoul. A specialist in Chosŏn-period painting, Mr. Hong contributed entries on paintings.

Kang Woo-bang is chief curator of the National Museum of Korea. A specialist in early Korean Buddhist art, Mr. Kang contributed an essay and entries on the religious objects.

Hongnam Kim is associate professor of art history at Ewha University, Seoul. Dr. Kim has published on Chinese and Korean art; she served as editor of the catalogue and contributed an essay as well as entries on art for royalty.

Park Young-Kyu is assistant professor of art at Yongin University, Yongin. A historian of Korean woodwork and lacquerware, Mr. Park contributed entries on furniture.

Yi Sŏng-Mi is associate professor and chairperson of art history at The Academy of Korean Studies, Sŏngnam. Dr. Yi has written on Chinese, Korean, and Japanese art; she contributed entries on royal objects and textiles.

Photograph Credits